Iconography of Power

STUDIES ON THE
HISTORY OF SOCIETY AND CULTURE
Victoria E. Bonnell and Lynn Hunt, Editors

VICTORIA E. BONNELL

Iconography of Power

Soviet Political Posters
under Lenin and Stalin

UNIVERSITY OF CALIFORNIA PRESS
BERKELEY LOS ANGELES LONDON

University of California Press
Berkeley and Los Angeles, Califoria

University of California Press, Ltd.
London, England

First Paperback Printing 1999

Library of Congress Cataloging-in-Publication Data

Bonnell, Victoria E.
 Iconography of Power : Soviet political posters under Lenin and Stalin / Victoria
E. Bonnell.
 p. cm. — (Studies on the history of society and culture ; 27)
 Includes bibliographic references (p.) and index.
 ISBN 0-520-22153-2 (pbk. : alk. paper)
 1. Soviet Union—Politics and government—1917–1936—Posters. 2. Soviet
Union—Politics and government—1936–1953—Posters. 3. Political posters,
Russian. I. Title. II. Series.
DK266.3.B58 1997
947.084—dc20 96-36252

Printed in the United States of America
9 8 7 6 5 4 3 2 1

Grateful acknowledgment is made to the following for permission to reprint
previously published material:

"The Iconography of the Worker in Soviet Political Art," in *Making Workers Soviet:
Power, Class, and Identity,* ed. Lewis H. Siegelbaum and Ronald Grigor Suny. © 1994
by Cornell University Press. Used by permission of the publisher.

"The Leader's Two Bodies: A Study in the Iconography of the *Vozhd',*" *Russian
History/Histoire Russe,* vol. 23, nos. 1–4 (1996). Reprinted with permission of *Russian
History/Histoire Russe.*

"The Peasant Woman in Stalinist Political Art of the 1930s," *American Historical
Review,* vol. 98, no. 1 (February 1993). Reprinted with permission of the American
Historical Association.

"The Representation of Women in Early Soviet Political Art," *The Russian Review,*
vol. 50, no. 3 (July 1991). © 1991 by the Ohio State University Press. All rights
reserved.

For Grisha

The publisher gratefully acknowledges the contribution
provided by the General Endowment Fund, which is supported
by generous gifts from the members of the
Associates of the University of California Press.

CONTENTS

ILLUSTRATIONS

PLATES

xi

Following page 46

1.1. Nikolai Kogout, "Oruzhiem my dobili vraga" (We Defeated the Enemy with Weapons), 1920

1.2. Rikhard Zarrin, "Patriotichno i vygodno! Pokupaite voennyi 5½% zaem" (Patriotic and Profitable! Buy the 5½% War Bonds), 1914–1917

1.3. "Tovarishch!" (Comrade!), 1917

1.4. "Vserossiiskaia liga ravnopraviia zhenshchin. Golosuite za spisok N. 7" (All-Russian League for Women's Equality. Vote for List No. 7), 1917

1.5. "Oktiabr' na severnom Kavkaze" (October in the Northern Caucasus), 1927

1.6. Aleksandr Matveev, *Oktiabr'skaia revoliutsiia* (October Revolution), 1927

1.7. "Da zdravstvuet pobeda truda" (Long Live the Victory of Labor), 1920

1.8. Boris Zvorykin, "Bor'ba krasnogo rytsaria s temnoi siloiu" (Struggle of the Red Knight with the Dark Force), 1919

1.9. Aleksandr Marenkov, "1 maia—zalog osvobozhdeniia mirovogo truda" (May 1—The Pledge of World Labor's Liberation), 1921

1.10. Petr Kiselis, "Belogvardeiskii khishchnik terzaet telo rabochikh i krest'ian" (The White Guard Beast of Prey Is Tearing the Body of Workers and Peasants to Pieces), 1920

1.11. "1 oktiabria—vsesoiuznyi den' udarnika" (October 1—The All-Union Day of the Shock Worker), 1931

1.12. "B'em po lzheudarnikam" (Down with the False Shock Workers), 1931

1.13. Gustav Klutsis, "Dadim milliony kvalifitsirovannykh rabochikh kadrov" (We Will Produce Millions of Qualified Workers' Cadres), 1931

1.14. Adolf Strakhov, "Dneprostroi postroen" (Dneprostroi Has Been Built), 1932

1.15. Viktor Govorkov, "Vasha lampa, tovarishch inzhener" (Your Lamp, Comrade Engineer), 1933

1.16. Vera Mukhina, *Rabochii i kolkhoznitsa* (Worker and Collective Farm Woman), 1937

PREFACE

THIS BOOK IS ABOUT SOVIET political posters between 1917 and 1953. It opens with the October Revolution and ends with the death of Stalin. In the course of these three and a half decades, many thousands of posters were designed, produced, and distributed. They had a variety of styles and imagery, but all belonged to a vast propaganda effort aimed at creating a new *Homo sovieticus.*

When I began the study, I wanted to understand the function of political art in transmitting official ideas, values, and norms. In essence, I was captivated by the role of posters in the symbolic representation of power. As the research proceeded, I became more and more interested in the contemporary reception of the messages conveyed by visual propaganda. How could I comprehend the "eye" of the Soviet viewer, so distant from myself in time, place, and cultural background?

To address these issues, I have tracked the evolution of certain images over time and attempted to make sense of the changes I uncovered— sense, that is, in terms of the broader historical, visual, and mythological context in which the transformations of images took place. Pierre Bourdieu has written that "the 'eye' is a product of history reproduced by education."[1] In carrying out the study, I have taken as a point of departure the idea that viewing pictures is a learned experience, one that is cumulative over time.

I have been greatly assisted in all of these tasks by various funding agencies that have allowed me to travel, view posters, and write about them. I am especially grateful to the John Simon Guggenheim Foundation, the American Council of Learned Societies, the President's Research Fellowship in the Humanities, the International Research and Exchanges Board (IREX), and the Center for Slavic and East European Studies, the Committee on Research, and the Institute of International Studies at the University of California at Berkeley. I want to extend special thanks to the Center for Advanced Study in the Behavior Studies, where this project originated.

I am indebted to the Hoover Institution Archives and Elena Danielson, who helped to launch me on this project by giving me access to the original posters in their collection. Nina Baburina and Svetlana Artamonova made it possible for me to examine hundreds of posters at the Russian State Library (formerly, the Lenin Library). Without their assistance, I could not have conducted such a comprehensive study of posters, many of them never before examined closely. Nikolai Alekseev provided photographs of the posters from the Russian State Library collection.

I have welcomed the advice and comments provided by colleagues, friends, and anonymous reviewers. Burton Benedict, Rose Glickman, Gail Kligman, Lynn Hunt, Moshe Lewin, and Reginald Zelnik have read various chapters of the manuscript. Evgenii Dobrenko was kind enough to read the entire manuscript and provide many valuable suggestions. My research assistants, Howard Allen, Elzbieta Benson, and Jeffrey Rossman, helped with many different tasks relating to the preparation of this book.

Finally, I want to express my extraordinary debt to my husband, Gregory Freidin, a scholar of great erudition and imagination. Without his stimulating comments and his cooperation in many matters, both big and small, I could never have written this book. Its completion was delayed by the illness of my father, Samuel Bonnell, who came to live in California during the final three years of his life. He was a cultivated and spirited man who loved the visual arts and was, in his youth, deeply moved by the very images that are the subject of this study.

KEY TO ABBREVIATIONS

BM British Museum, London

IWM Imperial War Museum, London

KP Kollektsiia plakatov (Poster Collection), Russian State Library, Moscow

MR Muzei revoliutsii (Museum of the Revolution), Moscow

RU/SU Russian and Soviet Poster Collection, Hoover Institution Archives, Stanford, California

TsGALI Tsentral'nyi gosudarstvennyi arkhiv literatury i iskusstva (Central State Archive of Literature and Art), Moscow

V/A Victoria and Albert Museum, London

NOTE ON TRANSLITERATION

THE SYSTEM OF TRANSLITERATION used here is the Library of Congress system. Names and places that are well known are given in their more familiar English form.

INTRODUCTION

THE CRITICAL ISSUE FACING the Bolsheviks in 1917 was not merely the seizure of power but the seizure of meaning. The Russian revolutions challenged old ways of comprehending the world and aroused profound uncertainty over the meaning of the past, present, and future. At no point was this crisis more severe and widespread than in October, when the Bolsheviks proclaimed the new Soviet state. As Lenin and other Bolshevik leaders understood, there was no consensus, even among their own supporters, about many fundamental issues of interpretation. In the turbulent months following the October Revolution, the Bolsheviks attempted to gain control over the sphere of public discourse and to transform popular attitudes and beliefs by introducing new symbols, rituals, and visual imagery. Their aim was nothing less than the redefinition of "all social values by an immense message designed to liberate, but also to create a new mystique."[1]

The medium for the message was what Eric Hobsbawm has characterized as "invented tradition," that is, "a set of practices . . . which seek to inculcate certain values and norms of behavior by repetition, which automatically implies continuity with the past."[2] Invented traditions, according to Hobsbawm, can perform three (possibly overlapping) functions.[3] First, they are created for the purpose of "establishing or sym-

bolizing social cohesion or the membership of groups, real or artificial communities." For the Bolsheviks, whose claim to power was based on an ideology that accorded world-historical importance to the proletariat, it was critically important to establish in public discourse the heroic position and collective identity of the working class. The party urgently needed to convey to the population at large an image of the new worker-heroes, the "conscious" workers who were the chosen people of Marxism-Leninism. Equally important was the need to inculcate the concept of "class" as the central epistemological element in the new official ideology. Class, rather than nationality, religion, gender, or ethnicity, was to serve as the basis for social and political solidarity. During the immediate postrevolutionary years and well into the 1920s, the Bolshevik party wrestled with the problem of defining collective identities and making policies consistent with these definitions.

Invented traditions perform a second function of "establishing or legitimizing institutions, status or relations of authority." Revolutions, such as the one in Russia in October 1917, discredit and destroy existing institutions and relations of authority, opening up the discursive field for an entirely new definition of the social order of political power. The key problem for the Bolsheviks in the months following the revolution was to legitimize the new party-state and a novel set of relations between subordinate and superordinate groups. The former dominant classes, and the Provisional Government that had ruled Russia since February 1917, lost power as a consequence of the October Revolution. In their place was the Bolshevik party and the new Soviet state, with its commissars, secret police, Red Army, and a small but vociferous band of true believers, fellow travelers, opportunists, and henchmen. The Bolsheviks recognized very early that power without legitimacy provided a precarious basis for a new regime. A key element in their legitimation strategy was the formulation and dissemination of their own master narrative of world history, which justified the establishment of a "dictatorship of the proletariat" under Bolshevik leadership and fortified the party's authority among the population.

A third major function of invented traditions is to promote "socialization, the inculcation of beliefs, value systems and conventions of behavior." In the years before seizing power, the Bolsheviks, under

Lenin's leadership, were distinguished from most other left-wing radi-
cal parties and groups in Russia by their profound commitment to a
monolithic view of the truth. After the October Revolution, this readily
translated into an effort to reorder all of individual and social life
in accordance with ideological precepts proclaimed by the Bolshevik
party. Although comprehensive socialization and indoctrination re-
mained beyond their reach until the 1930s, from the very inception the
Bolsheviks aimed at reconstituting the individual citizen so that even-
tually everyone would think, speak, and act Bolshevik as well.

Invented traditions, to be effective, must be invariant and repetitive,
and they must convey ideas in a way that will be comprehensible to the
intended audience. In the course of 1918, the Bolsheviks put into mo-
tion a propaganda apparatus designed to transmit the party's ideas to
the population by means of words (both spoken and written) and im-
ages.[4] By any previous standard, the effort was impressive and exten-
sive. Within a year of taking power, they had created compelling em-
blems and symbols (for example, the hammer and sickle, the red star,
and the image of the heroic worker), new or reconstituted rituals (the
November 7 [October 25] and May Day celebrations),[5] and novel de-
vices for transmitting their message (agit trains and ships, village read-
ing rooms, *instsenirovki*).[6] In addition, they used political posters,
monumental sculpture, books, newspapers and journals, and film to
bring their ideas to a broad audience. Not since the French Revolution
of 1789 had there been a regime so unequivocally committed to the
transformation of human beings through political education.

VISUAL PROPAGANDA

Mass propaganda took many different forms during the early years of
Soviet power, but there was a privileging of the eye in the task of polit-
ical education. This meant that a great deal of effort and ingenuity went
into the production of visual propaganda of all types. Visual methods
for persuasion and indoctrination appealed to Bolshevik leaders be-
cause of the low level of literacy in the country and the strong visual
traditions of the Russian people.

When the Bolsheviks took power, a majority of the population was still illiterate, especially outside major urban centers. Data for 1917 are not available, but twenty years earlier a national census disclosed that about 83 percent of the rural population and about 55 percent of the urban population was illiterate. As a result of the widespread literacy campaign waged by the Bolsheviks after taking power (an adjunct to their propaganda efforts), overall levels had substantially improved by 1926.[7] Nevertheless, about half of the rural population and one-fifth of the urban population still did not have even rudimentary literacy skills.[8] The "literate" classification was applied in the 1920s to a range of people, including some with only the most elementary ability to read and write. On the eve of the First Five Year Plan, a substantial proportion of the population (especially peasants) was still poorly equipped to read simple texts, such as newspapers. Visual propaganda, which greatly minimized the need to comprehend the written word, offered a means of reaching broad strata of the population with the Bolshevik message.

The centrality of visual images and rituals in old regime pageantry and especially the Russian Orthodox Church made for a highly visual traditional culture.[9] The Russian Orthodox icon occupies a special place in Russian religious practice. As Leonid Ouspensky observes in a study of icons: "It can be said that if Byzantium was preeminent in giving the world theology expressed in words, theology expressed in the image was given preeminently by Russia."[10] For the Orthodox believer, "the holy image, just like the Holy Scriptures, transmits not human ideas and conceptions of truth, but truth itself—the Divine revelation."[11] The image itself had sacred powers for the Orthodox believer. The power of saints, for example, "was thought to be especially concentrated in their icons, sometimes referred to as 'gods' (*bogi*), which in time of need or on ritual occasions were used for special blessings."[12] The prevalence of religious icons in Russian life—virtually every peasant hut had its own icon, as did many urban dwellings—gave Russians familiarity with a certain type of imagery and an assumption of its sacredness.

The Bolsheviks appreciated the effectiveness of images for reaching ordinary people with their message. Nadezhda Krupskaia, Lenin's wife, expressed the sentiments of many fellow party members in 1923, when

she observed: "For the present and the near future, a peasant can learn to improve his production only if he is taught by visual example. And in general, the peasant, just like the workers in their mass, think much more in terms of images than abstract formulas; and visual illustration, even when a high level of literacy is reached, will always play a major role for the peasant."[13]

Another factor promoting the heavy reliance on mass forms of visual propaganda, such as political posters, was the disruption of the printing industry caused by the revolution and Civil War (1918–1921). Major shortages of paper, breakdowns and closings of printing plants, and transportation problems sharply curtailed the printing and distribution of newspapers in these years. The main party organ, *Pravda,* had a daily press run of only about 138,000 copies, and all twenty-five Red Army newspapers combined had a daily run of less than 250,000.[14] Even taking into account that a single newspaper was often shared by several readers, this was not an impressive outreach in a population of many millions of people.[15] Political posters displayed in public places offered a more effective way of using limited supplies of paper and ink to reach a wide audience.

Whatever the reasons, the party accorded exceptional importance to visual propaganda during the Civil War. The first political posters appeared in August 1918, as the Civil War was getting under way. Over the next three years, about 3,100 different posters were produced by more than 450 different organizations and institutions.[16] A massive number of posters went into circulation. Litizdat, a major organization for poster production operating under the Political Directorate of the Revolutionary Military Council of the Russian Union of Federated Socialist Republics (RSFSR), distributed a total of 7.5 million posters, postcards, and *lubok* pictures between 1919 and 1922. Gosizdat, the state publishing house established in 1919, printed 3.2 million copies of seventy-five separate posters in the course of 1920. The Rosta (Russian Telegraph Agency) collectives in Moscow, Petrograd, and other major cities produced a unique form of poster that combined the functions of a newspaper, magazine, and information bulletin (called Okna ROSTA, or Rosta Windows). The Moscow Rosta collective alone produced over two million poster frames during the Civil War.[17] All manner of public spaces were decorated with posters, whose color, design,

and imaginative imagery enlivened an otherwise drab society. "The visitor to Russia," wrote American journalist Albert Rhys Williams in 1923, "is struck by the multitudes of posters—in factories and barracks, on walls and railway-cars, on telegraph poles—everywhere."[18]

With the end of the Civil War and the introduction of the New Economic Policy in 1921, the exhortatory fervor of visual propaganda became attenuated, only to be fully restored eight years later, at the time of the adoption of the First Five Year Plan. The role of the written and spoken word grew considerably in the 1920s with the spread of the Bolshevik press and the introduction of the radio. But the onset of the First Five Year Plan brought a resurgence in political posters and other forms of visual propaganda. Now political art was again accorded a central place in the Bolshevik strategy to mobilize the population on a grand scale and implant a new orientation toward the self and the social and political world. The party leadership understood that traditional ways of thinking were deeply rooted and resistant to change, and that the transformation of mass consciousness would require extraordinary measures. A new political art was created to correspond to the new epoch of crash collectivization and industrialization.

As the 1930s proceeded, visual propaganda became more intensive and widespread. For the first time, in 1931, all poster production was brought under the supervision of the Art Department of the State Publishing House (Izogiz), which operated under the direct supervision of the Central Committee. Henceforth, the themes, texts, and images of posters were dictated to artists and closely regulated by official censors. This centralization and control over poster production coincided with a tremendous expansion in the volume of posters. Whereas Civil War poster editions seldom exceeded 25,000 or 30,000, in the 1930s (especially the second half) key posters appeared in editions of 100,000 to 250,000. In the city and the countryside, in the factory and collective farm, in rooms and apartments and huts and dormitories, posters confronted virtually every Soviet citizen with an exhortation, admonition, or declamation.

Russia's entry into the Second World War in 1941 coincided with yet another major effort to use visual propaganda for the purpose of mass mobilization and indoctrination. World War II posters, also produced in vast editions, presented a new set of images resurrecting traditional

themes that dated back to tsarist posters of World War I. A period of High Stalinism (1946–1953) followed when political art was once again transformed into a vehicle for an otherworldly socialist realism depicting life in the Soviet Union as paradisiacal.

In each of these periods—the Civil War, the 1920s and 1930s, World War II, High Stalinism—the style of representation and the visual vocabulary and grammar changed in significant ways. Where did these different visual languages come from? The Bolsheviks were committed to the Marxist paradigm that art was part of the superstructure determined by the base (mode of production). Accordingly, some sought to create a new, specifically proletarian culture.[19] The problem was that the effectiveness of political art depended on the artist's ability to "speak the language" of the viewer, to use images, symbols, and styles of representation that people could understand. This meant drawing on familiar vocabularies and forms in order to convey a new message. The pattern, as Hobsbawm observes, was to use "ancient material to construct invented traditions of a novel type for quite novel purposes. A large store of such materials is accumulated in the past of any society, and an elaborate language of symbolic practice and communication is always available."[20]

Political artists drew on the rich traditions of Russian popular culture, commercial advertising, fine arts, religious and folk art, classical mythology, the imagery of Western European labor and revolutionary movements, and political art of the tsarist era. Different elements were incorporated at different periods. Mythical elements from these various sources were fused with contemporary ideology to create a special visual language. Mythology, in combination with political ideology, gave Soviet propaganda a unique and compelling character.

POLITICAL ICONOGRAPHY

By 1920, Bolshevik artists had generated distinctive images that incorporated elements from various traditions but were also unmistakably expressive of the Bolshevik ethos. These were the new icons—standardized images that depicted heroes (saints) and enemies (the devil and his accomplices) according to a fixed pattern (the so-called *podlinnik* in church art). The icons of Soviet political art did not reflect the

social institutions and relations of the society. Rather, they were part of a system of signs imposed by the authorities in an effort to transform mass consciousness. Like other "invented traditions," these iconographic images were consistent and incessantly repeated, and they resonated strongly with mythologies from the Russian past.

This study focuses on four sets of iconographic images that appeared in political posters, visual displays for holiday celebrations, and monumental sculpture. I begin by discussing the icon of the worker, a pervasive image at the very core of Bolshevik rhetoric. The worker-icon provides a versatile symbol of changing official conceptions of the proletarian basis of political power. It also conveys important ideas about the location of the sacred in Soviet society, since the proletariat was designated as the equivalent of the chosen class in Bolshevik ideology and possessed superhuman powers capable of transforming nature in accordance with the "laws" of Marxism-Leninism.

Through the creation and re-creation of the worker-icon, the Bolsheviks sought to assert their continuity with the past and their vision of the future. From 1919 to 1930, a single iconographic image of the worker-blacksmith predominated in Bolshevik visual propaganda. After 1930, however, the blacksmith is seldom encountered in political art. A new image of the worker takes its place. The transformation of the worker-icon in the 1930s coincides with a general decline in the representation of workers in political art and the shift of the sacred center to a new locus. The history of this imagery is recounted in chapter 1.

A second theme centers around the iconography of women. As Joan Wallach Scott has persuasively argued, "gender is a primary way of signifying relationships of power . . . [It] is one of the recurrent references by which political power has been conceived, legitimated, and criticized."[21] Visual imagery of men and women thus conveys important messages about relations of domination and subordination, both in the realm of social interaction and in the broader sphere of political life. The depiction of gender has particular significance in periods when authority relations are in flux, such as the Civil War years and the 1930s.

Civil War posters depicted a predominantly male world. Women were often represented allegorically until 1920, when images of the woman worker and the peasant woman first become established. These

new, more realistic female images were usually depicted in a subordinate relationship to male workers and peasants, thereby conveying the idea that women had only a weak claim to membership in the pantheon of heroes. The implication of these patterns for the emerging Bolshevik discourse on power is examined in chapter 2.

Whereas women occupy a position of secondary importance in visual propaganda produced between 1917 and 1929, they appear very prominently in connection with the campaign for the collectivization of agriculture beginning in 1930. Collectivization, one might say, is presented visually in the female idiom. Chapter 3 analyzes this important episode in visual representation as part of the new Stalinist ideology and the broader changes taking place in the function of political art.

The third theme examined in this study concerns the iconography of the *vozhd'* (leader). Images of Lenin appear early in political posters, increasing in frequency and prominence after his death in 1924. It is not until the early 1930s that representations of political leaders—particularly Stalin—are centrally featured. Stalin, depicted as a living god, moves to center stage in visual propaganda, displacing both his predecessor Lenin and the proletariat as the core elements in Bolshevik mythology. These trends, which continued during World War II and reached their peak during the years of High Stalinism, are discussed in chapter 4.

Chapter 5 focuses on the depiction of internal and external enemies. In contrast to other iconographic images examined in this study, the representation of enemies shows a good deal of continuity between 1917 and 1953, due to the consistent application of standard styles of satire and caricature. But beginning in the 1930s and continuing in the 1940s, the representation of enemies expands to include a multiplicity of new images corresponding to the categories of transgressors concurrently introduced into verbal political discourse. These are images of "the other," the negative figures against which Bolsheviks attempted to define their positive heroes and create models for acceptable thought and action. Such images served to reinforce a Manichean view that divided the world into two camps (analogous to the forces of good and evil), which existed in a state of irreconcilable conflict.

Finally, chapter 6 shifts in emphasis from a particular visual theme to an examination of the years 1946 to 1953. Political art created during

the final years of Stalinist rule incorporated elements from earlier periods and in some ways brought to a culmination many trends of the preceding decades. Nevertheless, the postwar posters were distinctively different from anything that had preceded; to view them is to appreciate their almost magical qualities. Saturated by a newfound imperial ethos and an intensified Stalin cult, these posters conveyed a vision of the "divine order" of Soviet society, in which abundance and harmoniousness were the essence of the new Stalinist imperial order. In the Soviet paradise conjured up by political art, many traditional class markers and attributes for Soviet citizens had disappeared, to be replaced by a new image of *Homo sovieticus.*

My overall strategy is to use an analytic framework based on a linguistic analogy, treating images as part of a visual language (with a lexicon and syntax) in which all the elements are interdependent. As we have seen, key figures (for example, the male worker, the female peasant) in the Soviet visual lexicon changed significantly over time. These changes will be analyzed in detail, in the hope of identifying the distinctive attributes of these representations (the appearance, physiognomy, clothing, activities, gestures, emotions, and so forth).

I will also pay close attention to what I am calling the visual syntax of the posters: the positioning of figures and objects in relation to each other and the environment. As images changed, so did the syntax. By way of illustration, the positioning of the female peasant in relation to other figures changed significantly at the same time that the image of peasant woman changed, around 1930. Formerly she had been presented in combination with other heroic figures (workers of both sexes or male peasants) but virtually never alone, thereby conveying the idea that her inclusion among the heroes depended on a relationship of contiguity (metonymy). From 1930 on, she appeared alone in posters or in a dominant position, a shift in the syntax that profoundly altered the meaning being conveyed.

THE PRODUCTION AND RECEPTION OF VISUAL PROPAGANDA

Like books, images and their combinations may be "read" in unpredictable ways. Pictures meant to emphasize class identity also conveyed—often unintentionally and subliminally—ideas about gender

and gender relations, ethnicity, and other forms of cultural and social identification. Though it is not possible to establish with certainty how various groups in the population "read" visual material, this study attempts to map out the repertoire of references available in contemporary culture and to suggest some possible interpretations. We can try to comprehend the aims of the officials and artists who produced visual propaganda. But whatever the intention, images are almost always polyvalent. Depending on context and audience, many different kinds of messages may be extracted from them. In the Civil War years and afterward, visual symbolism constituted one of a number of key areas in which contemporaries struggled over issues of meaning and interpretation. Ultimately, these struggles were about the nature and uses of political power.

The artists who produced posters in the early Soviet period were a diverse group, with training in painting and political and religious art.[22] Their backgrounds and relations to the Bolshevik regime also varied greatly. Some, such as the masterful artist Dmitrii Moor (1883–1946), had professional careers as satirical artists under the old regime, but immediately threw in their lot with the Bolsheviks after the October Revolution. Moor created some of the masterpieces of Soviet political art and served for many decades as the unofficial "commissar of propagandistic revolutionary art."[23] Aleksandr Apsit (1880–1944) was one of the earliest and most influential political artists of the Civil War years. Originally trained as an icon painter, he had been a political artist under the old regime. In 1921 Apsit emigrated to his native Latvia and never returned to the Soviet Union. After the revolution, schools were established to train political artists, and by the 1930s there was a new generation of people—such as the three Kukryniksy (Mikhail Kupriianov, Porfirii Krylov, and Nikolai Sokolov)—whose artistic experience was acquired under Bolshevik auspices.[24]

Prior to 1931, the dispersion of poster production among many different organizations and institutions precluded any centralized directives concerning content or execution, though as we shall see, there was nonetheless remarkable consistency in the creation and dissemination of certain iconographic images. From 1931 on, however, visual propaganda was highly centralized, and poster production originated in a single government department. Due to the extreme sensitivity of

political art and its critical role in indoctrination, it was supervised by the Central Committee and other top party and government organs. After 1931, poster artists were invited to submit sketches appropriate for particular slogans and texts prepared by Izogiz and its counterparts in the republics. Poster production was monitored closely, and from the 1930s on, most posters were published with the name of both the artist and the official responsible for the poster's ultimate content.

The audience for political art was highly variegated. It encompassed educated groups who had traveled to Berlin and Paris and peasants who had never strayed far from their hut, those who visited museums and those who knew only the *lubok* (illustrated broadside). What they all had in common, however, was exposure to a highly visual culture dominated, above all, by the icons of the Russian Orthodox Church.

Until the end of the First Five Year Plan in 1932, the audience for political posters, monumental sculpture, and holiday displays was predominantly urban. But even within the urban population, there were many different groups, set apart by education, social background, geographical location, ethnicity, gender, and religion. Given this diversity, it is impossible to speak about a single interpretation of the images discussed in this study; there were many possible ways of understanding these pictures.

What about the reception of posters and other visual propaganda by ordinary people? The content of images can be described and analyzed, but this tells us little, if anything, about the way contemporaries may have *interpreted* what they saw. Unfortunately, the evidence concerning contemporary reactions to posters is quite limited. What we have applies mainly to the first half of the 1930s, when journals were published with extensive reviews of posters and occasional reports of meetings held among workers or peasants to evaluate posters. Memoirs, newspapers, and unpublished documents provide additional material on this subject.

In the absence of direct reports of popular reactions, the sociologist must look at the cultural repertoires of the viewers. By cultural repertoires I have in mind, first, the habits of seeing and interpreting images that people brought to visual material.[25] In Russia, this was based on viewing some combination of religious icons, *lubki,* commercial advertising, Western European and tsarist art of all kinds, and by the end of

the Civil War, the accumulated legacy of Bolshevik art. In this highly visual culture, people had considerable opportunity to look at pictures and learn the conventions for comprehending them. Take the case of religious icons, undoubtedly the most familiar visual medium before 1917. Icons used certain key devices, such as color symbolism, to convey meaning. People accustomed to viewing icons knew that red was a holy color, used in connection with figures worthy of veneration. When Bolshevik artists used red to represent workers, they were invoking a long-standing convention in color symbolism familiar to most Russians. Of course, red had also been associated with revolution since 1792, when the Jacobins raised a red flag as a symbol of rebellion.[26]

A second aspect of what I am calling cultural repertoires centered around the context for interpreting political art. Viewers apprehended images in relation to relevant past and current experiences. From this point of view, the depiction of a woman blacksmith assisting at an anvil must have struck contemporaries as exceedingly odd. Neither in the city nor in the countryside did women customarily engage in this occupation. Most viewers must have noted the disjuncture between the image and the reality. The question posed in this study is how their cultural repertoire equipped them to make sense of such an image. Some probably dismissed the image as preposterous; others may have looked for symbolic meaning in popular culture or classical mythology. We cannot know for certain. The best we can do is suggest alternative "readings" based on contemporaries' frames of reference.

NOTES ON THEORY AND METHOD

This study is based on the assumption that official ideology mattered. As expressed through visual propaganda, it contributed to the definition of new social identities and helped to create new modes of thought and action in Soviet society. Official words and images should not be dismissed as having little to do with the "real" and important developments taking place in other spheres, such as the economy or politics. To be sure, major shifts in propaganda coincided with far-reaching changes in other areas. But the relationship among these developments is far from clear. Official ideology must not be treated as epiphenomenal. It had its own internal dynamic and functioned as an independent

force in situations where the discursive field was undergoing important changes and popular attitudes were in flux.

My aim is to provide an analysis of the mental universe conjured up by political art, to use visual language as a way of comprehending the "new mystique." Visual propaganda provides us with a revealing expression of the official ideology (even in its deepest subrational aspects) that was produced by those in authority for those who were not. It also allows us to see what was encompassed by the discursive field and what was off limits; which options were open in terms of orientation and action and which were closed off.

A central argument in this study is that the purpose of political art, beginning in the 1930s, was to provide a visual script, an incantation designed to conjure up new modes of thinking and conduct, and to persuade people that the present and the future were indistinguishable. In important respects, the visual medium anticipated developments in Soviet society and provided a model for them, rather than simply reflecting processes already under way. Images gave a reality to concepts whose "expression was novel, pregnant with the future."[27]

Official imagery, somewhat like commercial advertising in other societies, provided models for individual appearance and conduct. From the 1930s onward, for example, political posters visualized the *kolkhoznitsa* (collective farm woman) and "the new Soviet man." These pictures prescribed clothing, hair style, demeanor, facial expression, and emotions for Soviet heroes. Posters also taught viewers what to look for in the appearance and conduct of "class enemies," who proliferated in the 1930s. But however powerful and persuasive these images may have been, however shrewdly they incorporated popular mythologies, viewers' responses were unpredictable because visual representations are inherently polyvalent.

This study analyzes political art using the critical terms usually applied to spoken and written language. This application of linguistic terminology (for example, lexicon and syntax) is not meant to suggest, however, that the spoken and written language is the same as visual language. Although functionally related to spoken and written discourse, political art presented its own complementary system of signification, with its own implicit mythology, associations, and assumptions. The elaboration of meaning generated by visual propaganda

served not only to amplify the related verbal message (say, a cartoon accompanying an editorial) but also to introduce into it heterogeneous elements which produced a new and often unintended surplus of meaning. Posters almost always had words as well as images, though usually very few of them. These words provide an important component of visual representation, but pictures captured something that words could not ("a picture is worth a thousand words"). Throughout the book, I will juxtapose oral and written discourse to its visual counterpart.

The study of official ideology is also a study of change, since Bolshevik ideology and practice did not remain static throughout the period covered by this book. The three and one half decades between 1917 and 1953 witnessed dramatic and abrupt shifts in the style and content of representation (1920, 1930, 1941, and 1946 mark the critical turning points). I will be comparing the images over time, in an effort to establish the changes in meaning that took place. In some ways, this methodology bears resemblance to the work of Reinhart Koselleck and William Sewell. Koselleck's application of the methods of *Begriffsgeschichte* to social history focuses attention on the changing semantic significance of concepts, much as I will be looking at the changing semantic significance of images.[28] Sewell's study of the language of labor in France between 1789 and 1848 uses the methods of cultural anthropology to chart the changing social construction of key concepts.[29]

The empirical basis for this study consists of about 5,500 posters, viewed in their original form at the Hoover Institution Archives (Stanford, California), the Poster Collection at the Russian State Library (Moscow), the Imperial War Museum (London), the Victoria and Albert Museum (London), and the British Museum (London). In addition, I examined photographs of several hundred posters at the Museum of the Revolution in Moscow.

The Hoover Archives contain about 3,000 Soviet posters, randomly collected over several decades, and dating from 1904 to the present. I went through the entire Hoover collection in the spring of 1987, before it was cataloged. The Russian State Library Poster Collection, the largest of its kind in the world, houses some 400,000 posters. The catalog for this collection was not available to me when I conducted research there in 1988 and 1991; I was permitted access to it for the first time in

1995, when I returned to photograph posters. The research was thus conducted without the benefit of a catalog, and I requested posters by general topic, theme, or period, such as the collectivization of agriculture, women in various periods, the New Economic Policy, labor discipline in the 1930s, the years 1946–1953, and the *vozhd'* (the latter turned out to be one of the categories used for classification in the archive).[30]

On the basis of archival research, I assembled a computerized data base consisting of detailed information on 1,022 posters. Using this data base, I have attempted to identify patterns in the production of images and visual syntax as well as changes in thematic emphasis and style. The quantification of evidence was not my main aim in creating the data base, but I have found it useful for establishing proportions in certain instances.

In addition to archival sources, I have collected information on other posters from contemporary journals devoted to reviews and analysis of poster art: *Produktsiia izobrazitel'nykh iskusstv* (1932), *Produktsiia izo-iskusstv* (1933), and *Plakat i khudozhestvennaia reproduktsiia* (1934–1935). I have also perused many published collections of pre-Soviet and Soviet posters. My research has extended to other forms of political art besides posters, such as monumental sculpture and displays at holiday celebrations. Though this type of evidence has not been included in the data base, it has figured importantly in my analysis. I have generally found consistency in some of the patterns of development and iconography across a range of propaganda media, including films and popular literature.

The scholarship on Soviet political art can be divided into several categories. A vast Soviet literature exists on this topic, extending back to the earliest years of Soviet rule. Soviet critics, propagandists, and officials took great interest in the theory and practice of visual propaganda during the 1920s, and a number of studies appeared at that time. By far the most sophisticated and informed account is by Viacheslav Polonskii, a former Menshevik and leading literary critic who directed Litizdat during the Civil War.[31] Polonskii's study, *Russkii revoliutsionnyi plakat* (1925), offers a sharp analysis and critique of political posters during the Civil War.[32]

In the post-Stalin era, the most useful study is *Sovetskii politicheskii*

plakat by G. L. Demosfenova, A. Nurok, and N. Shantyko.[33] Published in 1962, this general history of posters raises a number of important issues, such as the representation of the hero in political art and the early emphasis on allegorical and symbolic imagery. But this and other Soviet accounts, however informative, are limited in their analytical scope by the tendency to measure artistic production with a yardstick of political correctness. The authors do not investigate the origins or implications of particular images; they seldom step outside the enchanted circle of Bolshevik ideology to consider the messages that pictures conveyed.

Relatively few works on the subject are available in English. Richard Wortman has done pioneering work on court rituals and symbols of the imperial era.[34] The first study to present a political analysis of the Bolshevik aesthetic in mass propaganda was René Fueloep-Miller's *The Mind and Face of Bolshevism: An Examination of Cultural Life in the Soviet Union,* which appeared in an English translation from the original German in 1927.[35] Stephen White's indispensable study, *The Bolshevik Poster,* concentrates on the contributions of individual artists during the Civil War.[36] Articles by French author François-Xavier Coquin provide a valuable survey of some Bolshevik imagery during the first decade after the revolution.[37] Brief but important discussions on the theme of Soviet political art can also be found in Nina Tumarkin's study of the Lenin cult, Peter Kenez's book on the propaganda state, and Richard Stites' *Revolutionary Dreams.*[38] Igor Golomstock's *Totalitarian Art,* Boris Groys's *The Total Art of Stalinism,* and Hans Günther's edited volume *The Culture of the Stalin Period* offer thought-provoking analyses of visual propaganda.[39]

On related topics, Katerina Clark's *The Soviet Novel: History as Ritual,* Christel Lane's study of Soviet rituals, and James von Geldern's *Bolshevik Festivals, 1917–1920* contain stimulating arguments concerning the transmission of official ideology through literature, rituals, and public festivals.[40] Though these studies provide a context for my own work, they do not address the problem of visual propaganda as a system of signs whose production and reception were shaped by political ideology in combination with popular mythology.

For research models to guide this study, I have turned to Western Europe, and particularly France. Historians of France have undertaken

pathbreaking research in the area of visual representation. Studies by Maurice Agulhon, Lynn Hunt, and Mona Ozouf provide particularly influential accounts of the symbols and rituals of the French revolutionary tradition, viewed from a semiotic perspective.[41] Two collections have provided important contributions on this topic: *The Invention of Tradition*, edited by Eric Hobsbawm and Terence Ranger; and *Rites of Power: Symbolism, Ritual, and Politics Since the Middle Ages,* edited by Sean Wilentz.[42]

In addition to his seminal work on the invention of tradition, Hobsbawm has produced an influential, though controversial, essay on socialist iconography which bears directly on the subject discussed in this book.[43] He argues that, in contrast to the emphasis on female imagery in the iconography of the French Revolution or nineteenth-century labor movements in England and France (the countries from which his major examples are drawn), socialist iconography gradually excluded female images. Hobsbawm's central problematic is this: "Why is the struggling working class symbolized exclusively by a *male* torso?" This male torso, he goes on to argue, is quite often the naked torso of an unskilled worker, until realism takes over in the late nineteenth century and workers are depicted in clothing. This trend culminates with the image of the worker in the Russian revolutionary poster.

As this study will demonstrate, Hobsbawm's account of Soviet socialist iconography is incomplete. He does not take into consideration the allegorical and symbolic images of women that were common in early Soviet political art, much as they were in labor and revolutionary art of nineteenth-century England and France. His main point, however, is incontestable: male images of the worker predominated in early Soviet political art. But from 1930 onward, Soviet imagery underwent a major transformation, bringing female peasants into prominence, while downgrading the importance of the worker (male and female). Soviet iconography thus presents a somewhat different problematic when viewed from a longer-term perspective. The central explanatory problem is not to account for the early prevalence of male imagery but to analyze the changing emphasis in the representation of gender and the implications of these changes for the social construction of power.

This study lies at the intersection of several disciplines: cultural his-

tory, historical sociology and the sociology of culture, cultural anthropology, and art history. The term "iconography" is, of course, borrowed from art history, where it has been applied by such scholars as Erwin Panofsky.[44] The iconographic approach has generated a good deal of controversy.[45] Without entering into these debates, I want to clarify my sociological interest in this type of analysis. Nearly everyone who lived in Russia after 1917 had some familiarity with stock images of the male worker, the great leaders, the peasant woman, the capitalist, and others. These images functioned as icons. My analysis of iconographic images is aimed at understanding three issues: the genesis of these images (origins, sources, history); the resonance of various mythologies in these images; the range of possible interpretations contemporaries may have given to these images.[46]

Following Clifford Geertz and Michael Baxandall, I am approaching Soviet political art from the point of view of "social contextualization."[47] Images mean nothing by themselves, taken in isolation from their historical context. They acquire meaning only when seen with a "period eye," to use Baxandall's phrase. I have tried to re-create key elements in the intellectual and visual framework of the artists who created, the officials who administered, and the citizens who viewed political art—something I am calling cultural repertoires. As part of this effort, I will discuss contemporary perceptions of gender, the body, and social categories, as well as the value of colors and the function of images.

Ultimately, this book is about the iconography, in the literal sense, of *power,* that is, about the relations of domination as they were visually inscribed on the hearts and minds of the Soviet Russian people. Visual propaganda allows us to comprehend the official discourse on power in Soviet Russia and its transformation over time. Art of any kind is best understood as part of a cultural system because it expresses a comprehensive worldview that has its own inherent logic.[48] My aim is to map the principal coordinates of that cultural system, to show how the propaganda art created between 1917 and 1953 shaped the mentality of the Russian people (the legacy is present even today) and, in turn, was itself shaped by popular attitudes and assumptions.

One

ICONOGRAPHY OF THE WORKER IN SOVIET POLITICAL ART

EVERY REVOLUTION NEEDS its heroes. In social revolutions of the modern era, the heroes have included both individuals and collectivities, such as the sans-culottes in France and the proletariat in twentieth-century Russia. Revolutionary heroization has entailed a dramatic reordering of social groups. Those who were despised under the old regime are adulated under the new. The revolutionaries place great symbolic and ritual importance on the new heroic collectivity, using all the verbal and visual means at their disposal to celebrate the carnivalesque reversal that has taken place.

We can see this process at work in the French Revolution of 1789. During the Jacobin dictatorship, the people, or to be more precise, the sans-culottes, were elevated to the status of heroes in political rhetoric and political practice. The figure of Hercules, who was depicted as slaying the hydra of the *ancien régime,* came to symbolize the sans-culottes.[1] Hercules, together with Marianne, the female figure symbolizing liberty, dominated the political iconography of the French Revolution.[2]

When the Bolsheviks came to power in October 1917, they set about identifying and promoting their own heroes. In the spring of 1918, Lenin unveiled a plan for monumental propaganda aimed at creating public statuary of revolutionary heroes to replace those of the tsarist era. More than forty monuments subsequently appeared, representing a wide range of Russian and European political, artistic, and cultural figures. Lenin's enthusiasm for monuments to deceased heroes was intended, above all, to make credible and comprehensible the inexorable march of history projected by Marxism-Leninism.[3]

The historical actors monumentalized by Lenin's plan—a motley group of assassins, authors, rebels, and martyrs—acquired special heroic significance once they were located in the sequence of events that culminated in October 1917. According to the Bolshevik master narrative, these individual heroes anticipated and prepared the way for the

collective hero of world history: the proletariat. Party rhetoric and pro-
paganda of the early years, with its relentless emphasis on the *prole-
tarian* revolution and dictatorship of the *proletariat,* left no doubt con-
cerning the centrality of the worker in the new pantheon.

Soon after seizing power, party leaders turned to the problem of
disseminating their message to the population at large. With encour-
agement and leadership from Lenin and his commissar of enlighten-
ment, Anatolii Lunacharskii, party members came to understand that
the creation of compelling visual symbols—"invented traditions," as
Hobsbawm has called them—was a key aspect of the campaign to cap-
ture public enthusiasm, inculcate novel ideas, and implant loyalty in a
semiliterate population accustomed to the elaborate pageants and visual
imagery of the old regime and the Russian Orthodox Church. Political
posters, monumental sculpture, and displays at holiday celebrations (es-
pecially May Day and November 7) provided the major vehicles for
Bolshevik visual propaganda.

At the time of the October Revolution, the Bolsheviks had little ex-
perience with political art. Under the repressive conditions of the tsarist
regime, no public displays were permitted except those authorized by
the government or the Church. Publication opportunities were circum-
scribed, and most of the satirical journals produced by left-wing groups
during the 1905 revolution had disappeared after 1907. When the Bol-
sheviks took power, therefore, they had not yet developed a visual im-
age to represent the working class, comparable, say, to Hercules in the
French Revolution.

The creation of a compelling visual language proved to be particu-
larly critical in the campaign to establish the "working class" as the
heroic collectivity of the Bolshevik revolution and of world history
more generally. In a country where about 85 percent of the population
lived in villages in 1918, the identity and characteristics of the "working
class" remained murky and mysterious to many people. The Bolsheviks
faced the task not only of establishing the heroic position and role of
the worker but also of bringing an image of the new worker-heroes to
the population at large. Verbal propaganda, however ubiquitous, could
not achieve this objective.[4]

During the early years of Soviet power, political artists groped for a

visual language that viewers could comprehend. Given the diverse cultural background of the population, they drew on a variety of sources: religious and folk art, classical mythology, Russian painting, and the imagery of Western European labor and revolutionary movements. Before long, a new iconography had arisen in Soviet Russia, with its own distinctive lexicon and syntax. As in the religious art of the Orthodox tradition, a set of standardized images was created, depicting worker-heroes (saints) and class enemies (the devil and his accomplices).

Although the party had no single visual image of the worker when it took power, a year later the representation of "the worker" had acquired a definite form. He was almost invariably depicted as a *kuznets,* or blacksmith.[5] Aleksandr Apsit's poster "God proletarskoi diktatury oktiabr' 1917–oktiabr' 1918" (Year of the Proletarian Dictatorship, October 1917–October 1918), produced for the first anniversary of the October Revolution, can be considered the first major statement of a new image in Bolshevik iconography (plate 1).[6] The blacksmith's distinctive markers were his hammer (*molot*), a leather apron, and sometimes an anvil. Typically he had a mustache (a beard was associated with the male peasant), a Russian shirt, and boots (peasants wore bast shoes). Sometimes, he was presented as bare to the waist, but more often he wore a shirt. He was neither very youthful nor particularly old; generally, he had the appearance of a mature and experienced worker.

The imagery of the worker in late nineteenth-century and early twentieth-century socialist iconography is overwhelmingly male, and Soviet visual propaganda conformed to this pattern.[7] A female version of the blacksmith does not emerge until early 1920 (figs. 1.1 and 2.9).[8] She is a replica of the male worker and is presented as his assistant. Since women virtually never served as blacksmiths' helpers, the imagery can only be interpreted allegorically. The female worker derived heroic status from her association with the male worker. She holds the hot metal on the anvil=altar while he fashions it into a new object=world. Her representation as his helper reinforces the theme of male leadership, or as we now put it, male domination in the ranks of the proletariat.

In the course of 1919, the image of the male blacksmith began to

function as a virtual icon in Bolshevik visual propaganda, conforming to a fixed pattern. The blacksmith appeared in posters and holiday displays, on stamps and official seals, even on pottery and fabric. No other visual symbol—except for the emblems of the red star and the hammer and sickle, introduced in the spring of 1918—was as widely disseminated in Bolshevik Russia or as closely associated with the new regime. This image remained central until 1930, and then was abandoned.

<div align="center">THE BACKGROUND</div>

The origin of the blacksmith image in Bolshevik iconography remains uncertain. The first examples I have located date back to the revolution of 1905. An easing of tsarist restrictions on the press led to a proliferation of left-wing journals and newspapers. A number of them contained visual material, mainly satirical. From time to time, they printed representations of the worker.

In 1906, for example, the left-wing Odessa journal *Svistok* carried an illustration by D. I. Shatan, "Zakliuchenie soiuza" (The Conclusion of a Union). It shows a muscular worker shaking hands with a woman in red, presumably Russia, while minuscule blue figures in crowns (the imperial court?) cower at her feet. The worker has a trim beard and a sleeveless shirt. In 1907, the journal *Volga* featured a grim-looking blacksmith on its cover, his right wrist in a handcuff. Below is the caption "Staryi god" (The Old Year). The blacksmith exhibited attributes or class markers that later became part of the standard image: the mustache, the Russian shirt, the apron, and the hammer.[9]

Tsarist propaganda did not gain momentum until the outbreak of World War I, when many political posters were issued on behalf of the war effort. My research has not turned up any instances of the blacksmith image in these posters, although other types of workers were sometimes depicted. In a striking poster by Rikhard Zarrin, "Patriotichno i vygodno! Pokupaite voennyi 5½% zaem" (Patriotic and Profitable! Buy the 5½% War Bonds), a young, serious-looking munitions worker wearing an apron stands in front of a lathe (fig. 1.2).[10]

Although tsarist political posters did not include images of the blacksmith, the blacksmith's *hammer,* together with the anvil, was common

in traditional Russian armorial art. An emblem from the Kursk region in the late nineteenth century includes two blacksmith hammers framing a boar's head with large fangs.[11] Hammers and anvils also appeared in Western European labor and socialist imagery.

The image of the blacksmith made an occasional appearance in the propaganda of social democratic and other left-wing groups between the February and October revolutions. In August 1917, the cover of a satirical journal, *Spartak,* featured a blacksmith wearing a Russian shirt. He stands with his legs parted, leaning both hands on a hammer.[12] During the election campaign for the Constituent Assembly, the Committee of the Communist Party of Bolsheviks of the Ukraine distributed a poster with a blacksmith holding a proclamation with the heading "Tovarishch!" (Comrade!) (fig. 1.3).[13] Standing against a stark background of factories with smoking chimneys, he wears a red shirt in the Russian style, an apron, and boots and holds a hammer in his left hand. A political poster issued during elections to the Constituent Assembly, "Vserossiiskaia liga ravnopraviia zhenshchin. Golosuite za spisok N. 7" (All-Russian League for Women's Equality. Vote for List No. 7), illustrates the broad appeal of the blacksmith image (fig. 1.4).[14] It depicts a rather haughty-looking woman holding a piece of hot metal on an anvil, while a male worker strikes it with a hammer. The male worker has a muscular bare torso; his face is only partially visible.

Bolshevik imagery of the collective heroes of the revolution began to take form during 1918. In April, Bolshevik leaders adopted their first official emblem: a crossed hammer and plow inside a red star, to serve as a breast badge of the Red Army. Soon afterward, a jury of artists and officials gathered to select an official seal for the Soviet state. Out of the many submissions, they chose a design with a hammer and sickle.[15] The Fifth Congress of Soviets adopted the hammer and sickle as the official emblem on July 10, 1918.[16]

The adoption of a hammer as the emblem of the working class must have encouraged the use of blacksmith imagery, but as late as November 1918, there was still no consensus over how the worker should be represented. Some artists depicted a generic worker (no specific occupation) with a cap, on horseback, or in a chariot.[17] Boris Kustodiev's panels for Ruzheinaia Square in Petrograd in November 1918 included

images of artisanal workers: a tailor, a carpenter, a shoemaker, and a baker. In addition, the panels show a young man in an apron, perhaps a blacksmith, with the title "Labor" and images of women who were designated as "Reaper" and "Abundance."[18] Another artist depicted a miner with a pickax and called him "Rabochii" (The Worker).[19] Artists often represented the worker fully clothed, wearing an apron and a Russian shirt, but some depicted him with a naked torso.[20] In the case of Mikhail Blokh's sculpture of a giant metalworker (ten meters tall), the figure—intended to rival Michelangelo's *David*—was originally presented entirely in the nude, to the shock and dismay of local officials. At first the statue was given a fig leaf. When that did not do the job, however, an apron was added, but only after some modifications to the original sculpture.[21]

The diversity of representations in 1918 indicates that a standard image of the worker had not yet been established, as it would be in the course of 1919. More fundamental still, the various visualizations of the worker show that the term initially encompassed a broad range of occupational groups. In Apsit's famous poster "God proletarskoi diktatury" (Year of the Proletarian Dictatorship) (plate 1), a worker and a peasant stand on either side of a window. A long, winding demonstration of people with red flags is visible, with a factory and the stylized rays of a rising sun in the background. The debris of the old order (imperial shield, crown, double-headed eagle, chains) are strewn across the foreground. The worker on the left has a mustache and wears a leather apron and boots. His right hand rests on the handle of his hammer, and he has a rifle on his back. Opposite him stands the male peasant, wearing a Russian shirt and bast shoes and holding a scythe in his right hand and a red banner in his left. Each man has a red ribbon on his shirt, and there are two decorative wreaths with red ribbons hanging above them. The man who created this poster, Apsit, was born in Latvia, the son of a blacksmith.[22] One of the earliest and most distinguished poster artists of the Civil War years, Apsit helped to create an image of the blacksmith that soon acquired archetypal status in Bolshevik visual propaganda.

Two basic variants of the worker-blacksmith emerged during the years that followed. In the first, exemplified by Apsit's 1918 poster and many others, the blacksmith was depicted with a composed and dig-

nified demeanor, a hammer by his side. A second variant portrayed the blacksmith in the act of striking an anvil—exemplified by Nikolai Kogout's 1920 poster, "Oruzhiem my dobili vraga" (We Defeated the Enemy with Weapons) (fig. 1.1)—or in some other physical act, such as slaying a hydra, doing battle with the enemy, or warding off a rapacious eagle.[23] These contrasting images emphasize different aspects of the worker-icon: skill, dignity, and poise are accentuated in some representations; physical prowess in others.

The two aspects of the worker image—contemplation and action— also characterized the imagery of Hercules in the French Revolution.[24] And as in France, the dualism betokened quite different ways of representing and conceptualizing the collective heroes. In one set of action-oriented images, the proletariat emerges as powerful and aggressive, capable of great acts of prowess. These images appeared most frequently during the Civil War years. The imagery of the motionless worker conveyed a very different message, emphasizing instead the self-possession and confidence of the victorious proletariat proudly presiding over the new epoch. The latter image predominated in the 1920s.

During the Civil War, the blacksmith symbolized the collective hero of the revolution, the working class. But how to represent the vanguard of the working class, the Bolshevik party members, who had led the proletariat to victory? The imaginative artist Kustodiev addressed himself to this question in his famous 1920 painting, *Bol'shevik* (The Bolshevik). Here was a larger-than-life man striding across the Kremlin. Dressed in winter clothing and carrying a red flag, the Bolshevik has an intense, almost maniacal expression.[25]

In the course of the 1920s, a subtle but important change took place in the image of the blacksmith, which came to symbolize not just the working class generally but the *Bolshevik worker* in particular—the party member, the loyal follower of Lenin. The 1927 poster, "Oktiabr' na severnom Kavkaze" (October in the Northern Caucasus), exemplifies this development (fig. 1.5).[26] Here the traditional worker carries a red flag with the inscription: "With the Leninist party for the victory of the worldwide October Revolution, 1917–1927." Photographs of six leading Bolsheviks (Lenin and party heroes of the Caucasus) are in the center of the frame. In this poster and in many others of the late 1920s, the blacksmith acquired a far narrower focus than ever before.[27] The

revolutionary worker had become the Bolshevik worker. The change in visual signification took place against the background of turbulent political events, including the intensified campaign against Leon Trotsky and left-wing opposition groups and the consolidation of the monolithic party-state.

The exceptional status of the worker was manifested in the visual syntax, that is, the relationship among images. Images of peasants (male and female) or the woman worker seldom appeared alone but nearly always in pairs or clusters. Their position in the Bolshevik hierarchy of heroes was defined by contiguity, by their close visual association with others. Thus male peasants often appeared with male workers or female peasants; male and female peasants were depicted together or with workers. By contrast, the figure of the male worker did not depend for definition on a relationship of contiguity. The presence of the male worker conferred heroic status on those nearby. The worker himself, however, needed no other figure to establish his position in the hierarchy of heroes. He sometimes appeared alone, sometimes in a larger-than-life format. Only the Red Army soldier, as depicted during the Civil War, occupied a syntactic position similar to that of the worker.

Aleksandr Matveev's famous monumental sculpture completed in 1927, *Oktiabr'skaia revoliutsiia* (October Revolution), illustrates the visual language that was used to depict heroic figures (fig. 1.6).[28] The sculpture shows three nearly naked men. The Red Army soldier, identified by his Budennyi hat, is kneeling; the worker stands in the center, resting his arm on his hammer; the bearded peasant sits, his left hand outstretched. The commanding presence of the worker in this composition leaves no doubt about the hegemonic status of the proletariat. The constellation of figures and their hierarchical arrangement betoken a particular worldview—a view propagated by the Bolshevik party and enshrined in its official ideology.

CULTURAL FRAMEWORKS FOR INTERPRETING
THE WORKER-ICON

During the Civil War, chaotic conditions and poor communications prevented the establishment of a centralized authority in poster pro-

duction. By the end of 1920, some 453 separate organizations were producing posters.[29] Despite the dispersion and lack of coordination, there was remarkable consistency and uniformity to the imagery beginning in 1919, especially the representation of the worker-hero. The adoption of the hammer and sickle as the official Soviet emblem in July 1918 must have provided strong support for the blacksmith image. But the appeal of such an image and its widespread adoption by Bolshevik political artists rested, above all, on its extraordinary polyvalence.

The figure of the blacksmith meant many different things to different people. It resonated with folk and religious art, the imperial art of the old regime, and the traditions of Western art and socialist iconography. Moreover, the blacksmith was an important figure in urban centers and rural villages, in giant factories and small artisanal enterprises. He crossed many boundaries.

What kinds of associations did contemporaries have with the image of the blacksmith? Given their preexisting cultural frameworks, how did artists, officials, and viewers "read" this image? Of course, there was not just one interpretation but a multiplicity of responses depending on the viewer's social class, education, gender, geographical location, and other factors. Our information about the audience for political posters during the Civil War years is limited, but it appears that most were displayed in locations accessible to urban dwellers and to soldiers.[30] Even if poster displays were for the most part limited to these groups, the viewers included a broad spectrum of the population (most soldiers were recruited from the peasantry), and it is not possible to identify a single interpretation of a particular image. Artists, officials, and spectators conceptualized and interpreted the new worker-icon within diverse cultural frameworks shaped by a variety of traditions as well as by practical experience and observation.

Of all the types of workers associated with nonagricultural labor, the blacksmith might arguably be considered the most nearly universal. The term *kuznets* was applied in a wide range of contexts: rural and urban, artisanal and industrial. In the countryside, every village had a blacksmith who produced agricultural implements, tools, wheels, and many other necessities for the local population. His basic equipment—a hammer, an anvil, and a forge—was a familiar sight. At the same

time, the *kuznets* could also be found in all types of manufacturing, from the traditional artisanal-type blacksmith shop in a village or city to the large industrial plant.

The status of the blacksmith in society depended on his location. In the village, he belonged to the elite by virtue of his skills, his relative prosperity, and his critical function in rural life. A city blacksmith, working in a small shop, occupied an intermediate position within the ranks of artisanal craftsmen. The *kuznetsy* in a large metalworking plant, laboring in the "hot shop" (*goriachii tsekh*), were looked down on because of their peasant ways and the physical as opposed to mental effort involved in their work.[31] The *kuznets* had a lower status than his fellow workers in the machine shops, such as metal fitters and lathe operators. But if the blacksmith remained inferior to the metal fitter within the plant's status hierarchy, he nonetheless occupied an important position within the enterprise. Unlike the unskilled laborers in metalworking plants, textile mills, or food processing plants, the *kuznets* performed a critical function in industry requiring skill and considerable physical prowess.

The exceptional significance and role of the blacksmith were reinforced by Slavic folklore, which contains many references to the blacksmith, who was thought to possess concealed sacred abilities. Wedding songs spoke of the blacksmith as hammering out the wedding crown, the ring, the wedding itself. There were also references to the blacksmith hammering out a tongue=language=speech. A blacksmith had godlike features and could perform heroic feats.[32]

The supernatural attributes of the blacksmith were readily carried over into Bolshevik propaganda. A popular revolutionary song was titled "My—kuznetsy" (We Are Blacksmiths). Composed in 1912 by a factory worker, Filip Shkulev,[33] the song was sung in the aftermath of the February Revolution and especially during the Civil War. Its effectiveness was due, in large measure, to the skillful combination of popular mythology and political ideology. The first stanza sets forth the miraculous powers of the blacksmith:

> We are blacksmiths, and our spirit is young.
> We hammer out the keys to happiness.

Rise ever higher, our heavy hammer,
Beat in the steel breast with greater force, beat,
Beat, beat!
We are hammering out a bright road for the people,
We are hammering out happiness for the motherland,
And for the sake of cherished freedom
We all have been fighting and shall die,
Die, die![34]

For some urban and educated groups in Russian society, the black-smith image was also familiar from Western art. The earliest examples of this image derive from ancient Greece and Rome, where the Greek god Hephaestus (Roman: Vulcan) appeared with hammer in hand.[35] Images of the blacksmith god Hephaestus reappeared during the Italian Renaissance. In these paintings Hephaestus was generally depicted naked, seated or standing, about to strike the anvil with a hammer.[36] During the seventeenth century, the French painters (brothers) Le Nain created several canvases on the subject of Vulcan which present a more realistic picture of work in a blacksmith's shop.[37] It was not until the late nineteenth century, however, that a major change took place in the representation of the blacksmith and workers more generally.

The Belgian artist and sculptor Constantin Meunier was largely responsible for opening up a new era in the depiction of workers. First in painting and then in sculpture from 1884 until his death in 1905, Meunier concentrated on the theme of working people.[38] In contrast to previous representations of the laboring classes, which tended to emphasize hardship and suffering, Meunier presented workers (male and female) in a heroic mode. He sculpted many figures connected with the metalworking industry. Among them is a statue of *"der Schmied"* (the blacksmith), shown as a youthful half-naked figure with regal bearing, seated with a hammer between his legs.[39] Though some of Meunier's workers show signs of heavy labor and exhaustion, they also convey pride, dignity, and strength.

In late nineteenth- and early twentieth-century Europe, representations of the worker became more and more important in monumental, decorative, and political art. Images of the blacksmith, in particular,

served as a symbol for all types of workers associated with the new age of manufacturing. During the Third Republic in France, blacksmiths provided the subject matter for many public monuments as well as the decorative facades of public and private buildings.[40]

The blacksmith image, as we have seen, was remarkably polyvalent and evoked an extremely rich set of associations. Considering the powerful effect of religious icons, it is not surprising that conventions in church art affected how both artists and viewers approached political art. The first great master of the Bolshevik poster, Apsit, had extensive prior training in icon painting.[41] The blacksmith does not appear, to my knowledge, in icons of the Russian Orthodox Church, but Soviet artists borrowed a number of key features from icons and used them to sacralize the new worker-hero.[42] During the Civil War, the worker-hero was sometimes depicted as St. George slaying the dragon of capitalism.[43]

A poster produced in the fall of 1920, "Da zdravstvuet pobeda truda" (Long Live the Victory of Labor), incorporated one of the most important symbols of religious art: the cross (fig. 1.7).[44] In this remarkable poster, a blacksmith is seated on top of an altar and surrounded by a globe and the works of Karl Marx. The altar rests on a platform, and the entire structure bears resemblance to the shape of a cross.[45] The blacksmith holds a hammer in his right hand; his left hand is raised, bearing a wreath encircling a hammer and sickle. Scenes depicting the past and present surround the central image, much as marginal scenes (*kleima*) appear in icons, conveying characteristic episodes from the life of a saint.[46]

Color symbolism in political posters also resonated with religious art. The color red served in religious icons to identify the sacred (black was the color of evil).[47] In Apsit's 1918 anniversary poster, the worker and peasant both wear red ribbons; the peasant holds a red flag, and wreaths tied with red ribbons hang above each figure. It was quite common for the blacksmith to wear a red shirt, hold a red flag, or be surrounded by the color red. To be sure, the color red also had positive connotations in Western European socialist art. But the great majority of Russian spectators were probably far more familiar with the icon, which graced many huts and urban households, than with European art.

Other devices common to religious icons were applied to Soviet political posters. In religious icons, key images are presented with full or three-quarter face views. Soviet political artists almost invariably presented a frontal view of the blacksmith, and his gaze was seldom turned directly to the spectator (by contrast, some key posters of Red Army soldiers utilized the direct gaze).[48] Perspectival distortions of the background are common in religious painting.[49] The device of perspectival distortion was occasionally used in tsarist posters issued during World War I. Typically, a larger-than-life Russian peasant was shown towering over the countryside and his enemies. One such poster features a giant peasant wielding a club; another depicts a peasant with minuscule enemies.[50] In early Soviet posters, the worker-blacksmith replaces the oversize peasant as the object of magnification and heroization.

When contemporaries "read" the image of the blacksmith, they sometimes drew upon their knowledge of allegory in Russian folk and Western classical traditions. From 1918 until the end of the Civil War, Bolshevik political artists combined various types of allegory with the worker image. In Boris Zvorykin's 1919 poster, "Bor'ba krasnogo rytsaria s temnoi siloiu" (Struggle of the Red Knight with the Dark Force) (fig. 1.8),[51] a blacksmith on horseback wields a shield and hammer in the guise of the "red knight," or *rytsar'*. A 1921 May Day poster from Kiev depicts a blacksmith carried by giant birds, against the background of a red star and a sun. This poster, "1 maia—zalog osvobozhdeniia mirovogo truda" (May 1—The Pledge of World Labor's Liberation), by Aleksandr Marenkov, was produced in an edition of 5,000 copies (fig. 1.9).[52]

Whereas Hercules served to symbolize the sans-culottes in the iconography of the French Revolution, the Russian proletariat sometimes became associated during the Civil War years with the Titan Prometheus. In visual propaganda, this is exemplified by Petr Kiselis's 1920 poster, "Belogvardeiskii khishchnik terzaet telo rabochikh i krest'ian" (The White Guard Beast of Prey Is Tearing the Body of Workers and Peasants to Pieces) (fig. 1.10).[53] The sovietization of the Prometheus myth had the proletariat bound to the rock of capitalism and attacked by an eagle, the official emblem of the old regime.[54] The poster presents a beleaguered worker-Prometheus with a hammer in his right hand to

ward off a rapacious eagle. In literature, music, drama, and ballet, the myth of Prometheus Unbound attracted special attention during these years.[55]

THE NEW FUNCTION OF POLITICAL ART

In 1930, the traditional image of the blacksmith disappeared almost entirely from Bolshevik political art; only occasional and schematic representations remained. Beginning in the late 1920s, a few artists, such as Iurii Pimenov, experimented with new images of the worker that anticipated later developments.[56] The transition was complete by the time the Central Committee issued its resolution of March 11, 1931, placing all poster production under the auspices of the Art Department of the State Publishing House (Izogiz), which was directly subordinate to the Central Committee. The centralization and coordination of visual propaganda reinforced the trend already under way among poster artists to replace most of the old iconography from the Civil War period with a new visual language suited to the era of the First Five Year Plan.

The once standard worker-icon came under increasingly severe criticism in the early 1930s. In a 1930 book on posters, Nikolai Maslennikov described the blacksmith image as "petty bourgeois [*meshchanskii*] in ideology."[57] When a rare poster appeared in 1932 depicting two muscular men standing at an anvil with hammer in hand, a Moscow critic commented that "the image does not take into account the essence of socialist labor and is based entirely on a bourgeois conception of workers' labor. The artist was entirely wrong in drawing from the archive of poster clichés these stereotypical blacksmiths with heavy sledgehammers."[58] Thus, the blacksmith image, having occupied a central place in Bolshevik iconography before 1930, was considered unacceptable and "bourgeois"—a grave epithet—by 1932.

The abandonment of the conventional worker-icon coincided with a reevaluation of the hero in Soviet society.[59] In literature, writers and critics advocated a turn away from individual heroes (they disappeared almost entirely from literary works until 1932) and their replacement by what Katerina Clark has called "the cult of 'little men,'" that is, ordinary

workers. Literature was "deheroized," and writers focused, instead, on the emerging future society or on production.[60] This development had its counterpart in political art. Some posters produced in 1930 and 1931 relied heavily on the silhouette, a technique which had been utilized in Civil War posters but had lapsed during the 1920s.[61] The silhouette, with its lack of detail or facial expression and its general vagueness, appealed to political artists groping for new imagery in a period that stressed the ordinary man.

The 1931 poster "1 oktiabria—vsesoiuznyi den' udarnika" (October 1—The All-Union Day of the Shock Worker), illustrates the shift in imagery that took place during the early 1930s (fig. 1.11).[62] Issued in an edition of 25,000 copies, it shows a line of workers presented in a minimalist fashion with few distinctive markers and similar facial expressions. We see here the clustering of workers who are all but indistinguishable from one another. This poster was designed to promote the shock worker campaign, a mass mobilization effort that recruited 1.5 million workers in the first four months of 1930 alone.[63]

The trend is carried still further in the anonymous 1931 poster "B'em po lzheudarnikam" (Down with the False Shock Workers) (fig. 1.12), which had a press run of 30,000.[64] A suggestion of the blacksmith image remains, but now it is presented in an entirely new way. The old class markers of the worker have vanished, except for the hammer. Workers are presented in groups rather than individually—the visual counterparts of the "little heroes" who populated Soviet novels of these years. Virtually all such posters emphasize motion, one of the distinctive features of the new visual language that emerged during the First Five Year Plan. As the old class markers began to disappear, color symbolism became more important than ever before. The silhouetted figures of workers were usually represented with red or orange. In this poster, the three orange silhouetted workers wield hammers against those, pictured below, who violate work rules.

Contemporary reviewers did not always approve of posters with silhouettes. Another 1931 poster similar to those discussed above was criticized for its "extreme schematism." Instead of live builders of socialism, the critic wrote, there were "mechanized dolls."[65] In the wake of such criticism (analogous comments were made about literary works

emphasizing the "little men"),[66] artists soon moved away from the silhouette, and by the mid-1930s posters of this type seldom appeared.

In the course of 1931, the official policy toward heroes began to change once again. The party newspaper *Pravda* launched a campaign, under the title "The Country Needs to Know Its Heroes," designed to publicize leading shock workers. The same year, Izogiz published a book under that title and another called *Udarniki* (Shock Workers).[67] By the time the First Congress of the Union of Soviet Writers assembled in 1934, official policy had shifted dramatically. The glorification of anonymous little heroes had been replaced by praise for the individual hero. Speaking at the congress, Andrei Zhdanov proclaimed that the new Soviet literature should emphasize "heroization."[68] In a similar vein, Maksim Gorky spoke at length about the role of heroes, reminding his audience that oral folklore had created the "most profound type of heroes," figures such as Hercules, Prometheus, and Dr. Faustus, as well as others from Russian folktales.[69]

During the 1930s, heroic status was accorded first to shock workers and then, from the fall of 1935, to Stakhanov and his fellow Stakhanovites. Aleksei Stakhanov, a coal cutter in the Donbass mines, was heroized in 1935 when he reorganized his work to produce an enormous increase in output. A mass campaign was soon launched to encourage workers to increase their productivity and overfulfill quotas, in exchange for which they received monetary bonuses, new apartments, and other rewards and honors. Katerina Clark and Lewis Siegelbaum have drawn attention to the important shift that occurred in the middle of the decade when the cult of the individual hero acquired central focus in official propaganda, presided over by Stalin.[70] Elevated to the status of national heroes and exemplars, Stakhanovites were compared to Hercules, the unbound Prometheus, and the warrior knight of Russian folk epics, the *bogatyr'*. In official rhetoric they were portrayed as representing a new order of humanity.[71] Together with shock workers and others who performed great feats (for example, reaching the North Pole), they acquired unprecedented recognition in the Soviet pantheon.

The worker-hero of the Civil War, who had become the *Bolshevik* worker-hero by 1927, was again transformed in the course of the 1930s into the "new man" (*novyi chelovek*) or, literally, new human being.

The "new man" was, of course, a worker—though not, as we shall see, exclusively so. But what kind of worker? One paradoxical aspect of the First Five Year Plan is that official propaganda became obsessively preoccupied with the theme of class war. Class designations acquired more significance than ever before, but at the same time, rapid social and demographic change fundamentally altered the class structure of Soviet society so that class distinctions became, in practice, more muddled. Large numbers of peasants migrated from villages to cities and factory centers. In 1931 alone, 4.1 million peasants joined the industrial labor force. They were now officially designated as "workers," but it was the village, not the factory, that shaped their outlook and conduct.[72] At the same time, tens of thousands of workers were promoted into the ranks of managers and technicians. What it meant to be a "worker"—much less a heroic Bolshevik worker and new Soviet man—became increasingly uncertain.

The shock worker and Stakhanovite campaigns were designed, at least in part, to provide a blueprint for becoming an exemplary worker and a new Soviet man. Visual propaganda provided another major means for transforming inner as well as outer conduct. The urgency and importance of this task can scarcely be overestimated. As Moshe Lewin puts it, "a semiliterate if not illiterate, predominantly rural labor force had to be broken into the industrial world and taught, simultaneously, to use machines, to get used to an unfamiliar, complicated organization, to learn to read, to respect authority, to change their perception of time, and to use a spitoon."[73]

The Central Committee resolution on political art, issued on March 11, 1931, left no doubt about the aim of visual propaganda. It was to serve as "a powerful tool in the reconstruction of the individual, his ideology, his way of life, his economic activity" and as a means of "entering the consciousness and hearts of millions of people."[74] The pronouncement accentuated the ambitious task of political art in the Stalin era: to change people's structure of thinking at its deepest level.

The disappearance of the figure of the blacksmith from political art signified not only a change in imagery but, more important, a fundamental shift in the *function* of this imagery. Political art in the 1930s aimed not merely at exhortation but at the "reconstruction of the

individual." Previously the worker-icon functioned as a symbol—a symbol of the heroic proletariat, which, according to Bolshevik mythology, had made the October Revolution. The image of the blacksmith was intended to capture some elements of what it meant to be a worker (hence the significance of the polyvalence of the blacksmith image). The worker-icon, initially representing the broad category of collective heroes of the revolution and later the more select group of Bolshevik worker-heroes, was rooted in a symbolic tradition of representation.

During the 1930s, the imagery of the worker in political propaganda had a different purpose. Now the image of the worker functioned as a model, an ideal type. Its purpose was to conjure up a vision of the new Soviet man, to provide a visual script for the appearance, demeanor, and conduct of the model Stalinist citizen. This new function performed by visual propaganda led contemporary commentators to focus intensively on the problem of *tipazh*.

In the Soviet lexicon, the term *tipazh* implied a correct rendering of a particular social category. The essence of *tipazh* was not typicality but, rather, typecasting or typicalization. As Lunacharskii put it in an article published in *Brigada khudozhnikov* in 1931, "The artists should not only describe what is, but should go farther, to show those forces which are not yet developed, in other words, from the interpretation of reality it is necessary to proceed to the disclosure of the inner essence of life, which comes out of proletarian goals and principles."[75]

Lunacharskii's prescription, with its respectable metaphysical pedigree and its close resemblance to the definition soon given to the emerging concept of socialist realism, encapsulates the difficulty facing poster artists in the early 1930s. Having abandoned the standard image, which Soviet critics labeled "stereotypical" and "bourgeois," artists faced the daunting task of making visually precise social types that corresponded not to contemporary experience but to current party analysis of the "inner essence of life," which would be fully realized only in the hoped-for future. This reformulation of the artist's task marked a fundamental shift from a symbolic representation of the past and present to a new mode of visual representation which depicted the present not as it actually was but as it should become. The trick was to create the illusion of an imaginary future in the visual terms of the present.

The application of *tipazh* in the first half of the 1930s did not imply a fully elaborated iconographic image comparable to the blacksmith. Correct *tipazh* required that the image of the worker convey a certain demeanor and expression. As one poster critic wrote in 1933, the depiction of the worker should include a "healthy, lively, intelligent, intellectual face. He is the prototype of the new man, a combination of physical strength, energy, fortitude, and intelligence."[76] Another reviewer complained that *tipazh* in a 1932 poster was uncharacteristic because "the face is not intellectual, not warmed by creative thought. It does not have the joy of mastering knowledge, curiosity, absorption in study."[77] This emphasis on the intellectual and cultural attributes of workers was part of a more general trend that found expression in the Stakhanovite campaign beginning in September 1935. The model Stakhanovite was not merely capable of great physical feats but also a person who valued learning and partook of high culture.[78]

THE SEMIOTICS OF STALINIST VISUAL PROPAGANDA

Even a cursory survey of 1930s political posters discloses a dramatic shift in aesthetic sensibility. These posters cannot easily be confused with those of the Civil War or the 1920s. In terms of images, syntax, and technique they belonged to a very different world—a world of feverish reconstruction in which "higher, farther, and faster" became the new incantations.[79]

Seeking to respond to the new political tasks, political artists in the first half of the 1930s widely applied the technique of photomontage. Unlike the silhouette, which stripped the image of all detail and distinctiveness, photomontage accentuated the particularities of the representation, making it more concrete and less abstract. Photomontage had been used extensively in film and commercial posters during the 1920s, but far less often in political propaganda.[80] Led by Gustav Klutsis, the master of photomontage in Stalinist propaganda, a number of key artists turned their attention to photography as a way of visualizing the worker-hero of the First Five Year Plan.[81]

Photomontage marked a sharp departure from the previous style of representing the worker. Photographs, unlike drawings and paintings, projected the aura of objectivity and were based on the principle of

realistic as opposed to symbolic representation. The power of the image derived from its seemingly authentic representation of the real world, its verisimilitude.[82] Photomontage was in some ways the quintessential application of socialist realism in the visual sphere. Using actual photographs of Soviet workers, it created the impression of "is" where before there had only been "ought." Since photographs conveyed, as did no other medium except film, a seemingly "real" picture of the world, photomontage perpetrated an illusion that the future and present were indistinguishable.

Relying on actual photographs, political artists developed a new approach to the problem of representing workers in the Stalinist era. Instead of subsuming all workers into a single image of the blacksmith or creating vague and abstract images of a multiplicity of identical worker-silhouettes, they began to portray workers as miners, construction workers, metalworkers, textile workers, and so on. There was no longer a single prototype of the worker. A 1931 large-scale poster by Klutsis, "Dadim milliony kvalifitsirovannykh rabochikh kadrov" (We Will Produce Millions of Qualified Workers' Cadres), exemplifies the application of photomontage (fig. 1.13).[83] The poster (in an edition of 40,000) consists of a column of workers, male and female, moving toward factory buildings in the distance. They belong to different occupational subgroups. Most are smiling, and some are looking directly at the viewer.

Not all 1930s posters utilized the silhouette or photomontage to depict the worker. There were many others that relied on conventional techniques of painting and drawing to convey their message; in the second half of the 1930s, these posters once again predominated. Experimentation with technique was part of a larger effort, under way throughout the 1930s, to create a new visual language suited to the era of Stalinist industrialization. This language no longer depended on the repetition of certain fixed iconographic images. Instead, artists brought their imagery in line with official ideology by incorporating visual elements designed to serve as markers for the new *Soviet* rather than "proletarian" man. A distinct set of attributes (though not all were present at the same time) became the markers for heroic citizens in the first half of the 1930s.

These attributes included, first and perhaps most importantly, youth

and a general appearance of vigor, freshness, and enthusiasm. This became a virtual requirement for positive images in posters of all types. The emphasis on youthfulness corresponded to actual changes in the labor force. By the end of the 1930s, the bulk of factory workers were under twenty-nine and many were twenty-three or younger.[84]

Second, the new Soviet man—the worker-hero of the Stalin era—was a perpetual builder of socialism, and he was usually shown in motion. Whereas formerly the worker had often been depicted in a static pose, now political artists were expected to represent workers engaged in action.[85] Indeed, the composition of posters—with their Constructivist diagonal—creates a sense of motion. Journals devoted to poster reviews sharply criticized posters that failed to include images of workers in motion. Thus, the 1931 Klutsis poster discussed above was received with reservations by a critic who noted that the figures were motionless and posed.[86]

A third attribute of the male Stalinist hero was his stature. Like Gulliver towering over the Lilliputians, he was depicted as larger than life. Perspectival distortion, as noted earlier, had been used occasionally during the Civil War years but receded in the 1920s. It was restored during the 1930s as a standard way of graphically depicting the heroic worker and others such as collective farm workers whose feats transformed them into "supermen" and "superwomen."[87] Female workers were generally depicted with attributes similar to their male counterparts, although they appear far less frequently in political art.

Another important element of the emerging visual sign system was the attribution of emotion. The blacksmith, as well as the silhouetted figures of the early 1930s, generally lacked emotional expression. In the course of the 1930s, political artists began to represent workers with feelings. The emotional range was limited to two basic dispositions: intense effort and determination on the one hand, joyfulness on the other. A 1932 poster by the artist Adolf Strakhov illustrates this trend (fig. 1.14).[88] In this poster, "Dneprostroi postroen" (Dneprostroi Has Been Built), we see the face of a worker beaming with emotion: his ecstatic expression and raised arm are a response to the opening of the Dneprostroi dam pictured in the background. Joyfulness and "lofty emotional agitation" (*vzvolnovannost'*) became characteristic emotions

ascribed to workers in the second half of the 1930s, facilitated, no doubt, by Stalin's declaration that Soviet life had become merrier.[89]

Finally, posters make use of the direct gaze. During the 1920s, political artists seldom made use of this device. In the 1930s, by contrast, political artists depicted workers looking directly at the viewer. Viktor Govorkov's 1933 poster, "Vasha lampa, tovarishch inzhener" (Your Lamp, Comrade Engineer) (fig. 1.15), shows a youthful larger-than-life figure holding out a lamp in his right hand.[90] He confronts the viewer with a penetrating direct gaze. The frequent use of this device altered the conventional relationship between the viewer and the image. Whereas formerly, the viewer was an observer looking in at the world of the image, now the relationship was reversed. The image confronted the viewer. It might not be far-fetched to compare this phenomenon with the presence of the all-seeing eye (*velikii glaz*) in Orthodox iconography.[91]

The Govorkov poster holds particular interest because it was intended to counteract the early campaign to vilify so-called bourgeois specialists as "enemies of the people." To ensure that viewers appreciated the new attitude toward specialists, the text at the bottom of the poster stated, "It is a matter of Soviet specialists' honor to give their experience and knowledge to socialist production. Away from desk jobs—into the mine, to the work site." A contemporary reviewer of the poster approved of the artist's "good *tipazh*" of the miner and expressed particular appreciation for the miner's "heroic" status in the poster as the initiator of "comradely solidarity in work" between workers and the engineer.[92]

The monumental sculpture by Vera Mukhina, *Rabochii i kolkhoznitsa* (Worker and Collective Farm Woman), designed in 1937 for the top of the Soviet pavilion at the International Exhibition of Arts, Crafts, and Sciences in Paris, exemplifies the coalescence of all the elements—youth, motion, stature, emotion—that composed the new Stalinist semiotic system (fig. 1.16).[93] In what was no doubt a deliberate choice, Mukhina revived the image of the male blacksmith. It is precisely the reference to this early image that makes her sculpture so arresting, for Mukhina's blacksmith belongs to a very different world from his earlier counterpart. He is strikingly youthful and handsome,

in the clean-cut masculine way that became standard for male workers in the Stalin era.[94] Rather than a static pose or the conventional hammer striking the anvil, his left arm is thrust forward on the diagonal. He holds up a hammer (the woman raises a sickle) not in an act of labor but rather in a gesture of triumph. His intense expression and direct gaze, brows slightly furrowed, indicate strong emotion and determination. He is the prototype for the new Soviet man.

STALIN AS THE SACRED CENTER

One of the most striking developments in the 1930s was the gradual but unmistakable decline in the importance of the worker in Soviet political art. Prior to the adoption of the First Five Year Plan, the official ideology focused, above all, on legitimating the October Revolution. These efforts reached their apogee in 1927. A key element in this effort was sacralization of the proletariat, which had performed its world-historical mission and earned its status as the chosen people by bringing the Bolsheviks to power. With the adoption of the First Five Year Plan, the vast Soviet propaganda machine directed its attention to a different issue: the legitimation of the Stalin revolution. Although workers constituted an important group in this massive transformation, the Stalin revolution was to be made not by a single class but by a whole society. It required total national mobilization. Despite the incessant rhetoric of class warfare, the key category in the 1930s was not class but citizenship.[95] Stalin, after all, was the Father of the Peoples, not the Father of the Proletariat.

The changing position of workers in visual propaganda can be judged from poster editions. In 1932, the average press run for posters was about 30,000; between 1935 and 1941, some poster editions ran as high as 100,000 or 250,000. But just as poster editions expanded, those devoted to industrial themes—those featuring workers—occupied a diminishing place in the now centralized production of political art. Thus, in 1937, posters on the theme of Aviation Day and the death of Lenin were produced in editions of 100,000. A poster celebrating Soviet aviation to the North Pole appeared in an edition of 200,000.[96] The largest press run of a poster on an industrial theme was 30,000,

compared to 75,000 for posters dealing with agriculture. Of the sixty-one different posters commissioned that year, only four were devoted to themes featuring workers.[97]

A similar set of developments took place in the Soviet film industry of the 1930s. Eighty-five films dealing with contemporary themes were produced between 1933 and 1939. Of these, only twelve can be described as "construction dramas," that is, they focused on achievements in heavy industry. As film historian Peter Kenez observes, the small number devoted to this theme is particularly surprising, given the importance of industrial production in propaganda more generally. He attributes the small number of films to the difficulties confronted by directors attempting to make the topic interesting for viewers, but the causes may, in fact, lie deeper.[98]

Workers and industrial themes had lost their hegemonic position in the visual syntax. Earlier, the male worker's incomparable status had been expressed relationally: he stood in front of or loomed over peasants, female workers, even Red Army soldiers (as in Matveev's sculpture discussed above, fig. 1.6). In the 1930s, however, workers took their place alongside collective farmers, aviators, and athletes—all of them inducted into the Stalinist hall of fame. Workers no longer had a special claim to sacralization; this honor was now bestowed on all those who performed exceptional feats for the Stalinist party-state. As it turns out, more films (20) were produced between 1933 and 1939 dealing with heroes such as pilots, explorers, and geologists than with industrial workers (12).[99]

These developments in visual representation correspond to what Lewin has described as the workers' "fall from grace." As he puts it, workers enjoyed preferential treatment during the New Economic Policy (NEP) of the 1920s, for theirs was "the right of social origin." By the end of the 1930s, this situation had changed, and workers "had become inferior to other groups and, most irritatingly, to the pettiest officials." The party, once the bastion of "conscious workers," had become "a vehicle for officialdom and specialists."[100] A fundamental shift in the country's social hierarchy and the status of different groups had far-reaching implications for the structure of power and its symbolic representation.

As the proletarian worker—once the essence of Bolshevik mythology—receded in importance in visual propaganda, the image of Stalin came to occupy a central and sacred place in Soviet iconography. Representations of the *vozhd'* (leader) occur very early in political art. Lenin's image was incorporated into posters during the Civil War and throughout the 1920s.[101] Stalin's appearance in political posters coincides with the First Five Year Plan. At first, he was shown in a subordinate relationship to Lenin. But by early 1932, Stalin's image was given equal status with Lenin's, and soon he began to emerge as the more important figure.[102]

A 1935 poster by A. Reznichenko, issued in connection with the Stakhanovite campaign, brings into sharp relief the complex of images and ideas that characterized the Stalinist visual discourse on power. In this poster, "Stakhanovskoe dvizhenie" (The Stakhanovite Movement), Stakhanov is shown carrying a red flag that bears an image of Stalin's face (fig. 1.17).[103] Behind him is a crowd of workers and, beyond them, the Kremlin. The poster uses the visual trope of metonymy to associate by contiguity the heroic worker Stakhanov, Stalin, and the Kremlin (symbolizing continuity of the Stalinist state with the ancient Russian tradition of the state). Reznichenko placed Stakhanov in the center of the poster, but peripheral elements (Stalin's image on the red flag and the Kremlin tower) dominate the composition and define the worker-hero. The significance of this constellation must have been unmistakable for contemporaries. Stakhanov's stature and greatness were inextricably linked to Stalin and the Kremlin; the worker-hero drew from them his inspiration, direction, and superhuman powers.

The Reznichenko poster appeared in a small edition (10,000 copies), but it exemplifies a style of representation that began with collectivization posters (see figs. 3.11 and 3.12 below) and in the mid-1930s was extended to workers, explorers, aviators, athletes, and construction crews.[104] Now the visual script was complete. Entry into the Soviet pantheon required not only joyful and diligent labor but also a talisman engraved with the image of Stalin. It was Stalin, the Great Helmsman, and not the worker-blacksmith, who generated the sacred powers that would make it possible to hammer out "the bright road for the people . . . happiness for the motherland."[105] The affinity between

the two figures did not elude Osip Mandelstam, who immortalized it in his irreverent 1933 epigram on the murderous Hephaestus in the Kremlin:

> He hammers ukazes one after another, like horseshoes—
> One gets it in the groin, one in the head, one in the brow, one in
> the eye.
> Each execution for him is a treat.
> And the broad chest of an Ossete.[106]

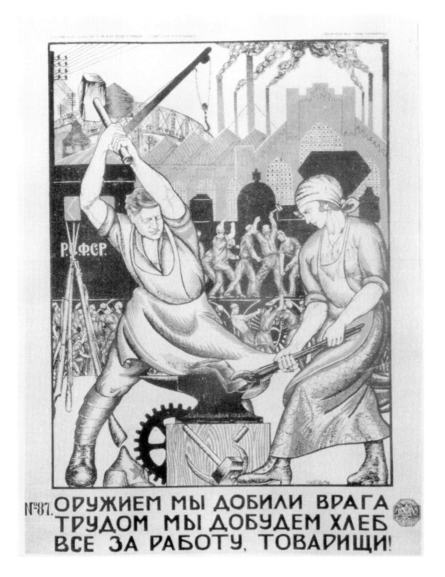

Figure 1.1. Nikolai Kogout, "Oruzhiem my dobili vraga" (We Defeated the Enemy with Weapons), 1920

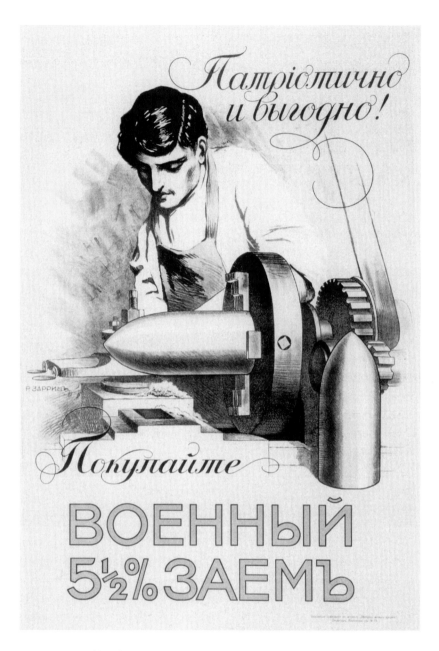

Figure 1.2. Rikhard Zarrin, "Patriotichno i vygodno! Pokupaite voennyi 5½%
zaem" (Patriotic and Profitable! Buy the 5½% War Bonds), 1914–1917

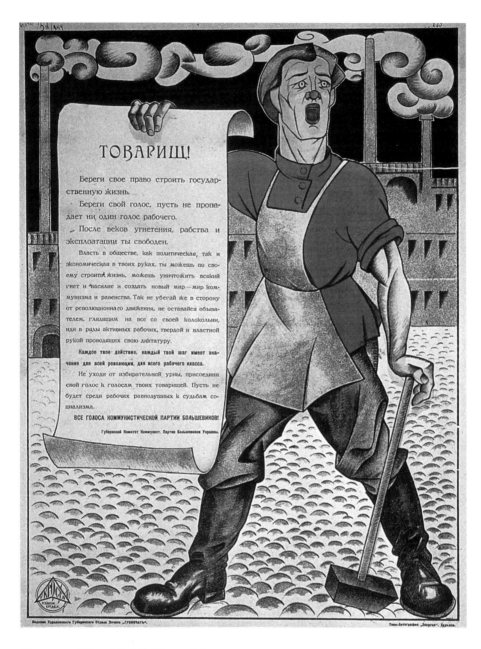

Figure 1.3. "Tovarishch!" (Comrade!), 1917

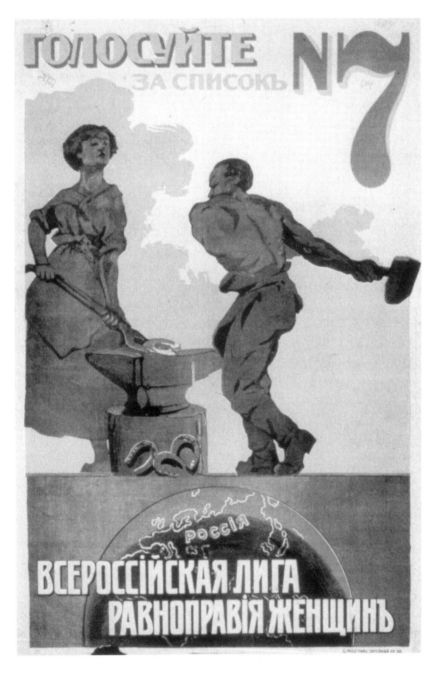

Figure 1.4. "Vserossiiskaia liga ravnopraviia zhenshchin. Golosuite za spisok N. 7" (All-Russian League for Women's Equality. Vote for List No. 7), 1917

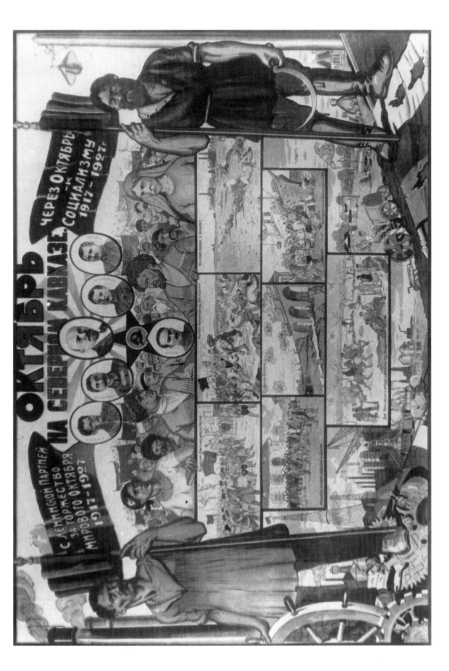

Figure 1.5. "Oktiabr' na severnom Kavkaze" (October in the Northern Caucasus), 1927

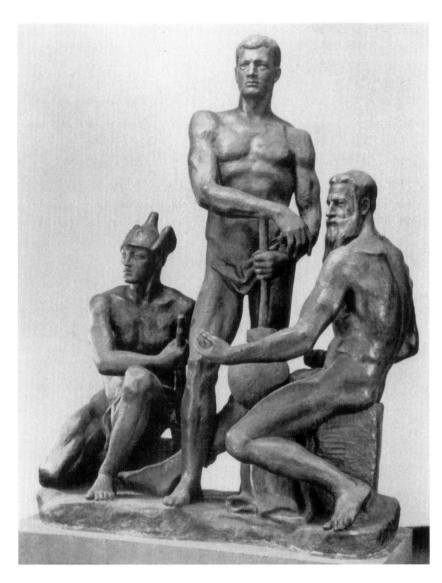

Figure 1.6. Aleksandr Matveev, *Oktiabr'skaia revoliutsiia* (October Revolution), 1927

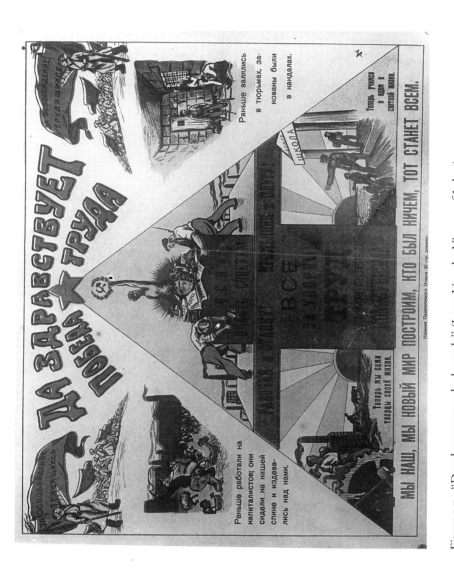

Figure 1.7. "Da zdravstvuet pobeda truda" (Long Live the Victory of Labor), 1920

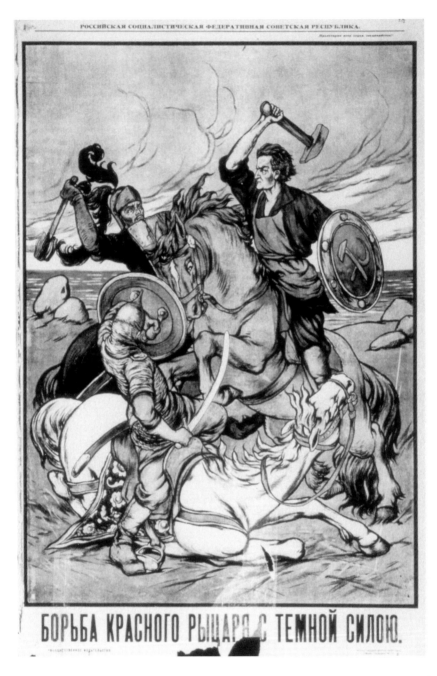

Figure 1.8. Boris Zvorykin, "Bor'ba krasnogo rytsaria s temnoi siloiu" (Struggle of the Red Knight with the Dark Force), 1919

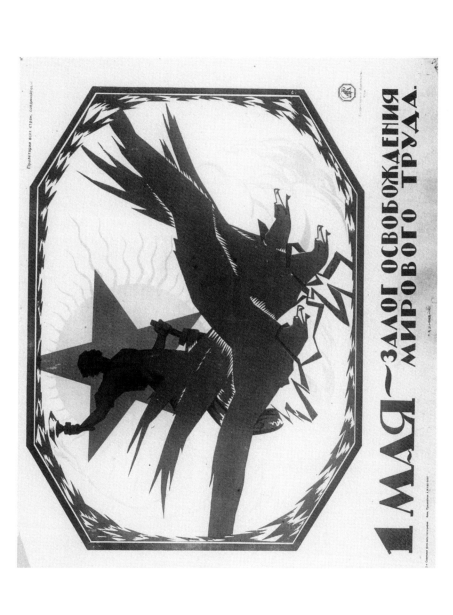

Figure 1.9. Aleksandr Marenkov, "1 maia—zalog osvobozhdeniia mirovogo truda" (May 1—The Pledge of World Labor's Liberation), 1921

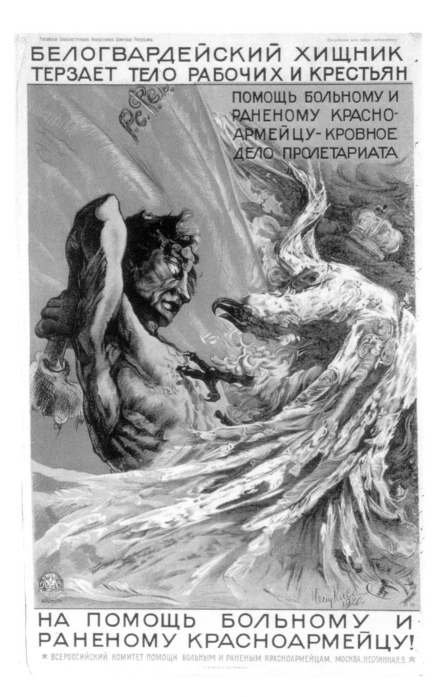

Figure 1.10. Petr Kiselis, "Belogvardeiskii khishchnik terzaet telo rabochikh i krest'-
ian" (The White Guard Beast of Prey Is Tearing the Body of Workers and Peasants
to Pieces), 1920

Figure 1.11. "1 oktiabria—vsesoiuznyi den' udarnika" (October 1—The All-Union Day of the Shock Worker), 1931

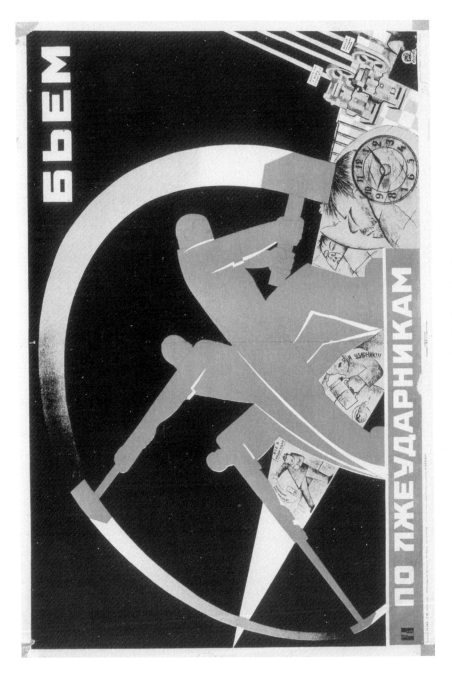

Figure 1.12. "B'em po lzheudarnikam" (Down with the False Shock Workers), 1931

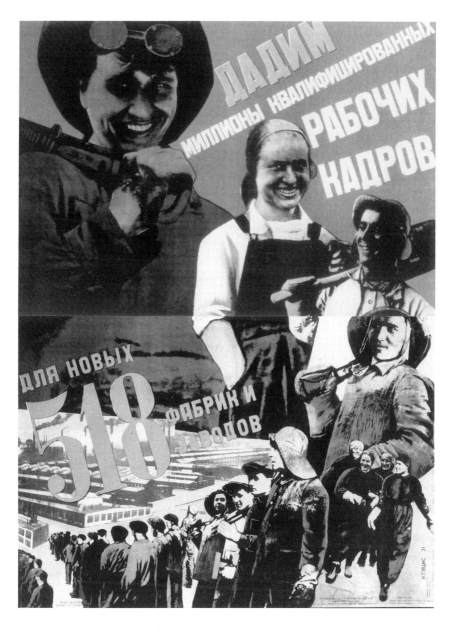

Figure 1.13. Gustav Klutsis, "Dadim milliony kvalifitsirovannykh rabochikh kadrov" (We Will Produce Millions of Qualified Workers' Cadres), 1931

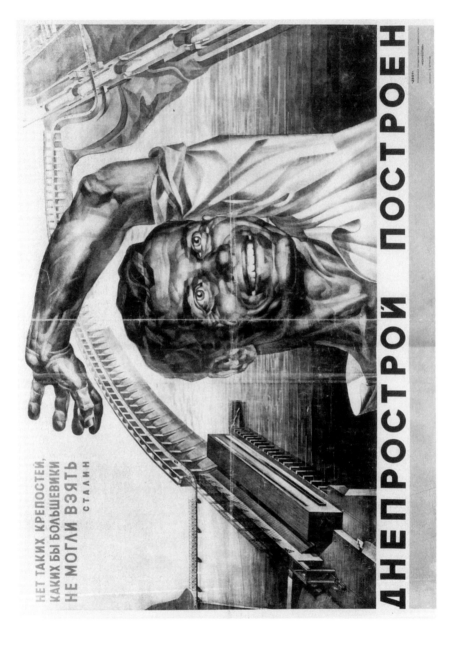

Figure 1.14. Adolf Strakhov, "Dneprostroi postroen" (Dneprostroi Has Been Built), 1932

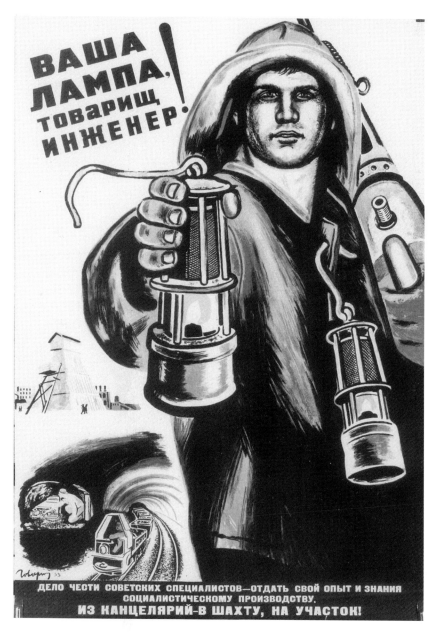

Figure 1.15. Viktor Govorkov, "Vasha lampa, tovarishch inzhener" (Your Lamp, Comrade Engineer), 1933

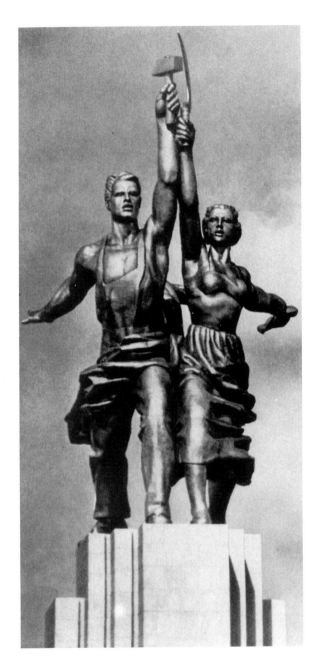

Figure 1.16. Vera Mukhina, *Rabochii i kolkhoznitsa*
(Worker and Collective Farm Woman), 1937

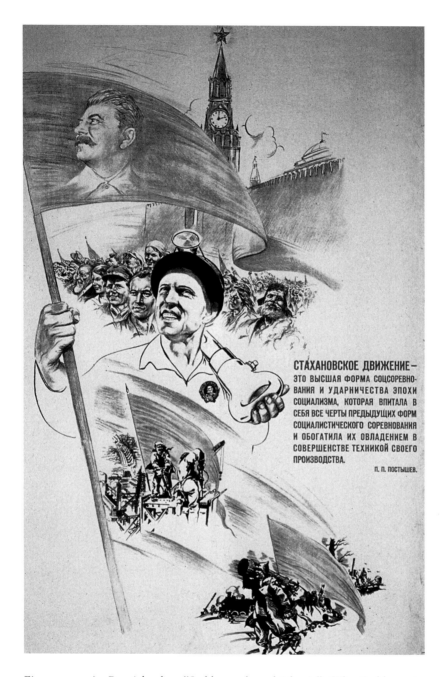

СТАХАНОВСКОЕ ДВИЖЕНИЕ—
ЭТО ВЫСШАЯ ФОРМА СОЦСОРЕВНО-
ВАНИЯ И УДАРНИЧЕСТВА ЭПОХИ
СОЦИАЛИЗМА, КОТОРАЯ ВПИТАЛА В
СЕБЯ ВСЕ ЧЕРТЫ ПРЕДЫДУЩИХ ФОРМ
СОЦИАЛИСТИЧЕСКОГО СОРЕВНОВАНИЯ
И ОБОГАТИЛА ИХ ОВЛАДЕНИЕМ В
СОВЕРШЕНСТВЕ ТЕХНИКОЙ СВОЕГО
ПРОИЗВОДСТВА.

П. П. ПОСТЫШЕВ.

Figure 1.17. A. Reznichenko, "Stakhanovskoe dvizhenie" (The Stakhanovite Movement), 1935

Two

REPRESENTATION OF WOMEN
IN EARLY SOVIET POSTERS

WHEN THE BOLSHEVIKS SEIZED power from the Provisional Government in October 1917, the party numbered no more than 350,000 people in a country of some 140 million. Transformed overnight from a revolutionary party into a ruling party, the Bolsheviks were eager to establish the legitimacy of the new party-state and disseminate their ideas to a large, overwhelmingly rural population. No consensus existed about the revolutionary events, or indeed about the major issues in the country's political, economic, and social life. Through mass propaganda, the Bolsheviks sought to establish the hegemony of their interpretation of the past, present, and future—their own master narrative—and to inculcate among the population new categories for interpreting the world around them. Political posters provided an effective vehicle for conveying Bolshevik ideas.

Political art attracted many outstanding artists who placed their talents at the service of the Bolsheviks at a time when the Civil War was polarizing the country and mass mobilization had become an urgent matter.[1] They came with enthusiasm, but there was no consensus among them or among officials in the cultural sector—or among the viewers, for that matter—concerning the kinds of visual symbols, images, and styles of representation that were appropriate for the new Soviet state. Artistic freedom was at its height, and visual propaganda had not yet come under centralized jurisdiction and control. For a brief period, political art became a terrain for experimentation and contestation over the most appropriate ways to express the Bolshevik message, and sometimes, also, over the content of the message itself.

Artists drew on a rich repertoire of cultural styles for visual propaganda. A gifted group of avant-garde artists took part in the early May Day and November 7 celebrations, creating futurist and cubist visual displays and posters. Other artists used visual allegories and symbols derived from the neoclassical and religious traditions to express Bolshevik ideas and appeals. Winged horses, chariots, hydras, St. George, and even angels appeared in early Soviet political art.[2] Some, such as the

creators of Rosta Windows,[3] had recourse to the popular Russian folk art style of the *lubok*,[4] while others applied styles of representation that incorporated elements drawn from popular culture, religion, prerevolutionary Russian painting and posters, and the classical myths.

The new images of Bolshevik male heroes—the worker, the peasant, and the Red Army soldier—were soon transformed into archetypal figures, the icons of Soviet Russia. As in religious icons, heroes (saints) and enemies (the devil and his accomplices) were standardized with remarkable consistency, in a manner resembling the pattern book or *podlinnik* in the art of the Russian Orthodox Church. During 1919, as we have seen, iconographic images of male heroes were widely circulated in political posters, holiday displays, and monumental sculpture.

The ease and rapidity with which political artists generated icons of male heroes did not apply to their female counterparts. In fact, it is striking to notice how few images of women appear in Soviet political art before 1920. When they did appear, women either were represented as allegorical figures symbolizing such abstract concepts as freedom, liberty, knowledge, art, and history or were shown as nurses or victims of the White Army.[5] Prior to 1920, few images of peasant women and women workers were incorporated into visual propaganda. Lenin's plan for monumental propaganda exemplified the general pattern. More than forty "heroes" were eventually monumentalized; only two of them were women.[6]

The sparseness of female imagery in early Bolshevik political art is notable because it represented a departure from some of the major visual traditions in prerevolutionary Russia. In the system of representation in religious icons, the Mother of God occupied a central place. Folk art, more specifically the *lubok*, included images of many different mythical and realistic female figures.[7] In the commercial, charitable, and educational posters that proliferated in Russia after the turn of the century, pictures of elegant and attractive women, often reminiscent of film stars, were widely used to promote movies, journals, society balls, theatrical productions, soap, perfume, and other products.[8] By contrast, tsarist political posters produced during the Russo-Japanese War

and between 1914 and 1917 emphasized scenes of male combat. Women were seldom depicted, and when they were, they usually appeared as allegorical figures or participants in the war effort.

Like tsarist political art of World War I, Bolshevik Civil War posters conjured up an overwhelmingly male world. It was only in early 1920 that artists created distinctive representations of the woman worker and the woman peasant. Some female allegories continued to appear throughout 1920 and 1921, but more and more often, images of women workers and peasants, dressed in clothing familiar to contemporaries, replaced the graceful figures in classical attire symbolizing freedom and knowledge. Instead of allusions to the classical age of Roman republicanism, viewers were invited to visualize a society populated by industrious women workers and robust peasant women, building socialism alongside their male counterparts.

Although figures of women appeared far less frequently than male heroes of the new regime, their presence serves as an important indicator of the official orientation toward hierarchical relationships. Gender images are intrinsically about issues of domination and subordination, a major problem in Civil War Russia, when traditional hierarchies had been discredited and new ones had not yet been established. The transformation of female imagery corresponded to the ascendancy of a new Bolshevik visual language, which gave expression to the party's conception of collective identities based on class and gender.

ALLEGORICAL AND SYMBOLIC REPRESENTATIONS OF WOMEN

Some of the first images of women produced after the Bolshevik revolution functioned as allegories.[9] A major source of inspiration for female allegorical figures was the neoclassical tradition transmitted by the French Revolution. The Bolsheviks paid close attention to French revolutionary history; it served as the key element in their master narrative of the world historical struggle for liberation and a source of symbols and images for expressing new political ideas.

In revolutionary France, the key images were Marianne, the "feminine civic allegory," and Hercules, the emblem of the radical Republic

and the sans-culottes. They were often accompanied by symbols such as the Phrygian cap, the fasces, and an altar, which further accentuated associations with the Roman Republic.[10] During the French Revolution, these images and symbols provided representations of the new political order, giving shape to the experience of power. They also served as a focus for struggles over contested issues.[11]

Allegorical images remained important in France throughout the nineteenth century.[12] Representations of Marianne continued to be produced, but with variations corresponding to political conditions.[13] In addition, there were numerous civic monuments, sculptures, and paintings that presented syncretistic allegorical figures, such as Republic. Syncretistic images drew on no single mythological referent (for example, Hercules), but incorporated a combination of "attributes or elements from traditional representations of Faith, Truth, Martyr-Saint, Prophetess, and Romantic Heroine."[14]

During the 1905 revolution, political artists seeking to represent abstract ideas such as freedom and history (*svoboda* and *istoriia*—both grammatically feminine nouns) created syncretistic allegorical images of women in the neoclassical style.[15] A drawing by D. I. Shatan, "Zakliuchenie soiuza" (The Conclusion of a Union), which appeared in the left-wing Odessa journal *Svistok* in 1906, shows a stately female figure in a long red garment and what appears to be a Phrygian bonnet shaking hands with a worker while conspicuously holding a palm frond in her left hand. In the French tradition, the "martyr's palm" was conventionally associated with Victory; the figure's Phrygian bonnet signified that the woman was a champion of liberty.[16] Similar images appeared in nineteenth-century France symbolizing the republic.[17] Shatan's drawing was intended to communicate certain ideas to an audience accustomed to "reading" visual allegory. As a style of representation, neoclassicism was, of course, thoroughly familiar to educated Russians. It was the common idiom in architecture and civic sculpture of eighteenth-century Russia and had been revived after the 1905 revolution.[18]

Following the overthrow of the tsarist autocracy, female allegory was again invoked as a means of expressing abstract ideas. On May Day 1917, a procession in Petrograd included a woman portraying freedom.

She stood in front of the State Duma building dressed in classical garb and holding a broken chain in her hands. The following year, also on May Day, Petrograd viewed the figure of a woman in a Roman tunic carrying a torch in her right hand and standing on a chariot drawn by horses. Similar displays were incorporated into the May Day celebration in 1919 and the November 7 processions in 1918 and 1919.[19] May Day and November 7 celebrations in these years presented a multiplicity of symbols and rituals drawn from the classical vocabulary, including chariots, altars, torches, winged horses, and Greek choruses (part of the *instsenirovki,* or theatrical reenactments of historical events).[20]

Female versions of the allegorical figures Freedom and Liberty also appeared in political posters and monumental sculpture. A Petrograd poster created by L. Radin in February 1919, "Smelo, tovarishchi, v nogu!" (Boldly, Comrades, March in Step!), features a woman in classical dress and a headdress suggestive of a Phrygian cap (fig. 2.1).[21] She holds a rifle in her right hand and a flag in her left. The depiction of the female figure bears strong resemblance to Eugène Delacroix's painting of 1830, *Liberty Leading the People at the Barricades,* including the partially bared breast and the combination of rifle and flag.[22]

The Soviet version of Liberty is considerably less assertive than her French counterpart. She is surrounded by the debris of the old order, rather than dead bodies, and, very significantly, two strapping workers flank her on either side. Insets around the periphery of the poster show scenes featuring workers, including one with a peasant and a worker shaking hands. The images and composition are indicative of the attempt in 1918–1919 to synthesize quite different styles and semantic systems of visual representation. Whereas the neoclassical female figure carried associations (for educated Russians) with Roman republicanism, the images of workers and peasants suggested a political ideology that foregrounded the concept of class rather than citizenship.

During the first postrevolutionary years, female syncretistic images also appeared in posters and holiday displays as representations of art, history, and knowledge. A 1919 poster, "Soiuz rabochikh i nauka" (The Union of Workers and Science), features a beautiful young woman with a laurel wreath in her hair and an earnest young man engaging her as they perch on a pile of books (fig. 2.2).[23] Female figures

depicted as abstractions of this type characteristically wore flowing white dresses and belonged to the same visual vocabulary of symbols as their French counterparts. The allegorical style carried over to monumental sculpture as well. In 1918–1919, Nikolai Andreev and Dmitrii Osipov created an obelisk in Moscow, *Svoboda (Sovetskaia konstitutsiia)* (Freedom [The Soviet Constitution]), which included a statue of a woman representing Freedom. She was dressed in classical garb, with ample breasts and exposed legs, her right arm raised as though pointing toward the sky.[24]

The French tradition of political iconography provided one important source for allegorical images in the immediate postrevolutionary period. The indigenous Russian tradition of religious and autocratic art provided another. In old regime Russia, allegorical images—both male and female—played a major part in the pageantry and symbolic system of both the autocracy and the Church. The most central image, which provided a "cultural frame" for organizing political narratives under the old regime,[25] was that of St. George. The legend of St. George was depicted in religious iconography, folk art, and the political art of the tsarist government.[26] During the First World War, the tsarist government had repeatedly used the image of St. George in its political propaganda.[27]

A basic part of the visual vocabulary, images of St. George quickly became incorporated into the revolutionary lexicon after the October Revolution. Early Bolshevik posters depicted a male worker, sometimes on a horse, slaying a reptilian monster—an image which must have reminded many viewers of the story of St. George. One of the earliest posters in 1918, "Obmanutym brat'iam" (To Our Deceived Brothers), was created by Aleksandr Apsit, an artist who was trained in religious painting and was well attuned to symbolic imagery (fig. 2.3).[28] Apsit depicted a worker bludgeoning a hydra, whose multiple heads resemble Nicholas II and other tsarist leaders. Holiday displays and stamps also incorporated references to St. George. The following year, for the second anniversary of the revolution, Boris Zvorykin created a poster, "Bor'ba krasnogo rytsaria s temnoi siloiu" (Struggle of the Red Knight with the Dark Force), portraying a worker on horseback holding a

shield (inscribed with a hammer and sickle) in one hand and a hammer in the other, poised to slay the enemy around him (fig. 1.8).[29] In 1920, a leading Bolshevik poster artist, Viktor Deni, represented Leon Trotsky as St. George slaying the dragon of counterrevolution. A postage stamp issued in 1921 featured a worker kneeling on a slain dragon.[30]

There was also a key female figure in tsarist iconography: the image of Russia. The visual representation of Russia as a woman corresponded to the word *rodina*, or motherland, etymologically connected to the word *rodit'*, to give birth.[31] At the time of the Russo-Japanese War, the government issued a poster entitled "K voine Rossii s Iaponiei" (Concerning the War between Russia and Japan).[32] Produced in April 1904, not long after the surprise attack on the Russian fleet by Japanese forces at Port Arthur, the poster presents a woman in a long dress, a chain mail shirt, and an ermine cap lined in red satin. She holds a palm frond in her right hand (symbol of victory), a double-headed eagle perches on her left shoulder (symbol of autocracy), and a white angel hovers over her head. In the background is a snarling serpent-like beast with huge fangs and Oriental features. She is the female counterpart of the medieval Russian warrior. In another 1904 poster, "Rossiia i ee voin" (Russia and Her Soldier), Russia is represented by a beautiful woman in a sarafan and a traditional Russian headdress (*kokoshnik*) (fig. 2.4).[33] She sits in a relaxed position of repose and gazes at a young soldier standing at attention to her left.

During World War I, female images of Russia again make an appearance. In "Rossiia—za pravdu" (Russia—for Truth) (fig. 2.5), a determined woman is depicted wearing a medieval warrior's helmet and chain-mail shirt.[34] She carries a sword in her right hand and a shield with the image of St. George in her left hand. Standing on a slain hydra with two heads and black wings, a victorious "Mother Russia" commands the field strewn with slain soldiers, charging cavalry, dirigibles, and explosions. The poster brings together into one image many of the stock ingredients of tsarist political iconography.

After the February Revolution, the liberal Party of People's Freedom (also called the Constitutional Democratic Party, or Kadet Party) used an image of Mother Russia to promote its cause during elections to

the Constituent Assembly. A black-and-white Kadet poster by Aleksei Maksimov, "Golosuite za Partiiu Narodnoi Svobody" (Vote for the Party of People's Freedom), shows a woman in a sarafan riding a horse. She holds a sword aloft in one hand and a shield inscribed with the word *svoboda* (freedom) in the other (fig. 2.6).[35] Whereas the Kadets appropriated imagery of Mother Russia derived from tsarist iconography, this option was not available to the Bolsheviks. The Bolsheviks did not hesitate to utilize other allegorical and representational images from old regime iconography (such as St. George), but representations of Mother Russia proved unacceptable during these years because of the party's emphatically internationalist perspective. Nevertheless, images of Bessarabia and Ukraine as female figures did appear, an indication that Soviet artists did not reject entirely female symbolism for an entire nation.[36] It was not until the country entered the Second World War that female images of Mother Russia began to appear in Soviet propaganda. Between 1941 and 1945, a number of memorable posters were issued resurrecting the traditional image of Mother Russia in a new guise—a stately, matronly woman (fig. 6.1), sometimes pictured with a small child in her arms. These posters made explicit reference to the *rodina,* thereby reaffirming the prerevolutionary link between word and image.

A striking symbolic female image can be found in Apsit's poster "Internatsional" (International), published in December 1918 (fig. 2.7).[37] This unusual poster features a monstrous female figure on a pedestal marked "Capital." She has huge bare breasts, fangs, the tsarist crown, and a serpentine tail. Men with hammers are tearing down her pedestal and attacking the monster. To my knowledge, this is the only instance of a Bolshevik poster representing capital (a masculine noun in Russian) as a woman, and one of the only instances of a distinctively female monster.[38] The image probably has most in common with the folk art tradition of the *lubok,* where women were sometimes associated with the devil and presented as schemers and liars.[39]

The emphasis on allegorical and symbolic representations of women in visual propaganda lasted only a few years.[40] There was considerable pressure from officials, critics, and others to adopt a different vocabu-

lary that would be more comprehensible to a working-class audience. A resolution of the Moscow Soviet in March 1919, in anticipation of the May Day celebration, declared that the aesthetic needs of workers should take precedence over particular artistic groups, a reference to the futurist art of the avant-garde. Henceforth, all artistic affairs in Moscow were to be conducted with the close participation and direct control of the Moscow proletariat. The Executive Committee of the Petrograd Soviet passed a similar resolution in April 1919 explicitly castigating futurists and excluding them from participation in the forthcoming May Day celebration.[41]

As late as May Day 1921, there were still occasional posters with symbolic female figures such as Sergei Ivanov's "1-oe maia. Da zdravstvuet prazdnik trudiashchikhsia vsekh stran!" (May 1. Long Live the Holiday of the Working People of All Countries!), which depicted a woman in a white flowing dress and long blond hair floating through the air and strewing roses to a demonstration below (fig. 2.8).[42] An unusual example of the influence of art nouveau, this poster probably owed some of its inspiration to Isadora Duncan, who was visiting Russia at that time.[43] But fanciful representations of young nymphs were a rarity by then, and women in long white garments as well as classical symbols such as chariots and altars had nearly disappeared.

When the Civil War drew to a close, Soviet propaganda artists turned their attention from classical themes to the concrete visualization of social categories and concepts. Instead of images drawn from a mythical, classic, literary, or religious context, they devised images that spelled out in graphic terms the class content of abstract ideas and the specific class attributes of social groups. "Capital" no longer appeared as a serpentine monster but as a fat man with a top hat and cigar. Heroes and enemies were henceforth represented with distinct visual markers, such as the worker with a hammer and anvil, the peasant with a sickle, and the cigar-smoking capitalist.[44]

Writing in the mid-1920s, Viacheslav Polonskii, an eminent literary scholar and historian, put forward a critique of the type of allegorical and symbolic representation that had enjoyed popularity during the Civil War years. He argued that the prevalence of allegories and

symbols was a consequence of the "bourgeois consciousness of those artists who came from the bourgeois class, bringing with them, together with technical skills, an alien approach to the interpretation of agitational lithography." Eventually the Bolsheviks were able to free themselves from bourgeois influence, from allegory and symbolism, and to "adopt themes [for posters] that are simple, close and comprehensible to the spectator to whom the poster is directed."[45] The shift described by Polonskii, from the classical language of visual imagery to the vernacular, was most strikingly evident in the changing representation of women.

Female images representing freedom and other abstract categories had become increasingly discordant with the dominant message imparted by the Bolsheviks. Implicit in the allegorical image of freedom and others like it was the notion of citizenship, associated with the Roman Republic and the French revolutionary tradition. Citizenship, in this tradition, was a universalistic concept which accorded all members of the polity a right to political participation. But in Soviet Russia, where the Bolsheviks had proclaimed a dictatorship of the proletariat, citizenship was far from universal, and entire categories of the population suffered automatic disenfranchisement because of social origin or occupation under the old regime.[46] Citizenship as an ideal was inconsistent with the realities of the Soviet system and with Bolshevik ideology. For the Bolsheviks, the key idea that explained history and the contemporary world was not citizenship but class. Class was the epistemological center of Marxism-Leninism, and by early 1920, the Bolsheviks had made it the center of their system of visual representation as well.

THE BOLSHEVIK WOMAN WORKER

The most important image in the visual lexicon, which remained part of the standard iconography until 1930, was that of the proud worker who represented the victorious proletariat. As we have seen, the visualization of the worker emphasized his class attributes: he was almost invariably a blacksmith, generally depicted in a standing position, often with a mustache (but significantly, not a beard, an attribute of the patriarchic peasantry), a Russian shirt, leather apron, and boots. He

sometimes held a hammer in his right hand; elsewhere he held the hammer poised to strike at the anvil.

Soviet artists did not generate an image of the female counterpart of the male worker until 1920. In that year, three important posters appeared depicting women workers whose external appearance and occupation replicated in essential respects the male worker-icon. One of these posters, "1-oe maia vserossiiskii subbotnik" (May 1 All-Russian Voluntary Work Day), was by the well-known poster artist Dmitrii Moor, a master of the medium whose posters were highly influential (fig. 2.9).[47] His poster, prepared for May Day 1920, depicts a man and a woman working at an anvil; she is holding a piece of hot iron with a pair of tongs, and his hammer is raised to strike it. Behind them are other workers, a railroad train, and a factory. Except for her skirt and hair style, the woman in the picture replicates the man's appearance. Both exude physical prowess, but the roles are unmistakably gender-marked, indicating male domination. Some 30,000 copies of the Moor poster were produced.

Two other influential posters with this kind of image of the female worker appeared in 1920. Nikolai Kogout's poster "Oruzhiem my dobili vraga" (We Defeated the Enemy with Weapons) was printed in a substantial edition of 50,000 (fig. 1.1).[48] Like Moor, Kogout depicted a man and a woman working together at an anvil; they have similar attire and prowess, but again she is represented in a subordinate position as the blacksmith's helper. In a third poster, "Chto dala oktiabr'skaia revolutsiia rabotnitse i krest'ianke" (What the October Revolution Gave the Woman Worker and the Peasant Woman), a woman wears a blacksmith's apron, a hammer and sickle lying at her feet (fig. 2.10).[49] She gestures with her right hand toward buildings marked "maternity home," "library," "women workers' club," and so on. Twenty-five thousand copies of this poster were printed. All three posters, especially the last two, were widely reprinted at the time.[50] The image was soon disseminated throughout the country and appears, for example, in a poster produced in Kiev for International Women's Day in 1921.[51]

The posters presented something new in the visual lexicon: an image of the woman worker, the female counterpart of the previously

all-male vanguard of the country's working class. What is surprising is that nearly two and a half years passed before the Bolsheviks presented a visualization of the politically conscious female worker, the *rabotnitsa*. Prior to that time, there were very few realistic representations of women of any kind.

The only antecedent image of the heroic woman worker that I have located appears in a poster produced by the All-Russian League for Women's Equality during the fall 1917 elections to the Constituent Assembly (fig. 1.4).[52] The league, a non-Bolshevik organization which agitated primarily for women's suffrage, distributed a handsome poster featuring a rather haughty-looking woman holding a piece of hot metal on an anvil and a male worker about to strike it with a hammer. The 1917 poster is so similar to those generated in 1920 that one wonders whether Soviet artists appropriated the image from this source or devised it independently.

The choice of image for the *rabotnitsa*—the blacksmith's helper—must have been surprising for contemporaries looking for realistic or typical representation. The factory woman was not, in itself, a novelty. Nearly one-third of the industrial labor force was already female by the outbreak of World War I, and many thousands entered factories between 1914 and 1917. A World War I poster, "Vse dlia voiny! Podpisyvaites' na 5½% voennyi zaem" (Everything for the War! Subscribe to the 5½% War Bonds), put out by the tsarist government during a fundraising drive for war bonds, pictured a woman standing demurely in front of a lathe (fig. 2.11).[53] This was rather unusual since relatively few women were employed as lathe operators; most could be found in the textile or food processing industries. But the Bolshevik image of a woman as a blacksmith's helper must have been even more baffling. Virtually no women could be found in the "hot shops," as smelting shops were called. Similarly, women did not hold positions as blacksmith's helpers in small artisanal establishments or in rural areas. This type of work was seldom, if ever, performed by women.

On the other hand, the Civil War years did mark the entry of women into areas previously considered exclusively male enclaves. Nearly 74,000 Soviet women were involved in actual combat during the Civil

War (about 1,800 became casualties), and, according to Richard Stites, "the defeminizing element among revolutionary women, dating from nihilist days, displayed itself in dress style and in the emulation of 'military' virtues."[54] Certain activist Bolshevik women could be seen clad in clothing previously reserved for men: soldiers' tunics, leather jackets, pants, boots, greatcoats.[55] A female blacksmith's helper may not have seemed more far-fetched to some observers than a woman dressed in men's military clothing.

Depending on one's point of view, then, the image of the woman worker may have been perceived as more or less relevant to the practical world. But contemporaries may have "read" the image not literally, but primarily on a symbolic level. As we saw in chapter 1, Slavic folklore contained many references to the blacksmith, who was thought to possess "concealed sacred abilities," godlike features, and the capacity to perform heroic feats.[56]

The characteristics of the blacksmith, mythologically the exclusive prerogative of males, were now extended visually, in Bolshevik posters, to women. The woman worker was presented visually as a replica of the male. She derived her special powers and aura from an association with the male worker. The analogical counterpart of the blacksmith, she acquired his symbolic attributes. In this way, and only in this way, women in the Bolshevik system of signification acquired heroic status.

Posters presenting male and female versions of the heroic worker deliver another message if viewed from a gender perspective. The addition of the *rabotnitsa* to the image of the victorious proletariat served to amplify and reinforce the theme of the hegemony of the working class, the dictatorship of the proletariat. On one level, the posters represent the worker's mythological power to refashion the world, to hammer out happiness and freedom. On another level, the juxtaposition of man and woman in these images conveys a relationship of domination: the male blacksmith is clearly the superordinate figure, the woman is his helper. Male domination is visually connected in this way to proletarian class domination.

The female blacksmith, who makes a dramatic appearance in 1920, generally drops out of sight during the early NEP period. It is only

during the second half of the 1920s that heroic female workers, bearing resemblance to the Bolshevik *rabotnitsa* of 1920, occasionally reappear in political posters. Adolf Strakhov's well-known poster of a woman worker holding a red banner, "Raskreposhchennaia zhenshchina—stroi kommunizm!" (Emancipated Woman—Build Communism!), was produced in Kharkov for International Women's Day in 1926 (fig. 2.12).[57] The strong handsome features and determined expression of this woman, shown wearing a kerchief (tied behind the neck as befitting working women) and holding a red banner, make this the most powerful image of a woman worker during the NEP period.

Generally speaking, women were kept in low profile in political posters during these years, just as they were in political life more generally. The party firmly resisted efforts to create an independent women's liberation movement in Soviet Russia—a movement which might have given gender predominance over class. Only women's organizations operating under direct party auspices gained acceptance, albeit partial, from the party leadership.[58]

Between 1918 and January 1924, women did not, with one brief exception, occupy seats on any of the leading party organs (Central Committee, Orgburo, Politburo, and Secretariat). In 1924, only 8.2 percent of the party's membership was female, most of them urban women. A similar pattern can be discerned in the governmental sector. By 1926, only 18 percent of the deputies to the city soviets and 9 percent of those to the rural soviets were women.[59]

Despite an increase in female membership in the Communist Party toward the end of the 1920s, reaching 13.7 percent of the total in October 1929,[60] the overall position of women in Soviet political life did not change significantly. A few months later, however, a major transformation took place in the representation of women, placing female images for the first time in the very center of the emerging Stalinist iconography. A *direct* correlation cannot, therefore, be established between female presence in political life and political art. There was, to be sure, some connection between the images that were produced and the political and social context. But the connection cannot be reduced to the presence or absence of women in Soviet politics. A complex

relationship existed between political realities and gender images in Soviet Russia, a situation illustrated by the representation of the peasant woman.

At the time of the October Revolution, Russia was an overwhelmingly peasant country. About four out of five Russians lived in the countryside; more than half of these were women. The Bolshevik party's social base was primarily among urban groups and, to a lesser extent, among soldiers (most of them peasants drafted into the army) in Petrograd and at the front. It could claim very little support from the vast rural population, as demonstrated by the results of the election to the Constituent Assembly which took place soon afterward.[61]

The Bolsheviks' lack of support in the countryside reflected, to a considerable extent, the party's reservations concerning the peasantry. At the level of both theory and practice, the Bolsheviks viewed the peasants with suspicion and hostility, at the same time recognizing the necessity for some kind of alliance with the vast rural population. The party hastened to proclaim a "dictatorship of the proletariat and the poor peasantry," and even middle peasants were thought to be suitable though unstable allies for the new regime.

From the very outset, Soviet political art depicted this alliance in visual terms as a coming together of two men: the blacksmith worker with his hammer, leather apron, and boots, and the bearded peasant with his scythe, bast shoes, peasant blouse, and homespun pants. Despite the absence of centralized coordination in poster production, virtually identical images of the worker-blacksmith and the male peasant were re-created over and over again with slight modifications, depending on geographic location and the ingenuity of the artist.[62] Dozens of posters with this picture appeared during the Civil War, beginning with Apsit's famous poster for the first anniversary of the revolution in November 1918, "God proletarskoi diktatury" (A Year of Proletarian Dictatorship) (plate 1).[63]

Male peasants appear in Soviet posters from 1918 onward, but female

peasants are encountered infrequently prior to 1920. In some respects, this pattern marks a continuation of the predominantly male representations in posters produced by the tsarist government during World War I. Nevertheless, peasant women appear often in traditional Russian folk art of the *lubok*.[64] During World War I, the tsarist government encouraged the use of traditional Russian folk art in the service of war propaganda. A group of artists and writers, many of them relatively young, produced posters for a government-sponsored publishing house, Contemporary Lubok, that specialized in visual propaganda using the popular *lubok* style. Among them were talented figures such as Vladimir Maiakovskii, Dmitrii Moor, and Kazimir Malevich, who later created political art for the Bolshevik regime.[65] In 1914, Malevich designed a poster, "Shel avstriets v Radzivily da popal na bab'i vily" (The Austrian Soldier Marched to Radzivily but Got Impaled on a *Baba*'s Pitchfork), which depicts a robust peasant woman, with bast shoes and big breasts, impaling an Austrian soldier on a pitchfork (fig. 2.13).[66]

A replica of Malevich's memorable image of the peasant woman resurfaced when Soviet artists created a similar image in 1920. But during 1918 and 1919, Soviet artists seldom depicted peasant women, and when they did, the imagery varied. The talented artist Boris Kustodiev created a massive display on the theme of labor for Ruzheinaia Square in Petrograd at the time of the first anniversary of the revolution that included a panel labeled "The Reaper," shown as a young female peasant with a cherubic face and a sickle. Another panel labeled "Abundance" presented a hefty female peasant with a basket of fruit on her head. During the early years, there was a powerful tendency to allegorize women, as noted earlier, even in a display that for the most part emphasized realistic representations of occupations (other panels portrayed a male carpenter, shoemaker, baker, and tailor).[67]

Although there were occasional images of peasant women in 1918 and 1919, it was only in early 1920 that Soviet artists began to create posters with a distinctive image of the female peasant that was subsequently reproduced. The image incorporated into 1920 May Day posters borrowed heavily from the style used to represent peasant women during the First World War in *lubok*-style posters such as "Shel avstriets v

Radzivily," by Malevich. The well-known May Day poster by Nikolai Kochergin, "1-oe maia 1920 goda" (May 1, 1920), exemplifies the carry-over of the Malevich image to Soviet political art (plate 2).[68] In Kochergin's poster, three figures in profile stride confidently over the debris of the old regime (crown, insignia, etc.). A male worker with a hammer over his shoulder is flanked on one side by a bearded male peasant with a scythe and on the other (in the foreground) by a buxom peasant woman. She wears a kerchief, a Russian blouse, and a skirt with an apron and carries a sickle. The poster is a classic example of early Bolshevik iconography.

The full-figured peasant woman makes an appearance in other posters in the course of 1920 and afterward. Thus, the poster, "Da zdravstvuet proletarskii prazdnik 1-oe maia" (Long Live the Proletarian Holiday May 1), by Ivan Simakov, produced for May Day 1921, incorporates an image of the female peasant virtually identical to the one produced a year earlier by Kochergin. For May Day 1923, Simakov created another poster that replicates the same peasant woman.[69]

Unlike the image of the woman worker, which can be found only in a highly symbolic and positive context, the representation of the peasant woman showed up in a variety of visual situations. Sometimes the image was incorporated into posters in a satirical mode. In these instances, the representation of the female peasant had negative connotations. Examples of the latter type can be found in posters created for the Rosta Windows, a unique form of satirical political art that combined "the functions of poster, newspaper, magazine and information bulletin."[70]

A famous poster by the satirist Mikhail Cheremnykh, "Istoriia pro bubliki i pro babu" (Story of the *Bubliki* and the *Baba*), tells the story of a *baba* who refuses to give a *bublik* (bagel) to a Red Army soldier going off to fight the Poles (fig. 2.14).[71] Soon afterward "the Pole sees the fat, white woman in the crowd. In a flash she's eaten up, she and her *bubliki*." The image in Cheremnykh's poster is quite similar to the one presented by Kochergin, only here the female peasant exemplifies many of the negative attributes the Bolsheviks perceived in this segment of the rural population—ignorance, political stupidity, blind

self-interest, and petty bourgeois greed. By surrounding the image with a certain type of narrative, Cheremnykh created a *baba.*

The word *baba* was used to connote a peasant woman or all adult females.[72] For politically conscious women and men of the postrevolutionary era, the word—and the visual image associated with it—had acquired distinctively pejorative connotations, signifying the wretched, brutal, and patriarchal world of the peasant wife, who was subordinated to husband, priest, and police. When someone proposed outlawing the word *baba* at the First All-Russian Congress of Women in November 1918, the audience roared its approval.[73]

The dual use of the peasant-woman image corresponds to the Bolsheviks' profound antagonism toward the peasantry more generally. The fact is that there was no unambiguously heroic symbolic image of the female peasant comparable to the *rabotnitsa.* Even the image of the proud peasant woman in Kochergin's poster probably could not erase the associations with the *baba,* so much disliked by politicized women. A radical break with this imagery and pattern of association did not come until 1930, when the drive for crash collectivization got fully under way. Only then did Soviet artists generate an entirely new and unambiguously heroic representation of women in the countryside: the picture of the young, aggressive, energetic, hardworking collective farm woman, with understated breasts and slender appearance, leading fellow peasants on the road to collectivization. In short, the very antithesis of the *baba.*

CLASS AND GENDER IN POLITICAL ICONOGRAPHY

What explains the kinds of images that were incorporated into early Soviet political art? As we have seen, Bolshevik visual propaganda began by representing women in an allegorical style, but by 1920 a new set of female images had been created that depicted women as workers and peasants. This shift, part of a broader trend away from allegory, marked the ascendancy of the ideology of class over the ideology of citizenship in visual propaganda.

During the immediate postrevolutionary years, a period of bitter

contestation over the meaning of things, the Bolsheviks sought to establish the hegemony of their interpretation of history and politics. They had to create images consonant with a distinctively Bolshevik ethos, but these images also had to resonate with the cultural repertoires of the artists, officials, and viewers. Cultural repertoires were, of course, highly diverse, and they incorporated elements from many different sources. Some of the earliest Soviet artists drew extensively on Western European traditions of political art, from which they appropriated various symbols and allegorical images. But only a small stratum of educated Russians could "read" these symbols and allegories, at least in their full implications. For a party that aimed at reaching broad strata of the population with its message, these kinds of images left much to be desired.

By the end of the Civil War, Soviet artists had created new images, far more accessible to ordinary people. The new images of the female worker and peasant also drew on mythology—the mythology of popular culture. Mythical elements from folklore and the popular idiom were fused with contemporary political ideology to create a special visual language for apprehending the unprecedented experiences of revolution and civil war. It was the combination of popular mythology and political ideology that gave the Bolshevik propaganda its persuasive power.

The new worker and peasant icons—both male and female—functioned as symbols in visual propaganda. Unlike images drawn from the neoclassical repertoire, they did not require access to special knowledge from classical antiquity and mythology. But they were symbols nonetheless—symbols of the heroic groups that had, according to the Bolshevik master narrative, made the October Revolution and laid the groundwork for achieving socialism. The image of the blacksmith was meant to capture some elements of what it meant to be a male worker or, in the case of his female helper, what it meant to share in the glory of being part of the chosen class. In contrast to the type of imagery produced by the Bolsheviks in the 1930s, these representations of workers and peasants were not intended to be prescriptive or to serve as models for conduct. They had a different function. Their purpose was

to give visual meaning to a worldview which foregrounded the concept of class and class conflict and defined gender in terms of class.

Class and gender provided the two principal coordinates of the new visual language in Soviet Russia, interacting and reinforcing each other in ways unanticipated by those who created and disseminated political art. But it was class, rather than gender, that provided the fundamental conceptual framework for the Bolsheviks. In the context of Marxism-Leninism, gender distinctions occupied a distinctly secondary position.

Iconographic images of workers and peasants served not only to re-map the social and political world but also to represent gender relationships. The *rabotnitsa,* an analogue of the male worker, exhibited the same iconographic attributes of proletarian class position. Yet there was an important difference. She labored as the blacksmith's helper, holding the hot metal on the anvil=altar, while he fashioned it into a new object=world. She assisted in the creation; he was the creator. He was the blacksmith-priest of the folk tradition; she was a reflection of his radiant aura. Gender domination and class domination were inextricably linked through this visual imagery.

The peasant woman encapsulated in the 1920 May Day poster by Kochergin conveyed a complex message. She was pictured as striding, alongside a male peasant worker, toward the bright future. She gained a place alongside other heroes of the revolution, but only conditionally. In this and other posters with similar imagery, the visual syntax conveyed a subtle message: the peasant woman could appear in combination with men or a woman worker, but not alone. Her position in the pantheon of heroes depended on a relationship of contiguity. Moreover, the image of the female peasant conjured up associations with the *baba,* a term with negative political connotations for many contemporaries. The representation of the peasant woman, like Bolshevik policy toward peasants generally, suffered from deep ambiguities and confusion.

When Theodore Dreiser visited the Soviet Union in the mid-1920s, he observed: "Banners and above all posters in vast numbers provided visual information with a minimum of words for illiterates and the newly literate. Walls, vehicles, shop-windows covered with them made the streets a kind of semi-literate's library."[74] Images, like books, could

be "read" in unpredictable ways. Pictures meant to emphasize class identity also conveyed, quite unwittingly, ideas about gender and gender relations. Regardless of official and artistic goals, political art contained heterogeneous messages. Posters and other forms of visual propaganda provided an intricate and influential form of political discourse for a society in which old assumptions had been shattered and new ones were still in the making.

Figure 2.1. L. Radin, "Smelo, tovarishchi, v nogu!" ("Boldly, Comrades, March in Step!"), 1919

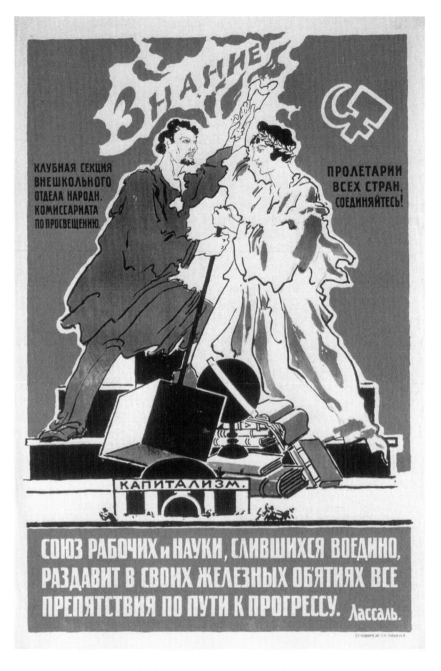

Figure 2.2. "Soiuz rabochikh i nauka" (The Union of Workers and Science), 1919

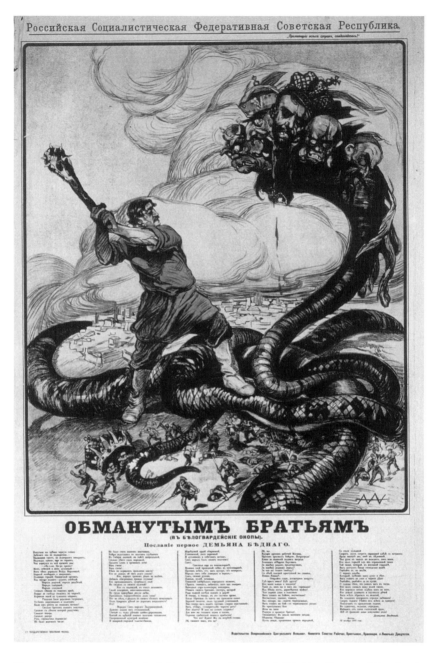

Figure 2.3. Aleksandr Apsit, "Obmanutym brat'iam" (To Our Deceived Brothers), 1918

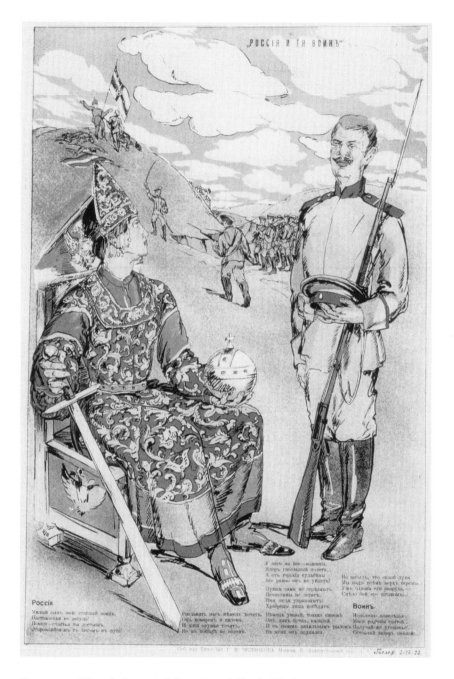

Figure 2.4. "Rossiia i ee voin" (Russia and Her Soldier), 1904

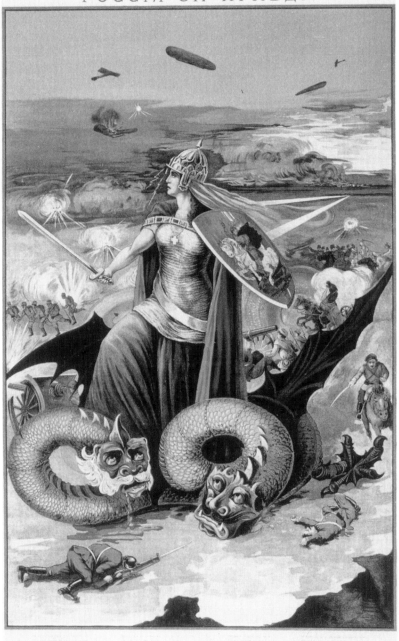

Figure 2.5. "Rossiia—za pravdu" (Russia—for Truth), 1914

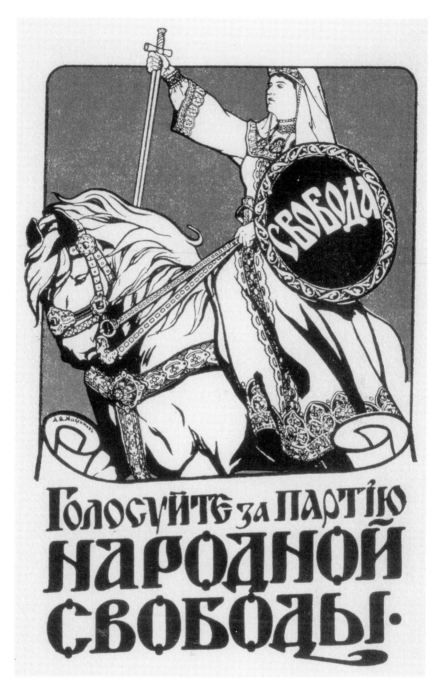

Figure 2.6. Aleksei Maksimov, "Golosuite za Partiiu Narodnoi Svobody" (Vote for the Party of People's Freedom), 1917

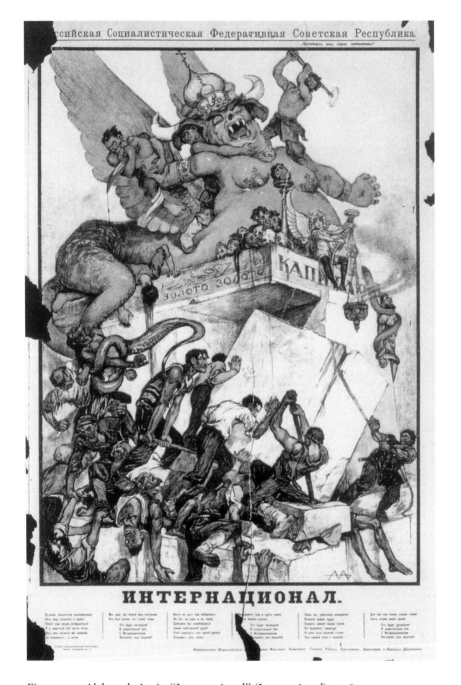

Figure 2.7. Aleksandr Apsit, "Internatsional" (International), 1918

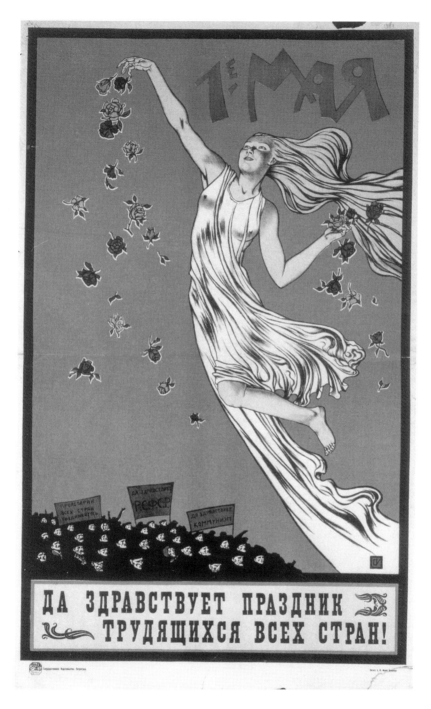

Figure 2.8. Sergei Ivanov, "1-oe maia. Da zdravstvuet prazdnik trudiashchikhsia vsekh stran!" (May 1. Long Live the Holiday of Working People of All Countries!), 1921

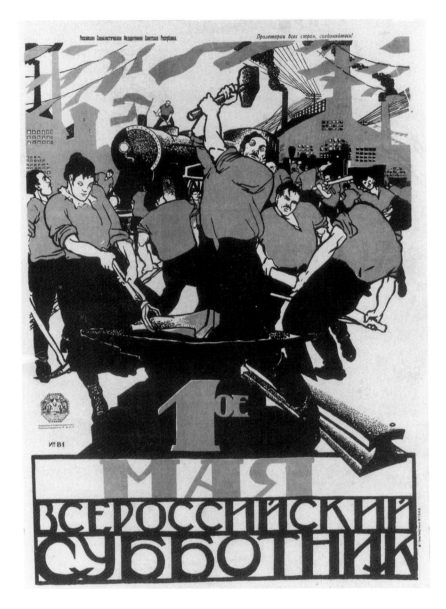

Figure 2.9. Dmitrii Moor, "1-oe maia vserossiiskii subbotnik" (May 1 All-Russian Voluntary Work Day), 1920

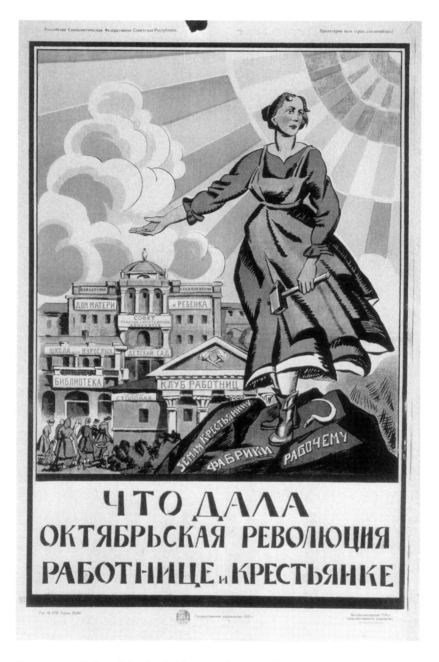

Figure 2.10. "Chto dala oktiabr'skaia revoliutsiia rabotnitse i krest'ianke" (What the October Revolution Gave the Woman Worker and the Peasant Woman), 1920

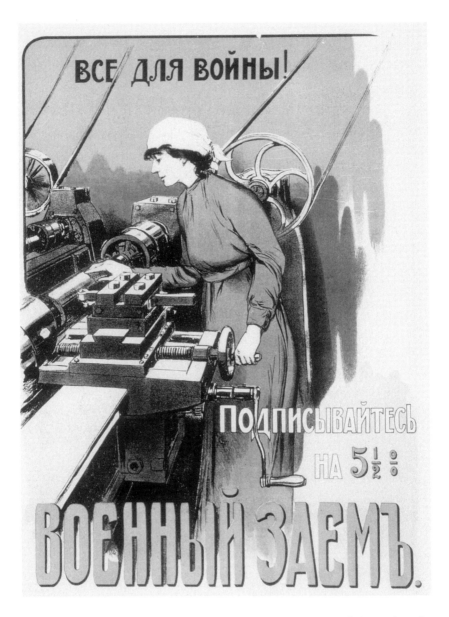

Figure 2.11. "Vse dlia voiny! Podpisyvaites' na 5½% voennyi zaem" (Everything for the War! Subscribe to the 5½% War Bonds), 1914–1917

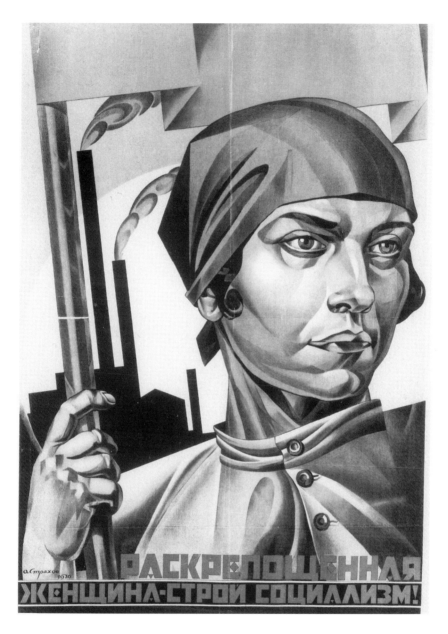

Figure 2.12. Adolf Strakhov, "Raskreposhchennaia zhenshchina—stroi kommunizm!" (Emancipated Woman—Build Communism!), 1926

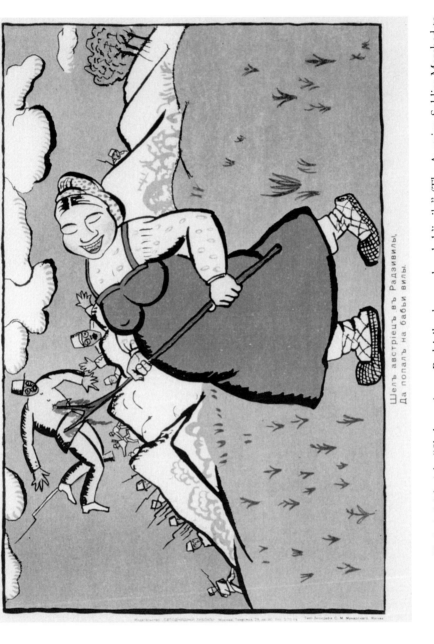

Шелъ австрiецъ въ Радзивилы,
Да попалъ на бабьи вилы.

Figure 2.13. Kazimir Malevich, "Shel avstriets v Radzivily, da popal na bab'i vily" (The Austrian Soldier Marched to Radzivily but Got Impaled on a *Baba*'s Pitchfork), 1914–1917

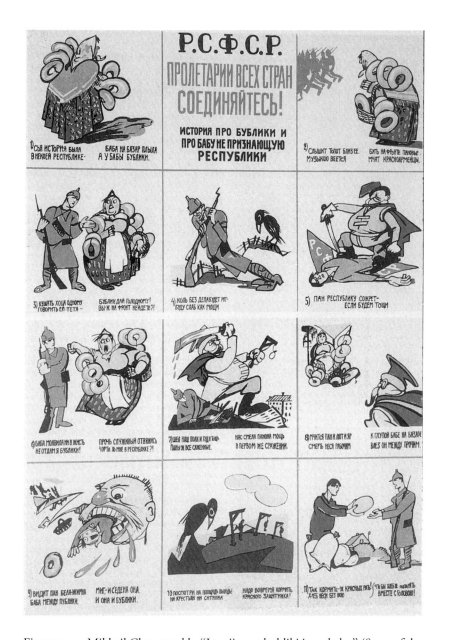

Figure 2.14. Mikhail Cheremnykh, "Istoriia pro bubliki i pro babu" (Story of the *Bubliki* and the *Baba*), 1920

Three

PEASANT WOMEN IN POLITICAL POSTERS
OF THE 1930S

IN 1929, A NOVEL IMAGE APPEARED in Soviet Russia: the *kolkhoznitsa* (collective farm woman). She was featured in Sergei Eisenstein's film *Staroe i novoe* (*Old and New,* or *The General Line,* as it was originally titled in English), released in October 1929.[1] The centerpiece of the film is a determined young peasant woman who helps to establish a collective farm, or *kolkhoz;* the villagers resisting collectivization ridicule her efforts and label her a *baba.* After much difficulty, she obtains a tractor for the farm. In the final scene of the film as originally edited by Eisenstein, she is pictured triumphantly at the wheel of the tractor.

A similar recasting of the female peasant image was taking place in political posters. In 1929, a poster by I. Meshcheriakov, "Na kollektivnuiu rabotu" (To Collective Work), anticipated visual conventions that became standard in the 1930s (fig. 3.1).[2] It depicts a group of peasants (men and women) cheerfully going to work in the fields. Women are prominently placed in the center of the poster. A woman is shown driving a tractor (a male tractor driver precedes her). Eighty thousand copies of the poster were printed—a substantial edition for the time, and evidence that this particular image of the new collectivized countryside was intended for widespread distribution.

These developments in 1929 anticipated major changes in iconography the following year. Beginning in 1930, the peasant woman, now transformed into a *kolkhoznitsa,* began to appear with unprecedented frequency in political posters devoted to rural themes. Out of a sample of 175 political posters dealing with agriculture issued between 1930 and 1934, I have found that 106 posters (61 percent) included images of women. Women occupied a central or prominent place in 68 posters, or 39 percent of the total.[3]

The volume of poster production does not tell the whole story; the size of the printing also gives an indication of the importance of certain posters. A typical press run in the early 1930s ranged from 10,000 to 30,000. But some posters, especially on agricultural themes, had much

larger print runs. As we have seen, Meshcheriakov's 1929 poster was issued in an edition of 80,000. Another collectivization poster, Zakhar Pichugin's "Kolkhoz v rabote" (Collective Farm at Work), appeared in 1930 in a printing of 100,000 (fig. 3.2).[4] This poster, created in the same style as the Meshcheriakov poster, places two sturdy young peasant women in the center of the composition. They are gathering hay. To their left, the young male driver of a horse-drawn harvester smiles at them as he passes by.

Details of this idyllic harvest scene illustrate the new visual language that was becoming established. Young, trim women are shown in the act of working; the old class marker, the sickle, has disappeared (the tractor will take its place). Each woman wears a red kerchief tied behind her head, in the style of women workers, rather than under the chin, as was formerly conventional in the representation of peasant women. Details of appearance, such as the style of the kerchief, conveyed the message to viewers that the *kolkhoznitsa* was different from the *baba* of the past; she belonged to a new breed of *Homo sovieticus* in the countryside.

The novel imagery was epitomized by Vera Korableva's widely disseminated and memorable poster, "Idi, tovarishch, k nam v kolkhoz!" (Come, Comrade, Join Us in the Collective Farm!) (fig. 3.3).[5] The poster was first issued in 1930, then reissued in 1931, and reproduced in many different national languages. The 1931 Russian-language version alone consisted of 40,000 copies, but the total output far exceeded that number. It shows a young woman standing in front of the young male peasant tractor driver; she is calling to others to join the *kolkhoz*. Her companion is smiling, and she, too, has a cheerful look. She is placed in the dominant position in the poster—that is, in front of the man and engaged in action. Her appearance has the same essential features as the peasant woman in Pichugin's poster (fig. 3.2).

Korableva was only one of a number of talented political artists who created memorable posters on the theme of collectivization. "Idi v kolkhoz" (Go and Join the Collective Farm), by Nikolai Terpsikhorov, appeared in a printing of 100,000 and in many different languages, including Ukrainian (fig. 3.4).[6] The most important poster in the regime's campaign to halt the massive slaughter of livestock by forcibly

collectivized peasants, it features a young peasant woman leading a horse and cow to the collective farm. She looks out at the viewer with a penetrating, direct gaze.[7] Below her on the left is a barn with collectivized cows, and on the right a male peasant is reeling backward and dropping his knife after slaughtering livestock. Here again, the artist has incorporated the attributes of the new *kolkhoznitsa*.

Terpsikhorov's poster illustrates another major development in the visual language used to depict rural life in the early 1930s. Whereas formerly, peasant women were defined by their place in a hierarchy dominated by the image of the urban worker, now they began to appear alone in posters. In other cases, they were placed in front of and in a prominent position vis-à-vis male peasants (as in the Korableva poster, fig. 3.3). Some posters showed peasant women in pairs or in groups, without any men in the picture. For example, a 1930 poster, "Delegatka, na udarnuiu uborku polei!" (Woman Delegate, to the Shock Work Harvest in the Fields!), presents an all-female harvesting scene, with a woman tractor driver in the lead.[8]

These kinds of compositions were virtually unprecedented in Soviet political art before 1930. To be sure, three out of five posters dealing with collectivization continued to represent peasant women in a secondary or recessed position in relation to men. But some posters contained a new visual syntax for placing the *kolkhoznitsa* in the hierarchy of heroic groups.

Rural women not only appeared in novel combinations in political posters, they were also represented in the larger-than-life format previously reserved only for workers and Red Army heroes. The magnification device had been used during the Civil War but had receded from visual propaganda in the 1920s. Its reintroduction in the early 1930s accentuated the importance, once again, of superhuman Bolshevik heroes whose deeds made them giants among the "masses." In the system of signification of political posters, perspectival distortions served to identify heroic figures. Thus, the *kolkhoznitsa* was now sometimes represented as a giant figure, towering over enemies and the landscape around her.

The 1930 poster "Krest'ianka, idi v kolkhoz!" (Peasant Woman, Join the Collective Farm!) (printing of 20,000) depicts a larger-than-life

young peasant woman resisting the tugs of a priest, drunkard, and kulak who seek to arrest her progress along the path leading to the *kolkhoz* (fig. 3.5).[9] Her severe and determined expression and her forceful gesture toward the collective farm make it clear that she is a person to be reckoned with. The formidable peasant woman heroically resisting "class enemies" in the countryside became a stock figure in visual propaganda of the early 1930s. Never before had the peasant woman been represented with this kind of perspectival distortion, which previously had been applied exclusively to the two unambiguous heroes of the revolution.

Nikolai Mikhailov's 1930 poster, "V nashem kolkhoze net mesta popam i kulakam" (There Is No Room in Our Collective Farm for Priests and Kulaks), encapsulates the new trends in political art (plate 3).[10] Printed in an edition of 42,000, it portrays a powerful-looking, larger-than-life young woman. She holds a rake to fend off priests and kulaks, represented as tiny figures clustered at her feet. A row of tractors passes behind her. She is entirely red and has the attributes reserved for heroic figures: she appears alone in the poster and fends off her enemies like a haughty giant. The diagonal lines, the woman's gesture, size, and appearance, and the color symbolism combine in this poster to illustrate the innovations in representation of the female peasant.

During the first half of the 1930s, the collective farm woman acquired a central place in Stalinist iconography. Her image was circulated throughout the country, with modifications to suit non-Russian areas of the country. Izogiz selected certain key slogans and then commissioned posters designed for non-Russian segments of the population. One slogan utilized in this way was "*Idi k nam v kolkhoz*" (Join us in the collective farm). A poster created to illustrate this slogan presents three Central Asian women—the new *kolkhoznitsy*. They have serious expressions and one of them sits at the wheel of a tractor. The poster was translated into many different Central Asian languages.[11]

THE NEW STALINIST ICONOGRAPHY

In analytic discussions of political art in the early 1930s, tremendous attention was devoted to the issue of *tipazh*. As we saw in chapter 1,

tipazh acquired central importance in discussions of posters because established images of class categories had disappeared. In the Soviet lexicon, the term *tipazh* implied a correct rendering of a particular social category. The essence of *tipazh* was not typicality, but typecasting or typicalization.

The problem for artists in the 1930s was that typicalization entailed a rendering of images not as they currently existed but as they would exist at some unspecified time in the future. This is what Anatolii Lunacharskii meant when he explained in 1931 that the artist's task was not to describe what existed in the present but to disclose "the inner essence of life, which comes out of proletarian goals and principles."[12] Like the concept of socialist realism then taking form, this prescription for artists involved a fundamental shift to a new mode of visual representation which presented only the future—the future in the guise of the present.

During the early 1930s, Soviet artists created a new image of the peasant woman—now no longer a female *muzhik* of the past but a *kolkhoznitsa* of the future. The contrast between the two visual images—the robust peasant woman *baba* and the trim *kolkhoznitsa*—must have struck many viewers. As we have seen, the collective farm woman had quite a different physiognomy and demeanor from her predecessor. She wore her kerchief in the style of women workers, and sometimes her hair was even cut short. Shoes often replaced the traditional bast sandals.[13] Above all, she was young and trim, especially during the First Five Year Plan.

Whereas earlier images of peasant women had often emphasized maturity and fecundity—broad hips and large bosoms—the new image stressed a far slimmer and more youthful body, with understated breasts. Collectivization posters seldom portrayed female peasants with their children.[14] The emphasis, instead, was on women's participation in agricultural labor. The attributes of youth, agility, and fitness were directly linked to the labor function. The new image of the peasant woman focused attention on production, not reproduction.

A 1930 poster by the distinguished Soviet artist Aleksandr Deineka, "Kolkhoznik bud' fizkul'turnikom" (Collective Farmer—Be an Athlete) (printing of 20,000), exemplified the new image of the female

body (fig. 3.6).[15] It features two young women and a man doing calisthenics. All are barefoot, wearing exercise clothes (short skirts or shorts); the women have short hair (in the style of women workers) and trim bodies. Two figures are in the background: a man driving a tractor and a man drying himself with a towel. The tractor driver serves as a reminder that exercise is connected to work, that it enhances labor power.[16]

The traditional class marker for peasant women, the sickle, disappears in the early 1930s (the scythe disappears in images of male peasants as well). The tractor takes its place. In fact, the tractor becomes a key signifier for collective farms in visual propaganda and a symbol of progress more generally. Many political posters included tractors, and men often sit in the driver's seat. But in collectivization posters, women also make an appearance as tractor drivers. Out of 106 political posters relating to agriculture between 1930 and 1934 that include images of women, 37 (35 percent) depict women behind the wheel of a tractor. An occasional poster in 1929 had incorporated images of female tractor drivers (see fig. 3.1), but the connection between women and tractors was heavily emphasized only from 1930 onward.

There are many examples of such posters. Some featured a column of women tractor drivers. These posters appealed to *kolkhoznitsy* to become shock workers and to join the ranks of the "krasnye traktoristy" (Red tractorists).[17] In others, women and men appeared together in a tractor column or female tractor drivers provided the background frames (a common stylistic device) for the main image. In the poster, "Krest'ianki! Povysim urozhai! Ob"edinim krest'ianskie dvory v kollektivy" (Peasant Women! Let Us Increase the Harvest! Let Us Unite Peasant Households into Collectives), a young *kolkhoznitsa* smiles as she drives a tractor (fig. 3.7).[18] The tractor is marked with the words: "All forces to the sowing campaign! Do not allow one kulak to interfere with the spring harvest." The woman tractor driver, who is brimming with confidence and authority, is depicted entirely in red. A red person on a red tractor was scarcely a realistic rendering of the rural scene. But viewers knew how to interpret the color red and to appreciate its positive connotations, since red was a privileged color in both religious and Bolshevik art. It conferred sacred status on a person or object.

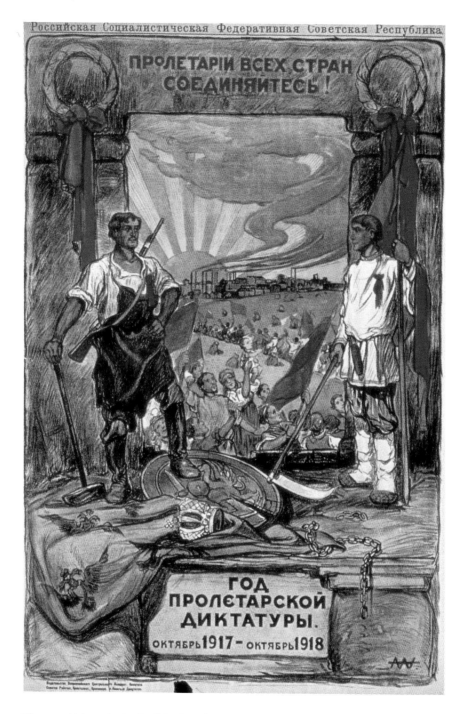

Plate 1. Aleksandr Apsit, "God proletarskoi diktatury oktiabr' 1917–oktiabr' 1918" (Year of the Proletarian Dictatorship, October 1917–October 1918), 1918.

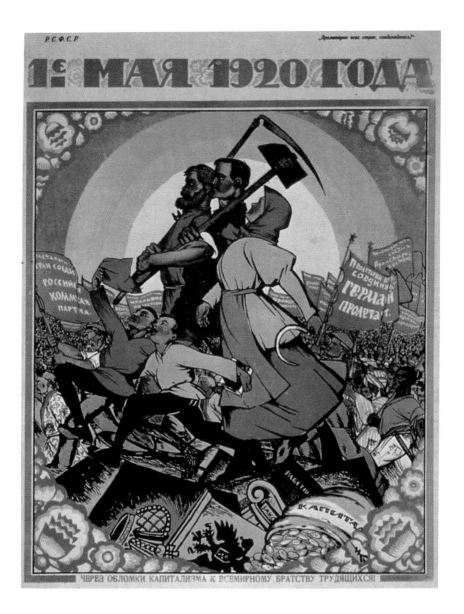

Plate 2. Nikolai Kochergin, "1-oe maia 1920 goda" (May 1, 1920), 1920.

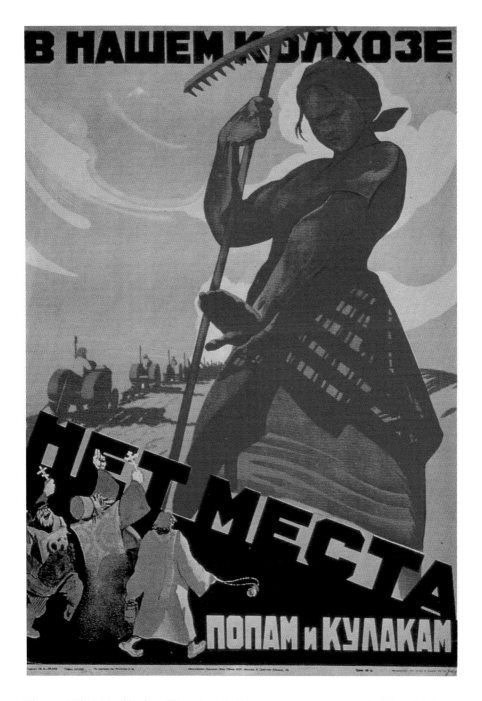

Plate 3. Nikolai Mikhailov, "V nashem kolkhoze net mesta popam i kulakam" (There Is No Room in Our Collective Farm for Priests and Kulaks), 1930.

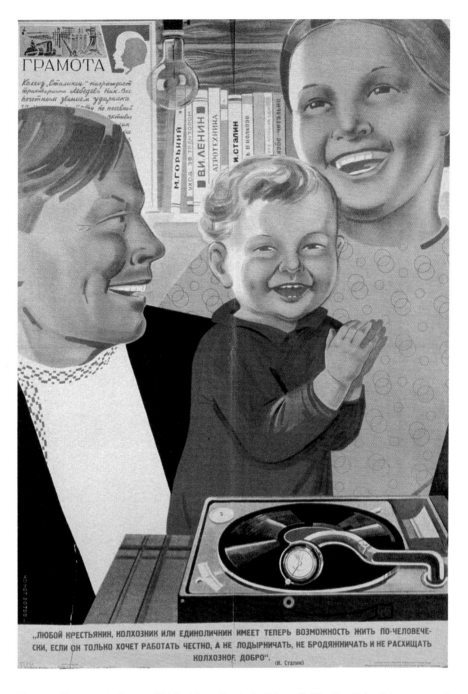

Plate 4. Konstantin Zotov, "Liuboi krest'ianin-kolkhoznik ili edinolichnik imeet teper' vozmozhnost' zhit' po-chelovecheski" (Every Collective Farm Peasant or Individual Farmer Now Has the Opportunity to Live Like a Human Being), 1934.

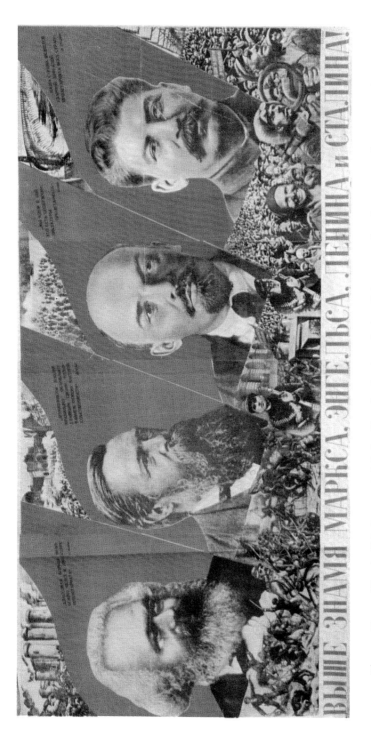

Plate 5. Gustav Klutsis, "Vyshe znamia Marksa Engel'sa Lenina i Stalina!" (Raise Higher the Banner of Marx, Engels, Lenin, and Stalin!), 1933.

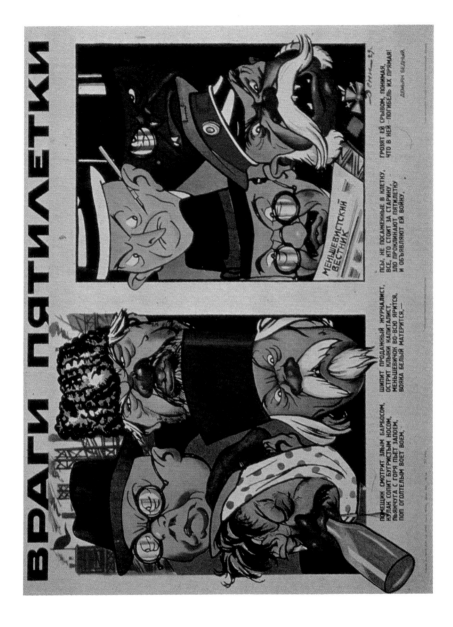

Plate 6. Viktor Deni, "Vragi piatiletki" (Enemies of the Five Year Plan), 1929.

Plate 7. A. Lavrov, "Sbylis' mechty narodnye!" (The People's Dreams Have Come True!), 1950.

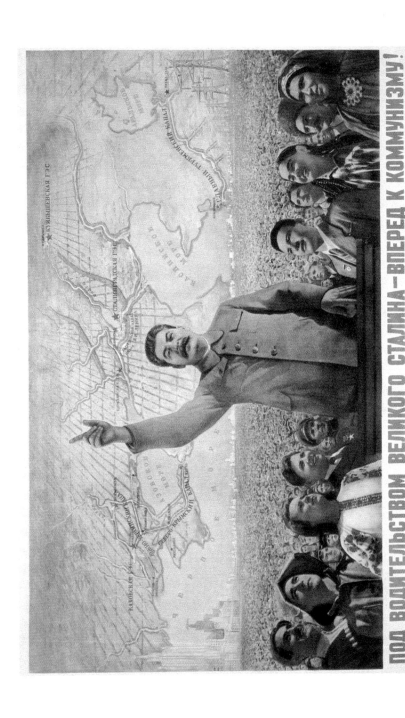

Plate 8. Boris Berezovskii, Mikhail Solov'ev, and Ivan Shagin, "Pod voditel'stvom velikogo Stalina—vpered k kommunizmu!" (Under the Leadership of the Great Stalin—Forward to Communism!), 1951.

Behind the smiling tractor driver in the poster are seven scenes contrasting the condition of women before collectivization and their position as beneficiaries of the collective farm system. The before/after format was characteristic of the folk art style of the *lubok,* which had been popular among lower-class groups (both urban and rural) before the revolution. But the *lubok* style was under attack in the 1930s by artists, and officials denigrated it as a relic from an antiquated culture that did not correspond to proletarian art. Writing in 1931, Moor observed that a "peasant poster" was developing and "sometimes this poster is absolutely the same as the Sytin *lubok.* They have one and the same form." He urged artists to study form seriously and to stop using the *lubok.*[19]

THE *BABA* AND THE *KOLKHOZNITSA*

The emergence of a new iconography can only be explained by a combination of circumstances; no single factor will suffice to account for such a shift in the basic pattern of visual representation. At the outset, it is worth noting that female poster artists achieved prominence for the first time in the early 1930s, many of them concentrating particularly on the theme of collectivization. As we have seen, some of the most memorable posters on this theme with large printings came from female artists such as Korableva.[20] The presence of female artists certainly deserves attention, but it cannot account for the prevalence and consistency of the new imagery. Many collectivization posters were created by male artists, who far outnumbered the women in the profession.

The shift in iconography coincided with momentous developments in the lives of rural women. When the collectivization campaign gathered momentum in late 1929 and early 1930, women became centrally involved in the growing resistance movement in the countryside. Opposition to forced collectivization was widespread in these months and, indeed, throughout the rest of 1930 and into 1931; sometimes, large groups of peasants mobilized in violent encounters with local authorities.[21] Rural women displayed particularly vigorous resistance to the collective farms, and they often stood in the forefront of these rebellions.[22] As one contemporary observed, "A significant proportion of the mass of peasant women turned against collectivization."[23]

Official commentators ascribed the hostile attitudes of rural women to their susceptibility to rumors and agitation by kulaks.[24] In fact, women had many grievances against the new collective farm system. One major issue centered on the socialization (communal ownership) of livestock, an aspect of the peasant household economy and culture traditionally under female supervision. During the early months of forced collectivization in 1929 and early 1930, local authorities confiscated peasants' farm animals, particularly the precious cow—the *burenushka* of Russian folklore—which provided milk for the children and often functioned as a ritual totem of the peasant household.[25]

Collectivization coincided with a vigorous campaign against institutionalized religion, and the establishment of the new farms often coincided with the closing of churches and suppression of religious activity in the countryside. The attack on churches and the clergy infuriated many peasants and galvanized women into mass resistance.[26] Women also feared rumored changes. Word had it that "collectivization would bring with it the socialization of children, the export of women's hair, communal wife-sharing, and the notorious common blanket under which all collective farmers, both male and female, would sleep."[27] Not all these rumors seemed far-fetched to rural women, many of whom had observed a libertarian attitude toward sex on the part of some Communist Youth League activists and incidents of sexual impropriety by local party bosses.

Faced with the destruction of their way of life, peasant women (and men) sought to explain their sudden and devastating misfortune with reference to two great calamities of the Russian popular consciousness, one historical and the other symbolic. According to the first, collectivization was a "second serfdom"; according to the other, it was the arrival of the Antichrist and the beginning of the Apocalypse. Of course, the two were historically related. Peter the Great, who extended the system of serfdom, appeared to the popular imagination—particularly among Old Believers—precisely as the Antichrist. The collective farm, together with its tractors, became a symbol of the Antichrist on earth. In late 1929, rumors began to circulate in many rural areas that the "antichrist had arrived and that the world would soon come to an end."[28]

Female resistance to collectivization took active as well as passive forms. Not only did many women refuse to join the farms (even when, in some cases, their husbands did so), they also participated in riots that led to violent incidents. In some cases, they burned down the *kolkhoz* stables, barns, haystacks, and houses; in other cases, they confiscated seeds, blocked and destroyed tractors, and attacked local officials. Women showed up at meetings on collectivization instead of the men, interrupted the proceedings, and mounted a vociferous protest.[29]

The authorities adopted a cautious and moderate response to peasant women who resisted collectivization, a circumstance that helps explain the predominantly female composition of the rebellions. In contrast to their male counterparts, the women who participated in violent collective actions were seldom accused of being kulak henchmen (*podkulachnitsy*), and relatively few were charged with counterrevolutionary crimes. Local authorities generally did not use force to contain women's protests and sometimes did not even report incidents to higher authorities. Even though women were arrested for their activities from time to time, they enjoyed an immunity from summary prosecution not extended to men.[30] Yet official indulgence was limited to acts of collective female resistance. Women enjoyed no special status when it came to the campaign to "liquidate the kulaks as a class." Entire families were expropriated and sent into exile, with no special dispensations for either women or children.[31]

The official terminology for the peasant women's rebellions was *bab'i bunty*. The words themselves conveyed official assumptions about the actors and their actions and shed some light on government leniency toward the protesters. The term *baba* had, as noted in chapter 2, strong pejorative connotations, especially for politically conscious women and men. *Bunt* referred to a particular type of mass action and carried the connotations of uncontrolled elemental rebellion or riot. The underlying implication was that ignorant, naive, oppressed women were engaged in spontaneous and irrational protests.[32] The term implied an attitude that was both dismissive (the protests could not be taken seriously) and demeaning (the actors belonged to a category of the population so lowly that they were unworthy even of retribution).

Verbal and visual discourse in 1930 thus offers a study in contrasts.

The pejorative characterization of women implicit in the term *bab'i bunty* differed sharply from the image of peasant women conveyed by political art. In fact, the new image of the female peasant represented the antithesis (and very deliberately so) of the previous imagery, which had carried associations with the much maligned *baba.* This circumstance accentuates the complexity of the new imagery and invites a consideration of the conditions that account for the ubiquitous presence of the *kolkhoznitsa* in visual propaganda just when peasant women were presenting the authorities with formidable and unrelenting opposition to collectivization in the countryside.

The new image of the female peasant conveyed several meanings simultaneously and must be comprehended as a complex symbol. Viewed against the background of women's resistance to the *kolkhoz,* the new iconography of peasant women functioned in much the same way as Stalin's pronouncements did. Moshe Lewin has given this characterization of the role of Stalin's verbal discourse: "Stalin's method consisted of presenting his plans and wishes as accomplished fact, so as to encourage the Party organizations and the other sectors of the administration to come into line with the 'actual situation' as it allegedly existed 'everywhere else.'"[33] In a similar fashion, the smiling woman tractor driver appeared in posters not as an accomplished fact but as an indication of what should be, as an incentive to make it happen. The poster constituted a kind of incantation designed to conjure up the new woman, who would perform certain roles in a specific spirit and manner.

Representing the countryside as though it were populated exclusively by vigorous young *kolkhoznitsy* and *kolkhozniki* may also have facilitated the imposition of agrarian policies in the early 1930s. Political art projected a rural world in which the *krest'ianka-baba,* together with traditional peasant customs and attitudes, no longer had any place. An old Russian proverb, originating in the countryside, was known to all: "A chicken is not a bird; a *baba* is not a human being."[34] Visual propaganda reinforced the old proverb by creating an image of the present-future in which the *krest'ianka-baba* had been replaced by the youthful and enthusiastic *kolkhoznitsa* building socialism. The new world of the village depicted by Stalinist posters effaced virtually all

aspects of the traditional peasant woman, her culture, her way of life. Within the context of a society undergoing forced collectivization, visual propaganda helped justify and make more palatable policies designed to reconstitute the countryside by brutal means.

THE ART OF SCIENTIFIC PROPAGANDA

How did contemporaries "read" political posters associated with the collectivization campaign? Officials concerned with visual propaganda, as well as poster artists themselves, placed great importance on this question. In the 1930s, those engaged in poster production focused their attention on the effectiveness of propaganda and its capacity to convey the desired message. Although there had been some research conducted in the 1920s on viewer responses to art of various kinds, the 1930s marked the beginning of what might be called "scientific propaganda," an attempt to gauge viewer responses to posters and systematically evaluate audience reception.

A Central Committee resolution of March 11, 1931, addressed the issue of reception directly and called for specific measures to improve information concerning viewer responses. These measures included broader, more systematic poster reviews in the press, the creation of poster review committees among workers and peasants, and the founding of a new organization of poster artists.[35] All these proposals were rapidly implemented in the spring of 1931.[36]

Contemporaries concerned with the production of posters proceeded from the assumption that worker and peasant audiences required different styles of political art to accommodate the different ways of viewing visual propaganda in the cities and countryside. One artist argued in March 1931, "The city poster must cry out, be eye-catching, because here people only catch a glimpse of it, see it in passing. The peasant, on the contrary, loves to stop in front of a poster and examine it in all its particulars." A leading official in poster production observed that "the eye of the peasant finds it easiest to comprehend the *lubok* and gets lost in the details of the usual 'city' poster."[37] The application of traditional folk styles to Soviet posters was a controversial issue in the 1930s, when artists and officials were eager to create an

entirely new "proletarian" style of political art. Despite the controversy, however, the *lubok* format, with such characteristic conventions as contrasting panels showing "then and now" and "we and they," was commonly utilized in the 1930s.

It might at first be assumed that posters on agricultural themes and especially those promoting collectivization were aimed at a rural audience. Certainly, some of these posters made their way to the countryside, where they hung in collective farm meeting rooms, reading rooms, and the headquarters for local party and government organizations. But in the early 1930s, when chaos and disruption prevailed in most rural areas, it is far from clear how extensively visual propaganda penetrated the countryside or was even intended to penetrate the countryside.[38]

Judging by the content of these posters, a rural audience hardly seems appropriate. What did peasants in 1930 or 1931 see in a poster featuring tractors driven by *kolkhoznitsy* when the number of tractors in these years was still small? As of December 1930, 88.5 percent of the collective farms still had no tractors of their own; Machine Tractor Stations served only 13.6 percent of all collective farms.[39] Women drivers were an even greater oddity. They made up only 6 percent of the tractor drivers in the country as a whole in 1932.[40] What kind of an impression did the image of a trim young peasant woman make on peasants, especially in the years 1932–1933, when millions were emaciated and dying in the famine? These and many other incongruities between the pictures and experience indicate that perhaps a different audience was intended.

Although further evidence is needed, I would argue that many of the posters relating to collectivization in the early 1930s were aimed at an urban and working-class audience to a far greater extent than at the rural population. The point of this visual propaganda was to generate support outside rural areas for state policies that were being imposed violently on the countryside. Images of the smiling, slender *kolkhoznitsa,* which must have appeared grotesque in a rural context, especially in the midst of devastating famine, were perhaps more plausible in an urban setting, where the image of the peasant woman now shared common features with the image of the woman worker.

In fact, visual representations generated by Soviet artists during the collectivization campaign were primarily projected through an urban lens. The specific images discussed above, accentuating as they did certain body characteristics and expressions, conveyed urban values and assumptions (slimness versus robustness, for instance) far more than rural ones. Even the emphasis on tractors played more effectively to an urban than a rural audience. Whereas workers easily comprehended the value of mechanization, "the reaction of peasants to the tractor was extremely varied."[41] Many peasants were deeply hostile to tractors and mistrustful about their function. The contemporary press reported incidents in which peasants destroyed tractors; others denounced them as "the work of the Antichrist" and a return to serfdom.[42]

The inappropriateness of some posters for a rural audience was underscored in reviews of posters by students, officials, artists, and even workers and peasants. These reviewers often drew attention to the lack of authenticity in the representation of rural scenes. They complained that some Soviet artists had little knowledge of the countryside and created images that contained gross inaccuracies relating to machinery, terrain, people, clothing, labor activities, and animals. One poster showed tractors sowing in green fields; another had peasants working in winter without suitable clothes.[43] Reviewers concluded that peasants laughed at such posters and did not take them seriously. But these inaccuracies presented fewer problems if the audience was urban and not rural.

We have very little information about the reception of posters by contemporary viewers, either urban or rural. A rare glimpse of viewer reactions is provided by a report of a meeting of fifty collective and state farm workers that took place on February 28, 1932, in accordance with the March 1931 decree requiring poster review committees composed of workers and peasants.[44] For two hours, they examined and discussed five posters on various themes. The first poster subjected to scrutiny was by Valentina Kulagina, an artist trained in Soviet art schools and a practitioner of photomontage.[45] Her poster, "Udarnitsy zavodov i sovkhozov, vstupaite v riady VKP(b)" (Shock Worker Women of Factories and State Farms, Enter the Ranks of the Communist Party [Bolshevik]), features a photograph of a woman with her

right arm raised high (palm forward), a copy of *Pravda* in her left hand. The woman's expression conveys pleasure, almost ecstasy. Compared to the crowd of people clustered below her, she is represented as a giant figure.

The collective and state farm workers viewing the poster had a number of serious criticisms of this poster. Most devastating of all was their observation that the woman presented by the artist did not resemble a shock worker woman but rather a female "kulak or a sales clerk." They further objected to the lack of communication between the giant woman and the demonstrators below, the inclusion of male rather than female tractor drivers, and the poster's failure to invite collective farm shock worker women into the party. Other posters were criticized because of the artist's ignorance of the countryside or the improper *tipazh* of the woman shock worker.

Some posters featuring young women were deemed positively dangerous, even counterrevolutionary. One reviewer of Korableva's "Idi, tovarishch, k nam v kolkhoz" (fig. 3.3), possibly the most emblematic of the collectivization posters, harshly criticized what he saw as an implicit sexual invitation in the poster. In a vituperative review, he argued that the poster was having a "counterrevolutionary and harmful effect in the contemporary countryside because the second half of the text is written on the woman and, undoubtedly, will be used by kulak-agitators in the broadest possible way."[46] His point was that the phrase "Join us in the collective farm" happened to be printed across her midsection—by implication, a sexual invitation. The suggestion that collective farm women proffered sexual invitations had grave significance in the contemporary context, amplifying fears of a linkage between communalization of peasant property and the peasant woman's body.

THE GREAT RETREAT

The First Five Year Plan lasted four years and three months. When the plan ended on December 31, 1932, the country was in the midst of a massive famine that claimed millions of lives in agricultural regions of the country. Against this background, the regime celebrated the success of collectivization.[47] By 1933, nearly four-fifths of all the cultivated land

in the Soviet Union had been collectivized and over three-fifths of the peasant households.[48] The Seventeenth Party Congress, held in February 1934 and proclaimed the "Congress of Victors," celebrated the victory of socialism.

The year 1934 has been described as the beginning of the "great retreat" from social, economic, and cultural policies introduced during the "socialist offensive" of the period 1929–1933. Nicholas Timasheff coined the phrase "great retreat" to describe the restoration of ideas and practices predating the First Five Year Plan or even the 1917 revolution.[49] The result was an amalgam of the old and the new, within the overall framework of the Stalinist party-state. In agriculture, the "great retreat" led to promulgation of the Model Charter for Collective Farms in 1935, supplanting the far more draconian version of 1930.[50] The 1935 charter eased various regulations and restored small personal farming on plots allotted to collective farm workers, while retaining the basic organization of collectivized agriculture imposed in the early 1930s.

Political art witnessed its own version of a "great retreat" beginning in 1934. Toward the end of 1933, artists and critics expressed dissatisfaction with the prevailing canons for visual representation of the countryside. A review of Natal'ia Pinus's 1933 poster, "Kolkhoznitsa, bud' udarnitsei uborki" (Collective Farm Woman, Be a Shock Worker of the Harvest) (printing of 30,000) focused attention on the inadequacies of the *tipazh* (fig. 3.8).[51] The reviewer disapproved of the artist's picture of two young, trim, and energetic *kolkhoznitsy* (one smiling, one serious) on their way to the field with rakes on their shoulders: "In the choice of *tipazh,* the artist Pinus wanted to present healthy, jolly, pretty, and intellectual faces, to show the new person who combines in herself physical strength and energy with a high level of culture. But it must be recognized that the artist did not succeed. The *kolkhoznitsy* are not typical. In the poster, we have instead some kind of 'Mashen'ka and Dasha,' pretty and rosy but completely uncharacteristic of the *kolkhoz* masses."[52]

The atypicality of the collective farm women in the poster acquired importance because of a transformation that was taking place in the objective of visual propaganda. Posters on rural themes were increasingly measured by their effectiveness in reaching and persuading a rural

audience, now that the great majority of peasants had been collectivized.[53] A growing preoccupation with peasant reception of posters, in combination with other factors, led to important modifications in the representation of the peasant woman. By 1934, the *kolkhoznitsa* had begun to fill out and acquire a fuller, more rounded look. The large bosoms and corpulence of the 1920s did not return, but the trim and athletic look of the early 1930s also faded from the scene.[54] Collective farm women were still generally depicted as youthful, but now older, more mature women occasionally made an appearance.[55] Smiles and quiet satisfaction became far more prevalent than before, and few posters conveyed the intensity and determination characteristic of *kolkhoznitsy* in the early 1930s.

The new demeanor of collective farm women disconcerted some reviewers, who criticized posters for failing to show the *kolkhoznitsa*'s "intensive struggle for socialist reconstruction of the countryside, resistance to the class enemy, resolute surmounting of obstacles, enthusiasm for collective labor and its pathos."[56] But in 1934, especially after the Congress of Victors, rural propaganda shifted its emphasis from struggle and confrontation to serenity and joyfulness amid abundance. Earlier posters characteristically showed peasant women engaged actively in work. Now they were often depicted in a contemplative or celebratory mood as they surveyed the results of collective farm labor. Symbols of prosperity abound: sheaves of wheat, plump and well-groomed farm animals—especially the venerable cow—and fields redolent with crops.[57]

The 1934 poster by Aleksei Sitaro, "K zazhitochnoi kul'turnoi zhizni" (Toward a Prosperous Cultured Life), presents five collective farm women (three agricultural workers, a mechanic, and a teacher) cheerfully striding forward carrying farm animals, wheat, books, and a wrench (fig. 3.9).[58] They are robust—obviously well fed—and joyous. The artist has included three women (the mechanic, the teacher, and the milkmaid) with kerchiefs tied at the back of their neck, in the new style of the *kolkhoznitsa;* the other two collective farm women wear their kerchiefs in the traditional way, a significant departure from the standard semiotic code. The clustering of farm women in this and other posters may have suggested to viewers that *kolkhoznitsy* of all types

had earned, perhaps for the first time, full confidence from the authorities, not just as individuals but as a social collectivity.[59]

Color symbolism changed as well. In the course of the 1930s, pastel colors, especially blues and greens, as well as pink and yellow, were often substituted for the harsher tones of red and black that dominated earlier collectivization posters. A fascinating report of collective farmers' reactions to posters in late 1934 noted that the viewers displayed a strong preference for soft muted colors and were especially partial to one poster with a "delicate blue background." They reacted negatively to bright garish colors. According to this report, the collective farmers paid attention to color and imagery and generally ignored the text.[60]

Although most *kolkhoznitsy* in posters from 1934 still wore a kerchief tied at the back of the neck in the fashion of urban women, their clothing was sometimes more decorative than previously and included traditional touches, like an apron, which had been part of the standard image in the 1920s but disappeared in the early 1930s. Mariia Voron's striking poster, "Udarnuiu uborku—bol'shevistskomu urozhaiu" (Shock Work at Reaping Befits a Bolshevik Harvest) (printing of 60,000), shows the complex combination of details that characterized rural imagery during the Second Five Year Plan (fig. 3.10).[61] The *kolkhoznitsa's* appearance (especially her stoutness, the blue color of the dress, and her apron) as well as her almost classically serene and motionless pose signify departures from visual conventions of the early 1930s. Except for the text, the only red in the picture is her kerchief, tied behind her head. A contemporary reviewer of the poster gave the artist high marks for *tipazh* and praised the "romantic solemnity" of the image of the *kolkhoznitsa.*[62]

An official campaign mounted in 1934 promoted personal cleanliness and attractive clothing.[63] When a new glossy magazine, *Na stroike MTS i sovkhozov* (Building Machine Tractor Stations and State Farms), appeared in June 1934, it heralded with pictures and accompanying text the "new life" in the countryside.[64] This slick propaganda organ, which attracted the services of Maksim Gorky and El Lissitzky, asserted in a later issue that "our rural youth are not dressed any worse than city youth. Many of our girls have begun to wear silk dresses, velveteen, and fine wool coats with fur collars, berets. The men

wear good suits, shoes, and always a necktie."[65] Political artists became more attentive to clothing and depicted peasant women wearing pretty blouses or dresses, sometimes accentuated by decorative articles such as embroidered scarves, even while at work.[66] The inclusion of traditional Russian folk-style embroidery—inconceivable during the early 1930s—reflected the nationalist and folk revival then under way.

A poster by Konstantin Zotov in 1934, "Liuboi krest'ianin-kolkhoznik ili edinolichnik imeet teper' vozmozhnost' zhit' po-chelovecheski" (Every Collective Farm Peasant or Individual Farmer Now Has the Opportunity to Live Like a Human Being), exemplifies some of the changes taking place in the semantic system of visual propaganda (plate 4).[67] Zotov's poster (printing of 60,000) depicted a peasant family—a mother, father, and toddler—joyfully gathered around a gramophone. The text is a quotation from Stalin: "Any peasant-collective farmer or individual farmer now has the possibility to live in a humane manner, if he only wants to work honestly and doesn't loaf, is not a vagrant, and doesn't plunder *kolkhoz* property."[68] What is unusual about the poster is that it emphasizes, at least implicitly, the woman's achievements in both production (she is a collective farm worker) and reproduction (she is a mother). Moreover, the poster shows collective farmers at leisure rather than at work. The labor process has been replaced by the fruits of labor, in the form of a gramophone, other household belongings, and personal attire.[69]

Both husband and wife in the poster are well dressed: she in a pink blouse and he in a black jacket with a peasant-style shirt, embroidered at the collar. He is strikingly handsome; she is lovely to look at and, with her gay smile, might well have appeared in a commercial advertisement for gramophones! A contemporary critic, reviewing the poster, considered the *tipazh* of the *kolkhoznitsa* the most successful of the three figures.[70] The child is plump, cute, and claps his hands in delight at the music; his hands also suggest a prayerful position, echoing Madonna and Child images in religious icons. Mothers and children can seldom be found in collectivization posters of the early 1930s and then only in those explicitly devoted to the theme of social services. Even during the Second Five Year Plan, few posters on general themes show

the peasant woman with her child, although such images did occasionally appear in contemporary magazines.[71]

The family is shown listening to the gramophone. Behind them are two items that signified a cultured and comfortable life in the countryside: an electric light and a shelf of books. The titles of the books include works by Maksim Gorky, *Maintenance for the Tractor,* works by V. I. Lenin, *Agrotechnology,* works by I. Stalin, a partially obscured title ending with the words "in the collective farm," *Improving Milk Yields,* and *Village Reading Room.*[72] The reading material for exemplary collective farmers was thus of three types: works of literature, especially by Gorky; political writings of Lenin and Stalin; and technical books relating to agriculture. The Gorky book is strategically placed first on the left, an indication of its importance. Highly visible in 1934 because of his role as an architect of socialist realism at the First Congress of Soviet Writers, Gorky advocated the use of literature as a force for remolding backward and predominantly rural Russians into a new generation of Soviet citizens. Gorky's own humble origins and his subsequent rise to fame helped to validate the Stalinist ideal of a society where industrious workers and loyal Communists could rise from rags to riches.

The books, together with the certificate on the wall, provide considerable information concerning the people in the poster. The man is a tractor driver by the name of Nikolai Vasil'evich Lebedev. He received recognition as an exemplary shock worker, and his accomplishments, by implication, can be attributed to mental as well as physical labor (thus the books on tractor maintenance and agrotechnology). His wife, judging by the books on the shelf, most likely works as a milkmaid on the collective farm, a common female occupation. The poster implies that both Lebedev and his wife are literate.

The implicit message of the poster is that exemplary collective farmers can expect to enjoy the accouterments of a good life, including a gramophone, books, and electric light. Visual propagandists devoted a good deal of attention to the issue of rural prosperity in the mid-1930s. As presented in posters and magazine articles, the good life had come to embrace a host of material possessions: samovar, sewing machine, camera, bicycle, watch, musical instruments, and such home furnishings

as "rugs, soft furniture, a dresser with a mirror, a radio, flowers, and lace curtains."[73]

The contemporary reviewer of the poster expressed particular dissatisfaction with the artist's rendering of the dwelling of the "new people of the countryside." Zotov's representation, he asserted, failed to contrast adequately the "bright, clean, cozy, and spacious home" of the present with the inhuman conditions of the precollectivization hut.[74] The figures, he thought, were too close together and gave the impression of lack of interior living space. The electric light, he noted, was not illuminated.

Beginning in 1933, political posters more and more often emphasized the linkage between the *kolkhoznitsa* and Stalin.[75] Occasionally, his presence was signified by a quotation or a book, as in the Zotov poster.[76] Other times, he appeared in the background, for example, as a silhouette on a red flag.[77] In some posters, he was placed alongside the peasant woman. Natal'ia Pinus's 1933 poster, "Zhenshchiny v kolkhozakh—bol'shaia sila" (Women in the Collective Farms Are a Great Force), takes the form of a triptych (fig. 3.11).[78] On either side are *kolkhoznitsy:* a tractor driver and a woman with a rake. Both are focused on their work and surrounded by scenes of abundance. Between them is Stalin—the ultimate talisman—appearing here in a photograph taken as he addressed a conference of collective farmers (the source of the famous quotation that provides the caption for the poster). The visual association of Stalin and the *kolkhoznitsy* suggests a close relationship between the leader and the new heroes of the countryside.

As if by contagious magic, Stalin enabled ordinary people to perform heroic feats. This point was clearly brought out by a poster published two years later: Iurii Tsishevskii's "Shire riady stakhanovtsev sotsialisticheskikh polei!" (Expand the Ranks of the Stakhanovites of the Socialist Fields!) (fig. 3.12).[79] Published in 1935, the poster had a press run of 200,000, an extraordinary number for that year and an indication that the authorities considered it important. The centerpiece of the poster is Mariia Demchenko, a Stakhanovite *kolkhoznitsa* who wrote to Stalin promising to achieve a record in the harvesting of beetroot.[80] She stands in a field, holds a red banner, and smiles modestly

while gesturing toward her accomplishments and toward Stalin. In the upper left-hand corner appears a sketch of Stalin reading Demchenko's letter to him that was published in *Pravda* (and is reprinted below Stalin's image).

Prior to 1930, when political artists represented the peasantry as a whole, they did so by depicting a *muzhik* (male peasant), usually bearded, wearing a Russian shirt and bast shoes, and sometimes holding a scythe. The image of the *muzhik* was often combined with a beardless male worker—a blacksmith with an apron and a hammer—who symbolized the working class.[81] With the coming of collectivization, the *muzhik* virtually disappears from political posters (replaced by a new image of the young beardless *kolkhoznik*), and the male peasant is no longer paired with the male worker to symbolize the union of the working class and the peasantry.

In 1937, a new image of the worker-peasant combination appeared in political art. This time, instead of two men, the artist presented a male worker and a female peasant. Vera Mukhina's sculpture *Rabochii i kolkhoznitsa* (Worker and Collective Farm Woman) brought together elements of old and new iconography (fig. 1.16). Her image of the peasant woman combined elements of the athletic and forceful *kolkhoznitsa* of the early 1930s with the ample figure of the peasant woman featured in visual propaganda from 1934 on. She does not wear a kerchief, and her hair is cut short in the style of urban women. Like the *krest'ianka* of the 1920s, she carries a sickle, a symbol that had disappeared from posters after 1929. In Mukhina's statue, the sickle and hammer function not only as class markers but also as the coat of arms of the Soviet nation-state. The eclecticism of the imagery contributed to its appeal, and the statue was widely reproduced during the Stalin era.[82]

How can we explain the substitution of a woman for a man in this important symbolic union between workers and peasants? The association of a female figure and agriculture seems natural given the many connections between fertility and the feminine, both in the classical and Russian folk art traditions. But it must not be forgotten that Bolshevik artists deliberately and consistently used a male figure—the *muzhik*—to symbolize the peasantry before 1930.

Mukhina's statue owes its inspiration to visual propaganda of the early 1930s, when the female figure acquired unprecedented significance. To a considerable extent, the *kolkhoznitsa* displaced the *muzhik* as the central image and symbol of the peasantry as a whole. The prominent position of the *kolkhoznitsa* in collectivization posters is indicative of a new gendered discourse about the countryside. Political artists promoted collectivization in the female idiom and, in the process, feminized the image of the peasantry as a social category.[83] Mukhina created the definitive statement of that feminization, using gender differences to convey the hierarchical relationship between the worker (male) and peasant (female) and, by implication, between urban and rural spheres of Soviet society.

In terms of both syntax and lexicon, Stalinist iconography expressed the domination of the cities over the countryside. Collectivization posters of the early 1930s were most likely directed at an urban audience and expressed quintessentially urban values concerning the body, the nature of labor, and the role of mechanization. Images of tractors, women, and hard work helped affirm the logic behind collectivization and provide a justification for the terror and famine inflicted on the rural population in the name of progress.

The focus of visual propaganda with agrarian themes shifted to the countryside after the First Five Year Plan. The *kolkhoznitsa* was not emphasized to the same extent as earlier, although she still appeared in memorable posters produced in large numbers. The "great retreat" in political art meant a recasting of the image of the collective farm woman to incorporate elements of the semantic traditions of both the *krest'ianka* (peasant woman) and the *kolkhoznitsa*. Nevertheless, an urban vision of rural life persisted. As the decade progressed, rural propaganda came to express more and more vividly the dreamlike quality of the Stalinist utopia, with well-fed joyous peasants in fields of plenty.

During the Civil War and the 1920s, images of social groups functioned as abstractions. Everyone knew that not all workers were blacksmiths with a hammer and not all peasant women carried a sickle. These images were symbolic, intended to capture an element of what it meant to be a worker or female peasant. In the early 1930s, a new type of image appeared in visual propaganda, an image that served as

a model, as an ideal type. This was the meaning of *tipazh,* the problem of typicalization that so concerned contemporary reviewers of political art.

The image of the *kolkhoznitsa* was not supposed to be realistic. Its purpose was to provide a visual script and an incantation, engendering a powerful illusion. To depict the rural woman was to invoke her. The image became a vehicle for anticipating and achieving the future. Stalinist propaganda created, in sum, a new political mythology. The picture, especially with the use of photomontage, acquired an unprecedented verisimilitude, not with the existing society but with the rural social world of the imagined future.

Figure 3.1. I. Meshcheriakov, "Na kollektivnuiu rabotu" (To Collective Work), 1929

Figure 3.2. Zakhar Pichugin, "Kolkhoz v rabote" (Collective Farm at Work), 1930

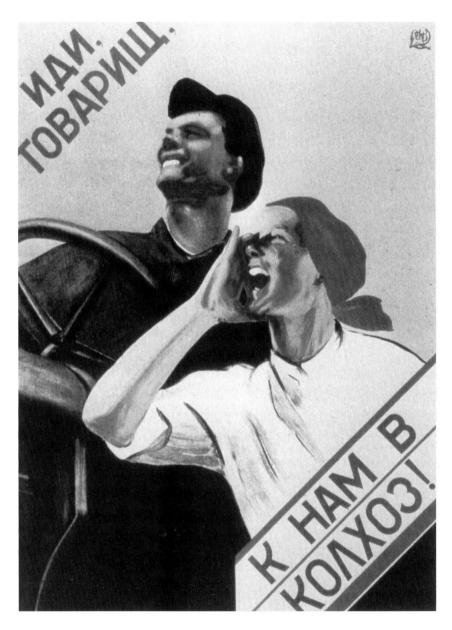

Figure 3.3. Vera Korableva, "Idi, tovarishch, k nam v kolkhoz!" (Come, Comrade, Join Us in the Collective Farm!), 1930

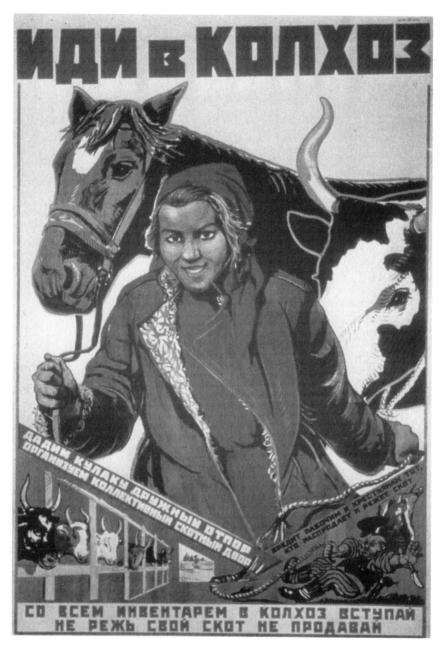

Figure 3.4. Nikolai Terpsikhorov, "Idi v kolkhoz" (Go and Join the Collective Farm), 1930

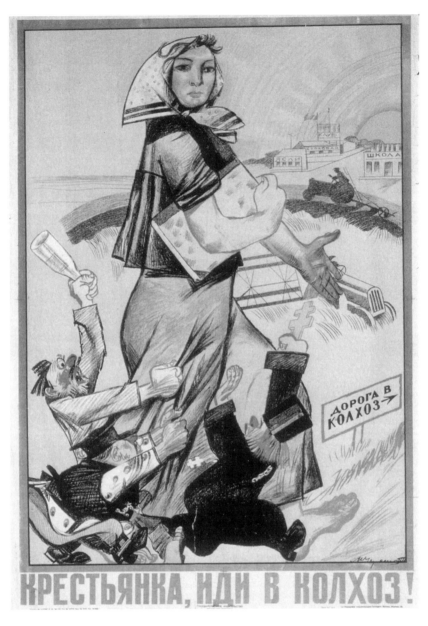

Figure 3.5. "Krest'ianka, idi v kolkhoz!" (Peasant Woman, Join the Collective Farm!), 1930

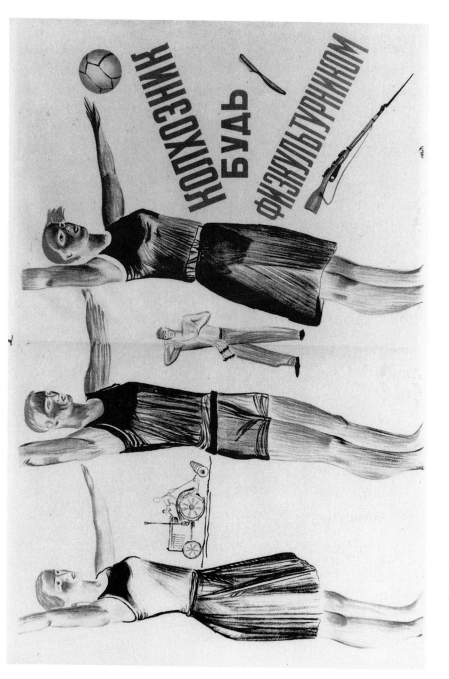

Figure 3.6. Aleksandr Deineka, "Kolkhoznik bud' fizkul'turnikom" (Collective Farmer—Be an Athlete), 1930

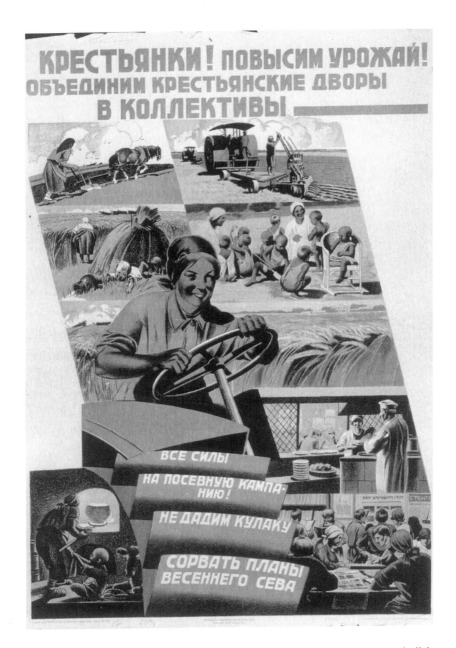

Figure 3.7. "Krest'ianki! Povysim urozhai! Ob"edinim krest'ianskie dvory v kollektivy" (Peasant Women! Let Us Increase the Harvest! Let Us Unite Peasant Households into Collectives), 1930

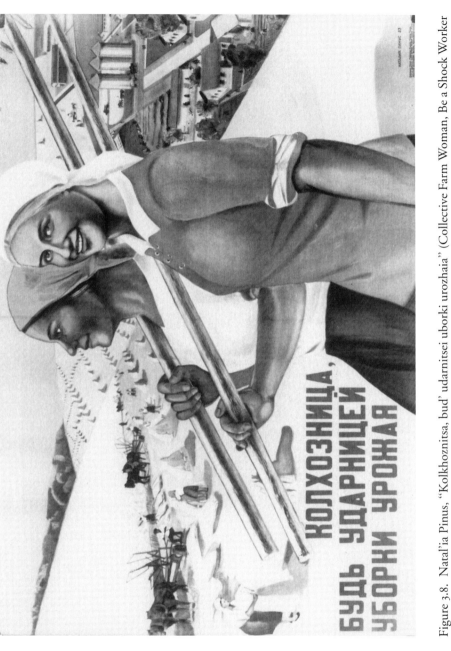

Figure 3.8. Natal'ia Pinus, "Kolkhoznitsa, bud' udarnitsei uborki urozhaia" (Collective Farm Woman, Be a Shock Worker of the Harvest), 1933

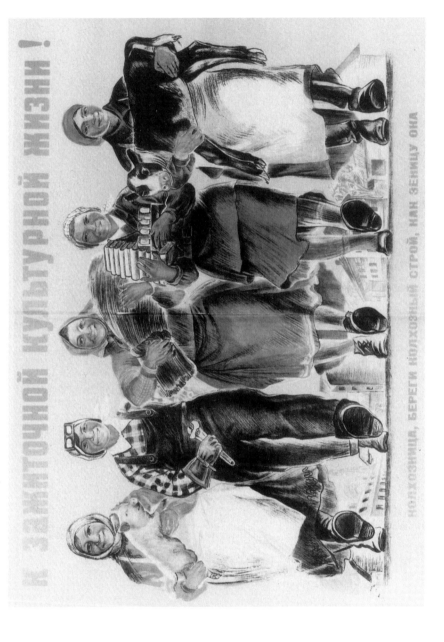

Figure 3.9. Aleksei Sitaro, "K zazhitochnoi kul'turnoi zhizni" ("Toward a Prosperous Cultured Life), 1934

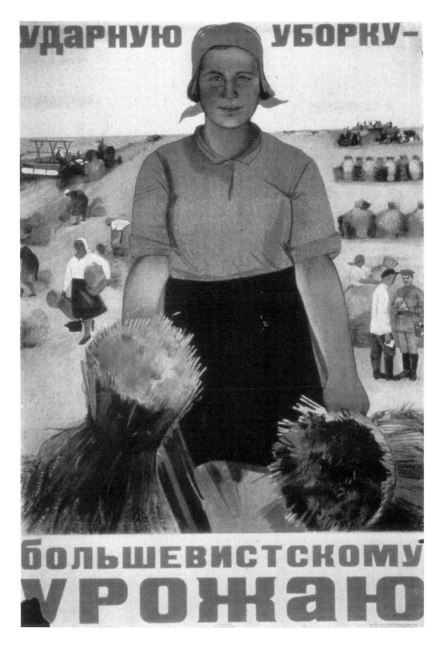

Figure 3.10. Mariia Voron, "Udarnuiu uborku—bol'shevistskomu urozhaiu" (Shock Work at Reaping Befits a Bolshevik Harvest), 1934

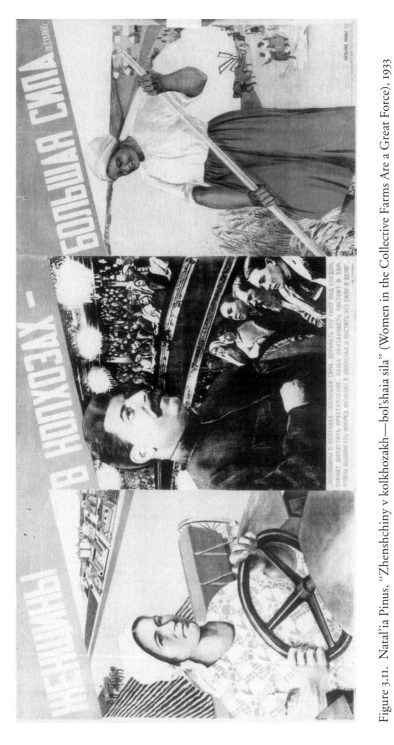

Figure 3.11. Natal'ia Pinus, "Zhenshchiny v kolkhozakh—bol'shaia sila" (Women in the Collective Farms Are a Great Force), 1933

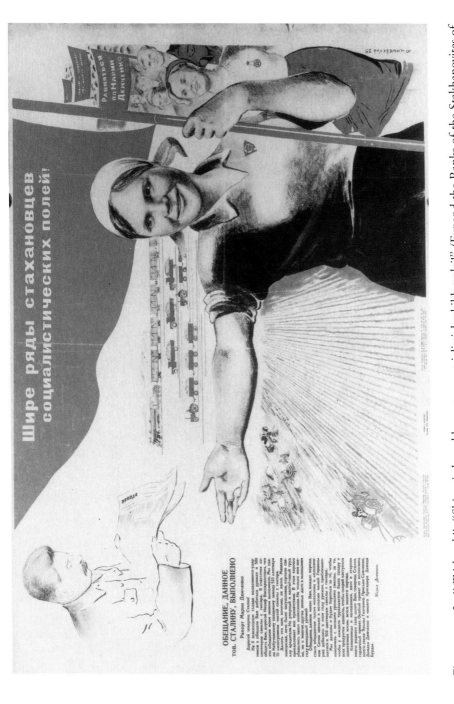

Figure 3.12. Iurii Tsishevskii, "Shire riady stakhanovtsev sotsialisticheskikh polei!" (Expand the Ranks of the Stakhanovites of the Socialist Fields!), 1935

Four

LENIN LED THE WAY IN CREATING a heroic legacy for the new regime. He conceived of the legacy as a series of collective and individual acts that originated in classical Greece and Rome and culminated in revolutionary Marxism and the eventual triumph of bolshevism in Russia. Highly attuned to the popular mood, Lenin also understood the need to provide ordinary people with substitutes for the political and cultural heroes of the old regime, whose splendid images adorned buildings and squares in the capital cities and throughout the country. In his memoirs, Anatolii Lunacharskii, the commissar of enlightenment, recalled:

> Already in 1918, Vladimir Il'ich called for me and told me that it was necessary to promote art as a means of agitation, and thus he proposed two projects. First, in his opinion, buildings and fences and those places where advertisements usually are located should be decorated with large revolutionary inscriptions. . . . The second project related to the creation of monuments to great revolutionaries on an extremely large scale, temporary monuments made out of gypsum.[1]

After several months of discussion, Lenin's ideas were incorporated into a decree, "On the Dismantling of Monuments Erected in Honor of the Tsars and Their Servants and on the Formulation of Projects for Monuments of the Russian Socialist Revolution," issued on August 14, 1918.[2] The aim of the decree was to provide guidelines and instructions for the political appropriation of public, especially urban, space. In designing the project, Lenin was influenced by Tomasso Campanella's *City of the Sun,* which appeared in two Russian translations during 1918. Like Campanella, he envisioned cities in which monuments, inscriptions, emblems, street names, and coats of arms would serve as "constant reminders for the pupils of his gigantic new revolutionary school."[3]

Lenin's plan called for a reconfiguration of urban public space and statuary by two means. In some cases, prerevolutionary monuments to

tsarist heroes were to be replaced by new statuary that celebrated the Bolshevik revolution. In others, a change in inscription or emblem was considered sufficient to convey the new meaning. As we have seen, in 1918 artists sympathetic to the Bolshevik regime created images of "the worker" and "the peasant" that were meant to symbolize entire social collectivities. Lenin's project, by contrast, was designed to celebrate individuals rather than social classes. It called for the erection of "busts or full-length figures, perhaps bas-reliefs" devoted to "predecessors of socialism or its theoreticians and fighters, as well as those luminaries of philosophical thought, science, art, and so forth, who, while not having direct relevance to socialism, were genuine heroes of culture."[4]

This was the first Bolshevik effort to identify and monumentalize individuals.[5] Given the generality of Lenin's guidelines, it was not easy to establish criteria for inclusion on the list of heroes. Writing in mid-July, Lunacharskii proposed a list of writers and thinkers with socialist sympathies, such as Kondratii Ryleev, Vissarion Belinskii, Nikolai Dobroliubov, Nikolai Chernyshevskii, and Nikolai Nekrasov. Soon the list expanded to include sixty-seven "heroes of culture" of different nationalities and backgrounds, as well as political assassins, leaders of rebellions, and political martyrs. Eventually it included such diverse figures as Karl Marx, Aleksandr Herzen, Maximilien Robespierre, Spartacus, Frédéric Chopin, Andrei Rublev, Paul Cézanne, Lord Byron, François Voltaire, Nikolai Rimsky-Korsakov, and Giuseppe Garibaldi. Only two women—Sofiia Perovskaia and Rosa Luxemburg—were granted monumental status.[6]

Many of the monuments never materialized. Those that were constructed received a mixed reception from critics and the public.[7] Lenin himself was unimpressed by the public statuary designed in response to the decree. His artistic preferences ran along conventional realistic lines, and some of the creations turned out to be too avant-garde for his taste. He disapproved not only of futuristic creations but also of some eccentric projects, such as the one that had Karl Marx standing on four elephants.[8]

Each monument was unveiled with an official ceremony meant to highlight the importance of the celebrated figure; inscriptions on the statuary served to convey a message concerning the individual's contribution to the great march of history. Often Lenin personally attended

the ceremonies, especially in November 1918, and made speeches there. He appears to have believed that by creating an association between a particular individual and the Bolsheviks, the party could establish its lineage and create the aura of an impressive historical legacy. Paradoxically, however, Lenin placed no importance on the permanence of these creations. Following his suggestion, many of the artists used perishable materials such as gypsum that rapidly disintegrated in the rain.[9]

In this fashion, Lenin initiated and presided over the implementation of the first effort to celebrate publicly individuals who were thought to have had some connection—however remote—with the great cataclysm of October 1917. But such celebrations were only for the dead. He firmly discouraged visual representations of living Bolsheviks, including himself. The list of figures designated for monumentalization did not include a single political leader of the new Bolshevik Russia, unless he had already passed from the scene. Moisei Uritskii, head of the Petrograd Cheka, and V. Volodarskii (M. Gol'dshtein), the first commissar for press, propaganda, and agitation, made it onto the list of those to be monumentalized only after they had been assassinated and had entered the Bolshevik pantheon.[10]

Lenin did not intend his project to become a vehicle for the aggrandizement of himself and fellow Bolshevik leaders. Nevertheless, the very fact that such a project was under way on Lenin's initiative legitimized the practice of singling out individuals for heroization. On this theme, Lenin's rhetoric was often contradictory. In the fall of 1918, Lenin asserted: "All our lives we have waged an ideological struggle against the glorification of the personality, of the individual; long ago we settled the problem of heroes."[11] But his plan for monumental propaganda conveyed a different message, and in fact Lenin's position on the matter was ambiguous. It was not long before the practice of monumentalization began to extend to contemporary Bolshevik leaders and to Lenin himself.

LENIN'S IMAGE, 1918–1923

While monuments were being erected to dead cultural and political heroes, contemporary leaders of Russia were, as yet, little known to

the majority of the population. The first official photograph of Lenin was taken by Moisei S. Nappel'baum in January 1918.[12] It shows the leader—face and torso only—looking with a direct and penetrating gaze at the viewer. He wears a suit, tie, and white shirt, as he would in all subsequent representations. The photograph was soon reproduced in poster form, with only Lenin's name and title as the text.[13]

Later that year, in an advertisement promoting *Izvestiia,* the Nappel'baum photo of Lenin was paired with a photo of Marx—both the same size—and placed opposite each other.[14] The *Izvestiia* advertisement provided the first image of Russia's leader in mass circulation. Through the spring and summer of 1918, there were few, if any, examples of visual imagery of Lenin. According to Nina Tumarkin, "in the press, Lenin was not singled out for praise or even special attention, except immediately after the seizure of power when the new leader was honored with a brief biographical sketch in *Izvestiia* and a smattering of verse."[15]

For May Day 1918, the Bolshevik poet Dem'ian Bednyi wrote a poem, "Vozhdiu" (To the Leader), one of the earliest examples of the application of the term *vozhd'* to Lenin. At the time of the revolution, *vozhd'* customarily referred to a military leader and only metaphorically to the leading figure of a social or political movement.[16] Beginning in 1918 and continuing through the 1920s, the term was extended to party leaders. Ever since Lenin wrote *What Is to Be Done?* in 1902, his followers had conceived of the party as analogous to a military organization. It was therefore entirely natural to apply a military term, *vozhd',* to the leadership of a party in which a military ethos had become deeply implanted.

When the term was first applied to Lenin in 1918, it did not yet have a lofty and sacred aura. This was acquired only in the course of the decade that followed. At first it was used particularly with reference to Lenin, but in the 1930s, Stalin and a few members of his entourage were honored with the appellation. The German term *Der Führer* (referring to Hitler) and the Italian term *Il Duce* (referring to Mussolini) were also widely used in the 1930s and conveyed the same connotations as *vozhd'.*

Lenin repeatedly voiced strong objections to the adulation of Bolshevik political leaders, including himself, and prior to August 1918

the new propaganda organs of the regime gave low-key coverage to the leadership.[17] The situation changed after August 30, when Fania (Dora) Kaplan, a Socialist Revolutionary, nearly succeeded in assassinating Lenin. After that, Lenin was for the first time described publicly in terms that evoked religious associations. On September 6, Grigorii Zinoviev, chairman of the Petrograd Soviet, made a long address to the Petrograd Soviet in which he characterized Lenin in religious terms. Lev Sosnovskii, editor of *Bednota,* wrote in *Petrogradskaia pravda* on September 1 that Lenin was Christ-like.[18] But such comments were still exceptional, and Lenin was not yet treated with "religious reverence" at party caucuses. His "prestige was enormous, but criticisms of party policies and of Lenin personally were often sharp."[19]

Visual propaganda featuring Lenin's image remained relatively low-key throughout 1919. In February, the first official bust of Lenin was unveiled, sculpted by Georgii Alekseev at the behest of the Moscow Soviet. Copies were placed in twenty-nine cities between August 1919 and February 1920.[20] This was the first public statuary celebrating a living Bolshevik leader. Lenin made an appearance in political posters during the early months of 1919 with the publication of three *lubok*-style posters by Cheremnykh. "Krichat kapitalisty" (The Capitalists Cry Out), "Zhili sebe, pozhivali burzhui" (Once upon a Time the Bourgeoisie Lived Well), and "Vygnal trudiashchiisia kapitalista" (The Worker Threw Out the Capitalist)[21] depicted Lenin preaching to workers and mobilizing them against the enemy. A festive May Day poster by Apsit, "Pervoe maia mezhdunarodnyi prazdnik truda" (May First Is the International Holiday of Labor), included allegory (a snake labeled "capital"), *lubok* conventions (inserts showing "then" and "now"), new Bolshevik icons and symbols (a blacksmith-worker, red flags, factory chimneys), and images of Lenin and Marx.[22]

On November 7, 1919, Lenin's picture, paired with Marx's, hung on the arch above the entrance to Smol'nyi in Petrograd.[23] The November 12 issue *Pravda* published an image of Lenin with the caption "Vozhd' revoliutsionnogo proletariata" (Leader of the Revolutionary Proletariat).[24] But not all representations of Lenin struck a solemn tone. Cheremnykh's satirical drawing of a cheerful Lenin, broom in hand, sweeping enemies from the surface of the earth, appeared in the newspapers *Bednota* and *Kommunar* around this time as well.[25] But these

and other examples from 1919 confirm the impression that Leniniana had only just begun to develop. Of the many thousands of Rosta posters produced during the Civil War, only ten include any reference—visual or textual—to Lenin.[26]

Lenin remained unenthusiastic about public adulation of himself and other leading Bolsheviks but in 1920 consented to a competition among artists who sought access to him for the purpose of producing sketches, sculpture, and paintings.[27] In the course of that year, Lenin's image began to develop additional features and to acquire a form that would last throughout the Soviet era. An important step in the development of Leniniana was the celebration of Lenin's fiftieth birthday on April 22, which provided an occasion for meetings, speeches, poems, articles, and political art praising him. During these festivities, key elements in the aesthetic of Leniniana became established: the superhuman qualities of the *vozhd'*, his simplicity and humaneness, the popular essence (*narodnost'*) of the *vozhd'*, and his power (*moshch'*). These attributes were later transferred to Stalin, with whom they acquired unprecedented proportions.[28] Lenin was critical of the praise lavished on him for his fiftieth birthday but, as Nina Tumarkin has put it, also "decidedly ambivalent. He may have felt uncomfortable in its presence, but he allowed it to go on." In this manner, he sent a mixed message to his followers, who persisted in adulating their leader, though still in a subdued manner.[29]

The year 1920 witnessed some important shifts in the style of visual propaganda. As noted earlier, political artists generally moved away from allegorical images; new images of the woman worker and peasant gained acceptance and soon acquired iconographic status.[30] In this atmosphere of rapid change in political art, two leading satirical poster artists—Mikhail Cheremnykh and Viktor Deni—designed the first significant political poster featuring Lenin (fig. 4.1).[31] Issued in November 1920, "Tov. Lenin ochishchaet zemliu ot nechisti" (Comrade Lenin Cleanses the Earth of Scum) presented a more elaborate version of Cheremnykh's November 1918 newspaper drawing.[32]

The Cheremnykh and Deni poster depicts Lenin standing on the globe, sweeping with a large broom. He towers over his enemies (tsar, priest, and capitalist), who are pictured as small satirical figures leaping to escape the broom. This is the beginning of the larger-than-life phe-

nomenon in the representation of Bolshevik political leaders. In adopting this device, artists were following a convention in painting whereby the hierarchical value of a depicted figure is translated into "perspective in a particular symbolic space."[33] As we have seen, perspectival distortion of heroes was commonplace in Russian culture; in *lubok* pictures, the hero was often a giant, although not all giants were heroes.[34] After the October Revolution, the iconographic worker or soldier was sometimes depicted as a larger-than-life figure. Boris Kustodiev's 1920 painting, *The Bolshevik,* provides the most dramatic example of this technique for highlighting the stature of heroic revolutionaries.[35]

The artists presented Lenin wearing a suit, vest, tie, and cap. Previous images of Lenin, particularly the Nappel'baum photograph and drawings based on that photograph, show him bareheaded and nearly bald. The addition of the cap must be considered a significant detail in the semiotic system that was taking form. Caps were considered informal, unpretentious attire in this period and were not uncommon. Nikolai Bukharin, for example, sported a similar cap. In England and France, the cap had been a common part of proletarian attire since the 1890s.

How might contemporaries have interpreted the presence of such a cap, particularly in combination with the suit, vest, and tie? One possibility, suggested by François-Xavier Coquin in his study of the imagery of Lenin, is that the cap suggested "Lenin the Bolshevik, the man of exile and clandestine struggle, the fighter in the October Revolution, and the internationalist leader."[36] This was in contrast to the hatless image of Lenin, the leader of Soviet Russia.

Though it is difficult to establish how contemporaries might have "read" the image of Lenin wearing a cap—and no doubt there were many different interpretations—we can say with certainty it had connotations that displeased the image-makers between 1929 and 1953. During these years Lenin appeared hatless in most political posters and monuments, although there were some exceptions. If anyone wore a hat after 1930, it was usually Stalin, whose military-style cap was included occasionally in images of the 1930s and more often during and after World War II.[37] The informality of the *vozhd'* implied by the cap did not correspond to the increasingly formal relationship between ruler and ruled in Stalinist Russia.

A novel image of Lenin appeared in a 1920 poster, "Prizrak brodit po

Evrope, prizrak kommunizma" (A Specter Haunts Europe, the Specter of Communism) (fig. 4.2).[38] This Moscow poster by an unknown artist shows Lenin in a jacket and tie but without the cap; his expression is determined, almost grim, and his right arm is outstretched with forefinger pointed. He stands on what appears to be a podium and seems to be addressing a large but invisible crowd below.

The poster contains several images that subsequently became standard ingredients in Leniniana. First, there is the outstretched arm, which was reproduced in many variations over the decades that followed (sometimes right arm, sometimes left). In "Prizrak," Lenin's outstretched arm clearly points the way for his followers, but later renditions of the outstretched arm also suggested a benediction (see the discussion of the 1922 poster by A. Sokolov [fig. 4.3] below). The image of Lenin's raised arm may well have reminded viewers of Russian Orthodox icons, in which the raised hand or arm (in benediction) was a usual feature of images of Christ or the saints (the right hand conferred a blessing while the left hand held a book or scroll).[39]

The podium in "Prizrak" anticipated another important element in the representation of the *vozhd'*. During the French Revolution, the podium (and paper) was used to indicate the "symbolic joining of word and law."[40] Soviet propagandists often adopted this convention in the early 1920s, beginning with "Prizrak." A particularly memorable image of Lenin and the podium can be found in the 1924 creation by El Lissitzky showing Lenin perched in front of a podium suspended high in the air.[41] Some years later, Dziga Vertov's film *Three Songs of Lenin* (1932) incorporated frequent images of Lenin at the podium.[42] The device was subsequently used from time to time in political posters featuring Stalin, but it acquired greatest importance in Leniniana.

For Lenin's fiftieth birthday in 1920 and to commemorate the introduction of Lenin's Plan of Electrification at the Eighth Congress of Soviets, Gustav Klutsis designed two posters using photomontage, which was just being introduced into Russia from Germany and England, where it originated. Klutsis was one of the earliest and most creative artists to apply this technique to visual propaganda. He subsequently emerged as a brilliant practitioner of Stalinist political art and served the regime loyally until his arrest in 1938. He was executed soon afterward.[43]

In "Elektrifikatsiia vsei strany" (Electrification of the Whole Country), Klutsis anticipated several later developments in visual Leniniana.[44] A larger-than-life Lenin in a cap is striding forward, holding an electrical station in his arms. Below him is a model city. Several aspects of this remarkable poster deserve note. It is the first to show Lenin striding forward, an image that had not previously appeared in visual propaganda but was often utilized in the 1920s. The poster achieves a startling effect by the use of photomontage. Lenin's figure was a photograph but all else in the poster was drawn by the artist.

Like the Cheremnykh and Deni poster discussed above, Klutsis uses the larger-than-life format for Lenin. But here the size of the leader and his gigantic proportions in relation to the environment and other people are far more accentuated—the only other human figure in the composition is scarcely the size of Lenin's shoe! As Margarita Tupitsyn has argued, Klutsis's 1920 sketch inaugurated a new era—not fully articulated until the 1930s—which celebrated the *vozhd'* as a Nietzschean Superman.[45]

A striking creation in these years was a 1922 poster by A. Sokolov, "Pust' gospodstvuiushchie klassy sodrogaiutsia pered kommunisticheskoi revoliutsiei" (Let the Ruling Classes Shudder before the Communist Revolution), produced for the November anniversary of the revolution (fig. 4.3).[46] Here Lenin is depicted with his left arm raised to shoulder height, his hand stretched forward with palm down; his right hand—a clenched fist—is at his side. In the background, the rays of a stylized sun create a halo behind Lenin. On either side are a peasant (on Lenin's right) and worker (on his left), both depicted in the iconographic form that had become conventional. Lenin stands on a globe and below him are various emblems: the hammer and sickle representing the Soviet state, and the sheaths of wheat symbolizing abundance. The slogan, "Proletarians of the world unite," frames the sun's rays and Lenin's figure.

The multivocality of the arm and hand position adds to the visual power of this highly symbolic composition. The position (arm and hand outstretched, but without an extended forefinger) both suggests forward movement—pointing in the direction of the future—and appears to confer a blessing on those below. Lenin's legs are spread apart as he stands firmly on the globe below him. Again, the larger-than-life

device is used to accentuate Lenin's stature: the peasant and worker are depicted on a far smaller scale than their leader.

We have no way of knowing for certain how contemporaries viewing this poster may have interpreted the images they saw. Certain symbolic forms probably recalled religious icons. The extensive use of the color red, the distorted perspective (Lenin is far larger than the sun, the globe, and the worker and peasant on either side), the composition (Lenin flanked by the worker and peasant, just as Christ was sometimes flanked by two apostles),[47] and the circular frame that surrounds Lenin (Christ was often situated in an oval frame)[48] must have been familiar to Russians accustomed to the conventions of religious icons. These visual analogies were reinforced by written and verbal comments of contemporaries who used religious terminology to describe Lenin, a trend that began in the aftermath of the Kaplan assassination attempt. In September 1918 and the months that followed, he was characterized as having the qualities of a saint, an apostle, a prophet, a martyr, a man with Christ-like qualities, and a "leader by the grace of God."[49]

Although the architects of the emerging cult of Lenin borrowed extensively from the Russian Orthodox Church in crafting verbal and visual symbols for the *vozhd'*, they were careful to produce images that appeared discontinuous with tsarist iconography. In contrast to the lavish ceremonial occasions, military parades, and scenes of the tsar's family that provided material for old regime iconography,[50] Leniniana cultivated the image of Lenin as a simple and modest man whose outstretched arm projected a new type of power. This image was reproduced in posters and holiday displays prior to 1924 and long afterward.[51]

Adolf Strakhov's 1924 poster of Lenin (fig. 4.4) presented yet another variation of the image originally created by Sokolov.[52] The poster has no text, apart from the dates "1870–1924" at the top and Lenin's signature on the bottom. The Strakhov composition was originally published as a cover for the Russian edition of John Reed's *Ten Days That Shook the World,* and in 1925 it won a gold medal at the Paris world exhibition.[53] It shows Lenin with his left hand raised in a gesture identical to the one in the Sokolov poster, suggesting both a direction and a benediction. He is depicted here entirely in red, more a silhouette than a sketch.

Strakhov reproduces several other features of Sokolov's earlier poster. Lenin appears as a larger-than-life figure (the silhouettes of soldiers in the background are very small by comparison) wearing a suit, tie, and cap. Like Sokolov's 1922 poster, this Lenin is no longer a jolly figure but a somber, determined, and forceful leader. Any trace of lightheartedness disappears from visual Leniniana after January 1924.[54]

By the time Lenin died, his image was already well established in political posters, and visual Leniniana had been extended to other media. In 1920, Sergei Chekhonin designed a plate with Lenin's head, surrounded by a red ribbon and oak leaves. The following year, a plate by Mikhail Adamovich featured a portrait of Lenin.[55] Soon afterward, Lenin's image appeared on a porcelain cup.[56] A fabric portrait made between 1922 and 1924 used a Grecian motif to present Lenin's head, bald and serious, in a circle, surrounded by figures of workers in classical garb.[57] In August 1923, a gigantic portrait of Lenin made from living plants was unveiled in Moscow.[58]

In all of these representations, Lenin invariably appeared in certain clothing and standard poses. The fixity of his appearance, like some of the other features of the posters, had much in common with religious icons and folk traditions. As Boris Uspenskii has noted, the saints in Russian icons, "except for very rare exceptions, are almost never parted from the clothing characteristic of them, just as the heroes in the Russian *byliny* are under no circumstance deprived of the 'fixed epithets' which characterize them."[59]

Considering Lenin's position in the Bolshevik pantheon, it is striking how few political posters with his image appeared before 1924 and how reserved was the depiction of his relationship with ordinary people. Often he was shown alone or with an invisible audience (see fig. 4.3). To the extent that Lenin was visually linked with others, it was with "workers" and "peasants," each symbolized by a single symbolic image or by silhouettes. Thus, in Sokolov's 1922 poster, Lenin was flanked on either side by an iconographically correct worker or peasant (male), just as the saints and apostles in religious icons stand on either side of Christ. Only after Lenin's death did crowds begin to appear in political posters. This shift in detail signaled a profound change taking place in Bolshevik hagiography.

Following Lenin's death, the party asserted firm control over his visual image by establishing a special commission to review all works of art depicting Lenin. With the departure of Lenin from the scene, the cult of Lenin proceeded virtually without constraint. In an atmosphere of grief and adulation, artists and writers embarked on a search for appropriate ways to represent the dead leader. Over the next several years they produced new images, rituals, and symbols incorporating both Russian Orthodox and traditional Russian folk rhetoric and practice. Henceforth, Lenin was often invoked as "our dear father," and at the funeral some mourners carried Lenin's portrait on tall sticks, like religious banners in a Russian Orthodox procession.[60] From this time on, we can chart the process of the "aestheticization of power" in Soviet Russia.[61]

The creation of Lenin Corners—a variant on the Red Corner (*krasnyi ugolok*) first introduced by the Red Army in 1921—provides another notable example of religious appropriation by the Bolsheviks. These corners were modeled after the *krasnyi ugol* that could be found in every Russian Orthodox home, the place where the icon was kept. Like its prototype, the *krasnyi ugolok* consisted of a room or part of a room with sacred pictures and writings—in this case of Bolsheviks. In February 1924, the main agency in charge of propaganda, Glavpolitprosvet, established guidelines for Lenin Corners, including lists of photographs of Lenin.[62]

Posters, stamps,[63] and holiday displays with images of Lenin or references to him began to appear after his death in greater quantity and variety than ever before. The May Day parade in 1924 included a float with a giant bust of a capless and somber Lenin—an unprecedented mode of veneration.[64] No other figure, not even Karl Marx, had been so honored. In many of these posters and holiday displays, Lenin's immortality provided an important theme. Some celebrated scenes from his life with photographs, in the style of icons depicting saints' lives. One such poster carried the text: "Il'ich dies—Lenin lives!"[65] The slogan "Lenin is dead! Leninism lives! Leninism will triumph!" was formulated almost immediately after Lenin's death.[66] Maiakovskii's

phrase "Even now Lenin is more alive than the living" was widely displayed throughout the country.[67]

The prompt creation of a mausoleum and the decision to embalm Lenin's corpse and make it available for public viewing further reinforced the theme of immortality, with its religious associations. The Commission for the Immortalization of the Memory of V. I. Ul'ianov (Lenin) (formerly the Funeral Commission) took charge of embalming the body and preparing it for public viewing.[68] The long-term preservation of Lenin's body was a remarkable achievement from a scientific point of view and a feat with particularly significant connotations for Russian Orthodox believers. According to Church dogma, saints' bodies were incorruptible and did not decay after death. A temporary structure containing Lenin's embalmed body was erected in Red Square and opened to the public for viewing beginning on August 1, 1924.[69]

An anonymous poster, "Velikaia mogila" (The Great Tomb) (issued in 1924 or 1925), depicts the mausoleum in which Lenin's body was placed, with the Kremlin tower centrally positioned behind it (fig. 4.5).[70] The composition, vaguely suggesting a cross, establishes a visual association between Lenin and the Kremlin (rather than the customary insets of revolutionary scenes), thus implying that Lenin should be remembered primarily as a statesman. The text in black letters across the bottom states that "Lenin died but his work lives." Henceforth, political artists strove to emphasize the theme of Lenin's immortality—the immortality, that is, of Lenin's "other body."[71]

In this and other representations of the mid-1920s, we can trace the beginning of the phenomenon of "the leader's two bodies" in visual representation of the *vozhd'*. To use the terminology of medieval politics and law, the representation of the king as visible and mortal was only one aspect of the "mystic fiction" of the "king's two bodies."[72] In addition to being a mere mortal, the king also had another body—an invisible body "politic" that was immortal, infallible, and capable of "absolute perfection." The cult of Lenin incorporated the idea of the "leader's two bodies" and created a system of visual signs for expressing these concepts in images.[73]

The dualism suggested by this medieval doctrine became enshrined in the post-mortem visual treatment of Lenin. Whereas previously

Lenin had been depicted as a great man and a revolutionary, after his death, for the first time, Lenin is represented visually as an immortal figure (the doctrine of infallibility was added by Stalin in 1931)—a great statesman assured immortality by the admiring "masses," who carried on Lenin's life after his death.

In the mid-1920s, Lenin was still celebrated for having destroyed the old regime, eliminated its enemies, and exported revolution to the international proletariat. But now his contribution as a leader of the new Soviet state was also celebrated. Political artists increasingly emphasized Lenin's role as a great leader of the Communist Party and Soviet state, who called upon people to work harder and to industrialize the country.[74] This development in visual iconography corresponded to a shift that was taking place more generally in the political outlook of Bolshevik leaders. With Stalin's introduction of "socialism in one country" and the retrenchment in foreign policy, the leadership began to focus more intensively on strategies for future industrial development than on issues pertaining to revolution.

The posthumous shift in iconography of the *vozhd'*, with its increasingly statesmanlike image of Lenin, found expression in monumental sculpture. On May 1, 1925, a statue of Lenin was erected in Stalingrad—the new name given to the city of Tsaritsyn in April 1925. As depicted in a poster issued around the same time, a capless Lenin stands with his right arm raised (thumb erect) on a giant screw and bolt (fig. 4.6).[75] The poster's brief caption, "Lenin—stal' i granit" (Lenin Is Steel and Granite), encapsulates the idea that Lenin's legacy called, above all, for the construction of a great and powerful state. The poster also implies, by verbal means, an intrinsic connection between Lenin the man of steel (*stal'*) and his acolyte *Stal*in. The suggestion must have been clear to contemporaries, for although Stalin is not mentioned explicitly, it was one of the earliest posters to appear in a city newly christened in Stalin's honor.

The monumental sculpture of Lenin erected at Finland Station in Leningrad (the new name given to Petrograd in January 1924) further exemplifies the transition taking place in iconography. Designed by Sergei Evseev and Vladimir Shchuko and unveiled in 1926, the monument presents Lenin in a standard pose and was no doubt meant to

provide a counterpoint to the statue of Peter the Great, the *Bronze Horseman*. The dead leader appears with his right arm raised to shoulder height; his fingers are pointed straight ahead, palm forward, with his thumb raised (fig. 4.7).[76] As in the Stalingrad monument, the gesture is ambiguous and suggests less a benediction than a sharp directional movement. Lenin's left hand holds the lapel of his overcoat and suit jacket. As in previous renderings, he is bareheaded, wearing a suit, vest, and tie. His distinguished appearance and his authoritative demeanor once again suggest a great leader of the Soviet state as much, if not more, than a revolutionary activist.[77]

A 1925 poster, "Da zdravstvuet mezhdunarodnaia proletarskaia revoliutsiia" (Long Live the International Proletarian Revolution), illustrates another new development in iconography after Lenin's death (fig. 4.8).[78] Here Lenin appears in the guise of a huge white statue towering over a crowd of marchers, his right arm outstretched. Led by four iconographically correct workers and peasants (both male and female) and a marching band, the crowd carries large banners with declarations of faith and exhortations: "We are Leninists," "People to the countryside," "Remember Il'ich's pledge to reduce illiteracy," "Raise the productivity of labor," and very importantly, "Long live the R.K.P. [Russian Communist Party] *vozhd'* of the working class." They are paying homage to Lenin's "other body."

Provincial posters used religious and folk idioms to tell a story of the king's other body. The Rostov poster, "Torzhestvo oktiabria" (Celebration of October), holds particular interest. Notwithstanding the title of the poster, Lenin is depicted as a statesman, not as a revolutionary (fig. 4.9).[79] He is surrounded by industrial, agricultural, and cultural accomplishments of the Soviet party-state and, even more importantly, by the (now obligatory) *narod* (people), in this case, men and women who are marching in great numbers, cheering, and carrying banners that promise to carry out Lenin's legacy. His portrait is encased in an oval frame, reminiscent of religious icons and implying an association between Christ and Lenin. Stylized rays of the sun—a common element in Russian folk art—brighten the scene as the celebrants acclaim their dead leader.[80]

The theme of the "king's two bodies" received eloquent treatment in

S. D. Merkurov's monumental sculpture, *Pokhorony vozhdia* (The Funeral of the *Vozhd'*), produced in 1927. It shows Lenin lying supine after death, his arms at his sides, born aloft by eight male pallbearers.[81] The bier appears to be very heavy and the pallbearers strain under its weight. Above them Lenin lies with an expression of serenity, even beatitude. The monument incorporates elements of both the leader's bodies. On the one hand, there is the tangible, corporeal Lenin carried aloft, and on the other, the immortal Lenin, the *vozhd'*, whose weighty legacy rests on the shoulders of his loyal followers.

At the time of his death, Lenin was not the only Bolshevik leader celebrated in political art, although he occupied a preeminent position as *vozhd'* and *uchitel'* (teacher). He was surrounded by the *vozhdi-soratniki* (the leader's comrades-in-arms), the most important of whom was Leon Trotsky, a hero of the October Revolution and the Civil War and commissar for military and naval affairs (1918–1925). By 1924, "the cult of Trotsky had achieved unprecedented scope in Soviet art."[82]

Portraits of Trotsky were on display in most official institutions.[83] Leading Soviet poster artists created arresting images of Trotsky for mass circulation during the Civil War years. In 1920, Moor designed a striking poster, "Bud' na strazhe!" (Be on Guard!), that featured a drawing of Trotsky holding a bayonet and standing, larger than life, on Russian territory, with minuscule enemies below him. It was issued in a substantial edition of 40,000 copies.[84] Another eminent poster artist of the Civil War period, Apsit, used Trotsky's words in the widely circulated 1919 poster, "Na konia, proletarii" (On Your Horse, Proletarian!).[85] Just as Lenin was immortalized on porcelain plates, so Trotsky's image also appeared on a plate celebrating the fifth anniversary of the Red Army in 1922.[86] Mikhail Adamovich, who also designed a plate honoring Lenin, placed a three-quarter face portrait of a distinguished-looking Trotsky against the background of a red star with a hammer and sickle. The following year (1923), the artist Iurii Annenkov depicted Trotsky as a larger-than-life figure in full military regalia, with his right arm raised to shoulder height—a pose quite similar to the one already used to depict Lenin.[87]

In the early 1920s, Deni created a remarkable illustration for a Soviet calendar issued by the magazine *Prozhektor*.[88] Labeled "Georgii Pobedonosets (L. Trotskii)" (St. George the Conqueror [L. Trotsky]), it has

an image of Trotsky seated on a white horse, slaying a serpent labeled "counterrevolution." The serpent wears a top hat, a pointed reference to the capitalist. The depiction of Trotsky as St. George conferred on the Bolshevik leader a lofty honor, rich with associations for viewers accustomed to St. George's unique place in the Russian religious, political, and folk traditions.[89]

Trotsky was not the only Bolshevik leader, apart from Lenin, who was heroized visually between 1918 and 1925. Grigorii Zinoviev, for example, also appeared on plates and other porcelain objects.[90] But Trotsky alone was accorded a visual status that rivaled Lenin's. As Evgenii Dobrenko has observed, "One can definitely assert that the conception of two leaders by no means arose in connection with Stalin, but much earlier—in connection with Trotsky. At the beginning of the 1930s a change in characters took place, when Stalin was placed on the second throne."[91]

LENINIANA, 1930–1934

By the late 1920s, the mass production of Lenin's image was fully under way. The Association of Artists of the Revolution (AKhR) published a *lubok* portrait of Lenin, as did four big printing houses in Moscow and Leningrad. In all, 12.5 million copies of Lenin's portrait were in circulation by 1929.[92] Over the next decade, some Lenin posters appeared in enormous press runs, as high as 150,000 or 200,000 copies, created by such well-known poster artists as Toidze and Dolgorukov.[93] Visual references to Lenin took many forms: a photomontage, a statue, a profile on banners, a name on books or on walls.[94]

The representation of Lenin in political posters acquired definitive iconographic features that functioned like the *podlinnik* in church art. These attributes of the Lenin image, carried over from the 1920s into the 1930s, included the following: Lenin always wore a suit, vest, and tie and sometimes an overcoat but rarely a cap (though sometimes he held it in his hand); one arm was outstretched, but the precise position of the hand continued to vary; his expression was serious, determined, thoughtful, or slightly ironic, but never jovial.[95] Often Lenin was depicted as a larger-than-life figure, with pronounced perspective distortions. The consistency and uniformity of the imagery were, of course,

facilitated by the rapid and thoroughgoing centralization of visual pro-
paganda that was under way in 1931, when Izogiz was given primacy,
and 1932, when artistic organizations were disbanded and replaced by
a single officially sanctioned Union of Soviet Artists.[96]

Critics in these years placed great emphasis on the appropriate rep-
resentation of Lenin's relationship to "the masses." We have seen that
"the masses" were first introduced into the semiotic system for repre-
senting the *vozhd'* following Lenin's death. In contemporary termi-
nology, it behooved the artist to depict effectively the leader's activity,
which was "organically connected with the proletarian masses." As one
critic put it: "The idea of the proletarian *vozhd'* demands the introduc-
tion of the masses into the basic composition."[97] By the early 1930s, the
masses had become an indispensable ingredient in posters featuring
Lenin. Their presence provided a visual symbol of Lenin's immortality:
he lived on in the hearts and minds of his followers, who carried for-
ward his ideas, his policies, his legacy.

The importance of this issue for contemporary critics emerges clearly
from the reception given to Aleksandr Gerasimov's 1930 painting of
Lenin on the tribune when it was issued as a poster in 1932 (fig. 4.10).[98]
The painting shows Lenin standing on a tribune high above the masses
gathered below; he appears to be giving a speech, and his left hand
clutches his cap, while his right hand holds his lapel; his face is almost
in profile, his chin slightly elevated. Beneath him, positioned on the
diagonal, is a red flag; the crowds are below. The placement of Lenin
on a tribune or in front of a podium, a visual convention originating
in 1922, can frequently be encountered in Leniniana of the 1930s.[99]

A contemporary reviewer, G. Lelevich [L. Kalmanson], opened his
review of Gerasimov's portrait with general observations about the por-
traiture of the "proletarian *vozhd'*."[100] Lelevich distinguished Soviet
portraits of the leader from both bourgeois and noble versions. The
former, he claimed, were too intimate; the latter suffered from "mili-
tary parade rigidity." The portrait of the proletarian *vozhd'*, by contrast,
must "combine individual likeness with an expression of the idea of the
vozhd' of the whole revolutionary class."[101] Turning to Gerasimov's
painting, Lelevich criticized the artist's depiction of Lenin's expression
and gesture, which he characterized as showing anguish and nervous-
ness unbefitting the *vozhd'*. Above all, he found objectionable the vague

treatment given the masses in Gerasimov's composition, since "a form-less and spontaneous mass" could not provide the "proletarian *vozhd'*" with the proper source of inspiration. He labeled the painting a "typical petty bourgeois interpretation." [102] Other reviews of the Gerasimov portrait made similar criticisms, emphasizing the artist's failure to depict "the masses." [103]

In 1932, a decree authorized construction of a Palace of Soviets in Moscow that would provide both a memorial to Lenin and a museum for the display of painting and sculptures of the deceased leader. [104] To be erected on the site of the former Church of Christ the Savior near the Kremlin, the building—designed by Boris Iofan—was to be 415 meters high (a wedding cake–style design) and crowned by a 100-meter statue of Lenin. The design for the statue has Lenin's right arm raised to the sky and his head (capless) uplifted, as though communicating with a higher authority. His left foot is stepping forward, and his entire body appears to be in motion. [105] If completed as planned, the entire edifice would have exceeded the height of the Empire State Building in New York City, then the highest in the world. But the project remained on the drawing boards, and a swimming pool was eventually constructed at the site.

On the tenth anniversary of his death, in 1934, the government issued a series of memorial stamps, each illustrating Lenin at a different stage of life, from toddler to *vozhd'*. [106] The same year, Izogiz conducted a contest for the best posters of Lenin, which elicited many entries by well-known artists. [107] Lenin had been transformed from a rousing revolutionary into a stern and dignified statesman whose immortality was continually reaffirmed by "the masses," who carried on his legacy and obeyed his commands, even after death. [108] His embalmed remains in the mausoleum provided further confirmation of the immortality of Lenin's "two bodies."

THE EMERGENCE OF STALINIANA

Just as the iconography of Lenin was becoming more settled in the first half of the 1930s, another major development was taking place: the coupling, for the first time, of Lenin's image or name with Stalin's. Political art performed a vital function in promoting the new cult of

Stalin. Posters graphically depicted the relationship between the two men, creating a visual subtext that implied a connection between Stalin's sacred aura and his association with Lenin.

Already in 1925, the two men were linked visually in a painting by A. N. Mikhailovskii, "V. I. Lenin i I. V. Stalin v Gorkakh letom 1922 g." (V. I. Lenin and I. V. Stalin in Gorki, Summer 1922).[109] Lenin and Stalin are seated side by side, in a relaxed fashion; both look directly at the viewer. The government printing house produced 200,000 copies of the painting, an extraordinarily large number for that time and a sign that this particular painting was to be widely disseminated. As noted earlier, a Stalingrad poster implicitly linked Lenin and Stalin in 1925 or 1926 (fig. 4.6).

The adulation of Stalin reached a new level in December 1929, on the occasion of his fiftieth birthday. An entire issue of *Pravda* was devoted to him on December 21, 1929, and a special anthology was published, *Stalin,* which included extravagant praise by many leading Bolsheviks. A Ukrainian journal, *Za gramotou,* placed a portrait of Stalin on the cover of the December issue, with Lenin's silhouette in the background.[110] The "beatification" of the party leader had begun.[111]

From 1930 on, all forms of mass propaganda were mobilized by the regime to sing Stalin's praises.[112] A turning point in the evolution of the cult took place in October 1931, when Stalin published a vituperative letter defending Lenin's historical record against criticism and asserting the infallibility of the *vozhd'*.[113] Lenin had already been pronounced immortal after his death; Stalin's letter established definitively Lenin's infallibility. These seemingly arcane arguments concerning Lenin's perfection actually had tremendous consequences for the development of the Stalin cult. As Robert Tucker has put it: "Stalin followed the strategy of cult building via the assertion of Lenin's infallibility. By making the party's previous *vozhd'* an iconographic figure beyond criticism, Stalin's letter implicitly nominated the successor-*vozhd'* for similar treatment."[114] Stalin was cultivating the mythology of Lenin's "other body."

Two posters appeared in 1930 and 1931 that visually connected the two men. "Pod znamenem Lenina za sotsialisticheskoe stroitel'stvo" (Under Lenin's Banner for Socialist Construction), was created by

Klutsis and issued in 1930 in an edition of 30,000 (fig. 4.11).[115] Klutsis uses photomontage to create a visual relationship between Lenin and Stalin. Two faces—both photographs—provide the focal point for the poster. Lenin looks directly at the viewer, but his face has a dreamy, far off, almost wistful expression. Positioned behind him, only one eye visible, is Stalin. Though his face is half hidden and partly in shadow, he projects determination and strength. This distinctive poster connects the two leaders by contiguity and juxtaposes the image of a soft intellectual Lenin to Stalin, a steely man of action.

The composition of Klutsis's poster exemplifies visual trends in the early 1930s, when the diagonal lines typical of Constructivist style were thought to convey a sense of dynamic movement and many artists used them to project the intensity of the First Five Year Plan. Klutsis framed the images of Lenin and Stalin with photographs of industrial scenes set on an angle, so that the entire poster projects a series of diagonal lines. But most important, from the point of view of the emerging cult of Stalin, was the association of the leaders by contiguity, in this instance by means of linked images; in other posters, the association was established through the text.[116] This metonymic device served to accentuate the idea of "a hyphenate cult of an infallible Lenin-Stalin."[117]

G. Kibardin's 1931 poster, "Postroim eskadru dirizhablei imeni Lenina" (Let Us Construct the Lenin Squadron of Dirigibles), not only connected but also ranked the country's leaders.[118] The poster was conceived in the same style as Klutsis's poster, using photomontage and diagonal lines. A larger-than-life Lenin (a photograph) presides over the scene with his right arm raised in what appears to be a benediction directed at a crowd of Lilliputian marchers below. But the eye-catching image in the poster is a squadron of six dirigibles hovering in a yellow sky. The largest dirigible is inscribed in red with the name "Lenin"; above it, the second largest is inscribed "Stalin"; others bear the inscriptions "Old Bolshevik," "Pravda," and "Klim Voroshilov." An electrical tower is positioned parallel to Lenin (both on a diagonal angle). In the early 1930s, electrical installations were a key symbol of industrial progress, and other posters of these years featured similar images.[119]

In the period 1930–1931, Lenin and Stalin were more and more often

connected in words and images, and Lenin usually took precedence visually. Nevertheless, developments were in progress that would soon change the way artists depicted this relationship. The *Pravda* report on the opening day of the Sixteenth Party Congress (June 26, 1930) included a drawing of Stalin in profile and, behind him, a picture of Lenin in profile. As Tucker has observed, "no subtlety was needed to grasp the message that Stalin was Lenin today."[120] The following year, an article in *Bol'shevik* for the first time ranked Stalin together with Marx, Engels, and Lenin as a source of wisdom on materialist dialectics.[121] These changes in Stalin's public stature and representation relative to the other great heroes of the regime found further visual expression on May Day 1932, when identically sized full-face portraits of Lenin and Stalin hung in Moscow's Pushkin Square.[122]

It was not long before some artists began to accentuate Stalin's image at the expense of Lenin's. A vivid example of this trend can be found in the 1932 poster by Klutsis, "Pobeda sotsializma v nashei strane obespechena" (The Victory of Socialism in Our Country Is Guaranteed) (fig. 4.12).[123] Stalin's torso (he wears a military-style hat and overcoat) looms over an industrial scene and a dense crowd of workers carrying red banners. One of these banners has a very small profile of Lenin—so small, in fact, that it might easily be overlooked. A similar though not so extreme enhancement of Stalin and diminution of Lenin can be found in Deni's 1932 poster, "15 oktiabria" (October 15).[124] These posters and others published in 1932 inaugurated a major new phase in the representation of the two leaders.

Following a meeting of the Central Committee plenum in January 1933, the adulation of Stalin as an "infallible genius" reached a new plateau.[125] A 1933 poster by Klutsis—"Vyshe znamia Marksa Engel'sa Lenina i Stalina!" (Raise Higher the Banner of Marx, Engels, Lenin, and Stalin!) (plate 5)—illustrates the intensification of the Stalin cult.[126] The poster first appeared in an edition of 50,000 and was reissued shortly afterward in an edition of 30,000. Other editions appeared in 1936 (250,000 copies) and 1937, and it was produced in more than twenty different languages.[127] Reprints of this magnitude over a period of four years—quite an exceptional, perhaps even unique phenomenon—indicate that Klutsis's rendering of the four great men remained consistent with official ideology.[128]

The poster is designed in an unusually large format. It consists of identically sized photographs of the faces of Marx, Engels, Lenin, and Stalin arranged horizontally, each against the background of a red banner. Above and below are scenes of revolutions, past and present, and smiling Soviet crowds.[129] A consummate poster artist, highly attuned to the prevailing political winds and sometimes even anticipating them, Klutsis understood well the power of detail in an officially inspired semiotic system. In this poster, the striking detail centers around the gazes of the four men. The photographs of Marx, Engels, and Lenin show them looking off to one side; Stalin, by contrast, is the only one of the four who makes direct eye contact with the viewer. The artist's choice was deliberate, since there existed at the time well-known portraits of both Marx and Lenin gazing directly at the viewer.[130] The direct gaze sets Stalin apart from the others and gives his image a particular magnetism. It accentuates in a subtle yet decisive manner the exceptionalism of Stalin, placing him on a different plane from the others. With one detail, the artist has conveyed the message that Stalin not only belongs in the pantheon of the great men but is the *primus inter pares.*

Prior to 1933, the direct gaze had seldom been used in Soviet political art, although there are a few notable exceptions.[131] In the early 1930s, several striking posters incorporate this device,[132] which was intended, no doubt, to capture the viewer's attention and intensify the impact of the poster. The eye gazing upon the viewer could also be found in Russian icons as late as the nineteenth century. Russian icon painters "had the custom of painting the so-called 'great eye' on the icon, and of writing the word 'God' beneath it."[133]

Poster reviews published during 1933 leave no doubt that a general consensus had been reached among political artists and critics regarding the relationship between Lenin and Stalin. As one reviewer put it, artists must "define and disclose the enormous revolutionary strength which characterizes comrade Stalin as the greatest strategist and theoretician of bolshevism, the genius, the pupil, and the continuer of Lenin's cause."[134] Following these guidelines, artists generally gave Stalin primacy in visual representations of the two leaders. This meant that Stalin's syntactical position in the semiotic system expressed his dominance: he was foregrounded, he alone gazed directly at the viewer, or his image was larger than Lenin's.[135]

From the foregoing, we can see that the depiction of the relationship between Lenin and Stalin passed through several phases beginning in 1930. Initially the dominant figure, Lenin was soon shown as the equal of Stalin. Gradually, by 1933, Lenin's position vis-à-vis Stalin was adjusted to accentuate—sometimes boldly, sometimes more subtly—the primacy of Stalin. On November 7, 1933, the sixteenth anniversary of the October Revolution, *Pravda* carried a montage on the front page designed by Klutsis. Serving as an illustration for an article entitled "Masses Create History," Lenin's portrait—"formal and dull"—was presented in a background position in contrast to a "fervent image of Stalin." Stalin is in a Napoleonic pose, his face turned away from Lenin, as he gazes over industrial and agricultural scenes and "determined, energetic faces." [136]

When the foreign correspondent Eugene Lyons counted portraits and busts of leaders on Gorky Street on November 7, 1933, Stalin led Lenin by 103 to 58.[137] The Izogiz production plan for 1936 called for two portraits of Marx, one of Engels, seven of Lenin, and ten of Stalin.[138] In 1938, the Izogiz plan called for one portrait of Marx, two of Lenin, seven of Stalin, and one of Lenin and Stalin together.[139] It was not only the number of posters devoted to individual leaders that proved significant but also the size of each edition. The propaganda campaign intensified in the mid- and late 1930s. Press runs varied from about 10,000 to several hundreds of thousands of copies. The really enormous press runs were generally reserved for posters featuring Stalin. A 1936 poster with a portrait of Stalin appeared in an edition of 250,000.[140]

In his 1935 poster, "Da zdravstvuet nasha schastlivaia sotsialisticheskaia rodina" (Long Live Our Happy Socialist Motherland) (fig. 4.13), Klutsis conveys Stalin's hegemonic position by using a familiar device.[141] A squadron of airplanes flies over Red Square, each of them bearing the name of a major figure, beginning with Lenin and Stalin and continuing with Gorky, Kalinin, Molotov, Voroshilov, and others. Stalin (in the forefront) and Voroshilov (standing slightly behind him) salute the airplanes from their reviewing stand.[142] Not only does Stalin preside over the scene, but adoring smiling faces look up at him and several people wave to him. Stalin's preeminence is affirmed by the text, which exclaims "Long live our beloved great [*liubimyi velikii*] Stalin!" Not

only have airplanes replaced dirigibles (as in Kibardin's 1931 version), but Stalin has displaced Lenin as the Soviet leader who is not only *velikii* but also beloved by all.

The first Stalin prizes in art were awarded in early 1941 for works dating from 1934 to 1940. Prizes were given by theme and by genre. There were five themes: Stalin, Lenin, comrades of the leader, workers, and historical themes. In 1941, first prizes were awarded to four works about Stalin, one about Lenin, two about comrades, one about workers, and two about historical themes.[143] Lenin remained an object of veneration through the 1930s and 1940s, but his star grew steadily smaller and dimmer next to Stalin's.

STALIN'S TWO BODIES

According to the Bolshevik "mystic fiction," Stalin the *vozhd'* inherited superhuman qualities of immortality, infallibility, and perfectibility from Lenin. Words and images connecting Stalin to Lenin served to reinforce this connection. But sometimes Stalin appeared in political posters without Lenin. Such posters were relatively rare before 1932.

The earliest poster of this type that I have located appeared in 1929. "Stalin sredi delegatok" (Stalin among the Female Delegates) was created by N. I. Mikhailov, an artist affiliated with the Association of Artists of the Revolution (AKhR). This organization was dedicated to the proposition that artists must depict the events of the revolution, the leaders and participants, and especially ordinary people: the workers and peasants. The poster shows Stalin seated at a table, assisting, in a kindly manner, the peasant women who surround him. The poster belonged to a series put out by AKhR that included such titles as "Kalinin sredi uzbekov" (Kalinin among the Uzbeks), "Krest'iane u Lenina" (Peasants Visiting Lenin), and "Krest'iane u Kalinina" (Peasants Visiting Kalinin).[144]

The following year, the well-known Soviet satirist Deni designed a poster with an image of Stalin. "Trubka Stalina" (Stalin's Pipe), a pencil drawing, depicts Stalin smoking a pipe.[145] A curl of smoke envelops the enemies—a wrecker, a kulak, and a Nepman—who are being blown away by Stalin.[146]

The representation of Stalin took a new turn 1931, with the publication

of an official portrait of the leader issued in an edition of 150,000 copies.[147] Created by Isaak Brodskii, an artist who had already established his reputation as an official painter of Lenin, the portrait depicts Stalin standing behind a table, his hands resting lightly on the table top, where a newspaper has been placed (fig. 4.14).[148] He wears a dark, military-style tunic and looks directly at the viewer with a serious but sincere gaze. Stalin's name (including patronymic) appears beneath the portrait. When Gerasimov's portrait of Lenin was issued as a poster the following year, it appeared in an edition of only 25,000.[149]

Although there were many subsequent images of Stalin in painting, sculpture, and political art, Brodskii's portrait is an important early example of the visual effort to depict Stalin the man—the "mortal body"—and the leader who, in later representations, patted small children, shook hands with collective farmers and workers, smoked a pipe, and was pleasantly avuncular. The image of Stalin as a kind and unpretentious figure—a simple man of the people—was carefully cultivated in political art of the Stalin era.

Klutsis, always finely attuned to the nuances of Staliniana, produced a poster in 1931 that pointedly accentuated Stalin's human and comradely qualities. In "Real'nost' nashei programmy—eto zhivye liudi, eto my s vami" (The Reality of Our Program Is Living People, You and I), Stalin strides alongside marching coal miners (fig. 4.15).[150] Looking unpretentious in a cap, overcoat, and high boots, one hand thrust in his pocket, he is depicted as the quintessential man of the people. It is fascinating to note that one of Klutsis's sketches for this poster depicted Stalin as much larger than the coal miners, a device that the artist used effectively in posters created from 1932 on.[151]

The poster marked a major point along the path toward a new sacred center. The appearance of Stalin alongside coal miners signaled the beginning of a process whereby the heroic proletariat was gradually displaced by Stalin. As Margaret Tupitsyn has argued, "a hitherto anonymous worker is now joined by a concrete image of the political leader, and the Five Year Plan's anonymous slogans are replaced by a statement signed by Stalin . . . we see [in this poster] the first steps of the state's encroachment upon the proletariat's position as the ultimate author of the socialist reconstruction."[152]

"Real'nost' nashei programmy" and other posters like it are note-worthy because they accentuate Stalin's mortal body. But the image of Stalin that developed in the 1930s was highly complex, and artists understood that the representation of the leader required vivid depiction of the leader's two bodies. Accordingly, artists searched for new and compelling ways to portray the leader's "other body"—the immortal and infallible Stalin, who was increasingly the object of extravagant verbal praise and whose deification posed challenging artistic problems.[153] How, in essence, to portray a living god?

One strategy was to show Stalin in his many guises: Stalin the great revolutionary; Stalin the Lenin of today; Stalin the great statesman, *vozhd'* and teacher; Stalin the wise master (*khoziain*) of the country and the father of his people; Stalin "the wisest of men."[154] Certain artistic devices found favor among artists and critics. One of these was the magnification of Stalin relative to other people and things. Perspectival distortion had a considerable history in Soviet political art; the artist who forged a new path in the creative application of this device for the glorification of Stalin was Klutsis.

In several 1932 posters of Stalin, Klutsis made highly effective use of perspectival distortion. We have already noted the large-than-life depiction of Stalin in "Pobeda sotsializma" (fig. 4.12). This and other posters like it—for example, "V kontse piatiletki kollektivizatsii SSSR" (At the End of the Five Year Collectivization of the USSR)[155]—emphasize Stalin's role in the economy. The latter poster features a photograph of a larger-than-life Stalin looking off into the distance. He has a magisterial demeanor and overwhelming presence.[156] A contemporary reviewer of this poster approved of Klutsis's image of Stalin and its centrality in the composition, but he was sharply critical of the artist's failure adequately to connect the leader and the masses.[157]

The issue of Stalin's relationship to the masses figured importantly in reviews of Stalin posters. We have seen that the crowd became a critical element in the representation of the *vozhd'* after Lenin's death. Critics of political art in the 1930s devoted a good deal of attention to this issue when they analyzed posters that included images of Stalin. More often than not, they registered their dissatisfaction. This is what happened to a 1934 poster by Deni and Dolgorukov, "Da zdravstvuet leninskaia

VKP(b), organizator pobedonosnogo sotsialisticheskogo stroitel'stva" (Long Live the Leninist VKP(b), Organizer of the Victorious Socialist Construction).[158] Published in an edition of 175,000, the poster shows a full-face drawing of Stalin held aloft by five arms. Flags and industrial scenes fill the background. The reviewer, V. Kalugin, was indignant: "In order to show Comrade Stalin as the *vozhd'* of the masses, as the genius leader, as the active participant in socialist construction (it is not for nothing that the toilers of the land of soviets call their *vozhd'* 'the best shock worker,' 'the best *kolkhoznik*'), the artists raise him above the masses and juxtapose them. The masses are deprived of class character, depersonalized in the direct sense of the word (the depiction of the masses is given only in the form of raised arms)."[159]

By contrast, a 1934 poster by Iosif Gromitskii, "Da zdravstvuet velikoe i nepobedimoe znamia Marksa, Engel'sa, Lenina" (Long Live the Great and Invincible Banner of Marx, Engels, and Lenin), elicited favorable comment from reviewers.[160] Issued by Izogiz in a relatively small edition of 10,000, the poster has an image of Stalin standing at a podium before a microphone, where he appears to be pronouncing the phrase noted above; another long quotation follows urging people to work harder. To the right of Stalin is a group of joyful demonstrators holding a flag with the inscription: "Da zdravstvuet nash velikii vozhd' t. Stalin!" (Long Live Our Great *Vozhd'* Comrade Stalin!). A reviewer commented: "We see in this poster the politically deep and correct attitude [of the working people] and the constructive behavior naturally arising from it."[161]

The term *velikii vozhd'*—*velikii* means great, mighty, exalted—was indicative of the hyperbolic language that appeared with increasing frequency in political posters glorifying Stalin.[162] A 1936 poster by Roziakhovskii, "Da zdravstvuet tvorets konstitutsii" (Long Live the Creator of the Constitution), was issued in an enormous edition of 250,000.[163] Given the size of the press run, the poster must be considered a major propaganda statement for that year. A drawing of Stalin nearly in profile against a red background fills the upper half of the poster. Below, in large letters, follows the text in bold black letters: "Da zdravstvuet tvorets konstitutsii svobodnykh, schastlivykh narodov SSSR, uchitel' i drug trudiashchikhsia vsego mira, nash rodnoi Stalin!" (Long live the

creator of the Constitution of the free and happy peoples of the USSR, the teacher and friend of laboring people of the whole world, our *rodnoi* Stalin). The term *rodnoi* shares common etymology with *rodina*—motherland. The root *rod*- serves as the basis for a number of terms, all implying a blood kin relationship, as in *rod,* blood kin, family, birth; *rodit',* to give birth; *roditeli,* parents; *rodstvenniki,* relatives, family relations; *rodnoi,* of blood kin, dear, beloved, closely related. The application of the adjective *rodnoi* to Stalin therefore implied a familial relationship between him and the population—in this case, the relationship between a father and his children.

Otets (father) was one of the many designations applied to Stalin in the course of the 1930s.[164] Among other connotations, *otets* was a term used to address a priest. The association did not, of course, escape contemporaries and was part of a general trend toward the appropriation and assimilation of key aspects of Russian Orthodox tradition. As Moshe Lewin has put it:

> In the course of the supposedly Marxist crusade against the "opiate of the people," the whole spiritual climate of the system showed signs of succumbing to some of the age-old currents of the Russian Orthodox civilization, absorbing some of its not necessarily most inspiring values. The traditional devotion to and worship of icons, relics of saints, and processions was apparently being replaced by a shallow imitation of iconlike imagery, official mass liturgy, effigies, and especially, processions and pilgrimages to the mausoleum sheltering an embalmed atheist.[165]

The immortalization of Lenin was surpassed in the 1930s by the veneration of Stalin, reminiscent in its form and content of the adoration of the Savior himself. Among Soviet political artists, Klutsis created some of the most striking and original posters of Stalin. His 1936 poster, "Kadry reshaiut vse" (Cadres Decide Everything), exemplifies the aggrandizement of Stalin (fig. 4.16).[166] The poster consists of two parts, each of them the size of a normal poster. The upper part shows a larger-than-life Stalin from the hips up, with his right arm raised and palm forward, a polyvalent gesture that might have been interpreted as

a greeting, an acknowledgment, or a benediction. The position has a strong resemblance to the posture of Christ and various saints in some icons of the Russian Orthodox church.[167] Like Christ in many icons, Stalin is posed against a red background. He is surrounded by smiling men and women (in a photomontage) bearing flowers.

The lower part of the poster is equally remarkable. It begins where the upper part ends, that is, with Stalin's hips. He is shown striding forward in black boots, with his long military coat extending down to the top of the boots. His left hand is visible by his side. In this portion of the poster he is truly a Gulliver among Lilliputians. The joyful marchers (by 1936 *emphatically* joyful) with red banners are minuscule in comparison with Stalin's boots, and with one stride forward he could easily crush them all.[168]

Stalin occupied a central place in the campaign of the 1930s to celebrate individual heroes. As we saw in chapter 1, heroes in production (industrial and agricultural) were soon superseded by new kinds of heroes, including aviators, athletes, explorers, and others who performed remarkable feats. Political art of this period conveyed the message that Stalin was not only the greatest hero of all but also the talisman for other Soviet heroes. By contagious magic, that is, by their association with the great leader, ordinary individuals attained the inspiration, talent, endurance, and courage needed to achieve heroic feats.

Some posters of this type spell out the message unambiguously. We have already noted the strategic placement of Stalin's image between two *kolkhoznitsy* in Natal'ia Pinus's 1933 poster, "Zhenshchiny v kolkhozakh—bol'shaia sila" (Women in the Collective Farm Are a Great Force) (fig. 3.11).[169] Similarly, Iurii Tsishevskii's 1935 poster, "Shire riady stakhanovtsev sotsialisticheskikh polei!" (Expand the Ranks of the Stakhanovites of the Socialist Fields!), featured the Stakhanovite Mariia Demchenko, while an image of Stalin hovered above her (fig. 3.12). He is shown reading an issue of *Pravda* with Demchenko's letter promising the *vozhd' naroda* (leader of the people) to exceed the harvesting norm.[170] This poster had a press run of 200,000, one of the largest of 1935.

A series of similar posters followed: Stakhanov carries a red flag that bears an image of Stalin's face (fig. 1.17); a red banner with Stalin's pro-

file is held aloft by a woman athlete in a bathing suit on a motorcycle; three aviators smile as Stalin looks down on them benignly; a banner with Stalin in partial profile flies above the Moscow-Volga canal; a red banner with Stalin's profile arches above a statue of the generic male and female collective farmers.[171] Posters with this theme continued to be produced in the years following World War II.

The extraordinary adulation of Stalin reached a climax in August 1939, with the opening of Moscow's All-Union Agricultural Exhibition (VSKhV). Situated on a 600-acre site north of Moscow, the exhibition included pavilions representing the agricultural achievements of each of the republics and regions of the USSR. With its emphasis on various national republics rather than social classes, the exhibition anticipated the imperial ethos of the post–World War II years. VSKhV functioned from the beginning as a showcase for the Stalin cult, indeed, as *the* showcase for the country and world. Stalin's remarkable symbolic presence in the exhibition has been described by Jamey Gambrell:

> [Stalin's] image, like his name, was omnipresent. . . . His sayings on every subject from dialectical materialism to sheep raising were incised on the exterior and interior walls of the pavilions. Tractors, combines, and kolkhozes bore his name. White plaster statues of his fatherly figure were placed at the center of altar-like constructions in every pavilion. In the Far East Pavilion he could be seen in Napoleonic pose against a painted backdrop of airplanes flying over the Kremlin. In Belorussia he walked with Lenin; in Uzbekistan they sat on a bench together; in Kazakhstan Kazakh farmers and shepherds knelt at his feet. Most imposing of all was the hundred-foot-high concrete statue of Stalin by the sculptor Merkurov that towered over the central "Plaza of the Mechanization of Agriculture," dwarfing the tallest pavilions.[172]

An exhibition at Moscow's Tretiakov Gallery, "Stalin and the Soviet People" (later reproduced in an album), also took place in 1939. Designed for workers' clubs, collective farms, and factories, these paintings glorified the leader's life, from his early childhood to the present. Some, such as N. Grzelishvili's *Comrade Stalin in His Early Years,* with the

young Stalin expounding his ideas to an admiring crowd, may have reminded viewers of religious icons showing the life of Christ in its various phases.[173] The association (visual and verbal) between Stalin and Christ was scarcely a novelty in the late 1930s. "Icons" of Stalin had become a familiar part of public life.

By December 1939, when the country celebrated Stalin's sixtieth birthday, several notable events had taken place. The mass terror of the preceding years had begun to subside and several thousand people had been released from custody; Stalin had unveiled his ten-year non-aggression treaty with Hitler and had begun a war against Finland. Stalin's birthday on December 21 elicited a great outpouring of accolades to the beloved *vozhd'*, "the great engine-driver of history's locomotive."[174] Posters issued in 1939 set the tone for public adulation. One of them proclaimed: "Stalin—the wisest of men—is closer to you than your beloved father. With bright rays he shines on children of all peoples, all tribes."[175]

Viktor Govorkov's compelling poster of Stalin, "O kazhdom iz nas zabotitsia Stalin v Kremle" (Stalin in the Kremlin Cares about Each One of Us), appeared in 1940 in an edition of 100,000 copies (fig. 4.17).[176] Illuminated by the soft glowing light of a table lamp, Stalin sits at his desk with pen in hand, appearing deep in thought as he writes. The darkness outside the window indicates a late-night hour, bolstering the popular mythology of Stalin as a tireless leader who worked far into the night. A silhouette of the Kremlin Tower with its bright star frames his image. The simplicity of the poster and its familiar symbols (the star, the light) served as reminder that Stalin, the "great engine-driver," was also a compassionate and benevolent leader. The leader's two bodies were alive and well in the Kremlin.

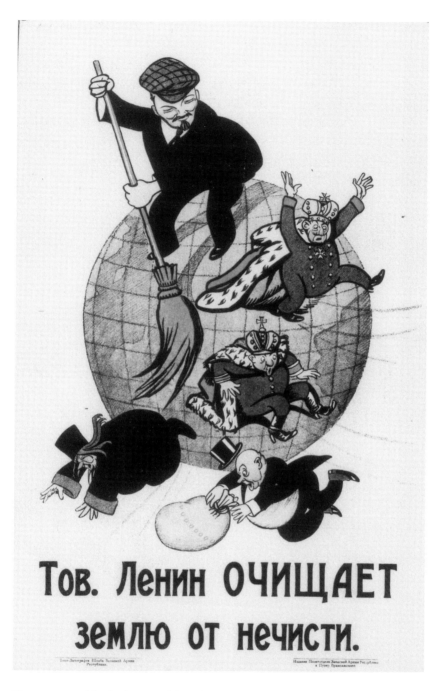

Figure 4.1. Mikhail Cheremnykh and Viktor Deni, "Tov. Lenin ochishchaet zem-liu ot nechisti" (Comrade Lenin Cleanses the Earth of Scum), 1920

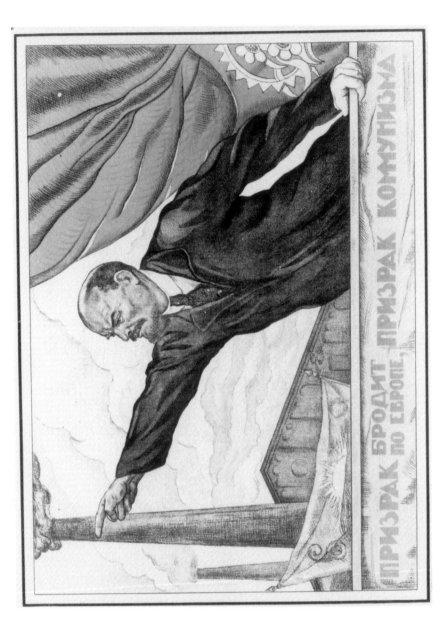

Figure 4.2. "Prizrak brodit po Evrope, prizrak kommunizma" (A Specter Haunts Europe, the Specter of Communism), 1920

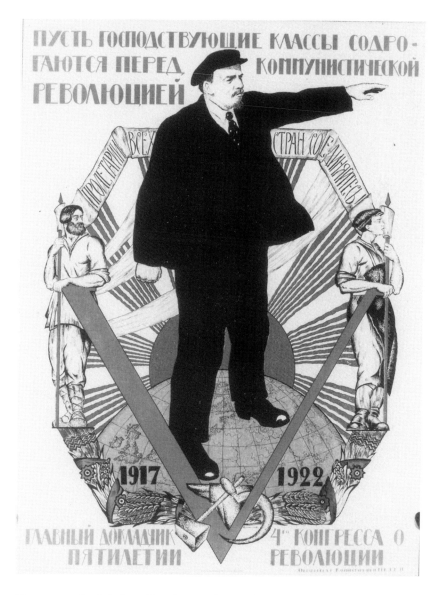

Figure 4.3. A. Sokolov, "Pust' gospodstvuiushchie klassy sodrogaiutsia pered kommunisticheskoi revoliutsiei" (Let the Ruling Classes Shudder before the Communist Revolution), 1922

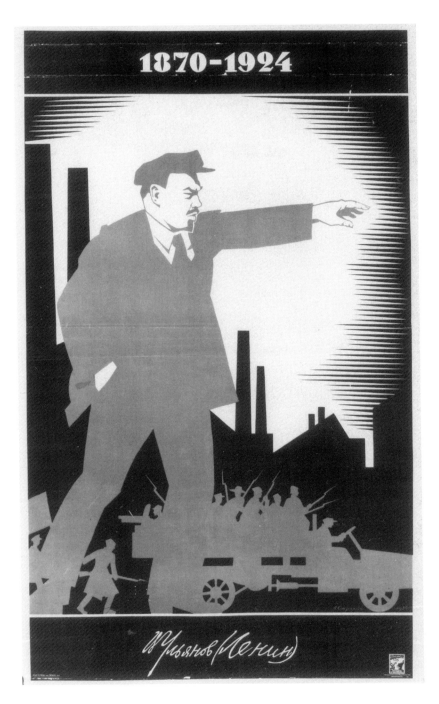

Figure 4.4. Adolf Strakhov, "1870–1924 V. Ul'ianov (Lenin)," 1924

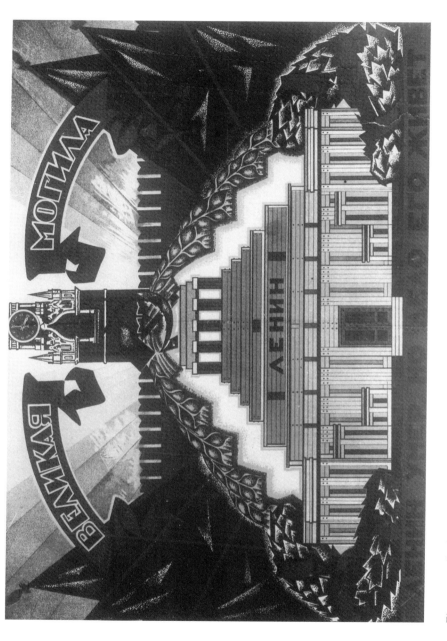

Figure 4.5. "Velikaia mogila" (The Great Tomb), 1924 or 1925

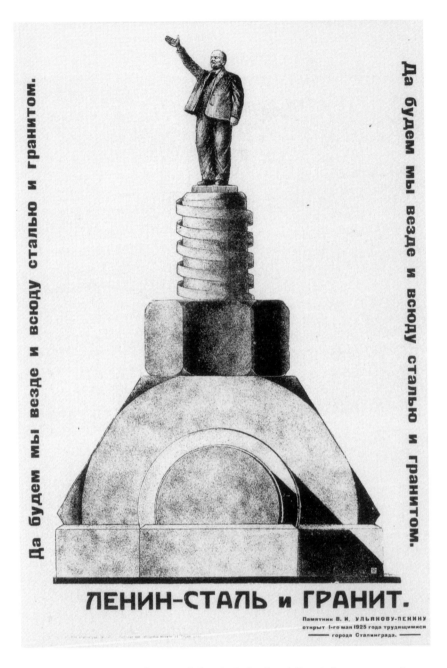

Да будем мы везде и всюду сталью и гранитом.

Да будем мы везде и всюду сталью и гранитом.

ЛЕНИН—СТАЛЬ и ГРАНИТ.

Памятник В. И. УЛЬЯНОВУ-ЛЕНИНУ
открыт 1-го мая 1925 года трудящимися
города Сталинграда.

Figure 4.6. "Lenin—stal' i granit" (Lenin Is Steel and Granite), 1925 or 1926

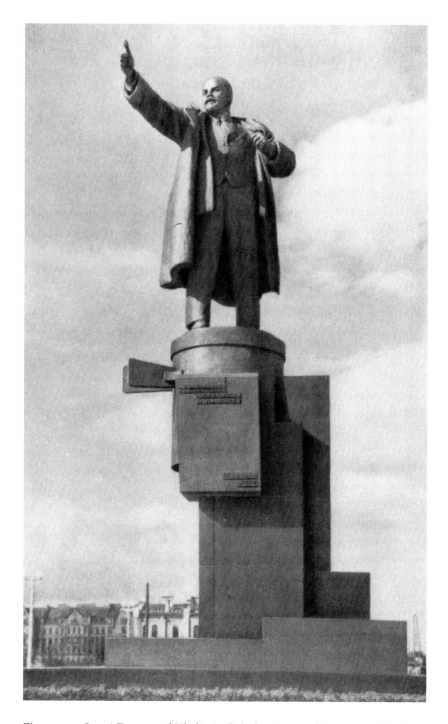

Figure 4.7. Sergei Evseev and Vladimir Shchuko, Statue of Lenin at Finland Station, Leningrad, 1926

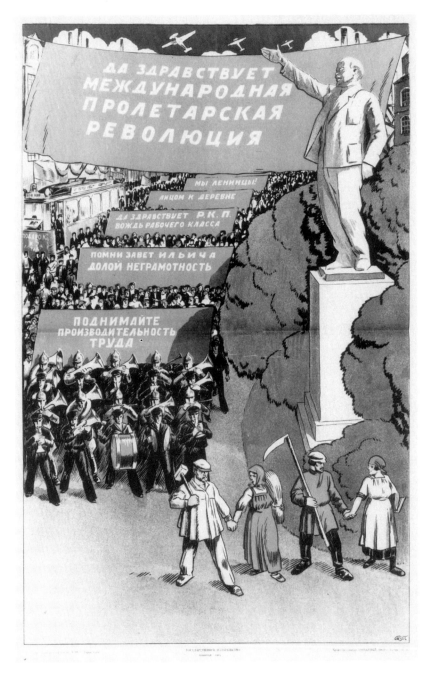

Figure 4.8. "Da zdravstvuet mezhdunarodnaia proletarskaia revoliutsiia" (Long Live the International Proletarian Revolution), 1925

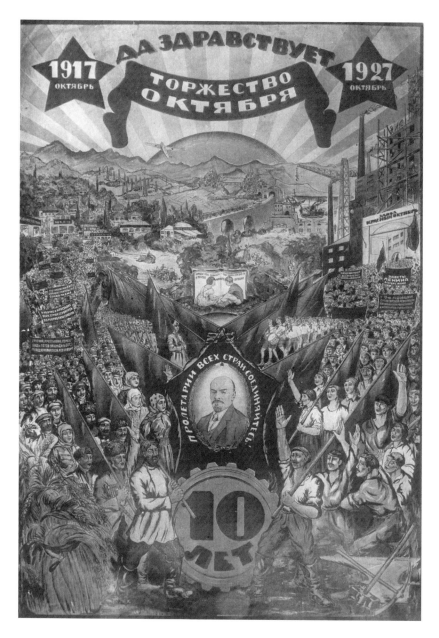

Figure 4.9. "Torzhestvo oktiabria" (Celebration of October), 1926

Figure 4.10. Aleksandr Gerasimov, "Vladimir Il'ich Lenin (Ul'ianov)," 1930

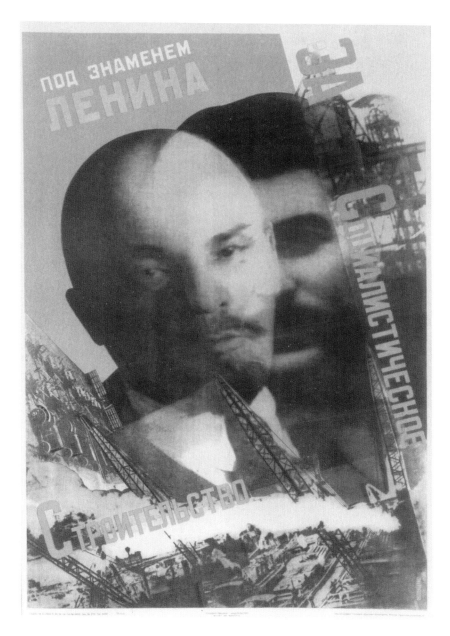

Figure 4.11. Gustav Klutsis, "Pod znamenem Lenina za sotsialisticheskoe stroitel'-stvo" (Under Lenin's Banner for Socialist Construction), 1930

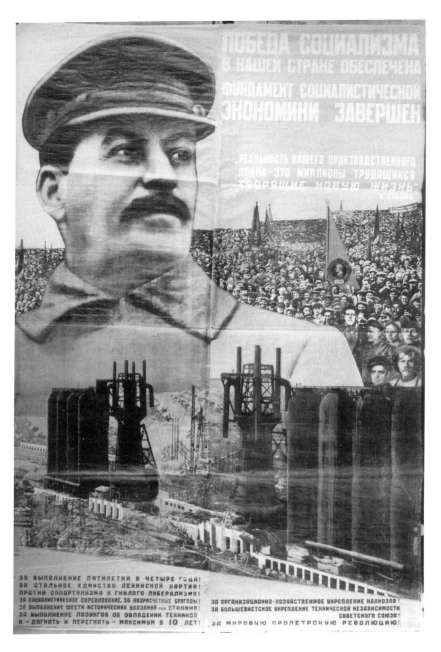

Figure 4.12. Gustav Klutsis, "Pobeda sotsializma v nashei strane obespechena" (The Victory of Socialism in Our Country Is Guaranteed), 1932

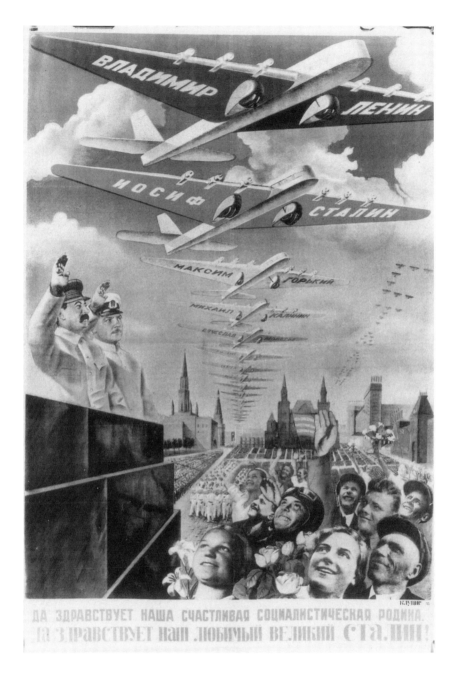

Figure 4.13. Gustav Klutsis, "Da zdravstvuet nasha schastlivaia sotsialisticheskaia rodina" (Long Live Our Happy Socialist Motherland), 1935

Figure 4.14. Isaak Brodskii, "Iosif Vissarionovich Stalin," 1931

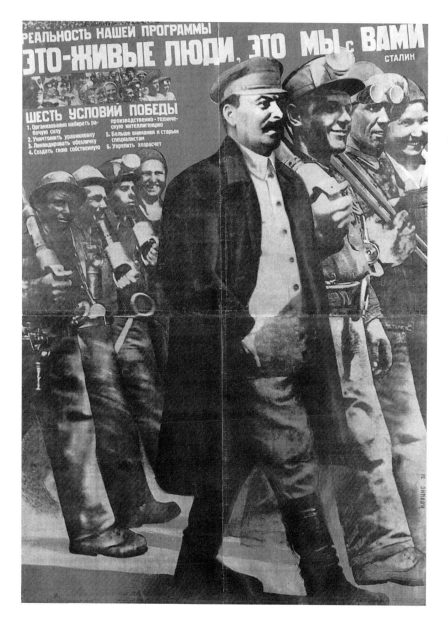

Figure 4.15. Gustav Klutsis, "Real'nost' nashei programmy—eto zhivye liudi, eto my s vami" (The Reality of Our Program Is Living People, You and I), 1931

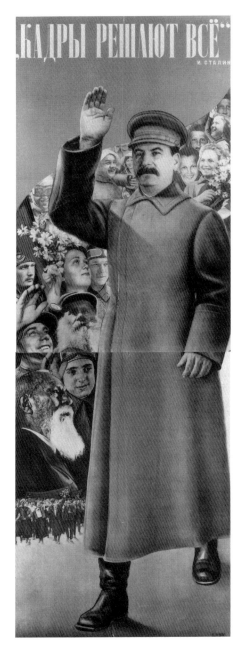

Figure 4.16. Gustav Klutsis, "Kadry re-shaiut vse" (Cadres Decide Everything), 1936

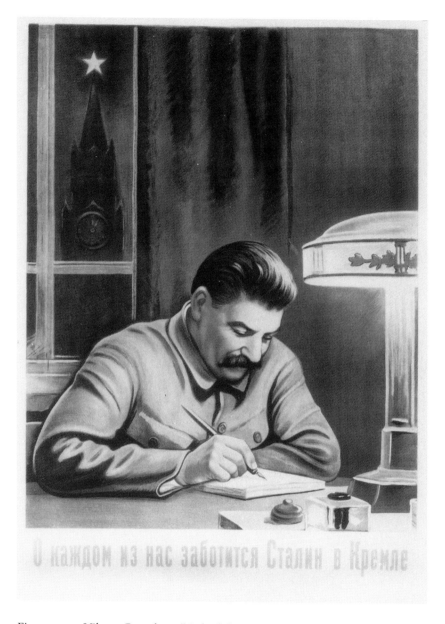

Figure 4.17. Viktor Govorkov, "O kazhdom iz nas zabotitsia Stalin v Kremle" (Stalin in the Kremlin Cares about Each One of Us), 1940

Five

BOLSHEVIK DEMONOLOGY
IN VISUAL PROPAGANDA

IN A WELL-KNOWN ESSAY, "Binary Models in the Dynamics of Russian Culture," Iurii Lotman and Boris Uspenskii argue that pre–nineteenth-century Russian culture was built around "a polarity expressed in the binary nature of its structure. The basic cultural values (ideological, political, and religious) of medieval Russia were distributed in a bipolar field and divided by a sharp boundary without an axiologically neutral zone."[1] In medieval Russia, this "accentuated duality" produced a set of binary opposites: heaven versus hell, holy versus sinful, divine versus diabolical, old versus new, Christianity versus paganism, Russia versus the West, and true faith versus false faith.[2]

Many centuries later, the Bolsheviks came to power with a worldview that also relied on a binary model of thinking. For them, all societies consisted of two basic groups: the collective and individual heroes who advanced the march of history toward a classless society, and their adversaries, the villains or enemies—*vragi*—who tried to prevent the great march forward. The disposition to see the world in terms of dualisms was reinforced by the Civil War. After seizing power in 1917, the Bolsheviks witnessed a rapid polarization of political forces in the country, a situation that soon led to brutal and protracted military conflict accompanied by foreign intervention. From the perspective of Bolshevik party activists, the events confirmed their basic assumption that internal and external enemies were inextricably linked and that, in the final analysis, everyone would line up on one side of the barricades or the other in the world revolution.

The binary model that shaped the Bolsheviks' structure of thinking came from two sources. The ideas of Marx and Engels, especially their relentless emphasis on the historical role of class and class struggle, provided intellectual support for the basic dualism in Bolshevik ideology. But the Bolshevik outlook also owed a great deal to the bipolar orientation in traditional Russian culture. Like their medieval precursors, the Bolsheviks were deeply rooted in a framework of antinomies, and

they organized their conception of the world around such diametric opposites as the bourgeoisie versus the proletariat, tsar versus people, kulak versus poor peasant, and White versus Red. Correspondingly, they showed little tolerance for ambiguities (an "axiologically neutral zone"). Social categories that occupied an uncertain and intermediate position, such as the middle peasantry or the intelligentsia, caused considerable ideological discomfort in their ranks and were eventually absorbed into the framework of a binary model.

CLASSIFYING THE ENEMY DURING THE CIVIL WAR

When the Bolsheviks launched their first campaign of visual propaganda in the summer of 1918, they were acutely aware of the urgent need to convey their ideas to a vast, semiliterate population. The challenge facing them was to give people a clear and unambiguous picture of the heroes and villains of the revolution. As we have seen, Lenin's project on monumental sculpture, conceived in the spring of 1918, was intended to celebrate "saints" in the Bolshevik pantheon.[3] The task of sacralizing dead heroes presented the Bolsheviks with many problems, but none could compare to the difficulties in representing enemies of the revolution—enemies who were alive and very much part of contemporary life.

The second political poster issued by the Bolsheviks in the summer of 1918 attempted to give precise coordinates for three key figures in Bolshevik demonology. This poster, created by an anonymous artist and entitled "Tsar', pop i kulak" (Tsar, Priest, and Kulak) (fig. 5.1),[4] was issued in many different versions designed for particular national and ethnic populations. The lengthy text that accompanies the rather primitive drawing exhorts "comrade peasants! the peasant poor" to take heed of kulaks and priests who were uniting against the soviets and in support of the tsar because they feared poor peasants.

From the point of view of iconography, the poster provides a remarkable illustration of iconographical experimentation in representing two social groups designated as leading "enemies" of the revolution: the kulak and priest. Whereas the image of the tsar remains constant in

various versions, the representation of the priest and the kulak shifts, depending on the subpopulation that is addressed.

The label "kulak," literally, "fist" (a reference to tight-fisted practices of the more prosperous peasants who were usurers or employers of labor), had acquired wide currency in 1917 in connection with the food supply crisis.[5] In 1918, there was not yet a single standardized image of the kulak in the Bolshevik visual lexicon. Thus, he appears in one version of the poster wearing a top hat, fancy evening clothes, and a gold watch chain—attributes that were also associated with the capitalist. In other versions, he has a black hat, jacket, and tie and appears decidedly less affluent. The Russian-language version of the poster depicts the kulak as a rather scruffy figure with a cap. Facial hair varied along with headgear in these representations. Whereas the kulak-cum-capitalist had sideburns and a mustache, the kulak with a cap sported an unkempt mustache, beard, and rather long hair. It was the latter version that soon became standardized in Bolshevik propaganda. Subsequent elaborations of the image added several other details: a vest and/or a Russian shirt, boots, sometimes a coat, a watch fob, and striped pants. The basic elements of the kulak image found in the Russian-language version of this early Bolshevik poster remained constant throughout the years that followed and were still utilized well into the 1930s, when finally the figure of the kulak ceased to be included in the litany of "enemies of the people."

The images of the priest presented in the 1918 poster proved less permanent. In "Tsar', pop i kulak," he is depicted in various ways: as a Roman Catholic priest with a skull cap and no facial hair, as a Russian Orthodox priest with a long flowing white beard or a short dark beard and eyeglasses. In all versions he has a fiendish expression and a large cross around his neck.

These representations evidently proved unsatisfactory to contemporary Bolshevik artists, who continued to experiment with the image of the priest throughout 1919 and 1920, finally settling on the image of a corpulent bearded man wearing black sacramental vestments and with an expression more often foolish than fiendish.[6] The visualization of the priest in Bolshevik propaganda has much in common with

paintings of clergy by Vasilii Perov, a nineteenth-century Russian realist painter whose anticlericalism found expression in such well-known works as *The Refectory* (1865–1876) and *The Peasant Procession at Easter* (1861).[7] *The Refectory,* in particular, provides a gallery of unflattering images of monks; the figure in the very center of the painting bears close resemblance to the Bolshevik satirical image of the rotund, self-satisfied, and greedy priest later popularized by such masterful artists as Dmitrii Moor and Viktor Deni.

In the early months of Bolshevik power, the list of enemies singled out in visual propaganda remained relatively limited. Apart from the tsar, priest, and kulak, there was the tsar's entourage (officials, officers, etc.), the "bourgeoisie of all countries," the German Kaiser, and the leaders of the Entente. As the Civil War progressed, the list of enemies—both individual and collective—grew longer. A survey of 200 posters and holiday displays that appeared between 1918 and 1921 has turned up references to more than fifty separate enemies, designated by word and/or image.

Virtually all are male. My research has uncovered only two female personifications of enemies, and in each case, the female image represented an abstraction. In Apsit's famous 1918 poster, "Internatsional" (International), a gigantic and grotesque female figure reposes on a pedestal labeled "capital" (fig. 2.7). She is a fleshy female with large pendulous breasts, a serpentine tail, wings, and horns. During the May Day celebration in 1920, Sarra Lebedeva prepared two sketches for a tram carrying a mobile theater group. One sketch, "Ruination," shows a slender female figure with hair and clothes in disarray, arms raised, and legs spread apart in a sexually suggestive position.[8] Occasionally, posters presented unflattering images of the peasant woman—the *baba*—who foolishly assists the enemy (fig. 2.14). But as we have seen, the *baba* was an ambiguous figure, sometimes placed in the company of male heroes of the revolution. The almost complete absence of females in Bolshevik demonology is noteworthy in light of the importance of the figure of Baba Yaga in Russian folklore. This complex female figure, with highly variable forms and functions, was often cast in the role of a witch who performed evil deeds and was associated with serpentine dragons, eagles, ravens, crows, and other creatures connot-

ing wickedness and misfortune.[9] Throughout the 1920s and the Stalin era that followed, individuals and collectivities designated as enemies in political posters were exclusively male.

In Soviet demonology, enemies were divided into two basic categories: those residing within the territory of the former Russian Empire and those operating abroad. Despite the profound Bolshevik conviction that internal and external enemies were inextricably intertwined, political posters generally distinguished between the two types. External enemies appearing in Civil War visual propaganda encompassed a relatively small group. Specific references can be found to capitalists, the German Kaiser, Clemenceau, Lloyd George, Wilson, Uncle Sam, the Entente, and a few others.

By contrast, the list of internal villains was extensive and detailed. Internal enemies visualized in Civil War propaganda art can be classified in three categories:

I. *Elements from the old regime:* the tsar and his wife, tsarist official, tsarist general, tsarist policeman, priest, rabbi, mullah, landowner (*pomeshchik*), high nobility (*boiarin*), kulak, capitalist (*burzhui*),[10] merchant, factory owner, banker, speculator, pogrom maker (*pogromshchik*)

II. *Political opponents:* Menshevik, Socialist Revolutionary, anarchist, White Guard general, Kadet, Viktor Chernov, Anton Denikin, Nikolai Iudenich, Aleksei Kaledin, Aleksandr Kerenskii, Aleksandr Kolchak, Lavr Kornilov, Petr Krasnov, Nestor Makhno, Petr Wrangel, Joseph Pilsudski, Vladimir Purishkevich, Pavel Skoropadskii

III. *Workplace and other villains:* sponger (*tuneiadets*), loafer (*lodyr'*), shirker (*progul'shchik*), plunderer (*khishchnik*), parasite (*parazit*), bagman (*meshochnik*), traitor (*predatel'*), deserter (*dezertir*), sleuth (*shpik*)

The first category includes people whose position under the old regime was considered reprehensible. Some had occupied posts in the tsarist government or belonged to the Russian nobility; others had

engaged in economic activity that the Bolsheviks despised because of its capitalist nature (e.g., *burzhui,* merchants, factory owners, bankers, speculators, landowners, kulaks); another group represented organized religion (priests, rabbis, and mullahs). In the weeks and months following the October Revolution, the Bolsheviks formulated harsh policies to deal with some of the groups in this general category, who were described variously as *klassovo-chuzhdye elementy,* or class aliens, *byvshie liudi,* or has-beens (literally, "former people"), *lishentsy,* or disenfranchised individuals, or simply *vragi,* that is, enemies.

The 1918 Constitution of the Russian Soviet Federated Socialist Republic (RSFSR) disenfranchised a broad spectrum of the population: "those who employed hired labor to extract profit; persons living on nonlaboring income such as interest from capitalist investments or returns from property; private traders and commercial middlemen; monks and clerics; employees and agents of the former police, corps of gendarmes, or Okhrana; members of the ruling house; the mentally ill, the insane, and persons under guardianship; and persons convicted for crimes of greed and depravity."[11] People in these categories, collectively labeled the *lishentsy,* were also subject to a multiplicity of civil and social disabilities. Their property was subject to confiscation, and they were excluded from the rationing system, cooperatives, and public office. They "paid much higher bills than the rest of the population for utilities, rent, medical care, schooling for their children, and public services."[12] The authorities made no distinction between individuals in this category and members of their families. In fact, the official approach to this group of people was genetic, since the class defect could not be removed by repentance or good deeds and family members were likewise considered unredeemable.

The second category, "political opponents," includes a variety of groups and individuals who acted in opposition to the Bolsheviks prior to 1917 or during the Civil War. White Army generals and other leaders of the anti-Bolshevik forces in the Civil War fell into this category as well as Mensheviks and Socialist Revolutionaries (SRs). Unlike those in the first category, who were considered unredeemable and deprived of citizenship, some of those in the second category could "convert" to

Bolshevism and reclaim their rights as citizens. Accordingly, Mensheviks, SRs, and others were permitted to repudiate their former political allegiances, cooperate with the new Soviet regime, and even join the Bolshevik party. This policy remained in effect until the 1930s, when "anti-Bolshevik" political associations of an earlier period could no longer be effaced by good works.

The third category, "workplace and other villains," includes several different types. There were miscreants in the economic sphere who did not work hard enough (loafers, shirkers) or engaged in activities displeasing to the Bolsheviks (bagmen, parasites [anyone involved in trade or commerce], plunderers [bankers]). In other cases, they were individuals who fled the Red Army or otherwise undermined the military effort. Until the 1930s, many of these people were considered redeemable, given proper guidance and enlightenment.[13]

During the Civil War, the regime created rituals to deal symbolically with those who occupied a place in the new demonology. Elaborate mass spectacles mounted for official holidays invariably included both the heroes and the enemies who played a role in the great march toward Soviet power. Although a carnivalesque spirit characterized many of the holiday celebrations in the early years, sometimes a harsh punitive mood intervened. In 1918, for example, an effigy of the kulak was burned on Red Square, and tsarist regalia were burned at various locations in Moscow, Petrograd, and other cities during holiday celebrations. These practices were still going on in 1920.[14] It was also commonplace to display enemies in "cages" during holiday parades. A Petrograd May Day float in 1919, for example, presented a collection of people—workers dressed up as Whites and undesirable prerevolutionary types—in a cage with the label: "Before they did the biting, now they are frightened."[15] As we shall see, the Bolsheviks had a tendency to dehumanize enemies by recasting them in the form of reptiles, birds, insects, or other animals.

There were many symbolic forms of retribution against enemies, apart from ritual burning and incarceration, that appeared in political posters and holiday displays. These included sweeping the enemy away with a broom,[16] beating the enemy with a club or hammer,[17] piercing

the enemy with a sword or bayonet,[18] severing the enemy's arm or hand with a sword,[19] striking the enemy with lightning,[20] and finally, exposing the enemy—bringing him into public view, where he could be scorned, ridiculed, and punished.

After the Bolshevik revolution, allegorical images provided a major source of inspiration for political artists attempting to depict enemies. Most spectators were already familiar with these symbols, having encountered them in both religious and secular art before 1917. It was commonplace, for example, for propaganda posters issued during World War I to represent the enemy by means of a serpentine creature. The image was particularly rich in associations, calling to mind the popular legend of St. George. The serpent/hydra is a well-known symbol of evil in Christian culture, where Satan has often been represented with "dragon-like features and his limbs . . . entwined with snakes."[21] In "Rossiia—za pravdu" (Russia—for Truth) (see fig. 2.5), a woman in medieval military attire stands on a slain hydra.[22] Another World War I poster, "Vrag roda chelovecheskago" (Enemy of the Human Race), skillfully combines religious and secular themes.[23] Here we see Kaiser Wilhelm II of Germany presented as a devil, complete with a serpentine coil in place of legs; he looms like a giant over cities in France and Belgium, holding skulls in each hand (these cities had been shelled by the Germans despite their heroic monuments). "Drakon zamorskii i vitiaz' russkii" (The Overseas Dragon and the Russian Knight), issued in November 1914, depicts a medieval Russian soldier raising his sword to slay a winged hydra.[24]

The serpent image and the device of distorted perspective remained important elements in the visual vocabulary of Russian artists and spectators after the fall of the autocracy. The serpent/hydra occupied a central position in the poster by Vasilii Seletskii, "Da zdravstvuet sotsial'naia revoliutsiia i demokraticheskaia respublika. Zemlia i volia" (Long Live the Social Revolution and the Democratic Republic. Land and Freedom).[25] This elaborate and highly detailed poster, created sometime

between February and October 1917, includes a hydra inscribed with the words "tsarism," "bureaucratism," "Christianity," and "war."

The serpent/hydra continued to provide one of the most popular allegorical images for representing the enemy during the Civil War. Aleksandr Apsit, formerly a novice monk-illustrator at a church in Mount Athos in Greece and well versed in Christian symbolism, created perhaps the earliest Soviet poster featuring a hydra.[26] "Obmanu-tym brat'iam" (To Our Deceived Brothers), issued in the fall of 1918, depicts a worker with a club battering a bloody hydra, whose multiple heads include the tsar and his entourage (fig. 2.3).[27] Following the pre-revolutionary examples above, many posters with allegorical images also made use of perspectival distortion—a standard feature of religious icons. In Apsit's poster, a giant hydra faces off with an equally giant worker; the enormous proportions of both are highlighted by the mi-nuscule soldiers and industrial landscape in the background. A giant enemy demanded a giant hero.

The hydra figured prominently in celebrations of the first anniver-sary of the revolution. In some cities, such as Voronezh, organizers staged a ceremonial "Burning of the Hydra of Counterrevolution." An enormous effigy was dragged through the streets with two hundred "counterrevolutionaries" towed alongside in cages. After judges sen-tenced the hydra to death, it was burned to the accompaniment of reading from proletarian poets and Walt Whitman.[28]

A few months later, Apsit created another memorable poster, "Inter-natsional" (International) (fig. 2.7).[29] As noted above, this monstrous serpentine female figure depicting capital, seated on a pedestal marked "gold" and surrounded by skulls and corpses, is attacked on all sides by workers with hammers and bare hands. She is much larger and more powerful than they are, and many of her victims lie crushed and blood-ied on the giant slabs that form her pedestal. Intermittently throughout the Civil War, leading Soviet poster artists used the serpent to represent capitalism or imperialism. Moor, for example, created a memorable poster in 1919, "Smert' mirovomu imperializmu" (Death to World Im-perialism), showing a serpent monster wrapped around a tall factory building.[30] Workers in the foreground use bayonets to attack the

monster. Sometimes capitalism appeared in the guise of a monster—usually golden—but without serpentine attributes. In 1919, a giant golden monster appeared in the anonymous poster "Vladyka mira—kapital, zolotoi kumir" (The Master of the World Is Capital, the Golden Idol). A different version was incorporated into a 1920 poster designed in Kiev, "Pravda proti sili, boem proti zla" (Truth against Force, We Fight against Evil).[31]

Other allegorical images that appealed to Soviet artists as a way of representing enemies included the eagle, a natural choice because of its obvious association with the old regime and the Provisional Government (which retained the symbol of the double-headed eagle) as well as the legend of Prometheus. In 1918, an unknown artist in Petrograd designed a poster, "Dobei vraga" (Defeat the Enemy), depicting a young man standing on a rock and grappling with a vicious-looking eagle.[32] An even more dramatic version of this poster was created in 1920 by Petr Kiselis, "Belogvardeiskii khishchnik terzaet telo rabochikh i krest'ian" (The White Guard Beast of Prey Is Tearing the Body of Workers and Peasants to Pieces) (fig. 1.11).[33] Here an eagle attacks a half-naked man, who wields a club against the predator.

The black crow was another familiar image from traditional symbolism, identified with hell and the devil.[34] A poster produced in Rostov-on-Don in 1919 or 1920, "Osteregaites' men'shevikov i eserov" (Beware of the Mensheviks and SRs), shows a large cluster of black crows in the background.[35] The crow is also strategically placed in an anti-kulak poster, "Doloi kulakov iz volostnykh sovetov!" (Down with the Kulaks in the Volost' Soviets).[36] Spiders, with their negative connotation, were used on occasion, either directly or by contiguity, to represent kulaks, *burzhui,* and priests. Traditionally a symbol of shrewdness and cruelty, the spider appeared in several 1919 posters by Viktor Deni, a highly original satirist who soon emerged as one of the leading poster artists of the new Soviet regime.[37]

When called upon to create an image of the White generals who led the battle against the Bolsheviks during the Civil War, political artists sometimes chose animals or birds. Snarling dogs turn up in the widely circulated poster by Deni, "Antanta" (Entente), printed in 1919 (fig. 5.2).[38] Deni presents three White generals, Denikin, Kolchak, and

Iudenich, as vicious salivating dogs on a leash held by Uncle Sam, and figures representing England and France. Canine imagery can be traced back to tsarist World War I posters, in which German soldiers were sometimes portrayed as snarling dogs.[39] Birds are used in Moor's 1919 poster, "Rano ptashechka zapela kak by koshka ne s"ela" (It Is Too Early for You, Bird, to Be Singing—the Cat May Get You Yet), to represent the same trio.[40] Both these posters were issued in editions of 50,000 copies, substantial printings for this period.

Apart from their rich religious and folkloric associations, images such as serpents, eagles, crows, spiders, dogs, and birds performed an important function in Bolshevik political art: they served to dehumanize the enemy, to transform people into nonhuman and often repulsive creatures. The art of representing enemies was, above all, the art of transforming people into something nonhuman and presenting them in a form that legitimated their destruction or, at the very least, their incarceration. A drawing by Deni in 1918 for the journal *Kommunar,* "V zverintse budushchego" (In the Menagerie of the Future), explicitly developed this idea. It placed the tsar, banker, and *belobandit* (White bandit) behind the bars of a cage in a zoo.[41] As we have seen, holiday celebrations during the Civil War sometimes included floats constructed to look like cages containing enemies. In these displays, the distinction between a cage for animals and a cage for enemies was deliberately blurred.

Fanciful allegorical abstractions played an important role in the early years of Soviet political art, but they were seldom used after 1920. By that time, a new type of image of villains, rooted in the use of satire, was replacing allegorical figures drawn from pagan and Christian sources.[42] Like allegory, satire had already made an appearance in Russia before 1917. Some eighty-nine satirical journals were published during the nineteenth century, but many were censored and proved to be quite short lived.[43]

The Russo-Japanese War in 1904 and 1905 prompted the authorities to take an interest in political art for the first time. In an effort to encourage support for the war effort, the government permitted the publication of a number of satirical posters. One such poster, "Posidim u moria, podozhdem pogody!" (Let Us Sit by the Sea and Wait for the

Right Weather!), probably issued in 1904, shows a giant Russian peasant—a bearded man with a fur hat and boots—sitting on the territory of Manchuria and holding a cannon in his arms as he looks down, with a smile, on the relatively puny figures representing Japan, America, and England (fig. 5.3).[44] We see here some of the visual conventions that became standard in later satirical political posters: the use of perspectival distortion to diminish the size of enemies and aggrandize their Russian (later Soviet) opponent, and a brief text that uses irony to achieve its effect.

It took the revolution of 1905 to unleash the tremendous satirical potential in Russian political art. During the brief interlude between 1905 and 1907, when a relatively free press emerged for the first time in Russia, 249 new satirical journals were published, containing about 3,000 satirical cartoons.[45] What made these satirical publications so distinctive was their critical stance toward the tsarist government.[46] Trenchant caricatures appeared in the pages of these journals, some of them by major contemporary artists or younger men, such as Moor, who would soon become prominent Soviet poster artists.[47] During World War I, Moor continued to turn out strikingly original satirical drawings for journals such as *Budil'nik.*[48] Some of his satirical drawings were circulated in poster form.[49]

Tsarist authorities encouraged artists to make use of the satirical *lubok* to disseminate effective wartime propaganda. As discussed in chapter 2, a group of Moscow artists lent their talents to a government-sponsored printing house, Contemporary Lubok, set up to produce patriotic propaganda.[50] Following the pattern of folk art, these artists used satirical images to tell a story in a single frame. Kazimir Malevich's pro-war *lubok,* "Shel avstriets v Radzivily" (The Austrian Soldier Marched to Radzivily) (fig. 2.13), illustrates this approach. Here a peasant woman—portrayed humorously as a rotund figure in bast shoes—impales a miniature Austrian soldier with a pitchfork. To "read" this poster is to grasp the story that the artist tells about a simple but clever peasant woman who outwits the soldier and his bayonet. The brief text of this poster is critical for understanding the narrative.

During the Civil War years, the satirical *lubok* was also used by So-

viet artists, especially those who participated in the creation of Rosta Windows. "Rosta" was the name of the Russian Telegraph Agency, established in September 1918.[51] Beginning in the spring of 1919, Rosta began to issue a wall newspaper designed to convey the latest developments graphically and in an eye-catching manner. In Moscow, the satirical artist Mikhail Cheremnykh was among the very first to participate in the production of Rosta posters that were hung in the windows of shops and on walls of public buildings. He was soon joined by the writer and artist Vladimir Maiakovskii, the artist Ivan Maliutin, and others. Vladimir Lebedev and Vladimir Kozlinskii provided artistic leadership for Rosta Windows in Petrograd.

The Rosta Windows consisted of four to twelve different frames that told a story, in the style of a *lubok.* They functioned, as Moor put it, as an "illustrated wire service report."[52] Because of the speed with which the Rosta Windows could be prepared, they offered a far more rapid means of communication than ordinary posters, whose production required many days, if not weeks, to print. Once the process got going, Rosta posters were duplicated by stencil and placed in different locations around the city. Soon the idea caught on in many other cities, forty-seven in all.[53]

Maiakovskii played a critical role in the history of Moscow's Rosta Windows. According to Stephen White: "It was, it appears, under the influence of Mayakovsky that the character of the Windows began to change: initially, they had treated several themes more or less in the manner of a satirical journal, but by the end of 1919 they had begun to concentrate upon a single theme treated in a consecutive series of frames in the manner of a comic book."[54]

Cheremnykh's well-known 1920 Rosta poster, "Istoriia pro bubliki i pro babu" (Story of the *Bubliki* and the *Baba*), illustrates the narrative technique, using sequential frames read horizontally (fig. 2.14).[55] In this poster, eleven frames suffice to tell a fairly elaborate story about a peasant woman who does not want to give her *bubliki* (bagels) to a Red Army soldier and is subsequently devoured (*bubliki* and all) by a Polish officer. This was a typical Rosta Window in that it told a story and it subordinated the images of individual figures,

both heroes and enemies, to the narrative frame in which they were embedded.

The Rosta style, drawn from the traditional folk *lubok,* fell out of favor at the end of the Civil War. The narrative style of the Rosta poster was superseded during the 1920s by other styles that gave primacy not to the story but to the effectiveness of particular images. To be sure, Rosta Windows and other *lubok*-type posters were still issued in the course of the 1920s, but the trend was in another direction. Instead of narrative, more and more posters emphasized the correct rendering of iconographic images—images of both heroes and enemies. Rosta ceased publication of posters in 1930, only to resume once again during World War II.

The emphasis on caricatured images of individual and group *vragi* provided a very different approach to satire than the *lubok*-style Rosta Windows. Deni's widely circulated 1920 poster, "Manifest" (Manifesto), illustrates this type of satire (fig. 5.4).[56] The poster foregrounds three seated figures: a kulak, Baron Wrangel, and a *burzhui* (each distinctly labeled). Pictured against the background of the tsarist crown and ermine, they hold a scroll with the text: "All power to the landlords and capitalists! Workers and peasants subject to lashing!" Wrangel snarls while the kulak and the *burzhui* display self-satisfied smiles. Few words but extremely suggestive caricatures suffice to convey a set of ideas. The emphasis in this type of poster is on the caricatures themselves rather than the narrative. One of the most widely reproduced caricatures in Bolshevik demonology was the capitalist/*burzhui*. The etymology of this figure and its incorporation in Civil War political art illustrate the party's quest for effective symbolic representations of the enemy.

Whereas the satirical *lubok* style had its origins in indigenous Russian folk art traditions, satire based on caricature drew its inspiration largely from Western European sources. The German journal *Simplicissimus,* published in Munich from 1896 on, was especially influential on Russian artists before and after the 1917 revolution.[57] Through exposure to *Simplicissimus* and other European satirical journals, as well as socialist journals and newspapers, Russian artists adopted certain conven-

tions for representing particular types. One of the most important and widely reproduced was the image of the fat cigar-smoking capitalist in a top hat.[58] Transference of the image of the capitalist had already taken place by 1906. In that year, an illustration by M. S. Linskii appeared in an Odessa newspaper featuring a fat cigar-smoking capitalist with a piglike face surrounded by money bags.[59] A 1916 drawing by Moor incorporates a merchant with some similar features.[60]

After the October Revolution, Bolsheviks introduced into popular discourse two terms—capitalist and *burzhui*—to describe the social class most vilified by Marxism-Leninism. *Burzhui* was a pejorative and insulting contraction of the Russian word for bourgeoisie—*burzhuaziia*. Although it had existed in the Russian language before 1917, the Bolsheviks elevated the term to general usage and popularized it as the designation for anyone who engaged in entrepreneurial activities.[61] "Capitalist" was a more formal term and in political art was often used as a designation for businessmen who operated outside Russia's borders, whereas the term *burzhui* was frequently applied to indigenous Russian capitalists.

By November 1918, an image of the capitalist/*burzhui* had become firmly established in the Bolshevik visual lexicon. Displays for the first anniversary celebration of the revolution included Sergei Chekhonin's "Smert' ugnetateliam" (Death to the Oppressors) designed for the Aleksandr Nevskii monastery.[62] This panel showed a worker with a hammer in his right hand ready to strike a miniature version of a capitalist/*burzhui*, whom he grips by the neck. The miniature figure is a corpulent male, wearing a top hat and striped trousers; his fingers have many rings. This image, sometimes with the addition of a cigar, was widely reproduced in late 1918 in theaters, journals, and other visual media.[63] The more elaborate versions of the capitalist/*burzhui* included facial figures that sometimes resembled a pig's. Frequently, a golden watch fob stretched across his ample midriff and he wore a monocle, rings on his fat fingers, and flashy cuff links. From time to time, striped trousers replaced the black trousers. Typically, the capitalist/*burzhui* was surrounded by money bags, gold coins, or some other visible sign of wealth.

The capitalist/*burzhui* was always represented as a corpulent male. In the visual symbolism of the period, corpulence meant that a person was well-to-do or had access to food supplies unavailable to others. Three other figures were almost always depicted as robust: the kulak, the priest, and the peasant woman. The first two were portrayed as unambiguously negative figures. In Soviet visual propaganda, there was no such thing as a positive image of a capitalist or a kulak. The same cannot be said for the peasant woman, whose rotund image made an appearance in political posters in 1920. As we have seen in chapter 2, the peasant woman's image was ambiguous.

Deni was one of the first Soviet artists to develop an iconographic image of the "type of *burzhui* (fat, like a balloon, an urban type—always in a top hat)." [64] Possibly the most influential elaboration of the capitalist/*burzhui* appeared in his poster "Kapital" (Capital) (fig. 5.5). [65] Published in November 1919, it was issued in an edition of 100,000—a rare occurrence in this period, when even a press run of 50,000 was considerable. The poster owes its effectiveness partly to the simple but dramatic composition and rendering of the image of the smiling capitalist. But it also makes skillful use of irony: the capitalist has a heart of gold hanging from his watch fob. In the background stretches a spider's web.

At the same time that Deni's poster "Kapital" was issued, an historical pageant, "The Fall of the Autocracy," was being staged for the second anniversary of the revolution. Originally held outdoors in Petrograd and repeated 250 times over the next seven months, it was the first of a series of mass spectacles staged for holiday celebrations. Photographs of "The Fall of the Autocracy" show a group of actor-soldiers pretending to be capitalists/*burzhui*. Each wears a top hat, black tie and jacket, a watch fob, and a boutonniere—distinctive class markers for this figure. [66]

The *burzhui*—and this figure was often labeled explicitly—usually appeared somewhat less grand than the "capitalist," and he was often in the company of a kulak, a priest, or a figure from the White Army. Two 1920 posters by Deni present images of the *burzhui*: "Manifest" (Manifesto) (fig. 5.4) and "Na mogile kontr-revoliutsii" (At the Grave

of the Counterrevolution).[67] In both these posters, a corpulent *burzhui* wears a top hat and evening jacket. In "Manifest" he smiles in a self-satisfied manner similar to the figure in "Kapital."

Images of the capitalist/*burzhui* were created by other satirical artists, such as Moor, using the same set of iconographic class markers. Thus, Moor's capitalist in "Ruku dezertir" (Give Me Your Hand, Deserter!) follows the same pattern with respect to clothing and accoutrements.[68] Similarly, his widely circulated 1919 poster, "Tsarskie polki i krasnaia armiia" (The Tsarist Regiments and the Red Army), presents the standard image of the cigar-smoking *burzhui* with his arm on a pile of money bags. This poster has particular interest because of its large edition—95,000 copies—and its elegant application of stylistic devices from both the *lubok* and religious icons.[69]

Notwithstanding similarities in class markers, the images of the capitalist/*burzhui* created by Deni and Moor—the two greatest masters of Soviet satire in this period—also displayed important differences in nuance. Writing in 1924, Viacheslav Polonskii analyzed these differences:

> The *burzhui* on Deni's pages arouse laughter. Moor's *burzhui* fill one with disgust. They are villainous, their brutal inside is turned inside out. The image of "Kapital" runs through some of his [Moor's] lithographs and many caricatures, and it is not similar to Deni's "Kapital." The latter is repulsive, Moor's "Kapital" is frightening. Deni's "Kapital" is an exaggerated type of corpulent banker, overflowing with fat. Moor's "capital" is lacking human form, and all of his features—greediness, cruelty, carnivorousness—are carried to their extreme. For this reason, Moor's lithographs seldom evoke laughter, but more often hatred, a desire to finish off the enemy, without leaving a trace.[70]

In 1920, Nikolai Kochergin, a highly original artist, created "Kapital i Ko." (Capital and Co.), depicting capital as a giant fat green monster wearing an ermine cape (fig. 5.6).[71] Seated below him, in three tiers, are various representatives of capitalism: Lloyd George, Clemenceau, and Wilson on the top tier, followed by White generals and anarchist rebels.

On the bottom tier is a rather large group of figures, each distinctly labeled (in this order): rabbi, Roman Catholic priest, mullah, speculator, kulak, Russian Orthodox priest, factory owner, sleuth, Kadet, pogrom maker, underground anarchist, diplomat, and landowner.

Kochergin's creation, which was reproduced in two editions (a total of more than 100,000 copies), brought together in one poster both allegorical and satirical styles for depicting the capitalist/*burzhui*. It is a complex poster, one that was probably designed for interior public spaces, where viewers could study the details. By creating a visual linkage among these various figures (representing, in some cases, not just individuals but entire social groups) and establishing their contiguity with the green monster of capital, the poster skillfully uses the metonymic trope to tell a complex story about world capitalism and its extended network in Russia. For those not yet versed in Bolshevik demonology, it functioned as a "who's who" of the capitalist enemy.

Posters of this type evidently enjoyed a great deal of support from party officials, who were eager to provide graphic visualization of the multitude of *vragi*. Another "who's who of the enemy" created by Moor, "Sud narodnyi" (People's Court), was produced in an enormous edition of 125,000 copies by Litizdat in 1919 (fig. 5.7).[72] Here we see a peasant, worker, and soldier wielding a broom and a shovel to expel a long and varied procession of people moving in a more or less orderly and apparently voluntary manner toward their destination (exit from the country? court of judgment?). In conformity with the poster's didactic emphasis, each group is carefully labeled, lest the viewer fail to recognize the caricature. All the enemies are male, with the exception of two naked women embracing a priest. Included among them are not only *burzhui*, priests, and kulaks but also "social conciliators" (*sotsial-soglashateli*) and "social traitors" (*sotsial-predateli*). The poster is conceived in the *lubok* tradition and is reminiscent of the famous eighteenth-century woodcut of the mice burying the cat.[73]

HOW THE WHITES REPRESENTED THE ENEMY

While the Bolsheviks were engaged in a lively campaign to vilify their enemies in the Civil War, the White forces carried on a similar effort

against the Bolsheviks. As Peter Kenez has put it: "Although the Bolsheviks understood the significance of propaganda far better than their enemies, the poster was such an obvious instrument for propaganda in Civil War conditions that the Whites also turned to it. The White regimes, especially the most stable one among them in the South, attracted a number of talented artists who produced good work. In comparison, however, the Reds outproduced their opponents both in quantity and quality."[74]

Both sides attempted to create visual propaganda that would be deeply affecting and persuasive.[75] Since political artists for both sides had acquired their training and experience under the tsarist regime, it is not surprising to find that they applied similar approaches to the representation of enemies. To reach ordinary people with their message, they drew upon a visual grammar and lexicon that belonged to the cultural repertoire. Like their Bolshevik counterparts, political artists conducting propaganda for the White forces used a variety of styles drawn from folk and religious art, the Russian and European satirical traditions, and Russian realism.[76] Viacheslav Polonskii's explanation for the similarity was that artists for both sides acquired their consciousness from the same teachers, who came from the bourgeois class.[77]

Artists collaborating with the Whites were particularly partial to allegorical images. They used many of the same images as the Bolsheviks but assigned to them a different meaning.[78] Thus, the hydra often signified anarchy; a frightening monster represented Bolshevism. A striking example is "Vozmezdie" (Retribution), an elegantly constructed poster filled with vivid religious imagery that included a serpent, a devil, the fires of hell, and an avenging angel (fig. 5.8).[79] Bolshevik leaders (Lenin, Trotsky, and others) are falling into a pit of flames, where they stand face to face with the devil and suffer Dantesque punishments for their sins: violence and theft, oratory and lies, blasphemy and outrage upon the church, murder and mockery over the dead, base betrayal of Holy Russia. Reversing Bolshevik color symbolism, the color red here stands for wickedness and the fires of hell.[80] Like their Bolshevik counterparts, White artists also used the image of the spider to vilify their enemies. It provides the centerpiece for a *lubok*-style

poster, "Zlovrednyi pauk. Rai kommunistov" (Pernicious Spider. The Communist Paradise).[81]

Posters issued by the Whites drew upon satire to convey their message, and some of their compositions replicated the satirical style of the Rosta Windows. The poster "Vypusk bumazhnykh deneg razlichnymi russkimi pravitel'stvami" (The Issuance of Paper Money by Various Russian Governments) tells a simple story using only three frames drawn in a satirical mode.[82] The artist conveys the essentials of the narrative—in this case, about the deterioration in the value of money after 1916—with minimum detail. Despite the seriousness of the message, the poster uses humor to convey its point. The figures are exaggerated to convey an atmosphere of incompetence and decay after the overthrow of the tsarist order.

Some of the Whites' most biting satirical posters presented caricatures of Trotsky and Lenin. As commander of the Red Army, Trotsky was often vilified in White propaganda. One poster, "Cherez krov' i cherez trupov grudy" (Wading through Blood and Climbing over Mountains of Corpses), portrays him as Judas looking on as Christ is led to Golgotha by a gang of Red Army men (fig. 5.9).[83] The theme of Jewish villainy played an important part in White propaganda generally and in the depiction of Trotsky in particular. The Whites took great pains to emphasize the alliance between Jews and Communists against "Russia."[84]

Another poster produced in Rostov-on-Don, "Lenin i Trotskii" (Lenin and Trotsky), shows a very tall Trotsky looming over a short pudgy Lenin.[85] Trotsky has one hand on Lenin's head and another points to a globe. Behind them is a pile of suitcases. The short accompanying text indicates that they are looking for a place to live. The artist depicts them both as foolish-looking figures, comical rather than fierce. The same artist created another satirical poster of Trotsky being booted out of the Kuban by a White Army soldier.[86]

Many of the satirical posters issued by the Whites were intended to create revulsion toward the Bolsheviks. Some of these posters used the "we/they" technique from folk art; others emphasized religious themes. A third type used satire and irony to make the point.

In "Krasa i gordost' russkoi revoliutsii" (The Beauty and Pride of the Russian Revolution), a smiling and bloodstained Bolshevik sailor— revolver in hand and knife in belt—walks through a river of blood.[87] A poem appears below the image, a common format in Soviet posters as well.

When the Civil War came to an end and the White forces and peasant rebels had been vanquished, the Bolsheviks turned their attention to reconstructing the economy. In the spring of 1921, they adopted Lenin's plan for a New Economic Policy designed to stimulate economic activity in trade, manufacturing, and agriculture. With this change in emphasis came a shift in the visual representation of enemies. Propaganda focused far less on enemies during the NEP years than on reconstruction and the alliance between workers and peasants.

It was not, of course, that enemies had ceased to exist for the Bolsheviks. Communists continued to see the world around them in terms of such binary opposites as proletarian versus bourgeois and poor peasant versus kulak. From a juridical point of view, a considerable portion of the internal population stood outside the framework of civil society. The provision of the 1918 Constitution of the Russian Republic disenfranchising private traders, rentiers, and kulaks remained in effect when a new constitution was adopted in 1923.

The internal class enemy in the 1920s had several components, depending on the point of view and the year. Throughout the decade, Bolsheviks generally continued to condemn the so-called *byvshie liudi*, a group that included all the old privileged classes and the clergy. The Nepmen (private traders of all types) and more well-to-do peasants (so-called kulaks) were vilified intermittently, although their activity had been sanctioned by the New Economic Policy. The noncommunist intelligentsia was often viewed negatively and labeled "bourgeois specialists"; beginning in 1928 they became particular objects of vilification in the wake of the Shakhty trial.[88] At the very end of the 1920s, with the onset of the Cultural Revolution, the list of enemies ex-

panded to include, as Sheila Fitzpatrick has put it, "conciliators of the peasantry, conciliators of the intelligentsia, bureaucrats . . . , Nepmen, kulaks, cafe-haunting literati, wreckers, expropriated capitalists, and foreign spies."[89]

Many of these people fell into the legal category of *lishentsy,* which subjected them to serious civil disabilities (disenfranchisement, exclusion from public office) and to socio-economic discrimination with respect to housing, education, and taxation. The regime's persecution of the *lishentsy* relaxed between 1921 and 1926, only to accelerate again in 1927.[90] Official policy concerning the proper definition of a person's identity was never clear-cut, but there remained a strong belief that an individual's position prior to the October Revolution rather than his or her current occupation was decisive in determining political attitudes. In the post-October period, people often had shifting identities: some workers became party officials under the new regime, the sons of priests became workers, and many others changed occupation. All this created a great deal of uncertainty and wariness about individual social (and political) identity.[91]

A review of posters produced by the Bolsheviks between 1921 and 1929 discloses a sharply reduced number of enemies identified by word or image—about one-half the number recorded for the Civil War years. Many of the posters featuring enemies appeared in the late 1920s, when the assault upon Nepmen and kulaks was gaining momentum. Artists paid relatively little attention to external enemies until the late 1920s, focusing instead on groups and individuals regarded as internal enemies. Among the latter, we find few references by word or image to the tsar and his entourage. By contrast, other elements of the old regime, such as the capitalists/*burzhui,* kulaks, priests, landowners, and former village policemen still figured prominently in political posters, as did the Mensheviks.

Artists concentrated most heavily on those who fell into the third category, "workplace and other villains." These included the thief, drunkard, bureaucrat (especially the one who took bribes), shirker (*progul'shchik*), loafer (*lodyr'*), thriftless person (*beskhoziaistvennik*), wrecker (*vreditel'*),[92] bribe taker (*vziatochnik*), embezzler (*rastratchik*), and red tape bureaucrat (*volokitchik*). In addition, there was the kulak hench-

man (*podkulachnik*), kulak saboteur (*kulatskii podryvatel'*), shopkeeper (*lavochnik*), and private trader.

Allegorical images, so central to political art during the Civil War, now seldom appeared, although nonhuman representations of enemies were occasionally used.[93] Rosta Windows lost their importance. What remained was a sharp satirical style that had been developed by such artists as Deni, Moor, Kochergin, and Cheremnykh, a style that depended on memorable caricatures rather than narratives. They were joined by a new generation of talented artists, such as the Kukryniksy, a group of three men (Mikhail Kupriianov, Porfirii Krylov, and Nikolai Sokolov) who studied together in Moscow and collaborated on satirical posters beginning in 1924.

Political artists in the 1920s drew on a traditional cultural repertoire. Color symbolism, established during the Civil War and based partly on religious icons, continued to predominate. Anything in the color red was by definition heroic; black and green had negative connotations and were generally applied to enemies.[94] Stylistic elements taken from the *lubok* were sometimes used, such as the "we/they" format that served to contrast heroes and enemies, good and evil, sacred and profane. Posters contrasting private as opposed to cooperative stores used this format, for example.[95] Perspectival distortion was also used to emphasize the power and dominance of the worker and the workers' state vis-à-vis the enemy. In the 1929 poster "Vrag prolezaet—gonite ego!" (The Enemy Is Sneaking In—Chase Him Away!), a giant red hand grabs the gray hand of a man who is stealing. The bottom frame of the poster features two rats and then lists "our major enemies": the wrecker and kulak, the bureaucrat and procrastinator, the thief and embezzler, the drunkard and thriftless person.[96] The two rats in the poster create an association between enemies and rodents, a dehumanizing device that was used in Civil War posters.[97]

By the end of the 1920s, the general tone of posters depicting enemies was growing sharper, more vicious, and increasingly reminiscent of the Civil War ethos. In 1927 there was a turn away from the tolerance of NEP and an increase in the number of officially designated *lishentsy*.[98] The years 1928–1930 witnessed the adoption of the First Five Year Plan, the defeat of the Right Opposition,[99] the expulsion of Trotsky from the

country, and the first public trials for industrial sabotage. Verbal attacks on "enemies of the people" who were "bourgeois," "right wingers," favorable to "class peace" rapidly accelerated in 1929.[100] By 1930, Stalin's position as the single most powerful leader in the country had become firmly established.

The mounting preoccupation with enemies manifested itself in visual propaganda. Large mannequins representing particular types (capitalist/*burzhui,* priest, kulak, and others) occupied a central place in May Day and November 7 celebrations in 1928 and 1929.[101] The number of posters foregrounding the theme of enemies increased substantially in 1929 and 1930, as did the number of enemies explicitly identified in these posters. Foreign enemies were added to the roster of villains. These included the German Social Democrats,[102] fascists, the French leader Poincaré, British imperialists, Mussolini, the Pope, and Mensheviks abroad. In addition, there were also new internal enemies: the Prompartiia (an alleged conspiracy of industrial managers), the Right Opportunists,[103] Trotsky, skeptics regarding the First Five Year Plan (*malovery*), and spies (*shpiony*). Seated alongside the traditional priest, capitalist, and White general on a float in Moscow's November 7, 1930, parade, there was now a rabbi.[104]

A poster by Deni, "Vragi piatiletki" (Enemies of the Five Year Plan), illustrates the approach to the visual representation of enemies introduced in 1929 (plate 6).[105] Issued in an edition of 75,000 copies, the poster is divided into two frames, showing internal and external enemies. On the left, Deni satirized the landowner, kulak, drunkard, and priest; on the right are the journalist, capitalist, Menshevik, and White officer. The foreign journalist is a recent addition to the list of external enemies, a figure who reappears from time to time throughout the remainder of the Stalin era.

Deni's 1929 poster conforms to the satirical tradition established during the Civil War. The image of the enemy—a standardized image that incorporated certain easily recognizable class or political markers—provided the centerpiece for the poster, rather than a narrative, as in the typical *lubok* format. The proliferation of class enemies that began in the late 1920s compelled artists to focus on the task of creating graphic images of the new villains. These developments were a manifestation

of the intense class war that accompanied rapid industrialization and collectivization drives inaugurated by the First Five Year Plan.

CLASS WARFARE IN THE 1930S

The preoccupation with enemies in the early 1930s calls to mind the intense atmosphere of struggle during the Civil War, but there are important differences. In place of armed conflict on Soviet territory and foreign intervention, the 1930s witnessed an official policy of class warfare and a government campaign of persecution and terror directed first against the so-called bourgeois specialists, then against the peasantry, and then, from 1934 on, against a broad spectrum of Soviet citizens, including many party members. The massive propaganda campaign invoked military metaphors, and the press "was filled with phrases like 'industrial front,' 'agricultural front,' 'battle for coal,' 'Red offensive,' 'light cavalry attacks,' 'militant discipline,' and 'shock brigades.' Literature was the 'literary front' where writers enlisted in the class war against bourgeois literary culture and for industrialization; other intellectual professions were similarly mobilized." [106]

Political artists played an important role in this mobilization. As we have seen, visual propaganda was centralized in the spring of 1931, and semi-autonomous organizations of artists were abolished a year later.[107] After 1931, political artists no longer worked with various presses and organizations to develop their own ideas and images. From that time on, the government publisher Izogiz produced posters in accordance with a master plan. Izogiz assigned slogans to selected artists, who were invited to submit drafts.[108] The entire operation was under the supervision of the Central Committee and remained highly centralized.

The types of enemies identified by word and/or image increased substantially between 1931 and 1933, compared to the 1920s. This increase coincided with a fundamental reorientation in Bolshevik ideology. Lars Erik Blomqvist has characterized the shift in the official attitude toward enemies:

> The leading theoreticians of the 1920s did not deny the existence
> of anomalies, illnesses, of Evil itself in society, but they were of

the opinion that with education and correction these problem areas could be reduced. . . . The ideologues of the Stalin epoch, on the other hand, considered every crime to be an anomaly and everything abnormal to be a crime. The Stalin epoch, in fact, needed Evil, preferably of an anthropomorphized type, as a clear definable opposite to Good, i.e., to the building of Socialism.[109]

The preoccupation with enemies (and heroes) in the first half of the 1930s represented an attempt to draw sharp boundaries where none had existed before, to map with precision a bipolar field in which everyone and everything stood on one side or the other of the heroic and historically unprecedented effort to build socialism in one country.[110] A similar quest for sharp boundaries had occurred during the Civil War, but the adoption of the New Economic Policy in the 1920s had blurred those boundaries and created a limited but significant "axiologically neutral zone" in which social groups such as the prosperous peasantry and the nonparty intelligentsia occupied an ambiguous position in official ideology. The adoption of the First Five Year Plan in April 1929 again made the issue of boundaries paramount in Bolshevik ideology. Above all, the regime sought to draw a clear distinction between binary opposites—heroes and enemies, good and evil, sacred and profane— and eliminate ambiguities in classification. Visual propaganda became a major vehicle for accomplishing this task.

A survey of posters issued between 1930 and 1933 includes more than fifty separate categories for enemies, a substantial increase over the NEP period. Some of these are external enemies: interventionists, White bandits (and White Guardists), German Social Democrats, social fascists,[111] monarchists, fascists, Hitler, Kautsky, and the Pope. But the majority of enemies in the early 1930s are inside the borders of the Soviet Union, including some from the old regime that had been on the Bolshevik demonology list since the Civil War.

The monarchist, tsarist gendarme, tsarist high official, members of the tsarist entourage, and the tsar still made an occasional appearance in political posters. Others, such as the kulak, capitalist/*burzhui,* priest, rabbi, and mullah, acquired exceptional importance in visual propaganda of the early 1930s. The latter groups occupied center stage in the

great dramas of collectivization and industrialization and the accompanying anti-religious campaign launched during the First Five Year Plan. These trends in visual propaganda coincided with a drop in the number of *lishentsy* who were officially registered beginning in 1931, a trend that continued until 1936, when the regime declared that a "classless society" had been achieved.[112]

White Guardists, Mensheviks, and SRs, together with Right Opportunists and Left Opportunists, also figured prominently in political art of the early 1930s. Some of these groups were alleged to have bases of operation outside the country, with agents inside the Soviet Union seeking to sabotage the five-year plans. These allegations figured prominently in the show trials of the second half of the decade.

A significant increase occurred in the number and types of enemies specified within the general category "workplace and other villains." In addition to the usual list that included the thief, bureaucrat, drunkard, loafer, and shirker, now there were the self-seeker (*rvach*), hooligan (*khuligan*), rolling stone (worker who frequently changed jobs, *letun*), fleecer (*zhivoder*), plunderer (*raskhititel'*), bad workman (one who botches the job, *brakodel*), skeptic (*malover*), whiner (*nytik*), and malicious feigner of illness (*zlostnyi simuliant*). Soviet demonology also came to include professors.

Entirely novel was the term of political opprobrium *shliapa,* or *partshliapa,* literally "hat" or "party hat," but meaning a person who was absent-minded, missed things, a bungler. The related verb *proshliapit'* means to miss an opportunity or, in case you are looking for a culprit or an enemy, to fail to recognize or miss catching one. The term *shliapa* refers to a fedora or any other form of formal civilian male headgear. Well before Stalin used the term *shliapa* in January 1933 to describe a kolkhoz official who hid under his big hat wreckers and others who destroyed kolkhoz property, the term was applied by lower-class groups in an urban context to ridicule people of superior station who were not street-wise. Hence, its common usage to designate a bungler. A 1933 poster, "'Shliapy' v kolkhoze" ('*Shliapy*' in the Collective Farm), by Konstantin Rotov, was one of the earliest to provide a visual image of this phenomenon. Issued in an edition of 50,000 copies, it shows a man with a large hat who holds a sign: "There are no

kulaks in our kolkhoz." Four miniature men (the thief, the former White Guard officer, the priest, and an unidentified figure) sit on the brim of the hat.[113]

During the first half of the 1930s, three styles were used to represent enemies. First, there were caricatures drawn in the style established during the Civil War by artists such as Deni, Moor, and Cheremnykh. The distinguishing feature of this approach to satire was the creation of fixed images with symbolic class markers that facilitated immediate and unambiguous identification of a particular figure. A few simple markers, sometimes even a single one, were sufficient to establish visual identity. For example, the tsarist crown, the top hat of the capitalist/*burzhui,* and the military cap of the White Guard officer or foreign general provided unmistakable clues as to social and political identity.

Throughout the 1930s, Deni, Moor, Cheremnykh and other artists continued to turn out this type of caricature, using old models, sometimes with modifications, and adding new ones to accommodate changes in the roster of enemies. Deni's poster "Schastlivyi grazhdanin, znakomyi s etimi tipami tol'ko po knigam" (It Is a Happy Citizen Who Is Acquainted with These Types Only from Books) illustrates the application of this approach in the early 1930s (fig. 5.10).[114] Issued in 1932 (20,000 copies), it presents portraits of eight standard Soviet villains, including the capitalist/*burzhui,* the tsar, the monarchist, the interventionist general, the SR, and the Menshevik. A few details, such as the notorious hats, make identification easy.

As the roster of miscreants increased, artists attempted to create corresponding caricatures with distinctive markers; once established, the new image usually persisted throughout the decade. By way of illustration, when the category "wrecker" grew important in the late 1920s, artists attempted to develop a standardized image with fixed markers. By 1930, a caricature of the "wrecker" had been developed by Deni, whose poster "GPU" depicted a "counterrevolutionary wrecker" as a bald elderly man with spectacles and a hook nose, dressed in a suit and tie.[115] Red lightning, in the form of the letters "GPU," strikes him in the head. He has the face of an intellectual and was no doubt meant to represent a "bourgeois specialist" recently tried for industrial sabotage.

The representation of Trotsky underwent a similar process of stan-

dardization. As we have seen in chapter 4, during the Civil War and early 1920s, many posters, portraits, and other visual displays heroized Trotsky, whose reputation was surpassed only by Lenin. Following Lenin's death, Trotsky's position in the Bolshevik pantheon declined rapidly, and by early 1929 he had been expelled from the country. Having once depicted him as a hero, artists now attempted to devise a new image of Trotsky as the enemy.

In 1930, an agit-automobile created by the Leningrad Academy of Art, "Trotskii v kolesnitse mirovogo imperializma" (Trotsky in the Chariot of World Imperialism), showed a small and scrawny Trotsky running after a large capitalist/fascist.[116] An emaciated figure with a large head and glasses, a black suit and a white shirt, Trotsky holds a briefcase labeled "Truth in the USSR." He runs with an outstretched arm toward a large capitalist/fascist figure who holds on a leash three snarling dogs representing the major Western powers (reminiscent of Deni's well-known poster from the Civil War, "Antanta" [Entente] [fig. 5.2]). An almost identical image of Trotsky appears in Deni's 1937 poster, "Shagaiut k gibeli svoei" (They Are Marching toward Their Ruin), printed in an edition of 150,000 (fig. 5.11).[117] A miniature Trotsky now leads rather than follows two burly military men with fascist insignia.

The two representations of Trotsky, though separated by seven years, have much in common. In both cases, perspectival distortion serves to diminish Trotsky's stature in relation to other external enemies. Furthermore, both posters use contiguity (in this case, Trotsky and the capitalist/fascists) as a substitute for a narrative. This convention was already well established by 1930, and contemporary viewers understood that physical proximity implied political and ideological affinity among enemies as well as heroes.

During the early 1930s, satirists experimented with modifications of one of the most well-established images in the Soviet visual lexicon: the capitalist/*burzhui*. A 1931 poster by an anonymous artist, "Protiv klassa eksploatatorov" (Against the Exploiting Class), had a novel image of the capitalist (fig. 5.12).[118] Like the traditional figure, this capitalist wears a black top hat, but there the resemblance ends; the fleshy face with features resembling a pig has been replaced by a more angular face

with a long pointed nose. He has a swastika as a cuff link and holds in his hand miniature priests and German Social Democrats. A similar modification was introduced by Deni and Dolgorukov in a 1933 poster, "Piatiletnii plan" (The Five Year Plan), which presents a capitalist who also wears a top hat and has a long pointed nose.[119] The revised image of the capitalist remained in the repertoire throughout the Stalin era.

In the course of 1931 and 1932, carnivalesque caricatures of the capitalist were erected during holiday celebrations and as part of agitational parades held in Moscow's Gorky Park. Photographs of these three-dimensional caricatures provide evidence of still other variations on the earlier iconographic image of the capitalist. Here, too, the capitalist retains his top hat, but other markers have disappeared. The most strikingly novel aspect of these caricatures is the teeth—large, fanglike teeth that protrude from the capitalist's open mouth. One of these capitalist figures has a swastika on his shirt cuff.[120]

Moor created a poster in 1933 that introduced yet another image of the capitalist/*burzhui*, "Itogi piatiletki pokazali, chto rabochii klass sposoben tak zhe khorosho stroit' novoe, kak i razrushat' staroe" (The Results of the Five Year Plan Showed That the Working Class Is As Capable of Building the New As It Is Capable of Destroying the Old). In this unusual poster, the standard capitalist is replaced by a decrepit old man with white hair.[121] Virtually all of the standard class markers have disappeared.

While some political artists carried on the tradition of satire based on class markers, others were making the transition to a new conception of representation based on typicalization. In place of the familiar set of symbolic class markers—such as the top hat for the *burzhui*—artists now sought to create an image that would capture some attributes of the enemy as he was supposed to be. Thus, the politically correct image was one that conformed to the official conception of a particular enemy and could therefore claim verisimilitude. This approach received strong reinforcement from Stalin, who observed in 1933: "Look for the class enemy outside the kolkhoz, look for him in the form of a person with a brutal physiognomy, enormous teeth, a thick neck, a sawn-off rifle in his hands. Look for the kulak that we would recognize from posters."[122]

Stalin's suggestion that political posters provide a guide for identify-

ing the real-life enemy was taken to heart by artists and critics alike and applied to various types of class enemy, not just those in the countryside.[123] The code word for this preoccupation was *tipazh*—the correct rendering of a particular social category. *Tipazh* aimed at creating a social type that corresponded to the party's conception of "inner essence." Images were supposed to have the correct combination of features that would capture the true "inner essence" of the enemy and elicit from viewers the appropriate emotion. Boris Groys has observed that "practically all art criticism of the Stalin period was devoted to endless analysis of the poses and facial expression portrayed in Soviet pictures in relation to the psychological content they conveyed." Artists and critics "jointly elaborated a distinctive and quite complex code for external appearance, behavior and emotional reaction characteristic of the 'true Soviet man'" and his enemy.[124]

Contemporary standards for assessing the *tipazh* of enemies can be judged from the reviews of a 1933 poster by Nikolai Korshunov, "Brak—podarok klassovomu vragu" (Spoilage Is a Present to the Class Enemy) (fig. 5.13).[125] The poster, which included a blank space for the names of the guilty individuals, depicted the "class enemy" as a dissolute overweight man wearing a cross around his neck. The reviewer, M. Neiman, approvingly described the figure as having "broad but hunched over shoulders, with folds hanging from his fat neck, a pot belly." Corpulence and wickedness remained linked in the early 1930s, just as they had been during the Civil War and 1920s. Neiman described with approval the artist's unusual ("far from the canon") *tipazh* of the class enemy: "The appearance of the class enemy drawn by Korshunov is a synthetic image, incorporating the characteristic features of kulak beastliness, the thieving slyness of the market tradesman, and the base hypocrisy of the wounded snake that is still sneakily doing its damage." The poster, he continued, evoked "strong emotion . . . against this dangerous hissing snake"; it aroused "loathing and nausea."[126] References to a snake and kulak beastliness were, of course, reminiscent of earlier allegorical images of the enemy as a reptile. The reviewer's language was typical of the discourse on enemies in the first part of the 1930s, with its dehumanizing emphasis.

Notwithstanding the emphasis on *tipazh,* many artists were drawn to

a visual language that used images of animals, birds, reptiles, insects, and even mythical creatures to represent the class enemy. This style of representation differed fundamentally from *tipazh* with its pseudo-realism; it also departed from the standard practice of Soviet caricature with its focus on images of people with distinctive class markers. In fact, the substitution of nonhuman creatures for human beings falls directly in the allegorical tradition, and many of the creatures had either folk or religious associations.

The use of nonhuman creatures in political posters encountered a mixed reception from reviewers. Writing in 1931, V. Vert criticized political artists who represented enemies as monkeys, frogs, crocodiles, and the like, arguing that the "superficial symbolism [of these images] conceals the political essence of class conflict."[127] But other commentators were more sympathetic. Two years later another critic observed: "The representation of human vices in the guise of animals is an approach that presents great possibilities and is utilized not only in literature but also in art."[128]

Some leading satirical artists, such as the versatile Cheremnykh, frequently used nonhuman images to represent objects of opprobrium. His 1932 poster "Da zdravstvuet mezhdunarodnyi proletarskii bezbozhnyi front!" (Long Live the International Proletarian Atheist Front), resurrects the hydra to represent organized religion and its alleged connections with capitalists and fascists.[129] A red hand strangles the hydra. The following year, Cheremnykh created another poster, "Tovarishch, bditel'nost' utroi beregi, kak zenitsu oka, kolkhoznyi stroi" (Comrade, Treble Your Vigilance; Guard the Kolkhoz System like the Apple of Your Eye), which uses the image of a spider to portray the kulak.[130]

Korshunov's poster discussed above includes a black crow looking down at the class enemy. The crow was, as we have seen, identified with hell and the devil in the tradition of Christian symbolism. The text of a poem by Dem'ian Bednyi on the poster further accentuated the importance of the crow for decoding the message of the poster. A stanza of the poem reads: "Crow above, crow below. Caw! caw! caw! caw! Gave work to an expert: Break! break! break! break!"[131]

In 1933, Viktor Govorkov designed a poster, "Kolkhoznik, okhraniai

svoi polia" (Collective Farmer, Protect Your Fields), which represented a *khishchnik* (beast of prey, spoiler, plunderer) in the guise of a gopher.[132] Kalmykov's 1933 poster, "Ochistim torgovye organizatsii ot khishchnikov, raskhititelei, klassovo chuzhdykh elementov, sryvaiushchikh rabochee snabzhenie" (Let Us Purge Trade Organizations of Spoilers, Plunderers, and Alien Class Elements Wrecking the Workers' Supply), presented alien class elements as rats.[133]

Sometimes enemies were portrayed not as fauna but as flora. The artist Aminadav Kanevskii created a poster in 1933, "My v kolkhozakh" (We Are in the Collective Farms), that depicted a male collective farmer pulling out a weed that had on it protrusions representing various "class enemies" in caricature and labeled the kulak, White officer, professor who is spreading glanders, and factory wrecker.[134] The reviewer, M. Neiman, expressed approval of the composition and the caricatures. He did not mention that Kanevskii's composition imitates a Civil War poster by Moor, "Sovetskaia repka" (The Soviet Turnip).[135]

In the course of the 1930s, efforts to dehumanize the enemy extended to other propaganda media besides posters and holiday displays. Socialist realist films produced during this decade were highly formulaic and invariably included three stock figures: the party leader, a simple person, and an enemy. The struggle against saboteurs was the most frequent theme in the eighty-five films on contemporary themes produced between 1933 and 1939. In more than half (52), the hero was engaged in a struggle against "hidden [domestic] enemies who had committed criminal acts." As Peter Kenez has put it:

> The enemy, whose function was to wreck and destroy what the Communists were building, was always a male. On occasion, but rarely, he attempted to win over the simple person to his side by lying and subterfuge, but mostly he limited his activities to blowing up things. . . . Film directors lent their talents to the creation of an atmosphere of hysteria and paranoia. Their scenarios closely resembled the tales of the most vicious storyteller of them all, A. Vyshinskii, the infamous prosecutor at the purge trials. In the films, as in the confessions at the trials, the "enemy" carried out the most dastardly acts out of unreasoned hatred for decent socialist society.[136]

By hyperbolizing heinous deeds, films helped to dehumanize the "enemy" and to justify vigilance and cooperation with the authorities even in the most difficult circumstances. Unflagging loyalty to the party-state was indeed critical in the 1930s, because anyone could turn out to be an "enemy"—even a close family member such as a father, a son, or a husband. It will be recalled that a major mythos of the decade centered around the story of young Pavlik Morozov, who was slain by irate relatives after he turned his father in to the authorities for hoarding grain.[137] His patricidal deed earned Morozov Communist sainthood, with monuments, buildings, posters, and parks serving as reminders of his exemplary conduct. Dehumanization of the internal enemy through visual propaganda fortified the regime's claims to exercise a monopoly over the conscience and allegiance of the Soviet people.

The technique of dehumanization used to represent internal enemies was also applied to external ones. By the end of the decade the balance began to shift and external enemies attracted more and more attention with the rise of fascism and the military buildup in Germany.[138] Non-human images, especially the ape, snake, and savage beast, appear in anti-fascist posters issued from the mid-1930s onward.[139] Typical of this style was the 1939 poster by Boris Prorokov, "Fashizm—vrag kul'tury" (Fascism—the Enemy of Culture),[140] which featured a gorilla-fascist wielding an ax.

Another 1939 poster, "Da zdravstvuet NKVD" (Long Live the NKVD), features an animal paw with long nails symbolizing the fascist enemy (fig. 5.14).[141] Created by the satirical artists Deni and Dolgorukov, the poster depicts a hand wielding a sword (representing the NKVD), in the act of severing the paw at the wrist. Stark color symbolism—the background is red, the sword is white, and the paw is black—reinforces the Manichean message of the poster. The image of an arm being severed by a sword may have been familiar to some viewers. Moor had used it in his widely circulated Civil War poster, "Vrangel' eshche zhiv! Dobei ego bez poshchady" (Wrangel Is Still Alive! Finish Him Off without Mercy).[142] In 1930, a similar image was again called into service for a poster, "Piatiletku ne sorvat'! Oblomaem lapu vrediteliam i interventam!" (The Five Year Plan Will Not Be Derailed! Break the Paw of the Wrecker and the Interventionist!).[143]

The Deni and Dolgorukov poster has a subtext. While dehumanizing the fascist enemy it also conveys the idea that external and internal enemies are organically connected. A swastika is inscribed on the animal's limb, and its fingers bear the names of domestic and foreign enemies: the Trotsky-Bukharin band, Mensheviks, SRs, bourgeois nationalist spies, and saboteurs. The explicit linkage of enemies was, of course, standard in visual propaganda since the Civil War, as was the idea that domestic foes did the bidding of hostile foreign countries seeking the destruction of the Soviet Union.

The poster's brief text hails the NKVD as the "indefatigable guardian of the revolution, the unsheathed sword of the proletariat." The anti-fascist idea was thus combined with an attack on internal enemies and a glorification of the secret police, thereby creating an implicit justification for political trials, massive arrests, and the incarceration of millions of Soviet citizens who had been accused of political crimes. The poster delivered a potent message, but anti-fascist propaganda was suddenly and unexpectedly halted when the Hitler-Stalin Pact was announced to the world on August 23, 1939.

ENEMY TYPES IN WORLD WAR II

The pre-1939 posters demonizing fascists as animals were but a prelude to the menagerie that appeared in political art following Hitler's invasion of Russia in June 1941. Between June 1941 and May 1945, a wide variety of nonhuman images served to represent the German and Italian fascists and their allies, including a wolf, a cow, a lion, a tiger, a pig, a crow, a rat, a kitten, a dog, a horse, a donkey, a boar, a monkey or gorilla, a crab, and a snake.[144]

Often these nonhuman images, such as the snake, had allegorical associations. Posters that included them—for example, Aleksei Kokorekin's "Smert' fashistskoi gadine!" (Death to the Fascist Reptile!)— would have been fully intelligible to viewers who recalled posters from the Civil War and World War I (fig. 5.15).[145] Produced in an edition of 150,000 copies in 1941, the poster's image of a soldier piercing a snake calls to mind the legend of St. George, with its rich set of historical references. The reappearance of allegorical and other animal images

was part of a more general trend during the war years to revive Russian religious, folk, and nationalist traditions, which had been suppressed since the 1920s or even earlier. For those old enough to remember, World War I artists had also attempted to dehumanize the German enemy by depicting him in the form of animals and devils.[146]

Even when fascists were depicted in human rather than allegorical form, political artists did their best to accentuate nonhuman or sub-human qualities. In one poster, the fascist has pointy ears and a swastika on his forehead;[147] in another, the fascist is a greenish ghoul with a swastika on his chest.[148] Viktor Ivanov's 1944 poster, "Blizok chas rasplaty" (The Hour of Retribution Is Near), depicted the fascists' inhuman character in a different way.[149] A smirking Hitler stands beside a young soldier with a cigarette dangling from his mouth. The soldier is about to shoot a young woman in the neck.

Satire served as a major vehicle for wartime demonology. The most skillful caricaturists of the era—Deni, Moor, Cheremnykh, the Kukryniksy, Boris Efimov, Nikolai Dolgorukov, and others—devoted their attention to the creation of satirical compositions that would simultaneously demonize and ridicule the enemy. But the satirical posters from these years (1941–1945) were seldom original. Nearly all made use of visual devices and compositions already familiar to viewers who were old enough to remember propaganda from the Civil War or the First World War. Indeed, some of the artists, such as Moor, had produced propaganda posters for the tsarist regime between 1914 and 1917.[150]

Political artists returned to the *lubok* format, which had been out of fashion for about a decade. It provided a convenient vehicle for narratives encapsulated in a few frames.[151] The Tass Windows (Okna TASS), a successor to the Rosta Windows, turned out hundred of posters in a satirical vein.[152] The satirical *lubok* style was adopted by many political artists during wartime and took precedence over other forms of satire. Most likely the satirical *lubok* was thought to provide an easy means of communication with broad strata of the population, especially those in the countryside.

Satirical posters sometimes used images or words drawn from an earlier time. Viktor Ivanov, one of the most prolific and effective poster artists of the war years, created a satirical poster in 1941 that followed

the *lubok* format, "Kak baby fashistov v plen vziali" (How the *Baby* Took the Fascists Prisoner) (fig. 5.16).[153] The four frames of Ivanov's poster, each with a text in verse, tell the story of a *baba* and her friends who find fascist soldiers sleeping in a barn. In cooperation with a Red Army soldier, they proceed to take the fascists prisoner while threatening them with grenades. To my knowledge, the term *baba,* with its unflattering connotations for women, had not been used in political posters since the Civil War. Although the terminology harked back to an earlier era, the image of the leading *baba* in Ivanov's poster was strictly in accordance with the revised figure of the peasant woman created in the early 1930s. Unlike her counterpart in the well-known 1920 poster by Cheremnykh, "Istoriia pro bubliki i pro babu" (Story of the *Bubliki* and the *Baba*) (fig. 2.14), Ivanov's *baba* is the new *kolkhoznitsa*—slim, energetic, with a kerchief tied behind her neck. She is the leader of a group that includes several women who still tie their kerchiefs under the chin in the traditional manner.

Wartime posters recycled visual themes and devices. For example, the image of sweeping enemies away with a broom originated in Cheremnykh's satirical drawing of Lenin that was published in November 1918 and then made into a poster in November 1920 (fig. 4.1). Several artists replicated the image of sweeping away the enemy during World War II.[154] Sometimes an artist recycled his own work. In 1921, Deni first created a poster showing a capitalist struck by lightning in the form of the words "III internats" (III International).[155] In 1930, he recycled this poster to show a "counterrevolutionary wrecker" struck by lightning in the form of the "GPU." Then, in 1942, Deni and Dolgorukov created yet another version, "Stalingrad," with a fat fascist struck by a bayonet in the form of a lightning strike (fig. 5.17).[156] The position and appearance of the capitalist in the 1921 version and the fascist in the 1942 version are virtually identical. Both are corpulent men; a Nazi helmet has replaced the top hat and hobnail boots are substituted for evening shoes with spats. In each poster, the capitalist or fascist raises his left arm to stop the strike. Unlike the capitalist, the fascist sprawls on a mound of skulls.

Of the hundreds of clever satirical posters that appeared during World War II, few are memorable. The posters that offered original

compositions, images, and compelling messages, such as Iraklii Toidze's creations featuring matronly women (fig. 6.1), did not represent enemies or use a satirical style.[157] Also effective were posters that incorporated elements from traditional Russian religious and folk art. Drawing upon earlier Soviet (Civil War) and tsarist (World War I) political art, wartime artists foregrounded symbols and images from Russia's past— for example, the *bogatyr'* and heroes of earlier centuries—all in the service of Russian nationalism.[158] By the end of the war, the celebration of the Russian people had become a central element in the regime's propaganda appeals, soon to be linked with the new imperial ethos that was the country's legacy from World War II.

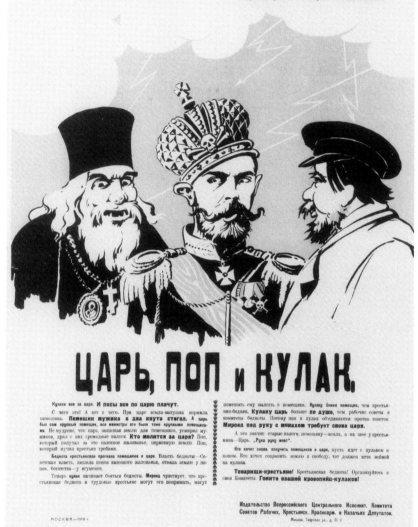

Figure 5.1. "Tsar', pop i kulak" (Tsar, Priest, and Kulak), 1918

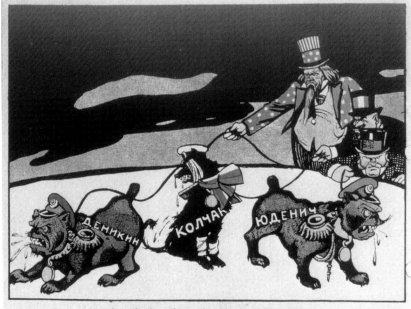

АНТАНТА

ПО ПОЯС УТОПАЯ В КРОВИ,
АНТАНТЫ ЗЛОБНАЯ ОРДА
ГЛЯДИТ, НАСУПИВ МРАЧНО БРОВИ,
НА ЗЕМЛЮ ВОЛЬНОГО ТРУДА.

ТАИТ АНТАНТА МЫСЛИ ЗЛЫЕ,
МЕЧТАЯ ЗЛОБНО ПО ЧАСАМ
ОТДАТЬ СОВЕТСКУЮ РОССИЮ
НА РАСТЕРЗАНЬЕ ХИЩНЫМ ПСАМ.

В УГОДУ РАЗЖИРЕВШЕЙ КЛИКЕ,
СВОБОДЫ РАСТОПТАВШЕЙ ФЛАГ,
РЫЧАТ ЮДЕНИЧ И ДЕНИКИН,
РЫЧИТ ГОЛОДНЫЙ ПЕС КОЛЧАК.

И ЗАПАХ ЗОЛОТА ПОЧУЯ,
ПО ВЕТРУ НАВОСТРИВ НОСЫ,
В ЗАЩИТУ МИРОВЫХ БУРЖУЕВ
ОСТЕРВЕНЕЛО ЛЕЗУТ ПСЫ.

НО МОЩНАЯ РУКА РАБОЧИХ,
ПОДНЯВ ВЫСОКО КРАСНЫЙ СТЯГ,
КАК СОР ОТБРАСЫВАЕТ ПРОЧЬ ИХ,
СКРЕПЛЯЯ БОЕМ КАЖДЫЙ ШАГ.

ТРЕЩАТ ПО ШВАМ АНТАНТЫ ПЛАНЫ
БОРЬБА ЧТО ДЕНЬ, ТО ГОРЯЧЕЙ;
ПУСТЕЮТ БЕЗ ТОЛКУ КАРМАНЫ
ГОСПОД СОЮЗНЫХ БОГАЧЕЙ.

НА ПСОВ НАДЕЖЫ ОЧЕНЬ МАЛО,
ПОБЕДЫ ПУТЬ НЕ ТАК УЖ ПРОСТ-
КОЛЧАК РАСШИБСЯ БЛИЗ УРАЛА,
БЕДНЯГЕ ОТДАВИЛИ ХВОСТ.

ПОДШИБЛИ ГЛАЗ, ПОМЯЛИ ЛАПЫ:
СКУЛИТ ОБЛЕЗЛЫЙ ПЕС КОЛЧАК;
ГЛЯДЯТ СОЮЗНЫЕ САТРАПЫ-
НА КРАСНЫЙ ЗАПОВЕДНЫЙ ФЛАГ.

И С ГРУДОЙ РЕНТ И ОБЛИГАЦИЙ,
РЕШАЯ ВСЕ ДЕЛА ВТРОЕМ,
СИДИТ УНЫЛО „ЛИГА НАЦИЙ"
В СОБАЧЬЕМ ОБЩЕСТВЕ СВОЕМ.

№42

Figure 5.2. Viktor Deni, "Antanta" (Entente), 1919

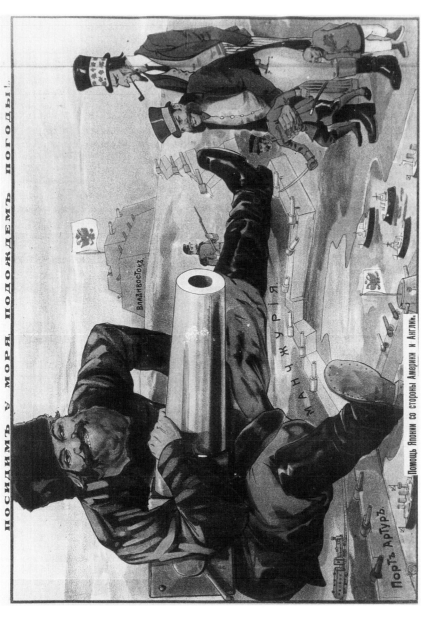

Figure 5.3. "Posidim u moria, podozhdem pogody!" (Let Us Sit by the Sea and Wait for the Right Weather!), 1904

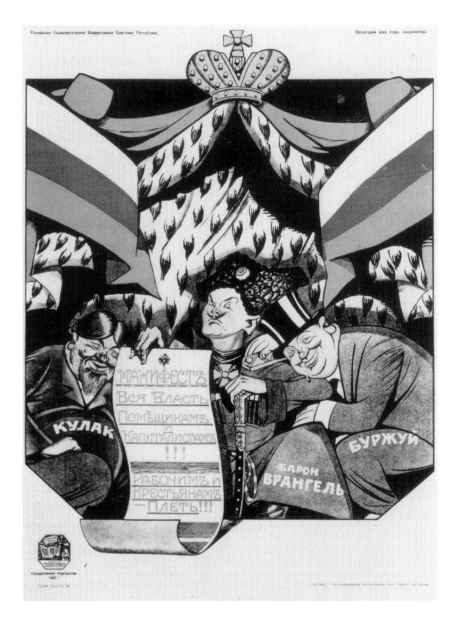

Figure 5.4. Viktor Deni, "Manifest" (Manifesto), 1920

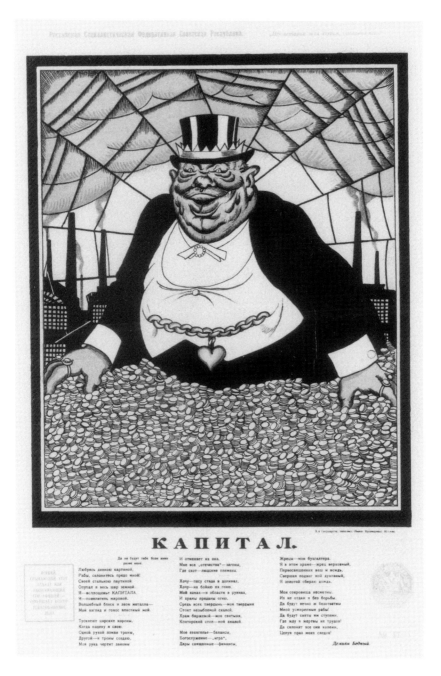

Figure 5.5. Viktor Deni, "Kapital" (Capital), 1919

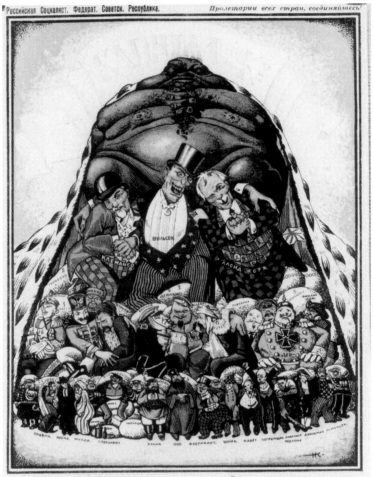
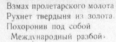
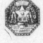

Figure 5.6. Nikolai Kochergin, "Kapital i Ko." (Capital and Co.), 1920

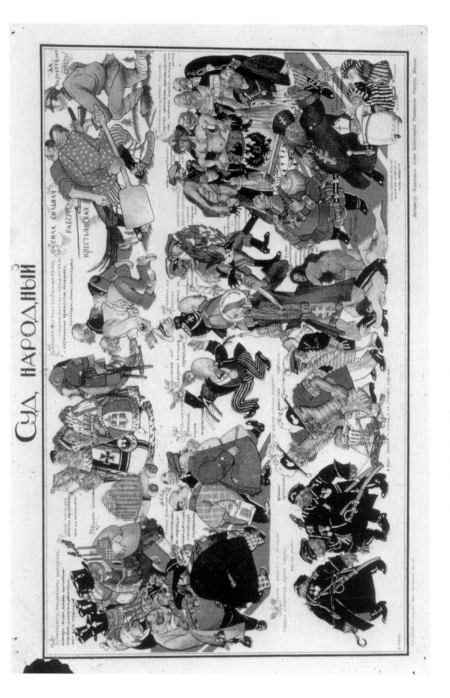

Figure 5.7. Dmitrii Moor, "Sud narodnyi" (People's Court), 1919

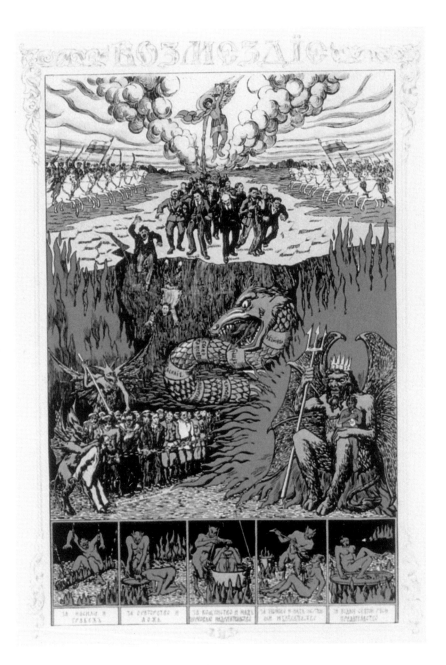

Figure 5.8. "Vozmezdie" (Retribution), 1918–1920

Figure 5.9. "Cherez krov' i cherez trupov grudy" (Wading through Blood and Climbing over Mountains of Corpses), 1918–1920

Figure 5.10. Viktor Deni, "Schastlivyi grazhdanin, znakomyi s etimi tipami tol'ko po knigam" ("It Is a Happy Citizen Who Is Acquainted with These Types Only from Books), 1932

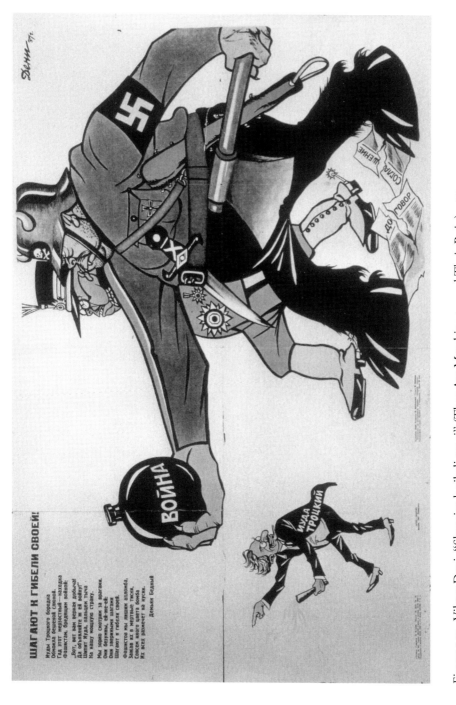

Figure 5.11. Viktor Deni, "Shagaiut k gibeli svoei" (They Are Marching toward Their Ruin), 1937

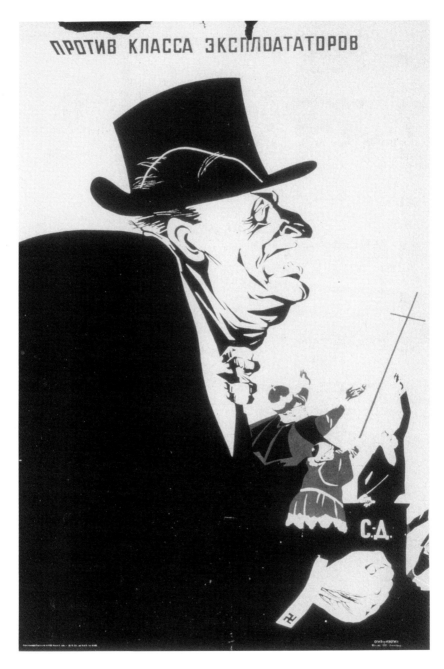

Figure 5.12. "Protiv klassa eksploatatorov" (Against the Exploiting Class), 1931

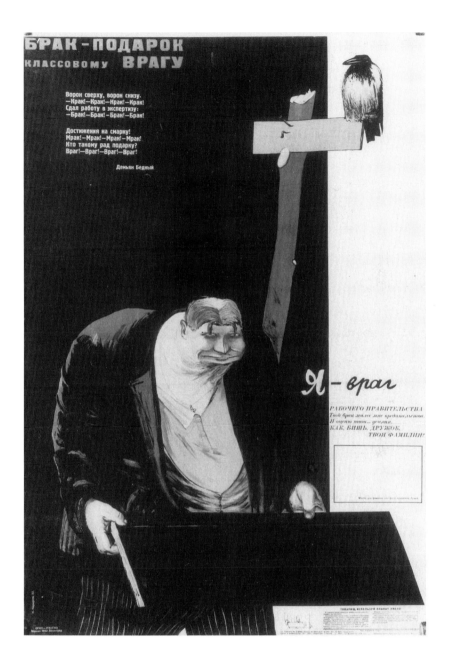

Figure 5.13. Nikolai Korshunov, "Brak—podarok klassovomu vragu" (Spoilage Is a Present to the Class Enemy), 1933

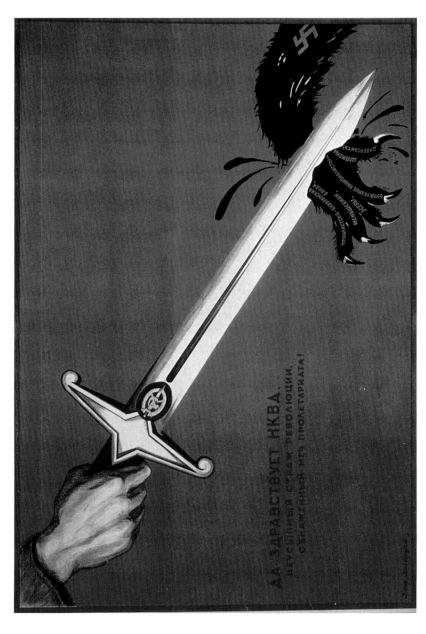

Figure 5.14. Viktor Deni and Nikolai Dolgorukov, "Da zdravstvuet NKVD" (Long Live the NKVD), 1939

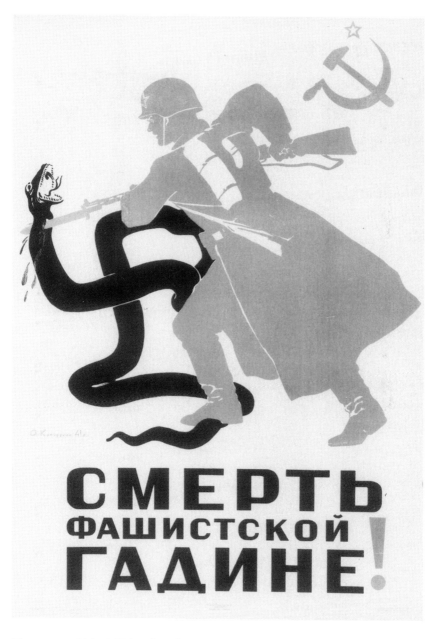

Figure 5.15. Aleksei Kokorekin, "Smert' fashistskoi gadine!" (Death to the Fascist Reptile!), 1941

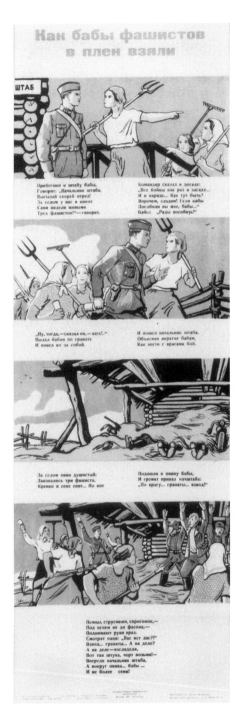

Figure 5.16. Viktor Ivanov, "Kak baby fashistov v plen vziali" (How the *Baby* Took the Fascists Prisoner), 1941

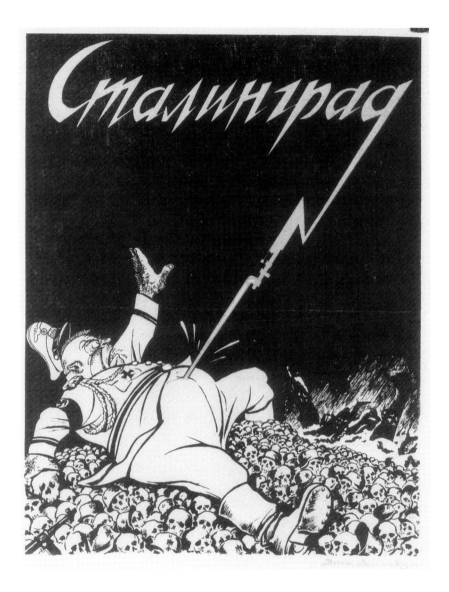

Figure 5.17. Viktor Deni and Nikolai Dolgorukov, "Stalingrad," 1942

Six

THE APOTHEOSIS OF STALINIST POLITICAL ART

POLITICAL POSTERS PRODUCED during the years following World War II (1945–1953) brought to a culmination many of the earlier trends we have identified in Soviet visual propaganda. Most notably, postwar posters raised to a new level the political mythology that projected the radiant future of communism as a present reality. These years can be described as "High Stalinism," a period when features of the Stalinist system worked out in the 1930s reached their fullest development. The atmosphere after 1945 was shaped by a complex set of emotions and circumstances arising out of the difficult war experience and the preceding decade of wrenching economic development and terror. Grief, deprivation, and hardship mingled with Russian chauvinism and pretensions to imperial glory during the twilight years of the Stalin era.

The general message of postwar visual propaganda was simple: paradise is at hand and Soviet men and women have entered a new state of being. A poster explicitly devoted to this theme, "Sbylis' mechty narodnye!" (The People's Dreams Have Come True!), by A. Lavrov, was issued in 1950 in a large edition of 300,000 copies (plate 7).[1] It is one of the most evocative propaganda creations of this era. The poster depicts an elderly man and a Young Pioneer boy (perhaps a grandfather and grandson) sitting together at a table in a ship's cabin.[2] With one arm affectionately wrapped around the young boy's shoulders, the man gestures with his other hand at the scene outside the large picture window, which frames a broad expanse of blue sky and water; an industrial plant can be seen in the distance and cargo ships in the foreground.

The text of the poster—"The People's Dreams Have Come True"— is a quotation from Nikolai Nekrasov, a nineteenth-century poet, writer, and publisher, known in the Soviet Union for his folk style and searing portrayals of urban lower classes, peasants, and the legacy of serfdom.[3] The boy holds an open book of Nekrasov's writings (perhaps he is reading "The Railroad," a narrative poem about a boy and his uncle traveling together). The painting hanging on the wall of the ship's cabin, Ilya Repin's *Barge Haulers on the Volga,* portrays the cruelty of

the old order and, like Nekrasov's work, was known to every Soviet school child.[4]

In the comfort of their deluxe cabin, with the sun lighting up their gay and untroubled faces, the old man and young boy share a moment of reflection as they ponder the happy life in the Soviet Union, where fairy tales have come true. A copy of *Pravda* resting on the table in front of them (and brightly illuminated by the sun's rays) serves as a reminder of the Communist Party's role in the great transformation, rather like a fairy godmother leading a country of Cinderellas to happiness ever after. The notion of Soviet socialism as a fairy tale actually provided the basis for a movie released in 1940, *The Shining Path,* which popularized the song: "We Were Born to Make Fairy Tales Reality."[5]

A quintessential Soviet "icon" of the postwar period, the Lavrov poster attempted to conjure up a perfect "classless" world of serenity, beauty, and harmony. The image of the Stalinist order reproduced in this and other posters of the period differs in important respects from Soviet visual propaganda of earlier years. The elderly man in Lavrov's poster represents a type of person previously excluded from the ranks of positive figures in visual propaganda. His clothing (a suit and tie), demeanor, and appearance—especially his beard—provide clues to his identity: he belongs to the ranks of the intelligentsia and has perhaps had a career as a scientist or an academic. In this period, few groups in Soviet society, apart from scientists and others engaged in scholarly work, continued to wear beards, which were considered a sign of backwardness and generally associated with the *muzhik.*[6]

Heroic status in the 1930s was primarily extended to workers, peasants, and others who performed exceptional feats—most of them involving physical exertion. During the First Five Year Plan, intellectuals and educated people were viewed with suspicion by the Bolsheviks and subjected to intermittent vilification. Only a very few exceptional individuals, such as Maksim Gorky, were celebrated for making contributions to the country's intellectual life. During World War II, some important posters featured images that had no distinctive class markings designating a worker or peasant, for example, Iraklii Toidze's famous representation of a mature woman in the poster "Rodina-mat' zovet!" (The Motherland Calls!) (fig. 6.1).[7] But in the postwar era, po-

litical artists went one step further: they depicted ordinary people engaged in nonphysical work, such as the elderly intellectual in Lavrov's poster, and presented them as exemplary citizens and valuable mentors for children. The inclusion of intellectuals and others engaged in mental as opposed to physical work was indicative of a general reorientation in the regime's policies and a realignment of social forces in the country. Most likely the shift was also connected, in part, to the changing nature of science and technology in the postwar era, when military competition depended more on sophisticated weaponry than on physical prowess and numerical superiority.

Vera Dunham has provided the most extensive discussion of this phenomenon. She argues that the Soviet party-state had relied on various social groups as allies in the past, but now that the war had ended it was looking for a "new force, sturdy and pliable. And it was the middle class which offered itself as the best possible partner in the rebuilding of the country." Dunham calls this the "Big Deal," a quid pro quo in which the middle class got material rewards and security in exchange for "loyalty to the leader, unequivocal nationalism, reliable hard work, and professionalism."[8]

Dunham's analysis has much to commend it, but her terminology raises serious problems. The term "middle class" is misleading and conjures up a host of normative and sociological connotations that pertain to non-Communist societies. Dunham's application of the category "middle class" encompasses a rather diverse collection of people including intellectuals, professional, technical, and managerial specialists, white-collar workers, and others. What all these groups have in common is their position among the educated elites and privileged groups of Soviet society.

After 1945, for the first time in Soviet history, political art presented images of these strata of society and conveyed messages intended for them. The educated Soviet elite and privileged groups now took their place alongside the workers, peasants, soldiers, sailors, pilots, and explorers. Physical exertion was no longer a requirement for inclusion among Soviet exemplars. The new acknowledgment of mental work also entailed a shift in *tipazh:* exemplary achievers under communism were no longer always youthful and energetic.

The man in the Lavrov poster belongs to the older generation of

people in the Soviet Union, those who were old enough to have witnessed the tsarist regime. His age helps to make an important ideological point about the rapidity of change (in a single lifetime) and its radical nature (dreams came true). Older people first began to show up occasionally in posters of the second half of the 1930s; a great many more were included in wartime political propaganda.

Viktor Koretskii's 1948 poster, "Soiuz nauki i truda—zalog vysokikh urozhaev!" (The Union of Science and Labor Is the Guarantee of High Yield Harvests!) (fig. 6.2), exemplifies the shift in *tipazh* that was taking place in political art with respect to both age and social class.[9] It shows a distinguished older man in a suit and tie examining specimens of wheat in a laboratory located on the premises of a farm (fields and a tractor appear out the window). A mature woman with refined features, an attractive dress, and a scarf tied around her hair is seated next to him. If not for the scarf, she might have been a scientific worker herself, but that single telling detail informs viewers that she belongs to the ranks of farm women. Koretskii attempts to show that both labor (symbolized by the woman) and science (symbolized by the man) have equal status in the symbolic union that will improve the harvest.

The earlier class markers that once served to label individuals and groups in posters tend to disappear or become muted after 1945. Peasants and workers are still depicted, but their identity now is defined more by context (i.e., the surrounding elements such as the tractor, the construction site, the factory) than *tipazh*. In fact, there is a general homogenization of *tipazh*, or typicalization, something earlier reviewers severely criticized. The image of the *kolkhoznitsa* becomes virtually interchangeable with the female worker; male workers and male peasants now belong to the same species of handsome new *Homo sovieticus*. All are attractive, well dressed, and cheerful. Many have blond hair, a quite striking departure from the brunettes in most earlier posters.[10] In some instances, it is no longer possible to identify the class position of figures depicted in posters.

The celebration of individuals continues in visual propaganda, but postwar heroes are older than their counterparts in the 1930s, and most importantly, they are now sometimes portrayed as part of the establishment. Boris Mukhin's 1952 poster, "Aktivnost' i initsiativa—vazhne-

ishii istochnik nepobedimykh sil kommunizma!" (Activity and Initiative Are the Most Important Source of the Invincible Strength of Communism!), provides an illustration of this important development (fig. 6.3).[11] Here the Stakhanovite of the postwar era is presented as a mature man who serves as a deputy to the USSR Supreme Soviet, belongs to the Soviet Committee for the Defense of Peace, and wins a Stalin Prize. Two of the three frames in the poster show the Stakhanovite N. A. Rossiiskii in his various roles: as mentor to a young worker on the shop floor, delivering a speech for the Defense of Peace, and sitting behind a desk in his office at the Supreme Soviet interviewing a young man, with a secretary at his left. The versatility in his daily life—from shop floor, to podium, to an office at the Supreme Soviet—may have suggested to contemporaries Marx's famous dictum that "in communist society, where nobody has one exclusive sphere of activity but each can accomplish in any branch he wishes . . . it is possible . . . to do one thing today and another tomorrow, to hunt in the morning, fish in the afternoon, rear cattle in the evening, criticize after dinner . . . without ever becoming hunter, fisherman, cowherd, or critic."[12]

A related theme was taken up in a 1951 poster by Boris Berezovskii, "Izuchaite velikii put' partii Lenina-Stalina!" (Study the Great Path of the Party of Lenin-Stalin!), which features a man impeccably dressed in a pinstripe suit, blue-striped shirt, and tie and reading a history of the Communist Party (perhaps the widely circulated *Short Course?*) (fig. 6.4).[13] He pauses from his book to look up at a frieze on the wall alongside, with its historical scenes of Lenin, Stalin, and others. One small detail in the poster has critical importance and surely did not escape contemporary viewers: the young man has dirty hands and fingernails. He is a worker, educating himself in the wisdom of party history and the works of Stalin and Lenin (placed on the table beside him).[14] Here again, visual propaganda conveys the message that in the era of postindustrialization, workers must study and reflect upon history, philosophy, and other matters; physical exertion is no longer enough. Like Mukhin's poster of the Stakhanovite-cum-deputy, Berezovskii's work conveys the message that Marx's vision of the versatile worker has become a reality and, by implication, that full communism must therefore be imminent.

As we have seen in earlier chapters, posters functioned prescriptively, telling people how to deport themselves, how to dress, and what heroes and enemies should look like. So it was after World War II that posters gave new signals concerning the dress code and demeanor for upright Soviet citizens.[15] Until the mid-1930s, heroic male workers and peasants were virtually always shown in their work clothes. If they had other outfits for holidays or nonworking time, these were not included in visual propaganda. Thus, posters depicted workers and peasants attending demonstrations and rallies in the same clothing they wore to work. Clothes in those years were essential class markers, and class identity provided the defining characteristic of each figure who appeared in political art.

In the second half of the 1930s, after Stalin's pronouncement that life had become better and merrier, posters begin to show workers dressed in something other than their overalls or plain factory dresses. A 1936 poster, for example, features a young couple—from the context (the Stalin factory is in the background) meant to be factory workers—with a small child walking down the street in their summer leisure clothes: a white shirt and pants for the man, a blue print dress for the woman. She carries a tennis racket.[16]

Formal men's attire, such as suits and ties, seldom appears on ordinary workers or peasants in earlier political propaganda but is reserved, instead, for distinguished people such as Lenin and Gorky. One poster issued in 1937 shows a sales clerk in a suit and tie assisting a female customer.[17] After 1945, by contrast, suits and ties were often worn by men depicted in political art, even by those working on the shop floor (see fig. 6.3)![18] A group of collective farm men in suits (some of the women in the poster also wear suit-type jackets) meet with Stalin in a 1948 poster (see fig. 6.12 discussed below). Casual clothing also appears more often. A 1952 poster shows a handsome young man leading a demonstration for peace, nattily dressed in well-tailored white slacks, a casual white short-sleeved shirt, and white shoes.[19]

In the postwar era, fashionable apparel was no longer looked down upon as something petty bourgeois, and even work clothes were sup-

posed to be attractive. To be sure, a transformation in the representation of work clothes had begun in the second half of the 1930s, when embroidered blouses and scarves appeared on peasant women. In the mid-1930s, the regime had already displayed a preoccupation with *kul'-turnost'*, a term that in the Soviet context came to mean a certain level of material culture and a "program for proper conduct in public" and was originally promoted in connection with shock workers and Stakhanovites. But these policies and images acquired a new centrality after 1945, a phenomenon that Dunham has analyzed in great detail based on a close reading of contemporary middlebrow Soviet fiction. During the postwar years, cultured behavior meant more than not spitting or cursing; it entailed an acquisitive spirit and the collection of possessions as befitted a new Soviet man and woman. "Deprivation, self-denial, and frugality," once the mark of a dedicated Communist and a good Soviet citizen, were decisively deheroized.[20]

According to the prescriptions in visual propaganda, the female version of the *Homo sovieticus* now always dressed up for work, whether in the fields or at the office. She wears attractive dresses, skirts and blouses, or sometimes tailored suits.[21] Smiling peasant women are presented in embroidered blouses and vests and even jewelry.[22] And since posters now include images of people who are not at work, the opportunities for attractive clothes are practically unlimited! At holiday celebrations, for example, people are dressed in rather elaborate outfits inspired by the Russian folk tradition. The nationalist and folk revival that began in the second half of the 1930s now gathers momentum in the chauvinist atmosphere of High Stalinism, and traditional Russian clothes are presented in posters celebrating Election Day in the countryside and May Day in Moscow.[23] A May Day poster, "Pogliadi: poet i pliashet vsia Sovetskaia strana . . . " (Take a Look: The Entire Soviet Nation Is Singing and Dancing . . .), created by Petr Golub' and Anatolii Chernov in 1946, shows women and men in folk costumes dancing gaily against the background of the Kremlin tower (fig. 6.5).[24]

The years following World War II were characterized by serious consumer shortages, and most of the clothing displayed in posters was out of reach of ordinary people. Nonetheless, political propaganda set a high standard for fashion and deliberately stimulated and encouraged

consumer aspirations. A 1950 poster by the well-known poster artist Viktor Govorkov, "Komu dostaetsia natsional'nyi dokhod?" (Who Receives the National Income?), comments precisely on this point (fig. 6.6).[25] The centerpiece of the poster is a man whose elegant clothes indicate that he is a discerning consumer, and, indeed, we see him as he departs from a department store loaded with bundles. This cheerful man wears a fur hat that matches the fur collar of his well-tailored overcoat; his elegant brown leather gloves are color coordinated with the fur trim. In all, he makes a dapper figure. The authorities were evidently eager to disseminate his image because they authorized a press run of 200,000 copies of this poster. Conceived in the *lubok* "we/they" format, the poster contrasts his earthly delights with the misery of a worker under capitalism. Govorkov, a talented and prolific poster artist, will be recalled as the creator of a memorable 1933 poster of a coal miner (fig. 1.15).

A 1946 poster by Govorkov, "S novosel'em!" (Happy Housewarming!), provides further illustration of the regime's campaign to promote the good life (fig. 6.7).[26] In the harsh postwar years, the acquisition of new living quarters signified for most Soviet citizens an improvement of tremendous significance. Govorkov depicts a lovely young woman who opens the window of her new home and gazes directly at the viewer with a sweet expression. Her appearance is striking. A long blond braid demurely hangs over one shoulder and her clothing is impeccable: a delicately printed red dress with a white lace collar, and an elegant belt to frame her comely figure. The line of her breasts and slightly parted lips, covered with red lipstick to match her dress (lipstick was quite unprecedented in earlier Soviet propaganda posters), accentuate her femininity. All the details in the poster—the lace curtain above the window, the carving on the wooden window frame, the green leaves of the plant—suggest a bucolic setting.

Coming almost directly after the war, with all its deprivations, the beautiful young woman in her new dwelling (what type is not specified) must have been quite a revelation to contemporaries. The poster appeared in several different editions with minor modifications, and at least 100,000 copies were disseminated. It will be noted that the poster makes no reference to any of the standard issues in propaganda of those years; neither Stalin nor Lenin is mentioned. Its only function is

to conjure up a powerful illusion that beautiful people live in beautiful places in the Soviet paradise.[27] Five years later, Aleksandr Laktionov's painting *In the New Flat* further explored the theme of housing, but in this composition, the image of a young boy holding a portrait of Stalin drew an explicit connection between the *vozhd'* and the joys of a new apartment.[28]

No monument to this period was quite so eloquent and grandiose as the Exhibition of Economic Achievements (VDNKh) in Moscow. Originally created in the late 1930s as an agricultural showcase, it was shut down in June 1941. The Central Committee decided to rebuild and expand VDNKh in 1947, and three years later, a general plan was approved.[29] Like other propaganda of High Stalinism, its purpose was to celebrate the arrival of prosperity and abundance in the Soviet Union. These were symbolized by numerous female allegories and a vast array of cornucopias, sheaves, and ears of grain, which appeared on everything from building facades to trash urns. VDNKh carried one step further the mission imposed upon visual propaganda: to create a compelling illusion of an earthly paradise. Here the elaborate and ingeniously constructed displays—rather resembling a Disney World of Socialism—gave tangible evidence that vegetables were bigger, chickens more plentiful, and people more cheerful than anywhere in the world. But the planners of VDNKh were not content only to accentuate the bountiful life under Soviet socialism; they also emphasized two other themes that formed the very foundation of Communist ideology in High Stalinism: the multiethnicity of the Soviet "motherland" and the glory of Stalin. These were embodied, respectively, in the Friendship of People's Fountain, which displayed life-size gilded female figures in costumes representing each Soviet republic, and a 100-foot bronze statue of Stalin, to be constructed opposite the fountain and intended to replace a giant concrete image of the Great Helmsman erected in the late 1930s.[30]

STALIN AND THE MOTHERLAND

The adulation of Stalin reached new heights during World War II. In the popular mythology, soldiers went to their death with the name of Stalin and the motherland on their lips.[31] But in contrast to the 1930s,

when Stalin's imposing image peered at spectators from ubiquitous posters and holiday displays, between 1941 and 1945 he was included in visual propaganda on relatively few occasions. Of the many thousands of window posters created by the Russian news agency Tass during the war, only a few included an image of Stalin.[32]

Iraklii Toidze, the consummate Soviet propaganda artist during World War II, created a distinctive poster featuring Stalin in 1943. In "Stalin vedet nas k pobede!" (Stalin Is Leading Us to Victory), Stalin wears a military cap with a single red star and a military overcoat (fig. 6.8).[33] He stands erect against a background of tanks, soldiers with bayonets, and airplanes, his right hand inserted into the front of his coat in the style of Napoleon. This pose had already been utilized in monumental sculpture and elsewhere before the war, for example, in the concrete statue of Stalin erected in 1939 at Moscow's All-Union Agricultural Exhibition.[34] In the Toidze poster, Stalin wears a light beige jacket trimmed in red with a gold star on the left breast. His hair and mustache, once a deep black, are now graying. By the end of the war, Stalin had exchanged the plain military tunic for a handsomely tailored military uniform, complete with epaulets and insignia of a generalissimo, a title conferred on June 27, 1945.

During World War II, Stalin was sometimes presented in posters as a silhouette on a banner or as an image within an image, for example, as a picture within a poster. Koretskii uses this device in his 1943 poster, "V radostnyi den' osvobozhdeniia iz pod iga nemetskikh zakhvatchikov" (On the Joyous Day of Liberation from under the Yoke of the German Invaders) (fig. 6.9).[35] A traditional-looking peasant family gathers around a portrait of Stalin held aloft by their young smiling blond son; departing soldiers are visible through the window of the hut. The text provides the narrative: "On the joyous day of the liberation from under the yoke of the German invaders, the first words of boundless gratitude of the Soviet people are offered to our friend and father, comrade Stalin, the organizer of our struggle for the freedom and independence of our motherland." The poster within the poster— the portrait of Stalin—presents the leader in a simple military tunic.[36] For those who recalled earlier posters such as Zotov's 1934 poster, "Liuboi krest'ianin-kolkhoznik" (Every Collective Farm Peasant) (plate 4), the family in Koretskii's poster must have been quite striking: a bearded

middle-aged man in an embroidered peasant shirt and his wife with a kerchief tied under her chin. The male peasant does, however, bear similarity to an image created by Koretskii two years earlier, in the wartime poster "Nashi sily neischislimy" (Our Strength Is Incalculable!).[37] No longer the youthful and prosperous new-style peasants depicted in Zotov's poster, Koretskii's peasants belong to a visual lexicon of earlier times.

Though seldom seen in visual propaganda between 1941 and 1945, Stalin's image reappeared in posters, medals, stamps, porcelain, holiday displays, and films once the war ended. The history of Staliniana in film provides a particularly interesting case study in the evolution of the cult. It was not until the late 1930s that Stalin was portrayed in feature films.[38] Only two films included Stalin during World War II, but the situation changed dramatically after the war came to end. Feature films such as *The Oath* (1946), *The Third Blow* (1948), *The Fall of Berlin* (1949), and *The Battle of Stalingrad* (1949) carried the Stalin cult to a new level, deifying Stalin not merely as a great civilian leader who had industrialized his country in record time but also as a military genius who had led the country—indeed the world—to victory over fascism. Now a generalissimo, Stalin was richly celebrated in all mass media.

The critical relationship between Stalin and the people finds a new visual expression in the postwar period. The "masses," once a virtual requirement in representations of the *vozhd'*, are now seldom encountered (this was more generally the case in all postwar posters). Large crowds become less important, and in their place appear smaller groups whose defining feature is not so much their class as their ethnicity within the Union of Soviet Socialist Republics. A 1951 poster, "Pod voditel'stvom velikogo Stalina—vpered k kommunizmu!" (Under the Leadership of the Great Stalin—Forward to Communism!), by Boris Berezovskii, Mikhail Solov'ev, and Ivan Shagin (plate 8), exemplifies the new imperial ethos that came to penetrate Soviet symbolism of power in the postwar era.[39] Stalin is surrounded by a group of people (some smiling) of different Soviet nationalities, against the background of a vast map of the southern portions of the USSR, an urban landscape, and oil fields.

Stalin stands majestically above the crowd at a podium with his right

arm raised and forefinger lifted to the sky (a posture reminiscent of the iconography of Lenin). He appears very large in relation to the background, although in scale not different from the people immediately surrounding him. This is a different use of perspectival distortion than in the 1920s and 1930s, but effective nonetheless in accentuating Stalin's power as the helmsman of a great empire. Stalin wears a plain tunic rather than his more usual military uniform and regalia, perhaps a symbolic suggestion that the source of his authority is something other than military rank and his position as commander-in-chief. The poster, which was produced in an edition of 500,000, exemplified the postwar imperial ethos in the Soviet Union. The imperial message was echoed in other political art produced after the war as well, such as the 1948 poster illustrating Stalin's meeting with a multiethnic group of exemplary collective farmers (see fig. 6.12 discussed below).

Basking in the glory of military victory, Stalin now thoroughly eclipsed his mentor. Posters with visual references to Lenin still appeared from time to time in the 1940s and early 1950s, reproducing the image and style of those issued during the 1930s.[40] Even more common during the war and postwar period were images pairing Lenin with Stalin, often on a banner where their two profiles would stand out against a red background or were etched on a frieze (fig. 6.4).[41] Stalin was celebrated not only as the "Lenin of today"[42] but also as "our happiness," "our fighting banner," "our *vozhd'* and our teacher," "our teacher, our father, our *vozhd'*," "the creator of the constitution of socialist society, *vozhd'* of the Soviet people," "the great *vozhd'* and general of the Soviet people," and "the beacon of communism."[43]

After many years of Staliniana that celebrated the infallible leader who stood above other men by virtue of his superhuman powers, iron willpower, and contagious magic, we see once again in the late 1940s and early 1950s the king's mortal body as an object of veneration. In the otherworldly socialist realism of the postwar era, when images often had an unprecedented softness of lighting and ambiance and pastel colors often replaced the harsher tones of red and black, Stalin's rough edges smoothed out and he emerged as a stately, wise, and kind leader. Viktor Ivanov's 1952 poster, "Velikii Stalin—svetoch kommunizma" (Great Stalin—Beacon of Communism), provides one of the most

memorable images of this type (fig. 6.10).[44] Here Stalin stands in his military uniform in front of a bookshelf filled with the leather-bound, gold-embossed collected works of Marx and Engels, Lenin and Stalin, as well as the Stalinist-inspired history of the Communist Party. Stalin holds a book in his left hand—Lenin's works, of course—and a pipe in his right hand. A small curl of smoke rises from the pipe bowl as Stalin appears to be pausing to look thoughtfully into the distance.

These small but intimate details of Stalin's private moment in his library give the viewer a sense of witnessing the human side of Stalin. In the fine arts, as well as political art, we find other examples from the late 1940s and early 1950s that dwell on Stalin the mere mortal who has passed through life's stages (for example, his childhood was celebrated in Zinaida Volkovinskaia's 1949 painting *Stalin's Childhood*)[45] to his present mature stage of life. Notwithstanding his graying hair, Stalin shows no signs of decay or diminished power; the passing of years only enhanced his stature.

The presence of the leader's temporal body did not detract in the least from the existence of the leader's other body, as everyone in the Soviet Union knew by 1952. The ubiquitous posters, portraits, and busts of Stalin in every public place, the paintings of Stalin that filled the museums, and the monuments in every city served as a constant reminder that the infallible, immortal, and utterly perfect *velikii vozhd'*—the living god—reigned supreme over the vast Soviet empire.

While the cult of Stalin continued to expand in the postwar era, references to the leading role of the Communist Party appeared far less frequently than in earlier years. The downgrading of the party in visual propaganda began in World War II, when the main appeal was to patriotism rather than party allegiance. After the war, posters still referred from time to time to the Communist Party, but it became far less important as an object of celebration than either Stalin or patriotism.

Patriotism and an imperial ethos replaced class as the primary allegiances cultivated by the Soviet regime among its citizens. As we have seen, class identification was already passing from the scene in the mid-1930s; Stalin provided a new sacred center to replace the proletariat. During World War II, the sacred name of Stalin became inextricably linked with the "motherland" (*rodina*) as the object of veneration. In

the immediate aftermath of the war, both Stalin and patriotism remained the twin pillars on which Soviet mythology rested.

But what did the "motherland" signify in an imperial age? The word *rodina* had been included in the some of the most widely distributed and celebrated posters issued during World War II. The most famous—Toidze's 1941 poster, "Rodina-mat' zovet!" (The Motherland Calls) (fig. 6.1)—shows a stately woman dressed in a flowing red garment. She holds a soldier's oath in one hand; the other hand is raised in a gesture toward bayonets in the background.[46] The choice of a woman to illustrate this slogan must have seemed entirely natural to contemporaries since the word *rodina* etymologically derives from the verb *rodit',* to give birth. The image also restored a long-suppressed tradition of female allegories, last seen in Soviet visual propaganda during the Civil War. As discussed in chapter 2, the use of a woman to symbolize Russia was commonplace during World War I, but Bolshevik artists shunned this type of imagery after the revolution because it did not correspond to the internationalist and class orientation of the new regime.

During World War II, artists not only utilized female figures to symbolize the "motherland," they also devised highly effective visual and textual metonymies to create powerful associations between the *rodina* and Russia. Another poster by Toidze, "Vo imia rodiny vpered bogatyri" (In the Name of the Motherland, Go Forward Bogatyrs), connected the motherland and the medieval Russian warrior.[47] After the war, artists used similar devices. Viktor Koretskii and Vera Gitsevich designed a poster in 1949, "Liubite rodinu!" (Love the Motherland!), depicting four Young Pioneers and a female teacher gazing out a window with expressions of reverent appreciation (fig. 6.11).[48] The window frames a great expanse of green grass, factories, and a waterway in the distance, as well as blue sky and, very importantly, a birch tree—a tree strongly associated with Russian national identity. A globe with the USSR marked in red rests on the windowsill, almost exactly in the center of the poster. Once again, visual metonymy implied a connection between Russia and the *rodina*.

By 1945, internationalism was but a distant memory in the Soviet

Union, and political artists were unreserved in their emphasis on Russian national pride and identity. One of the most widely disseminated posters at the end of the war, Leonid Golovanov's "Krasnoi armii slava!" (Glory to the Red Army!), included the phrase "Glory to the Russian people." [49] After the war as well, posters continue to accentuate *Russian* national identity, as in Viktor Ivanov's 1947 poster, "Slava russkomu narodu—narodu-bogatyriu, narodu-sozidateliu!" (Glory to the Russian People—the Bogatyr People, the Creator People!).[50] The poster shows a young man with plans for rebuilding and, behind him, the image of a *bogatyr'*. The term *russkii narod* (Russian people) appears in posters but never, as far as I can determine, the term *russkaia rodina* (Russian motherland). The term *sovetskaia rodina* (Soviet motherland), by contrast, was sometimes incorporated into postwar posters, such as the 1950 May Day poster with a banner inscribed "Velikaia sovetskaia rodina!" (the great Soviet motherland).[51] But the words and images of patriotism after 1945 continued to remind people that a very special relationship existed between the Russian people and the Soviet motherland.

While exhorting people to love their motherland, posters also reminded them that their motherland was a multiethnic union in which the Russians were first among equals.[52] A 1948 poster by Naum Karpovskii, "Trudis' s uporstvom boevym, chtoby stal kolkhoz peredovym!" (Labor with Martial Perseverance So Your Kolkhoz Becomes Part of the Vanguard!), visualizes this message (fig. 6.12).[53] An aging and benevolent Stalin stands in a Napoleonic pose amid a group of beaming collective farmers from different parts of the Soviet empire. A Russian woman is on his left, a Russian man on the right; collective farmers of other ethnic groups are clustered in the background. Dressed in their fanciest clothes, they gaze shyly but reverently at the gracious figure of Stalin (dressed in military regalia, smiling kindly), who fills the center of the poster. Stalin is illuminated by some unseen source of light, while the others—with the exception of the Russian woman—hover around him in partial shadow. Stalin radiates a sacred aura and virility. To love the motherland is to love the Father of the Peoples.

The inspirational quality of the posters by Berezovskii, Karpovskii, Koretskii, Gitsevich, and others typified many of the propaganda creations of the postwar years. They were designed to show that a new and paradisiacal life had been bestowed on the country. A description of Russian Orthodox icons captures some of the elements that were present in these political posters:

> . . . all that is depicted in the icon reflects not the disorder of our sinful world, but Divine order, peace, a realm governed not by earthly logic, not by human morality, but by Divine Grace. It is the new order in the new creation. That is why what we see in the icon is so unlike what we see in ordinary life. . . . All is bathed in light, and in their technical language iconographers call "light" the background of the icon. People do not gesticulate; their movements are not disordered, not haphazard. They officiate, and each of their movements bears a sacramental liturgical character. Beginning with the clothes of the saint, everything loses its usual haphazard character: people, landscape, architecture, animals.[54]

Functioning as secular icons, political posters of the postwar era conjured up the "divine order"—the socialist paradise—in which light, color, gesture, clothes, people, landscapes, and animals were perfectly harmonious. The colors used in posters after 1945 accentuated the serene and blissful mood. As we have seen, in the second half of the 1930s, pastel colors (especially blues and greens) appeared more often in political posters. This trend was reversed in wartime propaganda, when political artists once again reverted to heavy applications of black and red, but after the war ended, pastel colors enjoyed a revival. Dunham reports that the color pink was very fashionable in postwar middle-brow fiction.[55] In posters, light blue was favored by many artists, who missed no opportunity to include a halcyon blue sky or a blue waterway. To be sure, there were still many red banners and flags and red remained an important color, but now it was used more selectively for a woman's dress or the roses handed to Stalin by Young Pioneers, as in Nina Vatolina's affectionate rendering of "Spasibo rodnomu Stalinu

za shchastlivoe detstvo!" (Thank You Dear Stalin for a Happy Childhood!) (fig. 6.13).[56] The red tractor drivers have disappeared from visual propaganda.

When we compare the attributes of the new Soviet man and woman in the postwar era to those of the early 1930s, we find some striking contrasts. It will be recalled from chapter 1 that visual propaganda emphasized five features of the new Soviet person: youth (and a general appearance of vigor, freshness, and enthusiasm); motion (he/she was a perpetual builder of socialism); stature (often shown as larger than life); emotion (intense effort and determination or joyfulness); and the direct gaze. Many of the people depicted in postwar posters are still youthful, but now they are joined by people of varying ages, and the cult of youth has been toned down. Continuing the trend that began during World War II, elderly and middle-aged people are prominently displayed in political art (see, for example, plate 7 and figs. 6.2 and 6.12). Stalin is now shown with gray hair and a gray mustache—a dignified elderly statesman (fig. 6.10). Older men and women make their valuable contributions to Soviet society, such as the older collective farm worker who comforts a younger woman with the words "You too will be a hero!" (fig. 6.14).[57]

The theory and practice of political art after 1945 was, of course, firmly rooted in the doctrine of socialist realism first formulated in the early 1930s, but postwar applications of this doctrine differed from earlier efforts in one important respect. During the First Five Year Plan and again during World War II, Soviet political art relentlessly emphasized the act of striving, the intense collective and individual effort required to achieve the paradisiacal world that awaited people after the next battles had been won and production quotas surpassed. This feature of propaganda efforts did not, of course, originate with socialist realism but dated back to the era of the revolution and the Civil War. Nevertheless, socialist realism was conceived at a time when Herculean efforts acquired centrality in official ideology and mass media focused on the creation and celebration of heroes (first collective, then individual) and their capacity for superhuman achievements.[58] These exertions were visualized by various devices, often drawn from the Constructivist vocabulary: piercing

diagonals that stressed upward movement, bodies in motion, and strongly accented colors, especially during the first half of the 1930s.

Posters issued after World War II no longer had exhortation as their main theme; they no longer called upon people to perform superhuman feats on the battlefield, in the factory, on the collective farm, in the air (as pilots), or on the ground (as explorers). Hard work was, of course, part of the new and blissful postwar world projected by political posters, but now considerable emphasis was placed on the satisfaction and rewards derived from work well done and even, as we shall see, on contemplation of the good life provided by Soviet society. Like some posters with agricultural themes dating from the second half of the 1930s, postwar political art accentuated serenity and joyfulness amid abundance.

Although the word *bor'ba* (struggle) still appears in slogans, the images suggest quite a different orientation toward life. Gestures are more reserved, and there is less pointing and straining, except in posters focusing on the challenge posed by external enemies. The iconography used to represent enemies and those who vanquish them often reverts back to earlier patterns, with a giant worker or a giant arm and fist crushing minuscule enemies.[59] Otherwise, the larger-than-life heroic figure is seldom encountered after 1945.

Contemplation, cheerfulness, and attentiveness are the dominant emotions in postwar posters, with the exception once again of those dealing with enemies, where the old style of emotion—anger, determination, aggressiveness—still predominates. The direct gaze, used so effectively in some posters of the 1930s, is seldom encountered after 1945. When poster figures look viewers straight in the eye, as they do in Govorkov's "Komu dostaetsia natsional'nyi dokhod?" (fig. 6.6) and Govorkov's "S novosel'em!" (fig. 6.7), the gaze has lost its earlier penetrating exhortatory quality, functioning instead as an invitation to participate in the pleasures of the good life.

WOMEN AND CHILDREN

The collectivization campaign of the early 1930s was articulated, as we have seen, in the female idiom. Images of women again acquired cen-

trality during World War II. Toidze's masterful poster "Rodina-mat'
zovet!" (The Motherland Calls!) (fig. 6.1), with its revival of the female
allegorical figure representing "Mother Russia," set the tone for war-
time propaganda. Many posters subsequently appeared that featured
confident and determined women who called upon people to defeat
the fascists,[60] urged soldiers to fight more vigorously, and took over jobs
formerly performed by men.[61] Not since collectivization had Soviet po-
litical artists created such an array of forceful female figures.

In 1943, Toidze designed a second poster on the motherland theme,
"Za Rodinu-mat'!" (For the Motherland!). Again it features a mature
and stately woman in a red garment, but this time she holds a young
child in her left arm.[62] This was one of many wartime posters with a
maternal theme. In contrast to Toidze's poster, however, most artists
who emphasized the maternal theme portrayed women as terrified and
helpless creatures, threatened by fascist bayonets and clutching fright-
ened babies and young children to their breasts.[63] Indeed, an entire
genre of posters presented women (with or without children) as de-
fenseless victims of the fascist aggressors.[64] The maternal and martial
images represented the two poles of female imagery in wartime post-
ers.[65] Posters with these images included figures of all ages, many with-
out class markers or a specific context that conferred a particular social
identity.

The female idiom predominated in other types of Soviet wartime
propaganda as well. Peter Kenez has noted that "a strikingly high
percentage of the memorable figures of Second World War movies
were women. The themes that the directors emphasized—loyalty, con-
stancy, endurance and self-sacrifice—could be best expressed by show-
ing heroines."[66] The single most celebrated individual during the war
was a young woman, Zoia Kosmodem'ianskaia, the "Soviet Joan of
Arc," who died resisting the fascists.[67]

After the war had ended, images of women receded in importance in
political posters. Many artists placed female figures in their composi-
tions between 1945 and 1953 (see figs. 6.5, 6.7, 6.11, 6.12, and 6.14), but
women no longer occupied a position of centrality in visual propa-
ganda. Nevertheless, wartime compositions provided a template for
some new postwar (and soon Cold War) posters. Toidze's "Za Rodinu-

mat'" provided the inspiration for Viktor Ivanov's 1950 poster, "Materi vsego mira, borites' za mir" (Women of the Whole World, Fight for Peace). The central figure in Ivanov's poster is a dignified woman, graying at the temples, wearing a maroon shawl. Her left hand protectively encircles the shoulder of a Young Pioneer boy while the other is raised in a fist. The words "Prokliat'e podzhigateliam voiny!" (a curse on the war mongers) appear to issue from her.[68]

With the defeat of the fascists and the end of the war, the concept of the hero acquired, once again, its close connection with achievements in the production sphere. In Viktor Ivanov's 1948 poster, a middle-aged collective farm woman tells a young woman: "Ty tozhe budesh' geroem!" (You Too Will Be a Hero) (fig. 6.14).[69] The two women stand in a pasture against a pale blue sky, a handsome herd of cows gathered behind them. The younger woman is an attractive blonde with a perfect set of teeth; the older woman wears a pin signifying that she is a hero of socialist labor. The era of self-sacrificing young heroines like Zoia Kosmodem'ianskaia has passed, and now hearty milkmaids can also achieve heroic status.

After 1945, children remain highly visible in posters, where they are depicted not as victims but as alert Young Pioneers innocently enjoying the "divine order" created for them by wise elders. We find them in a variety of situations: they present Stalin with roses (fig. 6.13); gaze out a window as their teacher instructs them to "love the motherland" (fig. 6.11); listen as an elderly man tells them about how dreams have come true (plate 7); are carried in the arms of a fair-haired, handsome, smiling young man in a demonstration for peace.[70]

Women are seldom shown with their children, but images of women—with breasts no longer understated—make it clear that the regime now appreciates their reproductive function. A pronatal policy was encouraged after the war to compensate for the massive loss of life sustained during the fighting and the terror that preceded it. In 1951, a poster appeared with the slogan "Zabota o liudiakh—zakon sovetskoi zhizni" (Caring About People Is the Law of Soviet Life), which conformed, in all important respects, to the prevailing canon for depicting the "divine order" of things: blue sky, flowers, luscious green lawns, a clean and pleasant facility, and gracious interaction between mother and maternity nurse.[71]

The beatific faces and pastel colors that appeared so often in postwar political art were strikingly absent in posters that focused on enemies. As the war ended, the regime launched a major campaign against Soviet citizens who had contact with the West during World War II, followed in 1948 by an attack on "cosmopolitanism," a code word for official anti-Semitism and strident Russian chauvinism. The attack on the capitalist West (including some of Russia's recent allies in the war against Hitler) coincided with the onset of the Cold War. The United States and the United Nations were special propaganda targets.

The visual representation of enemies followed patterns already well established in the 1930s and during World War II: giant Soviet men (and now also women!) pitted against puny enemies;[72] red lightning striking the enemy;[73] an enormous red arm seizing the culprit.[74] But there was one important departure from previous practice: allegorical and animal images were now seldom used. A poster produced in Kishinev in January 1953 depicted an American soldier as a rat, but this was rather exceptional for the period.[75]

For the first time, posters focused a good deal of attention on life in the capitalist West—especially the United States—and graphically showed unemployed workers, victims of torture, and evil capitalists.[76] Capitalists made a comeback in visual propaganda after a period of absence during World War II (the capitalists, after all, were Soviet allies in those years!), but no single iconographic image of the capitalist predominated. A bald hook-nosed figure appears in some; a fat capitalist in others; still others combine elements of both caricatures.[77]

Ivan Semenov's "Tsel' kapitalizma vsegda odna" (The Goal of Capitalism Is Always the Same), created at the very end of the Stalin era by a political artist who was born in 1906 and trained in the 1920s, shows a bald elderly man with glasses and a hooked nose grasping a mound of gold coins (fig. 6.15).[78] Above are three frames showing the misdeeds of capitalism—exploitation, oppression, war—all carried out with the aim of maximizing profit. The original class markers of the capitalist— the top hat, the top coat, the corpulence—have been discarded. The poster was produced in January 1953 in an edition of 200,000 copies, its appearance coinciding with an intensification of anti-Jewish

propaganda and a public announcement of the "doctors' plot" involving Jewish Kremlin physicians who were allegedly serving as hired agents of foreign powers.[79] In this context, Semenov's hook-nosed capitalist acquired discernible anti-Semitic overtones. Such was also the case with other posters representing enemies.[80] Now artists depicted not only enemies but specifically *Jewish* enemies.

By 1953, many of the standard satirical images—such as the capitalist—had lost their consistency, and many had passed from the scene entirely. Instead of the earlier emphasis on the *tipazh* of enemies, poster artists turned to the *lubok* "we/they" format that was familiar to viewers and had been used from time to time during the preceding decades. In the postwar years, it involved only two frames; the text was usually very brief, sometimes only a few words. Perhaps more than any other format, the "we/they" *lubok*-style posters conveyed the message that the world consisted of binary opposites, of good and evil. The "we/they" posters focused on many different themes: freedom in America and the Soviet Union; planning the economy and planning for war; construction of the Volga-Don canal contrasted to the destruction carried on by Wall Street; the right to work under capitalism and under socialism; musicians under capitalism and under socialism.[81]

The late Stalinist worldview, deeply saturated by newly found imperial splendor, rested heavily on the conviction that socialism had created an unprecedented era of prosperity, freedom, and joyfulness for its citizens. Capitalism, by contrast, could offer only misery and oppression. As the Stalin era drew to a close, the regime focused on one great external villain: the capitalist warmonger whose headquarters were in the United States. Posters of the late Stalin era thematizing the enemy, especially those conceived in the "we/they" *lubok* format, resurrected and emphasized a deeply rooted bipolar conception of the world. In the postwar era, this "accentuated duality" centered around a capitalist/socialist dichotomy, which, in turn, defined all that was good and evil, heroic and villainous, sacred and profane. Amid the Arctic breezes of the Cold War, Soviet visual propaganda bifurcated the world into two camps: the United States on the one hand, and the Soviet Union and its Communist satellites and allies on the other. In conformity with the traditional Russian structure of thinking, there was no neutral zone.

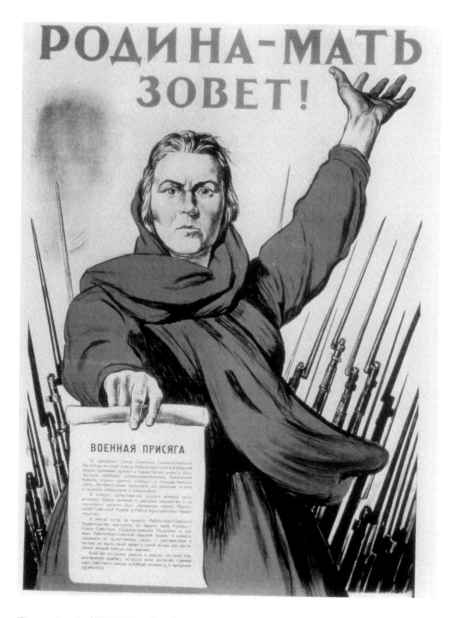

Figure 6.1. Iraklii Toidze, "Rodina-mat' zovet!" (The Motherland Calls!), 1941

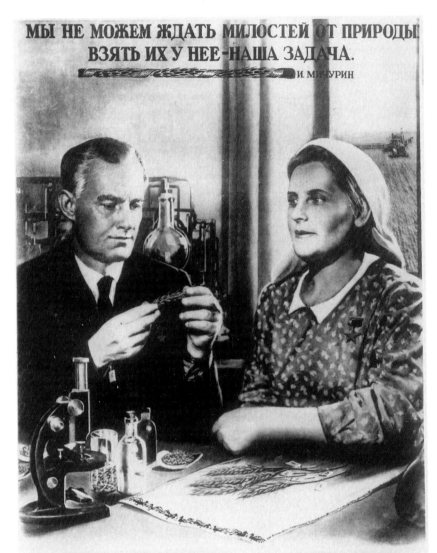

Figure 6.2. Viktor Koretskii, "Soiuz nauki i truda—zalog vysokikh urozhaev!" (The Union of Science and Labor Is the Guarantee of High Yield Harvests!), 1948

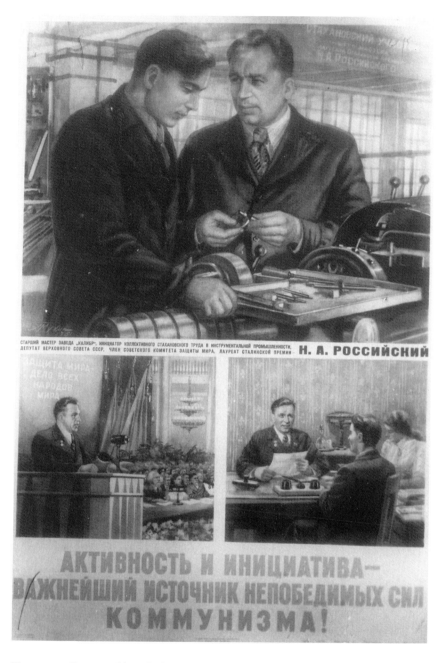

Figure 6.3. Boris Mukhin, "Aktivnost' i initsiativa—vazhneishii istochnik nepobed-imykh sil kommunizma!" (Activity and Initiative Are the Most Important Source of the Invincible Strength of Communism!), 1952

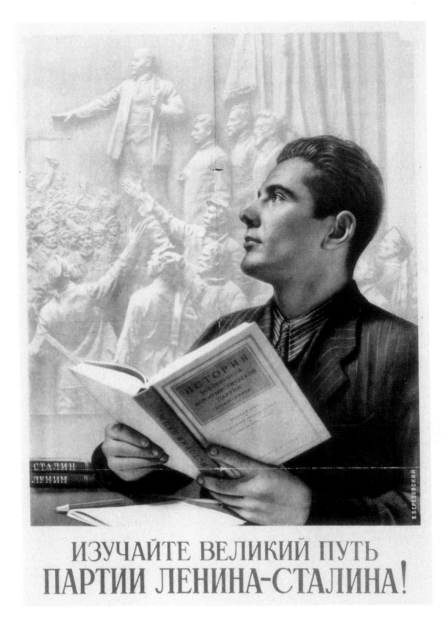

Figure 6.4. Boris Berezovskii, "Izuchaite velikii put' partii Lenina-Stalina!" (Study the Great Path of the Party of Lenin-Stalin!), 1951

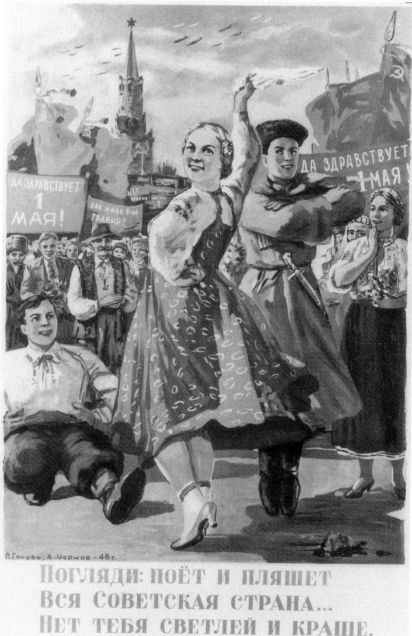

Figure 6.5. Petr Golub' and Anatolii Chernov, "Pogliadi: poet i pliashet vsia So-
vetskaia strana . . . " (Take a Look: The Entire Soviet Nation Is Singing and
Dancing . . .), 1946

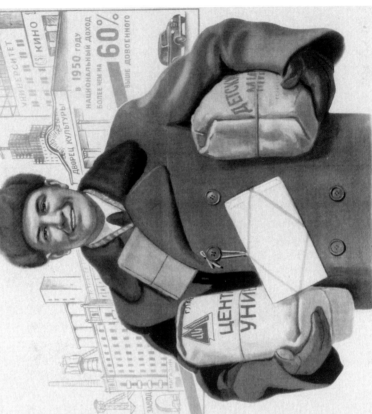

Figure 6.6. Viktor Govorkov, "Komu dostaetsia natsional'nyi dokhod?" (Who Receives the National Income?), 1950

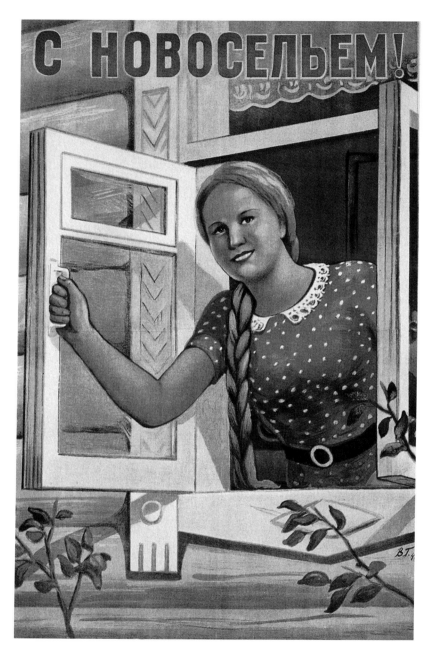

Figure 6.7. Viktor Govorkov, "S novosel'em!" (Happy Housewarming!), 1946

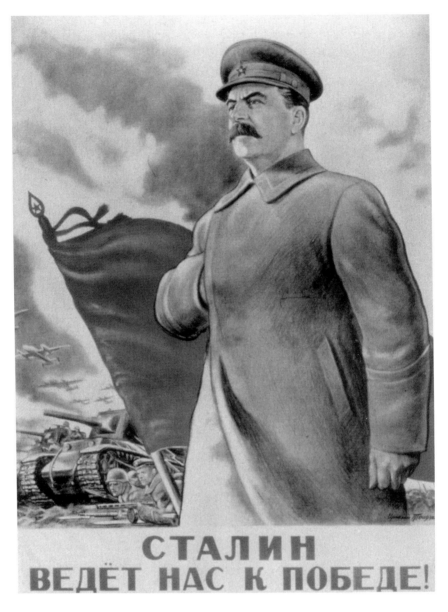

Figure 6.8. Iraklii Toidze, "Stalin vedet nas k pobede!" (Stalin Is Leading Us to Victory), 1943

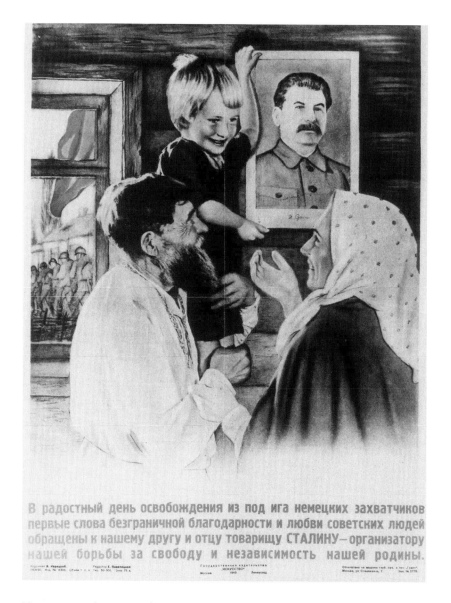

В радостный день освобождения из под ига немецких захватчиков первые слова безграничной благодарности и любви советских людей обращены к нашему другу и отцу товарищу СТАЛИНУ—организатору нашей борьбы за свободу и независимость нашей родины.

Figure 6.9. Viktor Koretskii, "V radostnyi den' osvobozhdeniia iz pod iga nemetskikh zakhvatchikov" (On the Joyous Day of Liberation from under the Yoke of the German Invaders), 1943

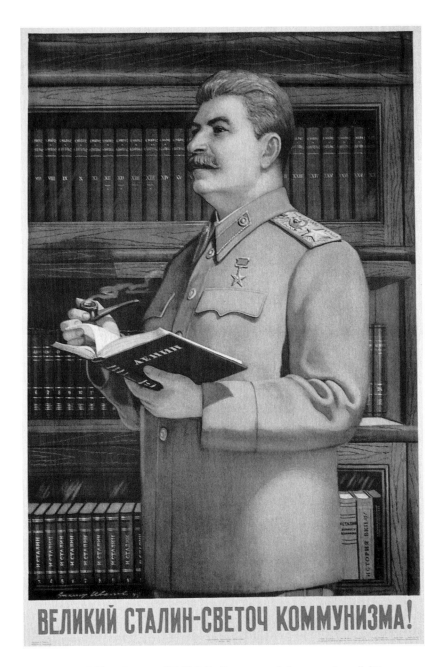

Figure 6.10. Viktor Ivanov, "Velikii Stalin—svetoch kommunizma" (Great Stalin—Beacon of Communism), 1952

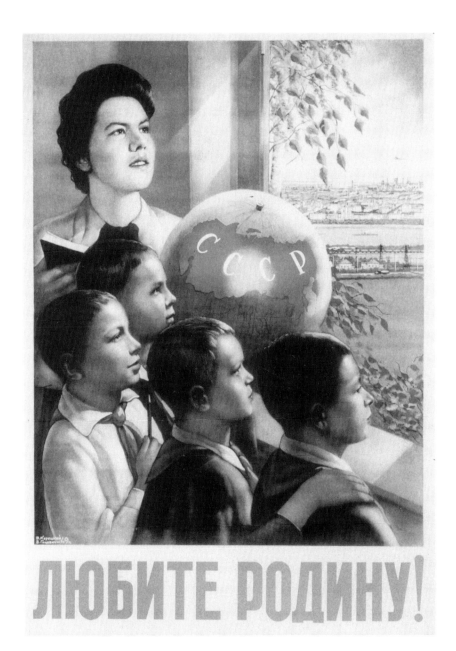

Figure 6.11. Viktor Koretskii and Vera Gitsevich, "Liubite rodinu!" (Love the Mother-land!), 1949

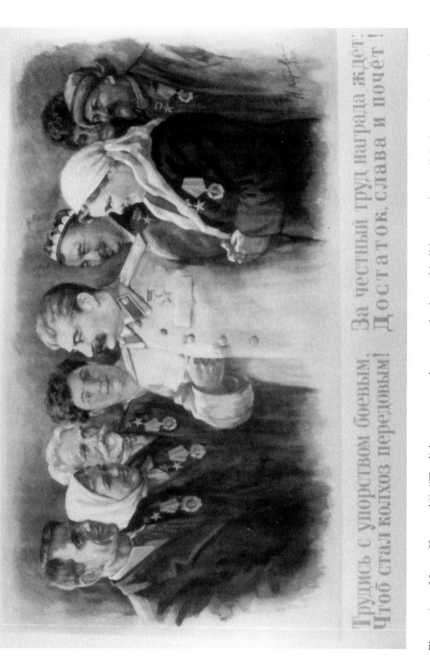

Figure 6.12. Naum Karpovskii, "Trudis' s uporstvom boevym, chtoby stal kolkhoz peredovym!" (Labor with Martial Perseverance So Your Kolkhoz Becomes Part of the Vanguard!), 1948

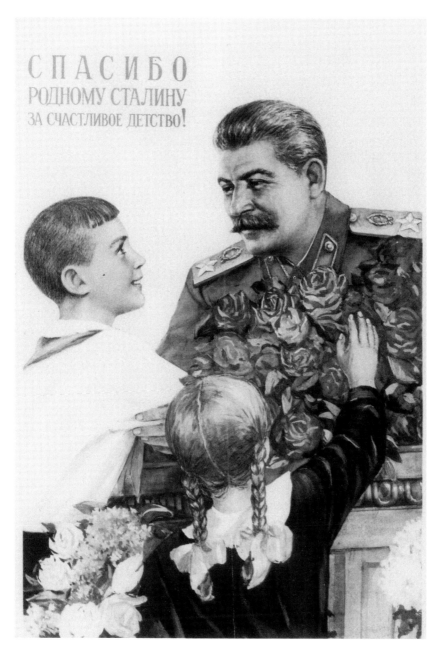

Figure 6.13. Nina Vatolina, "Spasibo rodnomu Stalinu za schastlivoe detstvo!"
(Thank You Dear Stalin for a Happy Childhood!), 1950

Figure 6.14. Viktor Ivanov, "Ty tozhe budesh' geroem!" (You Too Will Be a Hero!), 1948

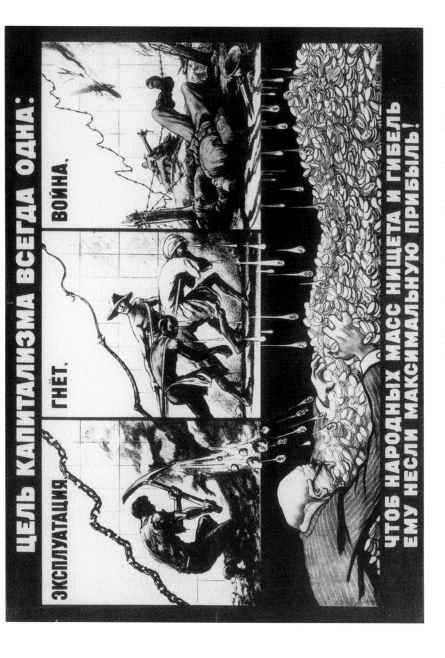

Figure 6.15. Ivan Semenov, "Tsel' kapitalizma vsegda odna" (The Goal of Capitalism Is Always the Same), 1953

NOTES

PREFACE

1. Pierre Bourdieu, *Distinction: A Social Critique of the Judgement of Taste* (Cambridge, Massachusetts, 1984), 3.

INTRODUCTION

1. Furet makes this statement with reference to the French Revolution of 1789. François Furet, *Interpreting the French Revolution,* trans. Elborg Forster (Cambridge and London, 1981), 114.
2. Hobsbawm, introduction to *The Invention of Tradition,* ed. Eric Hobsbawm and Terence Ranger (Cambridge and London, 1984), 1.
3. Ibid., 9.
4. Peter Kenez, *The Birth of the Propaganda State: Soviet Methods of Mass Mobilization, 1917–1929* (Cambridge and London, 1985); Richard Stites, *Revolutionary Dreams: Utopian Vision and Experimental Life in the Russian Revolution* (New York and Oxford, 1989); James von Geldern, *Bolshevik Festivals, 1917–1920* (Berkeley and Los Angeles, 1993).
5. A legislative act of January 13, 1918, replaced the Julian calendar (followed by the Russian Orthodox church) with the Gregorian calendar. After the shift to the Gregorian calendar, the revolution of October 25 was celebrated on November 7, but was still known as the "October" Revolution.
6. Von Geldern, *Bolshevik Festivals,* 31, describes the *instsenirovka* as "an adaptation of nondramatic material, usually prose, to the stage." One notable

example was the large-scale reenactment of the taking of the Winter Palace on the occasion of the third anniversary of the revolution.

7. Kenez, *Birth of the Propaganda State,* 73, 157.

8. Viktor Kumanev, *Sotsializm i vsenarodnaia gramotnost': Likvidatsiia massovoi negramotnosti v SSSR* (Moscow, 1967), 296.

9. On this subject, see Richard Wortman, "Moscow and Petersburg: The Problem of Political Center in Tsarist Russia, 1881–1914," in *Rites of Power: Symbolism, Ritual, and Politics Since the Middle Ages,* ed. Sean Wilentz (Philadelphia, 1985), 244–274; Richard S. Wortman, *Scenarios of Power: Myth and Ceremony in Russian Monarchy,* vol. 1 (Princeton, 1995).

10. Leonid Ouspensky and Vladimir Lossky, *The Meaning of Icons,* trans. G. E. H. Palmer and E. Kadloubovsky (Crestwood, New York, 1983), 45. On the origins of the worship of icons in the Eastern Orthodox Church, see Peter Brown's essay, "The Dark Age Crisis: Aspects of the Iconoclastic Controversy," in Peter Brown, *Society and the Holy in Late Antiquity* (Berkeley and Los Angeles, 1982).

11. Ouspensky and Lossky, *Meaning of Icons,* 41.

12. Linda J. Ivanits, *Russian Folk Belief* (Armonk, New York, and London, 1989), 23.

13. Nadezhda Konstantinovna Krupskaia, *Pedagogicheskie sochineniia v desiati tomakh,* vol. 7 (Moscow, 1959), 170.

14. Stephen White, *The Bolshevik Poster* (New Haven and London, 1988), 19.

15. In 1917, the population in the Russian Empire was roughly 140 million people. During the Civil War, substantial parts of the country were under White control.

16. B. S. Butnik-Siverskii, *Sovetskii plakat epokhi grazhdanskoi voiny, 1918–1921* (Moscow, 1960), 19, 23.

17. White, *The Bolshevik Poster,* 109. The *lubok* (plural *lubki*), an illustrated broadside, was popular among lower-class groups. See Jeffrey Brooks, *When Russia Learned to Read: Literacy and Popular Literature, 1861–1917* (Princeton, 1985).

18. Albert Rhys Williams, *Through the Russian Revolution* (London, 1923), 5, cited in White, *The Bolshevik Poster,* 109. When Walter Benjamin visited the Soviet Union in late 1926, he noted the ubiquitous presence of posters in workplaces, streets, clubs, and reading rooms. Walter Benjamin, *Moscow Diary,* ed. Gary Smith (Cambridge, Massachusetts, 1986), 49–50, 60–61, 64.

19. Lynn Mally, *Culture of the Future: The Proletkult Movement in Revolutionary Russia* (Berkeley and Los Angeles, 1990).

20. Hobsbawm and Ranger, eds., *Invention of Tradition,* 6.

21. Joan Wallach Scott, *Gender and the Politics of History* (New York, 1988), 42, 44, 48.

22. See White, *The Bolshevik Poster,* for a discussion of the background of key artists from the Civil War period.

23. The title was conferred by fellow artist Aleksander Deineka. White, *The Bolshevik Poster,* 43.

24. For an account of Soviet art training, see Natal'ia Adaskina, "The Place of Vkhutemas in the Russian Avant-Garde," in *The Great Utopia: The Russian and Soviet Avant-Garde, 1915–1932* (New York, 1992), 283–293.

25. On this general subject, see M. Baxandall, *Painting and Experience in Fifteenth Century Italy* (London, 1972).

26. Ronald Paulson, *Representations of Revolution, 1789–1820* (New Haven and London, 1983), 17.

27. Reinhart Koselleck, *Futures Past: On the Semantics of Historical Time* (Cambridge, Massachusetts, and London, 1985), 76.

28. "Begriffsgeschichte and Social History," in ibid.

29. William Sewell, Jr., *Work and Revolution: The Language of Labor from the Old Regime to 1848* (Cambridge, England, 1980).

30. I did not always obtain material on topics that I requested. For example, I saw relatively few posters pertaining to the period between 1939 and 1941, when the Hitler-Stalin Pact was in effect; nor was I able to obtain posters relating explicitly to the anti-cosmopolitanism campaign.

31. Polonskii was also a founder and chief editor of the journals *Novyi mir* and *Pechat' i revoliutsiia.* White, *The Bolshevik Poster,* 40–41; Jeffrey Rossman, "Politics, Culture and Identity in Revolutionary Russia: A Reading of the Life and Works of Viacheslav Polonskii," unpublished seminar paper, Department of History, University of California, Berkeley, May 1990.

32. Viacheslav Polonskii, *Russkii revoliutsionnyi plakat* (Moscow, 1925). A short earlier version appeared in *Pechat' i revoliutsiia* 2 (April–June 1922), 56–77.

33. G. L. Demosfenova, A. Nurok, and N. Shantyko, *Sovetskii politicheskii plakat* (Moscow, 1962).

34. Richard S. Wortman, *Scenarios of Power: Myth and Ceremony in Russian Monarchy,* vol. 1 (Princeton, 1995).

35. The first edition was under the title *Geist und Gesicht des Bolschewismus* (Zurich, Leipzig, and Vienna, 1926). The English edition was translated by F. S. Flint and D. F. Tait and published in the United States and England in 1927.

36. White, *The Bolshevik Poster.*

37. François-Xavier Coquin, "L'affiche révolutionnaire soviétique (1918–1921): Mythes et réalités," *Revue des études slaves* 59, no. 4 (1987), 719–740; Coquin, "L'image de Lénine dans l'iconographie révolutionnaire et postrévolutionnaire," *Annales ESC* 2 (March–April 1989), 223–249. François-Xavier Coquin, "Une source méconnue: Les affiches contre-révolutionnaires (1918–1920)" in *Russie–URSS, 1914–1991: Changements de regards,* ed. Wladimir Berelowitch and Laurent Gervereau (Paris, 1991), 52–60.

38. Nina Tumarkin, *Lenin Lives! The Lenin Cult in Soviet Russia* (Cambridge, Massachusetts, 1983); Kenez, *Birth of the Propaganda State;* Stites, *Revolutionary Dreams.*

39. Igor Golomstock, *Totalitarian Art in the Soviet Union, the Third Reich, Fascist Italy and the People's Republic of China* (New York, 1990); Boris Groys, *The Total Art of Stalinism: Avant-Garde, Aesthetic Dictatorship, and Beyond* (Princeton, 1992), originally published as *Gesamtkunstwerk Stalin* (Munich, 1988); Hans Günther, ed., *The Culture of the Stalin Period* (New York, 1990).

40. Katerina Clark, *The Soviet Novel: History as Ritual* (Chicago and London, 1981); Christel Lane, *The Rites of Rulers: Ritual in Industrial Society—the Soviet Case* (Cambridge, England, and London, 1981); von Geldern, *Bolshevik Festivals.*

41. Maurice Agulhon, *Marianne into Battle: Republican Imagery and Symbolism in France, 1789–1880* (Cambridge, England, 1981); Lynn Hunt, *Politics, Culture, and Class in the French Revolution* (Berkeley and Los Angeles, 1984); Mona Ozouf, *Festivals of the French Revolution,* trans. Alan Sheridan (Cambridge, Massachusetts, 1988). Other significant research in this area can be found in Pierre Nora's collection of essays, *Les lieux de mémoire,* vols. 1–2 (Paris, 1984–1986).

42. Hobsbawm and Ranger, eds., *Invention of Tradition;* Sean Wilentz, ed., *Rites of Power: Symbolism, Ritual, and Politics Since the Middle Ages* (Philadelphia, 1985).

43. Eric Hobsbawm, "Man and Woman in Socialist Iconography," *History Workshop* 6 (Autumn 1978); Maurice Agulhon, "On Political Allegory: A Reply to Eric Hobsbawm," *History Workshop* 8 (Autumn 1979); Sally Alexander, Anna Davin, and Eve Hostettler, "Labouring Women: A Reply to Eric Hobsbawm," *History Workshop* 8 (Autumn 1979).

44. Erwin Panofsky, *Studies in Iconology: Humanistic Themes in the Art of the Renaissance* (New York, 1962), and *Meaning in the Visual Arts: Papers in and on Art History* (Woodstock, New York, 1974).

45. For a discussion of issues relating to iconography, see W. J. T. Mitchell, *Iconology: Image, Text, Ideology* (Chicago and London, 1986).

46. Other studies in art history that have influenced my presentation of visual material include E. H. Gombrich, *Art and Illusion: A Study in the Psychology of Pictorial Representation* (Princeton, 1984); T. J. Clark, *Image of the People: Gustave Courbet and the 1848 Revolution* (Princeton, 1982); and Linda Nochlin, *Women, Art, and Power and Other Essays* (New York, 1988).

47. Clifford Geertz, *Local Knowledge: Further Essays in Interpretive Anthropology* (New York, 1983), 12, 109; Baxandall, *Painting and Experience in Fifteenth Century Italy,* part 2.

48. See Geertz's essay, "Art as a Cultural System," in *Local Knowledge.*

CHAPTER I. ICONOGRAPHY OF THE WORKER

1. Lynn Hunt, *Politics, Culture, and Class in the French Revolution* (Berkeley and Los Angeles, 1984), 104, 106, and more generally, chap. 3; François Furet,

Interpreting the French Revolution, trans. Elborg Forster (Cambridge, Massachusetts, and London, 1981). According to Greek mythology, a hydra had nine heads. When any one head was cut off, two others took its place.

2. On Marianne, see Maurice Agulhon, *Marianne into Battle: Republican Imagery and Symbolism in France, 1789–1880* (Cambridge, England, 1981); Hunt, *Politics, Culture, and Class.*

3. Christina Lodder, "Lenin's Plan for Monumental Propaganda," in *Art of the Soviets,* ed. Matthew Cullerne Bown and Brandon Taylor (Manchester and New York, 1993), 16–32; Richard Stites, *Revolutionary Dreams: Utopian Vision and Experimental Life in the Russian Revolution* (New York and Oxford, 1989), 88–89.

4. See Peter Kenez, *The Birth of the Propaganda State: Soviet Methods of Mass Mobilization, 1917–1929* (Cambridge, Massachusetts, and London, 1985), for a comprehensive account of these efforts.

5. In contemporary sources, the blacksmith is generally called a *kuznets* but occasionally also a *molotoboets* (hammerer). The latter term is more strictly limited to an industrial setting and reflects a greater division of labor than the term *kuznets;* however, *kuznets* was also a major occupational designation in large metalworking factories.

6. RU/SU 801.

7. Eric Hobsbawm, "Man and Woman in Socialist Iconography," *History Workshop* 6 (Autumn 1978), 127–128.

8. Two major works present this image: "Oruzhiem my dobili vraga" by Nikolai Kogout (October 1920) (fig. 1.1), RU/SU 1280; and "1-oe maia vserossiiskii subbotnik" by Dmitrii Moor (May 1920) (fig. 2.9), KP pi.II.3/1 maia vserossiiskii subbotnik.

9. V. V. Shleev, ed., *Revoliutsiia 1905–1907 godov i izobrazitel'noe iskusstvo,* 4 vols. (Moscow, 1977–1989). The Shatan picture appears at 3: 39; the illustration from *Volga* at 2: 102. Other examples of representations of workers from this period can be found at 1: 18, 22, 31, and 3: 6. Most of these present images of the blacksmith; one shows the head and torso of a "generic" worker in a cap and Russian shirt. There were also occasional illustrations of the blacksmith's hammer. See, for example, 3: 24.

10. RU/SU 1226. The poster appeared as a supplement to the journal *Vestnik melkago kredita.*

11. Richard Stites, "Adorning the Revolution: The Primary Symbols of Bolshevism, 1917–1918," in *Sbornik: Study Group of the Russian Revolution* (Leeds) 10 (1984), 40, and fig. 3.

12. The drawing is by E. V. Orlovskii. A reproduction of it appears in *V. I. Lenin i izobrazitel'noe iskusstvo,* 15.

13. RU/SU 1262. The proclamation urges people to vote and declares that "your every act, your every step has significance for the entire revolution, for the entire working class."

14. RU/SU 18. The league, a successor to the All-Russian Union for Women's

Equality founded in 1905, was registered in 1907; it became active at the end of 1909, mainly on behalf of women's suffrage. Before 1917, it attracted about 1,000 members. After the February Revolution, it organized one of the first mass demonstrations in Petrograd. On March 20, some 40,000 women marched to demand suffrage for women in elections to the Constituent Assembly. Richard Stites, *The Women's Liberation Movement in Russia: Feminism, Nihilism, and Bolshevism, 1860–1930* (Princeton, 1978), 220–222, 292.

15. Stites, *Revolutionary Dreams,* 85–87. The original drawing for the seal also included a sword, but Lenin requested its removal.

16. Alexis Khripounoff, "Un parcours parmi les timbres, des origines à nos jours," in *Russie–URSS, 1914–1991: Changements de regards,* ed. Wladimir Berelowitch and Laurent Gervereau (Paris, 1991), 250.

17. V. P. Tolstoi, ed., *Agitatsionno-massovoe iskusstvo. Oformlenie prazdnestv, 1917–1932,* Tablitsy (Moscow, 1984), fig. 32; O. Nemiro, *V gorod prishel prazdnik: Iz istorii khudozhestvennogo oformleniia sovetskikh massovykh prazdnestv* (Leningrad, 1973), 17–18.

18. Mikhail Guerman, ed., *Art of the October Revolution* (New York, 1979), plates 187–193; Tolstoi, ed., *Agitatsionno-massovoe iskusstvo,* Tablitsy, figs. 45–47.

19. V. I. Kozlinskii, in Tolstoi, ed., *Agitatsionno-massovoe iskusstvo,* Tablitsy, fig. 63.

20. Ibid., figs. 79, 82, 89, 94.

21. James von Geldern, *Bolshevik Festivals, 1917–1920* (Berkeley and Los Angeles, 1993), 169. The sculptor suffered a heart attack the day after his sculpture "had a couple of parts knocked off" to accommodate the apron. A photograph of the sculpture appears on 170.

22. Apsit's real name was Aleksandrs Apsitis. He signed his posters with the pseudonym A. Petrov. For a discussion of Apsit's life, see Stephen White, "The Political Poster in Bolshevik Russia," *Sbornik: Study Group of the Russian Revolution* (Leeds) 8 (1982), 26, and his study, *The Bolshevik Poster* (New Haven and London, 1988), 25–32.

23. RU/SU 1280. For other examples, see Apsit's posters "Obmanutym brat'iam" (1918) (fig. 2.3), RU/SU 1546, and "Internatsional" (1918) (fig. 2.7), RU/SU 2282; Zvorykin, "Bor'ba krasnogo rytsaria s temnoi siloiu" (1919) (fig. 1.8), RU/SU 1285; Kiselis, "Belogvardeiskii khishchnik" (1920)(fig. 1.10), RU/SU 1287.

24. Hunt, *Politics, Culture, and Class,* 109–110. The image of Marianne also appeared in several different versions. See ibid., 93, and Agulhon, *Marianne.*

25. Guerman, ed., *Art of the October Revolution,* fig. 9.

26. MR A52120.

27. Agulhon provides an example from French iconography that illustrates how a symbol can acquire not only complex but even contradictory meanings. Following the establishment of the Third Republic in 1870, the female allegorical figure of Liberty-the-Republic came to symbolize both the state and

the movement directed against the state. Maurice Agulhon, "On Political Allegory: A Reply to Eric Hobsbawm," *History Workshop* 8 (Autumn 1979), 170.

28. *Sovetskoe izobrazitel'noe iskusstvo: Zhivopis', Skul'ptura, Grafika, Teatral'no-dekoratsionnoe iskusstvo* (Moscow, 1977), fig. 193. Posters produced for the tenth anniversary of the October Revolution also emphasized the leading role of the worker. See, for example, Petr Shukhmin, "Pod znamenem VKP(b)" (1927), which shows a worker in the forefront, followed by a Red Army soldier, a woman worker, and a male peasant. *Soviet Political Poster,* 48.

29. The largest organization was the Literature and Publishing Department of the Political Administration of the Revolutionary Military Council of the Republic, established in October 1919 and headed throughout the Civil War by Viacheslav Polonskii. See B. S. Butnik-Siverskii, *Sovetskii plakat epokhi grazhdanskoi voiny, 1918–1921* (Moscow, 1960), 17–22; White, *The Bolshevik Poster,* 39–40.

30. François-Xavier Coquin, "L'affiche révolutionnaire soviétique (1918–1921): Mythes et réalités," *Revue des études slaves* 59, no. 4 (1987), 737.

31. A. Buzinov, *Za Nevskoi zastavoi: Zapiski rabochego* (Moscow and Leningrad, 1930), 21. The "hot shop" included the smelting, rolling, and blacksmith shops.

32. On these points, see V. V. Ivanov and V. N. Toporov, "Problema funktsii kuznetsa v svete semioticheskoi tipologii kul'tur," in *Materialy vsesoiuznogo simpoziuma po vtorichnym modeliruiushchim sistemam I (5)* (Tartu, 1974), 87–90. The sacred attributes of the blacksmith were not only celebrated in Slavic folklore but can be found in many popular traditions in Indo-European culture.

33. Shkulev was born in 1868, the son of poor peasants. At the age of fourteen, he lost his right hand in a factory accident. He wrote a number of songs; this was his most popular. *Sovetskie pesni* (Moscow, 1977), 14–15; *Russkie revoliutsionnye pesni* (Moscow, 1952), 127.

34. *Antologiia sovetskoi pesni, 1917–1957* (Moscow, 1957), 1: 27. During the Civil War, the figure of the blacksmith frequently appeared in poetry produced by proletarian writers. In 1920, some proletarian writers in Moscow withdrew from the Proletkul't organization to form a new group. They named their organization and journal *Kuznitsa* (Smithy). *Proletarskie poety pervykh let sovetskoi epokhi* (Leningrad, 1959), 50. See p. 77 for a poem, "Kuznitsa," by V. D. Aleksandrovskii.

35. Paul Brandt, *Schaffende Arbeit und bildende Kunst im Altertum und Mittelalter* (Leipzig, 1927), 62, 63, 105.

36. Paul Brandt, *Schaffende Arbeit und bildende Kunst vom Mittelalter bis zur Gegenwart* (Leipzig, 1928), 55–57.

37. Ibid., 58–59.

38. Ibid., 256–274; Micheline Hanotelle, *Rodin et Meunier: Relations des sculpteurs français et belges à la fin du XIX siècle* (Paris, 1982); Eugenia W. Herbert,

The Artist and Social Reform: France and Belgium, 1885–1898 (New Haven, 1961); Hobsbawm, "Man and Woman," 125.

39. Brandt, *Schaffende Arbeit und bildende Kunst im Altertum und Mittelalter,* 269, fig. 343. According to Brandt, this was Meunier's greatest work (342).

40. Agulhon, "On Political Allegory," 170–171. My research has not turned up examples of the blacksmith image in German socialist sources prior to 1918. The blacksmith appeared in other cultural spheres of that era, however. Richard Wagner's *Ring of the Nibelung,* a major cultural landmark, featured a blacksmith as one of its principal characters.

41. White, "Political Poster in Bolshevik Russia," 26.

42. In the discussion that follows, I have benefited greatly from Boris Uspensky, *The Semiotics of the Russian Icon,* ed. Stephen Rudy (Lisse, Belgium, 1976).

43. An example is Apsit's "Obmanutym brat'iam" (1918) (fig. 2.3), RU/SU 1546. See also White, *The Bolshevik Poster,* 34.

44. MR A52250.

45. The altar carries the inscription: "Vsia vlast' sovetam. Rabochii k stanku! Krest'ianin k plugu! Vse za upornyi trud vo imia pobedy kommunizma" (All power to the soviets! Worker take your place at the workbench! Peasant take your place at the plow! Let us all work steadily for the victory of communism).

46. Uspensky, *Semiotics of the Russian Icon,* 55. Posters issued by the Whites in the Civil War also drew extensively on religious themes and imagery. In one poster, the Russian people are symbolized by Jesus Christ carrying the cross while Trotsky looks on scornfully from the sidelines (fig. 5.9). RU/SU 898. In another poster, reminiscent of Dante's *Inferno,* the Bolsheviks are falling into a pit of flames and subjected to punishments for various crimes (fig. 5.8). RU/SU 1042. Still another depicts two scenes, one presided over by the devil (the Bolshevik side), the other dominated by a cross suspended from the clouds. RU/SU 1782. For a discussion of White posters, see chapter 5.

47. Ulf Abel, "Icons and Soviet Art," in *Symbols of Power: The Esthetics of Political Legitimation in the Soviet Union and Eastern Europe,* ed. Claes Arvidsson and Lars Erik Blomquist (Stockholm, 1987), 152–153. Contemporary Soviet artists were highly conscious of color symbolism. See, for example, comments by Dmitrii Moor on this subject in *Brigada khudozhnikov* 4 (1931), 14. *Krasnyi* also had the connotation of "beautiful."

48. G. L. Demosfenova, A. Nurok, and N. I. Shantyko, *Sovetskii politicheskii plakat* (Moscow, 1962), 84.

49. Uspensky, *Semiotics of the Russian Icon,* 60.

50. "Gorodki," RU/SU 853; "Ono poniatno, chto pogret'sia kazhdomu khochetsia, tol'ko zachem zhe . . . tae . . . gur'boi-to?" RU/SU 149.

51. RU/SU 1285. This poster was issued for the second anniversary of the revolution.

52. MR A26318.

53. RU/SU 1287. A different version showed a snake rather than an eagle attacking the worker. Butnik-Siverskii, *Sovetskii plakat,* no. 869.

54. Von Geldern, *Bolshevik Festivals,* 144–145.

55. Ibid., 32, 162, 183. For example, in November 1918, the Bolshoi performed Scriabin's symphonic poem *Prometheus.* In 1919, the Red Army Studio prepared a drama, *The Russian Prometheus;* in 1920, there was an amateur production, *The Fire of Prometheus,* performed by Red Army theater groups, and a May Day plan for a mass drama based on the myth of Prometheus. For a discussion of the Prometheus myth during the Stalin era, see Hans Günther, "Geroi v totalitarnoi kul'ture," in *Agitatsiia za schast'e: Sovetskoe iskusstvo stalinskoi epokhi,* comp. Hubertus Gassner (Dusseldorf-Bremen, 1994), 73–74.

56. See, for example, Pimenov's posters, "My stroim sotsializm" (1927) and "Vse na smotr!" (1928), in *The Great Utopia: The Russian and Soviet Avant-Garde, 1915–1932* (New York, 1992), nos. 390, 391. In both posters, the worker—a lean muscular figure—is depicted as engaged in heavy manual labor. These posters are also reproduced in *Agitatsiia za schast'e,* 43, 46.

57. Nikolai Maslenikov, *Plakat* (Moscow, 1930), 39.

58. *Produktsiia izobrazitel'nykh iskusstv* 3–4 (1932), 10.

59. For an excellent discussion of this topic, see Katerina Clark, *The Soviet Novel: History as Ritual* (Chicago and London, 1981), and "Little Heroes and Big Deeds: Literature Responds to the First Five-Year Plan," in *Cultural Revolution in Russia, 1928–1931,* ed. Sheila Fitzpatrick (Bloomington, 1984).

60. Clark, "Little Heroes," 200–201.

61. The silhouette dates from eighteenth-century France and was named after Étienne de Silhouette, a French magistrate, who attempted to restrict the king's spending. His silhouette was placed in windows as part of an effort to ridicule his policies ("Man reduced to a mere outline no longer inspired the same respect"). Robert Philippe, *Political Graphics: Art as a Weapon* (New York, 1982), 12–13. During the Civil War, the enormously successful Rosta posters, as well as some other notable posters, employed the technique of silhouette. For examples of Rosta posters, see *Soviet Political Poster,* 34–36, and White, *The Bolshevik Poster,* chap. 4. Another well-known example from the 1920s is E. Kruglikova, "Zhenshchina! Uchis' gramote!" (1923), RU/SU 519 and Guerman, ed., *Art of the October Revolution,* 82.

62. RU/SU 1670. The artists may be Fedorchenko and Lain.

63. Lewis H. Siegelbaum, *Stakhanovism and the Politics of Productivity, 1935–1941* (Cambridge, England, 1988), 45.

64. RU/SU 1748. For another example of silhouetted workers with hammers, see "Sol'em udarnye otriady v skvoznye udarnye brigady," 1931. RU/SU 1963.

65. *Za proletarskoe iskusstvo* (February 3, 1931), 12.

66. Clark, "Little Heroes," 203.

67. Régine Robin, "Stalinisme et culture populaire," in *Culture et révolution,* by Marc Ferro et al. (Paris, 1989), 158; *Brigada khudozhnikov,* 7 (1931), 27. The

shift in orientation appears to have taken place following a speech by Stalin in July 1931, which emphasized the need for good leaders and managers. Clark, *Soviet Novel,* 118.

68. Clark, "Little Heroes," 206.
69. Ibid., 155. On this subject, see also Clark, *Soviet Novel,* 147–148.
70. See Clark, *Soviet Novel,* and Siegelbaum, *Stakhanovism.*
71. Clark, *Soviet Novel,* 73–74, 119, 149.
72. Moshe Lewin, *The Making of the Soviet System: Essays in the Social History of Interwar Russia* (New York, 1985), 219–222, 241, 248–250; Hiroaki Kuromiya, *Stalin's Industrial Revolution: Politics and Workers, 1928–1932* (Cambridge, England, 1988), 92–107.
73. Lewin, *Making of the Soviet System,* 242.
74. *Brigada khudozhnikov* 2–3 (1931), 1–3.
75. Ibid., 5–6 (1931), 13.
76. *Produktsiia izo-iskusstv* 6 (1933), 6. Siegelbaum shows that the emphasis on culture and intellectuality became an intrinsic part of the Stakhanovite campaign beginning in late 1935. See Siegelbaum, *Stakhanovism,* chap. 6.
77. *Produktsiia izobrazitel'nykh iskusstv* 14–15 (1932), 5.
78. Siegelbaum, *Stakhanovism,* chap. 6.
79. Ibid., 225.
80. The German painter George Grosz claimed that he and John Heartfield invented photomontage in 1916. Heartfield subsequently became a major practitioner of this technique, and his work greatly influenced Soviet artists. M. Constantine and A. M. Fern, *Work and Image: Posters from the Collection of the Museum of Modern Art* (New York, 1968), 58.
81. The technique of photomontage was not without its critics, and the early 1930s witnessed lively debates over its application in a revolutionary context. See, for example, the discussion by M. Neiman, "Fotomontazh khudozhnika B. Klincha," in *Produktsiia izo-iskusstv* 7 (1933), 3–5; and Demosfenova, Nurok, and Shantyko, *Sovetskii politicheskii plakat,* 77.
82. Poster artists utilized three types of photomontage in the Soviet Union in the 1930s. The most widespread approach combined various photographs into a montage. In general, Klutsis used this style. The second combined photographs and drawings. The third used photographs that incorporated visual tricks and distortions. Neiman, "Fotomontazh," 3.
83. RU/SU 2281, pts. 1, 2. The text continues, "for 518 new factories."
84. Lewin, *Making of the Soviet System,* 250; Kuromiya, *Stalin's Industrial Revolution,* 90–92.
85. Demosfenova, Nurok, and Shantyko, *Sovetskii politicheskii plakat,* 86–87.
86. *Produktsiia izobrazitel'nykh iskusstv* 1 (1932), 8.
87. A 1931 poster by Vasilii Efanov, "Proletarii" (RU/SU 1632), exemplifies this technique. Efanov's poster shows a larger-than-life worker in leather jacket, cap, and leather boots (these are all visual markers for a Bolshevik), carrying

a book in one hand and gesturing forward with the other (also the pose Lenin often assumed in posters). His mouth is open as though he is calling to someone. The poster urges workers to study in technical schools in order to create "proletarian cadres." For a discussion of the "remarkable people," see Clark, *Soviet Novel,* 119–121. Women were also portrayed in the larger-than-life format during the 1930s, especially collective farm women.

88. KP p4.VII.4.g/dneprostroi.

89. On this general point, see Demosfenova, Nurok, and Shantyko, *Sovetskii politicheskii plakat,* 105–9. Demosfenova concludes that the image of workers is transformed in these years and that the "worker becomes a master [*khoziain*] of his life, fully empowered and proud."

90. KP p4.XXVI.1.b/1 zh.

91. Uspensky, *Semiotics of the Russian Icon,* 39.

92. *Produktsiia izo-iskusstv* 11 (1933), 5.

93. The Soviet pavilion at the exhibition was designed by Boris Iofan "as a large streamlined block, crowned on its main western facade by a tower eight storeys high. The 35-metre pilasters of the tower . . . performed a second role as a pedestal for a vast group-sculpture one third its own height—the previously mentioned 'Worker and Collective Farm Woman.'" Golomstock, *Totalitarian Art,* 133. The statue was subsequently relocated to the site of the Exhibition of Economic Achievements (VDNKh), Moscow.

94. This handsome and youthful image of the worker appears in posters as early as 1931. See B. Kudriashev, "Udarnik rabochii kolkhoznik, krepi moshch' krasnoi armii" (1931), RU/SU 1668. Govorkov's miner conforms to this image.

95. The argument is elaborated in Gregory Freidin, "Romans into Italians: Russian National Identity in Transition," in *Russian Culture in Transition: Selected Papers of the Working Group for the Study of Contemporary Russian Culture, 1990–1991,* ed. Gregory Freidin (Stanford, 1993), 241–274.

96. RU/SU 2288. The artist was Petr Karachentsov. The poster shows a red flag, airplane, and globe with a route drawn from Moscow to the North Pole; it includes a quote from Stalin: "There are no fortresses which Bolsheviks cannot conquer."

97. TsGALI, f. 1988, op. 1, ed. khr. 34, l. 11; Demosfenova, Nurok, and Shantyko, *Sovetskii politicheskii plakat,* 105.

98. Peter Kenez, *Cinema and Soviet Society 1917–1953* (Cambridge, England, 1992), 161–164. Kenez also notes (227) that of the 124 films produced between 1945 and 1953, only 4 dealt with workers, and 2 of these were not even distributed!

99. Ibid.

100. Lewin, *Making of the Soviet System,* 247, 254–255.

101. François-Xavier Coquin, "L'image de Lénine dans l'iconographie révolutionnaire et postrévolutionnaire," *Annales ESC* 2 (March–April 1989), 223–249.

102. See chapter 4 for further discussion of these developments.

103. RU/SU 1824.

104. See, in addition, "Da zdravstvuet sovetskie fizkul'turniki!" (n.d.), RU/SU 565; Viktor Deni, "Da zdravstvuiut sokoly nashei rodiny, stalinskie pitomtsy" (1938), RU/SU 1816; G. Kun, Vasilii Elkin, and K. Sobolevskii, "Privet velikomu Stalinu, kanal Moskva-Volga otkryt!" (1937), RU/SU 2151; P. Iastozhembolii, "Vsesoiuznaia sel'sko-khoziaistvennaia vystavka" (1939), RU/SU 1832.

105. Toby Clark, "The 'New Man's' Body: A Motif in Early Soviet Culture," in *Art of the Soviets*, ed. Matthew Cullerne Bown and Brandon Taylor (Manchester and New York, 1993), 43–44.

106. Quoted from Gregory Freidin, *A Coat of Many Colors: Osip Mandelstam and His Mythologies of Self-Presentation* (Berkeley and Los Angeles, 1987), 242. The epigram dates from November 1933. Mandelstam was arrested soon afterward.

CHAPTER 2. WOMEN IN EARLY SOVIET POSTERS

1. Leading artists such as Marc Chagall, Kazimir Malevich, and El Lissitzky contributed to the new political art; a number of highly gifted satirical artists and illustrators also joined the ranks of Bolshevik political artists, such as Dmitrii Moor, Viktor Deni, and Aleksandr Apsit. On the role of individual artists in this period, see Stephen White, *The Bolshevik Poster* (New Haven and London, 1988), chaps. 2–4.

2. There are many examples of posters and visual displays with these images. A notable example is Vladimir Fidman's 1920 poster, "Dva goda tomu nazad v ogne revoliutsii rodilas' Raboche-Krest'ianskaia Krasnaia Armiia," showing a Red Army soldier astride a winged horse. RU/SU 2088A. See also the anonymous 1920 poster, "Gramota—put' k kommunizmu" (RU/SU 7), which shows a half-naked man in Roman sandals astride a red winged horse. He holds a book in one hand and a torch in the other. Examples of serpent/hydras and St. George are discussed below and in chapter 5. Many instances can also be cited from holiday celebrations. An anonymous panel entitled "Slava" (Glory) produced for the first anniversary of the revolution in Petrograd featured angels blowing a horn. See V. P. Tolstoi, ed., *Agitatsionno-massovoe iskusstvo: Oformlenie prazdnestv 1917–1932*, Tablitsy (Moscow, 1984), figs. 107–9.

3. Rosta Windows (so named after the Russian Telegraph Agency, Rosta) were first produced in the fall of 1919. These posters, which hung in store fronts and public buildings, were originally hand produced on short order to communicate ideas and information during the Civil War. Later they were duplicated by cardboard stencils. See Stephen White's informative discussion of Rosta Windows in *The Bolshevik Poster*, chap. 4.

4. According to Jeffrey Brooks: "The lubki were lively illustrations similar to European broadsides. They had short texts, usually at the bottom of the pic-

ture, and were often the first printed materials to enter the homes of the common people." Many peasant cottages were decorated with a selection of *lubok* prints. See Jeffrey Brooks, *When Russia Learned to Read: Literacy and Popular Literature, 1861–1917* (Princeton, 1985), 62, 63, 66.

5. For examples of the latter types, see "Ranenyi krasnoarmeets," 1920 (anonymous), RU/SU 1243; Apsit, "Otstupaia pered krasnoi armiei belogvardeitsy zhgut khleb," 1919, RU/SU 1286 and in White, *The Bolshevik Poster,* 30, fig. 2.17; Sergei Ivanov, "Grazhdane! delaite sebe protivokholernye privivki," 1920, in *The Soviet Political Poster* (Middlesex, 1985), 32; Apsit, "Den' ranenogo krasnoarmeitsa," 1919, in White, *The Bolshevik Poster,* 30, fig. 2.16.

6. The two women were Sofiia Perovskaia and Rosa Luxemburg. Perovskaia participated in the plot to assassinate Alexander II in 1881 and was executed. Luxemburg, a leader of the Spartacus Party in Germany during World War I, was arrested and killed by soldiers in January 1919. For a discussion of Lenin's plan, see chapter 4.

7. For an analysis of the diverse representations of the Mother of God, see Leonid Ouspensky and Vladimir Lossky, *The Meaning of Icons,* trans. G. E. H. Palmer and E. Kadloubovsky (Crestwood, New York, 1983), 76–80. Representations of female figures—both mythical and real—were extremely common in the *lubok.* See *Lubok. Russische Volksbilderbogen. 17. bis 19. Jahrhundert* (Leningrad, 1984).

8. See N. I. Baburina's study, *Russkii plakat: Vtoraia polovina XIX–nachalo XX veka* (Leningrad, 1988), for many examples of this phenomenon.

9. An allegorical image refers "to another simultaneous structure of events or ideas, whether historical events, moral or philosophical ideas, or natural phenomena." Myth and fable are frequently used for allegorical purposes. The important thing about visual allegory is that the meaning of the image does not depend on the surrounding context; the meaning of the allegorical sign is determined exclusively by semantic (i.e., paradigmatic), rather than syntactic (i.e., syntagmatic), relations. Allegory is not inherent in the image but depends on the competence of the viewer. Only viewers conversant with the association between an image and an idea or conception will appreciate the complexity of meaning. See Alex Preminger, ed., *Princeton Encyclopedia of Poetry and Poetics* (Princeton, 1974), 12; and Boris Uspensky, *The Semiotics of the Russian Icon,* ed. Stephen Rudy (Lisse, Belgium, 1976), 15.

10. The Phrygian cap or bonnet was worn in ancient Rome by freed slaves; the fasces was a bundle of rods with an ax blade projecting, carried by Roman magistrates as a badge of authority.

11. See discussions in Lynn Hunt, *Politics, Culture, and Class in the French Revolution* (Berkeley and Los Angeles, 1984); Maurice Agulhon, *Marianne into Battle: Republican Imagery and Symbolism in France, 1789–1880* (Cambridge, England, 1981); and Mona Ozouf, *Festivals of the French Revolution,* trans. Alan Sheridan (Cambridge, Massachusetts, 1988).

12. On French allegorical sculpture, see Peter Fusco, "Allegorical Sculpture,"

in *The Romantics to Rodin: French Nineteenth-Century Sculpture from North American Collections,* ed. Peter Fusco and H. W. Janson (Los Angeles and New York, 1980). Fusco writes, "Allegorical sculpture entered the nineteenth century as part of an academic tradition of moral and propagandistic expression that for centuries had been vital to civic, court, and sacred life" (60).

13. This is extensively discussed in Agulhon, *Marianne into Battle.*

14. Fusco, "Allegorical Sculpture," 65.

15. V. V. Shleev, ed., *Revoliutsiia 1905–1917 gg. i izobrazitel'noe iskusstvo,* 4 vols. (Moscow, 1977–1989), 2: 11, 3: 39, 55.

16. Fusco, "Allegorical Sculpture," 65, esp. fig. 60, Jean-Pierre Corot's *Immortality,* 1835; Agulhon, *Marianne into Battle,* 76.

17. Agulhon, *Marianne into Battle,* 76.

18. On this subject, see William C. Brumfield, "Anti-Modernism and the Neoclassical Revival in Russian Architecture, 1906–1916," *Journal of the Society of Architectural Historians* 48 (December 1989), 374.

19. A. S. Gushchin, *Izo-iskusstvo v massovykh prazdnestvakh i demonstratsiiakh* (Moscow, 1930), 11, 12. For other examples, see Elizabeth Waters, "The Female Form in Soviet Political Iconography, 1917–1932," in *Russia's Women: Accommodation, Resistance, Transformation,* ed. Barbara Evans Clements, B. A. Engel, and Christine D. Worobec (Berkeley and Los Angeles, 1991), 229–230.

20. For examples, see Tolstoi, ed., *Agitatsionno-massovoe iskusstvo,* Tablitsy, figs. 39, 102, 106, 114; and James von Geldern, *Bolshevik Festivals, 1917–1920* (Berkeley and Los Angeles, 1993).

21. RU/SU 1272; MR A26382. The title of the poster derives from the revolutionary song which appears as the text below the image. The poster was produced in Petrograd and Ufa.

22. See Agulhon, *Marianne into Battle,* 39, for a reproduction of the Delacroix painting.

23. RU/SU 1372. Above the two figures appears the word "knowledge." The quotation below from Ferdinand Lassalle reads: "The Union of Workers and Science, that have fused into one, will crush in its iron embrace all obstacles on the road to progress." For another example, see the photograph of a November 7, 1918, display showing Science and Art bringing gifts to Labor. Tolstoi, ed. *Agitatsionno-massovoe iskusstvo,* Tablitsy, fig. 128.

24. Mikhail Guerman, ed., *Art of the October Revolution* (New York, 1979), 280–281.

25. For a discussion of the concept of a "cultural frame" and its application to France, see Hunt, *Politics, Culture, and Class,* 87–88.

26. For a discussion of the legend of St. George and its representation in icon painting, particularly the Novgorod school, see Ouspensky and Lossky, *The Meaning of Icons,* 137. Examples of this image in folk art can be found in *Lubok: Russische Volksbilderbogen,* 75, 76. The image of a rider on horseback—reminiscent of St. George—became the emblem of the city of Mos-

cow in the fourteenth century and later was incorporated into the coat of arms of both Moscow and the Russian Empire. See S. A. Tokarev, ed., *Mify narodov mira* (Moscow, 1987), 1: 275.

27. A poster issued in November 1914, "Drakon zamorskii i vitiaz' russkii," showed a medieval knight in armor wielding a sword and shield against a multiheaded winged hydra. RU/SU 331. See also RU/SU 1096, RU/SU 682.

28. RU/SU 1546. A text by Dem'ian Bednyi appears at the bottom of the poster.

29. RU/SU 1285.

30. White, *The Bolshevik Poster*, 7, fig. 1.6; Guerman, ed., *Art of the October Revolution,* no. 360.

31. For a discussion of the mythological antecedents of "Mother Russia," see Joanna Hubbs, *Mother Russia: The Feminine Myth in Russian Culture* (Bloomington, 1988).

32. TsGALI, f. 1931, op. 1, ed. khr. 21.

33. RU/SU 151.

34. RU/SU 1008. The tone and content of the text by M. Petrov can be discerned from the following fragment: "Not for the first time has our dear fatherland joined battle for truth and love. Not for the first time is it shedding its holy blood in defense of the honor of its brothers. . . . "

35. RU/SU 245.

36. A poster issued in 1919 or 1920 portrays Bessarabia as a female, her arms in chains, surrounded by a serpentine monster with a crown, representing Romania. Armed soldiers are poised to liberate her. The poster was published by the Department of Soviet Propaganda, under the Executive Committee of the Odessa Soviet of Workers' Deputies, MR Z100834; a poster by Deni, "Palachi terzaiut Ukrainu," shows a Polish "pan" and Petliura killing a young woman (Ukraine) whose position resembles that of Christ on the cross. V. Polonskii, *Russkii revoliutsionnyi plakat* (Moscow, 1925), 50.

37. RU/SU 2282. The text of "The International" appears below the image.

38. For further discussion of this point, see chapter 5.

39. O. Baldina, *Russkie narodnye kartinki* (Moscow, 1972), 131. Lynn Hunt discusses an engraving from 1793 that bears some resemblance to Apsit's unusual poster. The engraving, entitled "The French People Overwhelming the Hydra of Federalism," shows Hercules poised to club a "monster of federalism," whom some contemporary observers considered half-woman and half-serpent. Hunt, *Politics, Culture, and Class,* 97.

40. For a discussion of this phenomenon, see G. L. Demosfenova, A. Nurok, and N. Shantyko, *Sovetskii politicheskii plakat* (Moscow, 1962), 38–43.

41. Tolstoi, ed., *Agitatsionno-massovoe iskusstvo,* 85–87.

42. RU/SU 1371.

43. I am grateful to William C. Brumfield for this insight.

44. For different perspectives on the disappearance of allegorical representation, see the essays by Elizabeth Waters and François-Xavier Coquin. According to

Waters, "the Bolsheviks, who had come to power at a time when this particular artistic device was losing its force in a country where it had never been strong, were not likely to resist the trends toward non-allegorical representation, particularly since their ideology foregrounded the factory and industrial work and privileged the public over the private." "The Female Form," 5–7. My disagreements with Waters are twofold. First, I see the trend away from allegory as a direct consequence of the dissemination of Bolshevik ideas; second, it was the profound linkage between allegory and the concept of citizenship that discredited this form of representation and led to the adoption of new images more consistent with the Bolshevik emphasis on class. Coquin, by contrast, argues that allegorical images lost favor because they failed to communicate ideas succinctly to the poster viewer. I do not disagree with this argument, but consider it only part of the explanation. See François-Xavier Coquin, "L'affiche révolutionnaire soviétique (1918–1921): Mythes et réalités," *Revue des études slaves* 59, no. 4 (1987), 726.

45. Polonskii, *Russkii revoliutsionnyi plakat,* 75. An earlier article by Polonskii appeared in *Pechat' i revoliutsiia* 2 (April–June 1922), 56–77.

46. According to the first Soviet constitution of July 1918, rights of citizenship were extended only to those who "earn their living by production or socially useful labor, soldiers, and disabled persons." Excluded explicitly were persons who employed hired labor, rentiers, private traders, monks and priests, officials and agents of the former tsarist police.

47. KP p1.II.3/1 maia vserossiiskii subbotnik.

48. RU/SU 1280. The text of the poster reads: "With our weapons we finished off the enemy, with our labor we will procure bread. All to work, comrades!"

49. RU/SU 866. The poster was issued in October 1920.

50. For details on reproduction, see B. S. Butnik-Siverskii, *Sovetskii plakat epokhi grazhdanskoi voiny, 1918–1921* (Moscow, 1960), nos. 437, 736, 2290.

51. "8-oe marta vsemirnyi prazdnik zhenshchin" features a woman worker in a blacksmith's apron and a female peasant with a sickle. RU/SU 532.

52. RU/SU 18. On the league, see Richard Stites, *The Women's Liberation Movement in Russia: Feminism, Nihilism, and Bolshevism, 1860–1930* (Princeton, 1978), 220–224, 291–293.

53. RU/SU 1220.

54. Stites, *The Women's Liberation Movement,* 322.

55. Ibid., 320–322, and chapter 10, note 11.

56. On these points see chapter 1 and V. V. Ivanov and V. N. Toporov, "Problema funktsii kuznetsa v svete semioticheskoi tipologii kul'tur," in *Materialy vsesoiuznogo simpoziuma po vtorichnym modeliruiushchim sistemam I (5)* (Tartu, 1974), 87–90.

57. KP p3.XXVI.5/raskreposhchennaia.

58. The Zhenotdel, a party organization, was established in late 1919. For a discussion of its history, see Stites, *The Women's Liberation Movement,* 329–345.

59. Ibid., 326–328. Elena Stasova sat on the Central Committee in 1918–1919.

60. T. H. Rigby, *Communist Party Membership in the U.S.S.R. 1917–1967* (Princeton, 1968), 361.

61. The elections to the Constituent Assembly, held several weeks after the Bolshevik seizure of power, disclosed that the rural electorate supported the Socialist Revolutionary Party, which received 58 percent of the total vote. The Bolsheviks won 24 percent of the total.

62. For regionally distinctive versions, see RU/SU 1760 (from Georgia) and RU/SU 868 (from Kazan').

63. RU/SU 1760. See chapter 1 for further discussion of this poster.

64. See Denisov, *Voina i lubok* (Petrograd, 1916); *Lubok. Russische Volksbilderbogen.*

65. Denisov, *Voina i lubok,* 32; White, *The Bolshevik Poster,* 3.

66. RU/SU 61A.

67. Guerman, ed., *Art of the October Revolution,* nos. 187–193. The set included also a rendering of Labor, presented as a young man in a blacksmith's apron, standing beside a brick chimney. It is, of course, noteworthy that the artist selected artisanal occupations rather than those typically found in a factory setting. For contemporaries, the term "worker" encompassed a broad range of occupational groups.

68. RU/SU 2087. At the bottom of the poster appear the words: "Forward to the universal brotherhood of labor, leaving behind the debris of capitalism!"

69. RU/SU 1373; RU/SU 1375.

70. White, *The Bolshevik Poster,* 62, quoting the Soviet author Viktor Duvakin in the introduction to V. V. Maiakovskii, *Groznyi smekh: Okna satiry ROSTA* (Moscow, 1938), v.

71. This poster is reproduced in White, *The Bolshevik Poster,* 71, fig. 4.7; and Guerman, ed., *Art of the October Revolution,* nos. 41, 42.

72. For a discussion of the term, see Stites, *The Women's Liberation Movement,* 330; Lynne Viola, "*Bab'i Bunty* and Peasant Women's Protest during Collectivization," *Russian Review* 45, no. 1 (January 1986), 23; Cathy A. Frierson, *Peasant Icons: Representation of Rural People in Late Nineteenth Century Russia* (New York and Oxford, 1993), 162–163.

73. Stites, *The Women's Liberation Movement,* 330.

74. Quoted from *Dreiser Looks at Russia* (London, 1928), 90, in Roger Pethybridge, *The Social Prelude to Stalinism* (London, 1974), 160.

CHAPTER 3. PEASANT WOMEN IN POSTERS OF THE 1930S

1. The original version of the film can be viewed at the Pacific Film Archive, Berkeley, California. For a discussion of the history of the film, see Jay Leyda, *Kino: A History of the Russian and Soviet Film* (London, 1960), 262–269.

2. RU/SU 1658.

3. Posters for this sample were examined at the Hoover Archives and the Poster Collection in the Graphics Department of the Russian State Library (formerly the Lenin Library). To my knowledge, no published or unpublished catalogue of posters is available for this period. My sample includes all the posters on the theme of agriculture that were available to me for the period 1930 to 1934. I have excluded multiple editions of posters in various national languages. In defining posters in which women occupied a central or prominent place, I used the following guidelines: (a) posters exclusively featuring women (one or more); (b) posters with women and men in which women are not depicted as subordinate to men by virtue of their activity or relative placement; (c) any poster in which a woman is shown driving a tractor. I examined all posters relating to collectivization at the Hoover Archives. At the Russian State Library, where I did not have access to the catalogue, I requested all posters pertaining to the collectivization campaign.

4. RU/SU 1655.

5. KP p4.IX.3a/idi and RU/SU 641.

6. RU/SU 1856. The Ukrainian version was issued in a printing of 10,000. The text of the poster reads: "We shall jointly repulse the kulak; we shall organize the collective animal farm"; "Bring all your equipment; don't slaughter cattle, don't sell it." For this and other versions in various languages, see KP p4.IX.31/ide.

7. RU/SU 1856.

8. RU/SU 1724.

9. RU/SU 1431. The artist's signature is difficult to read but it appears to be Mikhail Cheremnykh. The term "kulak"—literally "fist"—was traditionally applied to relatively prosperous peasants, especially those who hired labor and lent money to fellow peasants. The term generally had pejorative connotations, even before the Bolsheviks came to power. On the nineteenth-century usage of "kulak," see Cathy A. Frierson, *Peasant Icons: Representations of Rural People in Late Nineteenth Century Russia* (New York and Oxford, 1993), chapter 7. In the 1930s, the label was applied to any peasant resisting collectivization.

10. RU/SU 1756.

11. KP p4.IX.3.g/idi. The precise date of publication is unknown. It was situated in the poster archive among posters dating from the years 1930–1934. The imagery, text, and theme strongly suggest it was produced sometime in the very early 1930s.

12. *Brigada khudozhnikov* 5–6 (1931), 13.

13. According to Maurice Hindus, who returned to his native village for a visit in the summer of 1929, colored factory-made kerchiefs had come to replace the traditional caps which girls and women wore in an earlier time. He also saw girls in shoes instead of the traditional *lapti*, or bast sandals. See Maurice

Hindus, *Red Bread: Collectivization in a Russian Village* (Bloomington and Indianapolis, 1988), 52. His account originally appeared in 1931.

14. There were a few notable exceptions, such as the Pichugin poster dicussed above (fig. 3.2) and "Krest'ianki! Povysim urozhai! Ob"edinim krest'ianskie dvory v kollektivy" (fig.3.7). In the early 1930s, images of children generally appeared only in posters devoted to social themes, such as communal dining and nurseries.

15. KP p4.XXV.2/kolkhoznik.

16. Deineka produced other posters and paintings in the early 1930s featuring slim women. See, for example, his 1932 painting, *Igraiushchie v miach,* with naked women playing ball (*Agitatsiia za schast'e,* 41) and his 1933 poster, "Rabotat', stroit' i ne nyt'!" featuring a trim young woman athlete (KP p4. XXV.2/1p).

17. Another illustration of this type of poster is "Krest'ianka! Kollektivizirui derevniu," 1930, artist unknown. It shows a column of tractors with female tractor drivers, all in the color red. At the bottom is a quote from Lenin stating that women will not achieve full liberation until they participate in production. The poster was printed in an edition of 40,000. KP p4.XXVI.7/1k krest'ianka.

18. RU/SU 1684. The poster appeared in an edition of 50,000.

19. *Brigada khudozhnikov* 4 (1931), 12.

20. Other important female poster artists who created key posters on the theme of collectivization were Natal'ia Pinus and Mariia Voron (see figs. 3.8 and 3.10).

21. On this subject, see Robert Conquest, *The Harvest of Sorrow: Soviet Collectivization and the Terror-Famine* (New York, 1986), chap. 7.

22. Ibid., 152, 154–155, 157, 166; Merle Fainsod, *Smolensk under Soviet Rule* (New York, 1953), 253; Moshe Lewin, *The Making of the Soviet System: Essays in the Social History of Interwar Russia* (New York, 1985), 179; Lynne Viola, *The Best Sons of the Fatherland: Workers in the Vanguard of Soviet Collectivization* (New York, 1987), 105; Lynne Viola, "*Bab'i Bunty* and Peasant Women's Protest during Collectivization," *Russian Review* 45, no. 1 (January 1986), 23–42; Robert William Davies, *The Socialist Offensive: The Collectivization of Agriculture, 1929–1930* (London, 1980), 136–137; A. A. Novosel'skii, ed., *Materialy po istorii SSSR: Dokumenty po istorii sovetskogo obshchestva* (Moscow, 1955), 327–367; Sheila Fitzpatrick, *Stalin's Peasants: Resistance and Survival in the Russian Village after Collectivization* (New York and Oxford, 1994), 65.

23. Viktoria Ulasevich, ed., *Zhenshchina v kolkhoze* (Moscow, 1930), 6.

24. According to a contemporary author writing in 1930: "It must be said that the kulaks, by means of their agents—well-to-do and middle peasants— knew how to win over a significant proportion of the masses of women, pull them into the anti-*kolkhoz* movement, direct their dissatisfaction with the hard conditions of life against the new form of economic organization." Ibid., 7.

25. Conquest, *Harvest of Sorrow*, 157; Lewin, *Making of the Soviet System*, 179. For a discussion of the significance of the cow in peasant religion, see Boris A. Uspenskii [Uspensky], *Filologicheskie razyskaniia v oblasti slavianskikh drevnostei (relikty iazychestva v vostochnoslavianskom kul'te Nikolaia Mirlikiiskogo)* (Moscow, 1982), 118, 128.

26. See Fainsod, *Smolensk*, 253–254, for an example of the involvement of local clergy in women's rebellions; Conquest, *Harvest of Sorrow*, 207; Viola, *"Bab'i Bunty,"* 29–30.

27. Viola, *"Bab'i Bunty,"* 31. Rural women were deeply hostile to the libertarian sexual attitudes and practices of Bolsheviks. On peasant women's attitudes toward sex, see Richard Stites, *The Women's Liberation Movement in Russia: Feminism, Nihilism, and Bolshevism, 1860–1930* (Princeton, 1978), 382.

28. Conquest, *Harvest of Sorrow*, 152. Peasants referred to the VKP (All-Union Communist Party) as the "second serfdom" (*vtoroe krepostnoe pravo*); Viola, *Best Sons of the Fatherland*, 105; Viola, *"Bab'i Bunty,"* 29–30; Fitzpatrick, *Stalin's Peasants*, 45.

29. An example of this can be found in Hindus, *Red Bread*, 45–47.

30. As Conquest describes it: "For the 'women's rebellions,' according to one activist observer, came to follow definite tactics. First the women would lead the attack on the kolkhoz; 'if the Communists, Komsomols and members of the village Soviets and Committees of Unwealthy Peasants attacked them, the men rallied to the women's defence. This tactic aimed at avoiding intervention by armed forces, and it was successful.' In the Southern Ukraine, the Don and the Kuban, the collective farm structure had virtually collapsed by March 1930." Conquest, *Harvest of Sorrow*, 158. The quotation is from Petro Grigorenko, *Memoirs* (London, 1983), 35. See also Fitzpatrick, *Stalin's Peasants*, 66.

31. Conquest, *Harvest of Sorrow*, chap. 6.

32. Viola, *"Bab'i Bunty,"* 23.

33. Moshe Lewin, *Russian Peasants and Soviet Power: A Study of Collectivization* (Evanston, 1968), 457.

34. Another version goes like this: "A crab is not a fish—a woman is not a person." Susan Bridger, *Women in the Soviet Countryside: Women's Roles in Rural Development in the Soviet Union* (Cambridge, England, 1987), 6.

35. *Brigada khudozhnikov* 2–3 (1931), 2–3, articles 6, 7, 8 of the resolution.

36. The first meeting of the review board under Izogiz took place on April 5, 1931, with representatives from five major Moscow factories. The meeting was devoted mainly to a discussion of twenty-two posters Izogiz intended to publish. Most were subjected to severe criticism and half were rejected outright. *Brigada khudozhnikov* 2–3 (1931), 3. The Union of Russian Revolutionary Poster Artists (ORRP) was established soon after the Central Committee resolution, under the leadership of Dmitrii Moor. See TsGALI, f. 1988, op. 1, ed. khr. 33, for a draft of the union's charter. Posters were subsequently reviewed in *Produktsiia izobrazitel'nykh iskusstv* (1932), *Produktsiia izo-iskusstv*

(1933), and *Plakat i khudozhestvennaia reproduktsiia* (1934–1935), published by the Kritiko-bibliograficheskii Institut.

37. *Brigada khudozhnikov* 2–3 (1931), 3, 4. The *lubok* was a folk art print, often satirical, popular among the common people, both rural and urban, before the revolution.

38. According to Lewin, "The extreme efficacy of this [anti-collectivization] propaganda was due, not to the strength of the kulaks, but to the weakness of official propaganda, and above all to the distrust which the peasants felt, and were so frequently justified in feeling, for the government during the collectivization campaign and more especially during the autumn and winter of 1929–30." *Russian Peasants and Soviet Power*, 487.

39. Conquest, *Harvest of Sorrow*, 180.

40. E. K. Kravchenko, *Krest'ianka pri sovetskoi vlasti* (Moscow, 1932), 46.

41. Davies, *Socialist Offensive*, 384.

42. For a discussion of peasant reactions to tractors, as reported in the contemporary press, see Edward H. Carr and R. W. Davies, *Foundations of a Planned Economy, 1926–1929* (Harmondsworth, 1974), 225–227; Davies, *Socialist Offensive*, 384–385. According to Fitzpatrick (*Stalin's Peasants*, 46), some peasants believed that the initials MTS, designating Machine Tractor Station, stood instead for Mir Topit Satana (Satan is ruining the world).

43. *Za proletarskoe iskusstvo* 3–4 (March–April 1931), 8; *Produktsiia izo-iskusstv* 2 (1932), 2. A meeting of collective and state farm workers to review posters under the auspices of the Kritiko-bibliograficheskii Institut criticized the depiction of a tractor because it consisted of parts of different tractor systems. *Produktsiia izo-iskusstv* 3–4 (1932), 20.

44. For a report on this meeting by L. Krylova and E. Serova, see *Produktsiia izobrazitel'nykh iskusstv* 3–4 (1932), 20

45. Kulagina was born in 1902. She produced numerous posters in the 1930s and belonged to the group of poster artists who used photomontage in the style popularized by Klutsis, her husband, whose work she publicly supported. See G. L. Demosfenova, A. Nurok, and N. I. Shantyko, *Sovetskii politicheskii plakat* (Moscow, 1962), 77, note 3.

46. *Brigada khudozhnikov* 2–3 (1931), 4.

47. In January 1933, Stalin announced that the "'economic foundation of a socialist society' had now been built and asserted that 'we have established the principle of socialism in all spheres of the economy by expelling the capitalist elements from it.'" Robert C. Tucker, *Stalin in Power: The Revolution from Above, 1928–1941* (New York, 1990), 213.

48. Alec Nove, *An Economic History of the U.S.S.R.* (Middlesex, 1982 [1969]), 174.

49. Nicholas S. Timasheff, *The Great Retreat: The Growth and Decline of Communism in Russia* (New York, 1946).

50. For details on these changes, see Lazar Volin, *A Century of Russian Agriculture: From Alexander II to Khrushchev* (Cambridge, Massachusetts, 1970), 244.

51. KP p4.XXVI.7/1k.

52. G. Martynov, "Plakaty k uborochnoi kampanii," *Produktsiia izo-iskusstv* 9 (September 1933), 7. Mashen'ka and Dasha are diminutive forms of common female Russian names.

53. At the end of 1934, collective farmers at the Kalinin Collective Farmers' Club were gathered together to view and criticize posters on the theme of livestock management. The participants included young and old, activists and leaders, rank-and-file farmers, men and women. This meeting and others like it are evidence of a growing concern with the reception of political posters by collective farmers. See A. Unkovskii, "Kolkhoznyi smotr sel'skokhoziaistvennykh plakatov," *Plakat i khudozhestvennaia reproduktsiia* 12 (December 1934), 16–17.

54. See below for a discussion of Vera Mukhina's famous statue of 1937, *Rabochii i kolkhoznitsa,* which partially restored the image of an athletic peasant woman.

55. See, for example, the poster by Iurii Alferov and M. Sokolov, "Uspekhi kollektivizatsii—torzhestvo ucheniia Lenina i Stalina" (1934). KP p4.IX.3.g uspekhi. This poster, which features two *kolkhoznitsy* (the younger one reading a book by Stalin), was widely reproduced and appeared in ten different national languages.

56. Review of Alferov and Sokolov's "Uspekhi kollektivizatsii" in *Plakat i khudozhestvennaia reproduktsiia* 7 (July 1934), 4.

57. Many posters of this type appeared. For examples, see note 66 below; "Pobyl'shevits'komu borotis' za visokii urozhai!" (1937), KP p5.IX.7/1p; and Mariia Voron's poster (fig. 3.10).

58. The poster was produced in Leningrad in an edition of 30,000. The text at the bottom reads: "Collective farm woman, care for the collective farm system like the apple of your eye." KP p4.XXVI.7/1.k.

59. Other examples of posters with women only: Pinus, "Kolkhoznitsa, bud' udarnitsei uborki urozhaia" (printing of 30,000) (1933), KP p4.XXVI.7/ 1/k; Alferov and Sokolov, "Uspekhi kollektivizatsii" (1934), KP p4.IX.3.g uspekhi; "Ide vesna, parue den', v kolgospi nasha sila, tsvite kraina moloda, mogutnaia i shchasliva" (printing of 20,000) (n.d. but probably mid-1930s), KP p4.IX.g.ide.

60. *Plakat i khudozhestvennaia reproduktsiia* 12 (December 1934), 16.

61. RU/SU 1843.

62. *Plakat i khudozhestvennaia reproduktsiia* 9 (September 1934), 16.

63. As *Pravda* and *Komsomol'skaia pravda* stated: "We endorse beauty, smart clothes, chic coiffures, manicures. . . . Girls should be attractive. Perfume and make-up belong to the 'must' for a good Comsomol girl. . . . Clean shaving is mandatory for a Comsomol boy." Cited in Timasheff, *Great Retreat,* 317. Various posters were devoted to the theme of cleanliness, such as the one by Lodygin, "Otkrytoe pis'mo ko vsei kolkhoznoi obshchestvennosti," 1934,

which appeared in a printing of 100,000. The large size of the press run indicates the importance attributed to this issue.

64. "Muzhik i kolkhoz," *Na stroike MTS i sovkhozov* 1 (1934).

65. *Na stroike MTS i sovkhozov* 1 (1935), 7.

66. Two posters of a *kolkhoznitsa* and a cow, issued in 1935 and 1936, respectively, exemplify this development. Each poster shows a peasant woman wearing a colorful outfit complemented by a white embroidered scarf stylishly draped over her shoulder. See Viktor Ivanov, "Kolkhozniki, organizuite molochno-tovarnye fermy!" which appeared in the fall of 1935 (printing of 75,000). KP pk5.IX.9/1.k. A similar poster by Petr Karachentsov appeared in 1936, "Vpered, k dal'neishemu razvitiiu zhivotnovodstva!" (printing of 50,000). KP p5.IX.12/1.v. A quote from Stalin appears at the top of the latter poster: "The combination of the personal interests of the collective farmers and the general interests of the collective farm—that is the key to the strengthening of the collective farms."

67. KP p.4.IX.1.b/liuboi.

68. The poster and a review of it appear in *Plakat i khudozhestvennaia reproduk-tsiia* 7 (July 1934), 10–11. Contemporary newspaper and journal articles devoted to the lives of outstanding individual farmers and workers (*udarniki* and later Stakhanovites) presented similar scenes of private life. See, for example, *Na stroike MTS i sovkhozov* 3 (1934), 3, for accounts of women production heroes. One is shown reading a newspaper. For a detailed discussion of the presentation of Stakhanovite workers, see Lewis H. Siegelbaum, *Stakhanovism and the Politics of Productivity, 1935–1941* (Cambridge, England, 1988), chap. 6.

69. This was not the only poster produced in 1934 focusing on the relationship between labor and material acquisitions. See also the poster by Viktor Govorkov, "Skol'ko vesiat trudodni" (printing of 30,000). It showed what collective farmers could acquire with their labor, including livestock, clothing, and household furnishings. *Plakat i khudozhestvennaia reproduktsiia* 12 (December 1934), 14–15.

70. *Plakat i khudozhestvennaia reproduktsiia* 7 (July 1934), 11.

71. See, for example, *Na stroike MTS i sovkhozov* 1 (1935).

72. The village reading room (*izba chital'nia*) performed a variety of functions for the party-state in the countryside, including agitation, propaganda, organization of special campaigns, and even tax collection and sanitation. Kenez, *Birth of the Propaganda State,* 138.

73. In this connection, see Govorkov, "Skol'ko vesiat trudodni," and the review of it in *Plakat i khudozhestvennaia reproduktsiia* 12 (December 1934), 15. The quotation is from *Na stroike MTS i sovkhozov* 1 (1935), 10.

74. *Plakat i khudozhestvennaia reproduktsiia* 7 (July 1934), 11.

75. On the development of the cult of Stalin in the 1930s, see the illuminating discussion in Tucker, *Stalin in Power,* esp. chaps. 7 and 20. For other ex-

amples of the visual connection between Stalin and exemplary collective farm workers, see *Na stroike MTS i sovkhozov* 1 (1934), 2 (1934), 5 (1935), 1 (1936), 3 (1936).

76. In Alferov and Sokolov, "Uspekhi kollektivizatsii—torzhestvo ucheniia Lenina i Stalina," the younger woman carries a red book prominently inscribed with author and title: I. Stalin, *Speech at the Congress of Collective Farm Shock Workers.*

77. See the frontispiece of *Na stroike MTS i sovkhozov* 2 (1934), which shows a smiling woman tractor driver. A banner on the tractor reads, "For a rich harvest," and there are silhouettes of Lenin and Stalin.

78. KP p4.XXIV.1.b/1.zh. The poster, issued in September 1933, was printed in an edition of 40,000.

79. KP p5.IX.5.b/1shire.

80. Demchenko was widely celebrated. She provided the centerpiece for the first 1936 issue of *Na stroike MTS i sovkhozov.* For a discussion of Stalin and peasant women celebrated for production achievements, see Fitzpatrick, *Stalin's Peasants,* 273–277.

81. One of the earliest and most influential examples was Aleksandr Apsit's poster, "God proletarskoi diktatury, oktiabr' 1917–oktiabr' 1918" (plate 1).

82. A poster appeared in 1937 featuring an image of the male worker and female peasant almost exactly like the one in the Mukhina statue: Aram Vanetsian's "Da zdravstvuet soiuz rabochikh i krest'ian!" Demosfenova, Nurok, and Shantyko, *Sovetskii politicheskii plakat,* 325. In August 1939, a major agricultural exhibition opened in Moscow, providing an occasion for a series of posters on rural themes. P. Iastrzhembskii created a poster (50,000 were printed) with neoclassical overtones commemorating the exhibition. Stalin's image appears on a red flag above Mukhina's statue of two collective farm workers; the pedestal is covered with a stylized drawing of fruit, and in the background is a photomontage of tractors against a light blue sky. RU/SU 1832.

83. Joan Scott argues that "gender codes" help establish and "naturalize" relations of domination. According to Scott, "middle-class reformers in [nineteenth-century] France . . . depicted workers in terms coded as feminine (subordinated, weak, sexually exploited like prostitutes) . . . [whereas] labor and socialist leaders replied by insisting on the masculine position of the working class (producers, strong, protectors of their women and children)." Joan Wallach Scott, *Gender and the Politics of History* (New York, 1988), 48. Eric Naiman argues that, during the 1920s, the New Economic Policy was sometimes discredited by critics applying a gender code that associated the NEP with feminine attributes. Eric Naiman, *Sex in Public: The Incarnation of Early Soviet Ideology* (Princeton, 1997), ch.5, especially 186.

CHAPTER 4. THE LEADER'S TWO BODIES

1. A. V. Lunacharskii, "Lenin i iskusstvo (vospominaniia)," *Khudozhnik i zritel'*, 2–3 (1924), 6.

2. John E. Bowlt, "Russian Sculpture and Lenin's Plan for Monumental Propaganda," in *Art and Architecture in the Service of Politics*, ed. Henry A. Millon and Linda Nochlin (Cambridge, Massachusetts, and London, 1978), 182–193; A. V. Lunacharskii, "Lenin i iskusstvo (vospominaniia)," *Khudozhnik i zritel'* (Moscow) 2–3 (1924), 4–10; Christina Lodder, "Lenin's Plan for Monumental Propaganda," *Art of the Soviets*, ed. Matthew Cullerne Bown and Brandon Taylor (Manchester and New York, 1993), 16–32; Richard Stites, *Revolutionary Dreams: Utopian Vision and Experimental Life in the Russian Revolution* (New York, 1989), 88–92; James von Geldern, *Bolshevik Festivals, 1917–1920* (Berkeley and Los Angeles, 1993), 82–84; Nina Tumarkin, *Lenin Lives! The Lenin Cult in Soviet Russia* (Cambridge, Massachusetts, 1983), 66–67; *V. I. Lenin i izobrazitel'noe iskusstvo. Dokumenty. Pis'ma. Vospominaniia* (Moscow, 1977), 253–285.

3. Stites, *Revolutionary Dreams*, 89; Bowlt, "Russian Sculpture," 185.

4. Bowlt, "Russian Sculpture," 185. The decree also mandated the storage of obsolete public monuments, a measure designed to stem the tide of iconoclasm that had already caused much destruction of tsarist statuary.

5. Commenting on Lenin's project, Richard Stites has written: "Lenin's monumental propaganda scheme should be read only partly as graphic heroization and the birth of cultic idols. His central compulsion—it was exactly that—was to get out the word." Richard Stites, "The Origins of Soviet Ritual Style: Symbol and Festival in the Russian Revolution," in *Symbols of Power: The Esthetics of Political Legitimation in the Soviet Union and Eastern Europe*, ed. Claes Arvidsson and Lars Erik Blomquist (Stockholm, 1987), 36.

6. Bowlt, "Russian Sculpture," 186; Stites, *Revolutionary Dreams*, 89. Photographs of some of the monuments appear in Mikhail Guerman, ed., *Art of the October Revolution* (New York, 1979), illus. 3–11.

7. Stites, *Revolutionary Dreams*, 90; von Geldern, *Bolshevik Festivals*, 83.

8. Lunacharskii, "Lenin," 5.

9. According to Bowlt, sculpture was weakly developed in Russia at the beginning of the twentieth century; there were "few sculptors who had any monumental experiences and whose studios were equipped for such work." Bowlt, "Russian Sculpture," 187; von Geldern, *Bolshevik Festivals*, 84.

10. Uritskii had joined the revolutionary movement in the 1890s and the Bolshevik party in July 1917. Volodarskii had begun his career in the Bund, moved to the Ukrainian Social Democratic Party, and then to the American Socialist Party after emigrating in 1913. He returned to Russia in 1917 and joined the Bolshevik party. In 1918 he was appointed commissar. Michael T. Florinsky, ed., *Encyclopedia of Russia and the Soviet Union* (New York, 1961), 591, 601.

11. Quoted from V. D. Bonch-Bruevich, *Vospominaniia o Lenine* (Moscow, 1965), 337–340, in Tumarkin, *Lenin Lives!*, 90. Lenin is also reputed to have remarked around the same time: "I've noticed with great displeasure that my personality is beginning to be extolled. This is annoying and harmful. We all know that our cause is not in a personality. I myself would find it awkward to forbid any such phenomenon. . . . But we must put the brakes on this whole business." Quoted from *Leninskie stranitsy* (Moscow, 1960), in Roy Medvedev, *Let History Judge: The Origins and Consequences of Stalinism* (New York, 1989), 317.

12. François-Xavier Coquin, "L'image de Lénine dans l'iconographie révolutionnaire et postrévolutionnaire," *Annales ESC* 2 (March–April 1989), 225; Tumarkin, *Lenin Lives!*, 79, and fig. 1. There were, of course, many other striking photographs of Lenin in the early years. See, for example, A. Bartanov, O. Suslova, and G. Chudakov, eds., *Antologiia sovetskoi fotografii, 1917–1940* (Moscow, 1986), 8, 11, 24, 26, 27, 34; the Nappel'baum photo appears on 104.

13. Tumarkin, *Lenin Lives!*, 79. Portraits of Marx alone were occasionally displayed in 1918, for example, in a metalworkers' union display on May Day and on the archway at the entrance to Smol'nyi Institute in November. Vladimir Tolstoy, Irina Bibilova, and Catherine Cooke, eds., *Street Art of the Revolution: Festivals and Celebrations in Russia 1918–1933* (London, 1990), illus. 12, 58.

14. B. S. Butnik-Siverskii, *Sovetskii plakat epokhi grazhdanskoi voiny, 1918–1921* (Moscow, 1960), no. 3689.

15. Tumarkin, *Lenin Lives!*, 79.

16. In *Tolkovyi slovar' zhivogo velikorusskago iazyka Vladimira Dalia*, vol. 1 (Moscow, 1903), 550, *vozhd'* does not even merit a separate entry and is clustered with other terms such as *vozhdenachal'nik, vozhdenie, vozhdestvovat'*, and *vozhevatyi*. By 1935, the term had earned a separate entry in D. N. Ushakov, ed., *Tolkovyi slovar' russkogo iazyka* (Moscow, 1935), 331, where it was defined as a military leader or a "leader of a social movement, party; ideological leader." The example given is "Lenin and Stalin are leaders of the working class."

17. See, for example, Tumarkin, *Lenin Lives!*, 90.

18. Ibid., 82–84.

19. Moshe Lewin, "The Civil War: Dynamics and Legacy," in *Party, State and Society in the Russian Civil War: Explorations in Social History,* ed. Diane P. Koenker, William G. Rosenberg, and Ronald Grigor Suny (Bloomington, 1989), 412.

20. A. N. Shefov, *Leniniana v Sovetskom izobrazitel'nom iskusstve* (Leningrad, 1986), 30, 40.

21. Stephen White, *The Bolshevik Poster* (New Haven and London, 1988), 25, illus. 2.10, and 69, illus. 4.4, 4.5.

22. MR A 26319; Butnik-Siverskii, *Sovetskii plakat*, no. 445.

23. V. P. Tolstoi, ed., *Agitatsionno-massovoe iskusstvo: Oformlenie prazdnestv, 1917–1932* (Moscow, 1984), Tablitsy, fig. 174.

24. Coquin, "L'image," 227.

25. Ibid., 226.

26. See Butnik-Siverskii, *Sovetskii plakat,* nos. 748, 1347, 2047, 2228, 2313, 2345, 2679, 2886, 3194, 3549; Coquin, "L'image," 229.

27. The winners of the competition were Natan Altman, Filipp Maliavin, and Georgii Andreev. Examples of the work of Maliavin and Andreev can be found in Guerman, ed., *Art of the October Revolution,* 276, together with sketches of Lenin by Sergei Chekhonin and Isaak Brodskii from 1920 and 1921, respectively.

28. Evgenii Dobrenko, *Metafora vlasti: Literatura stalinskoi epokhi v istoricheskom osveshchenii* (Munich, 1993), 75.

29. For a discussion of activities surrounding Lenin's fiftieth birthday and Lenin's reaction to them, see Tumarkin, *Lenin Lives!,* 95–107, especially 104.

30. For a discussion of these changes, see chapters 1 and 2.

31. KP p1.I.3./tov. Lenin.

32. Tumarkin, *Lenin Lives!,* fig. 4; Coquin, "L'image," 243, fig. 3; Butnik-Siverskii, *Sovetskii plakat,* no. 634.

33. Boris Uspensky, *The Semiotics of the Russian Icon,* ed. Stephen Rudy (Lisse, Belgium, 1976), 59–60.

34. A *lubok*-style poster produced in November 1914, "Ono, poniatno, chto pogret'sia kazhdomu khochetsia, tol'ko zachem zhe . . . tak . . . gur'boi-to?" featured a Russian peasant surrounded by Lilliputian Germans. RU/SU 149. A similar poster, "Gorodki," appeared during World War I, showing an enormous peasant wielding a club. RU/SU 853.

35. Guerman, ed., *Art of the October Revolution,* fig. 9. The painting shows a gigantic bearded man wearing a fur hat, scarf, and jacket and carrying a red flag, with an intense and determined expression, striding through a city of Lilliputians. Around his feet are crowds of people, very small relative to his giant boots. The scene is Moscow and there is snow on the ground.

36. Coquin, "L'image," 231.

37. A poster with Lenin and Stalin both wearing hats appeared in 1933: Gustav Klutsis's "K mirovomy oktiabriu." In this unusual composition, the two leaders—depicted as giants—are shown standing next to each other against an industrial background. Stalin wears a military coat and cap; Lenin is in his usual attire. Margarita Tupitsyn, "Superman Imagery in Soviet Photography and Photomontage," in *Nietzsche and Soviet Culture: Ally and Adversary,* ed. Bernice Glatzer Rosenthal (Cambridge, England, 1994), 304.

38. KP p2.I.3/prizrak. This poster is variously identified as having been produced in Moscow and in Baku. Polonskii (*Russkii revoliutsionnyi plakat,* frontispiece) places it in Moscow; Butnik-Siverskii (*Sovetskii plakat,* no. 491) places

it in Baku. According to Coquin (L'image," note 31), Moscow is the correct place of origin.

39. Leonid Ouspensky and Vladimir Lossky, *The Meaning of Icons,* trans. G. E. H. Palmer and E. Kadloubovsky (Crestwood, New York, 1983), 73. See, for example, the illustrations on 64A, 71, 75, 191, 210.

40. For a discussion of the importance of the podium in representations of Lenin and Stalin, see Mikhail Yampolsky, "The Rhetoric of Representation of Political Leaders in Soviet Culture," *elementa* 1, no. 1 (1993), 101–113. Another version of this article, "Quand les centaures deviennent icones," appeared in Wladimir Berelowitch and Laurent Gervereau, eds., *Russie–URSS, 1914–1991: Changements de regards* (Paris, 1991).

41. Guerman, ed., *Art of the October Revolution,* fig. 292.

42. Yampolsky, "The Rhetoric of Representation," 104.

43. Klutsis, a Latvian born in Riga, was arrested for alleged participation in a Latvian fascist-nationalist organization in Moscow in 1936. In February 1989, the Military Board of the Supreme Court informed Klutsis's son, Edvard Kulagin, that his father had been sentenced to be shot on February 11, 1938. *The Avant-Garde in Russia 1910–1930: New Perspectives* (Cambridge, Massachusetts, 1980), 172; Margarita Tupitsyn, "Gustav Klutsis: Scenarios of Authorial Pursuits," *The Print Collector's Newsletter* 22: 5 (November–December 1991), 165.

44. There is no entry for this poster in the comprehensive collection by Butnik-Siverskii, *Sovetskii plakat.* Larisa Oginskaia, in her book *Gustav Klutsis* (Moscow, 1981), 50, 52, refers to this composition as a "proekt" (draft). A study for the electrification poster appears in *The Great Utopia: The Russian and Soviet Avant-Garde, 1915–1932* (New York, 1992), no. 308. For a discussion of this poster and the poster design, see Christina Lodder, *Russian Constructivism* (New Haven, 1983), 189.

45. Tupitsyn, "Superman Imagery," in *Nietzsche and Soviet Culture,* ed. Rosenthal, 296; Elena F. Hellberg, "The Hero in Popular Pictures: Russian Lubok and Soviet Poster," in *Populäre Bildmedien: Vorträge des 2,* ed. Rolf Wilhelm Brednich and Andreas Hartmann (Göttingen, 1989), 183.

46. KP p2.I.3./pust'.

47. See, for example, the fifteenth-century Novgorod icon, "The Transfiguration," in Ouspensky and Lossky, *The Meaning of Icons,* 210.

48. See the Russian iconostasis, middle of the sixteenth century, ibid., 64A.

49. Tumarkin, *Lenin Lives!,* 82–84.

50. Richard S. Wortman, *Scenarios of Power: Myth and Ceremony in Russian Monarchy,* vol. 1 (Princeton, 1995).

51. One little-known poster with Lenin's image was produced in 1922 in Krasnodar in an edition of 500 copies: "Khleb golodnym za tserkovnye tsennosti." This *lubok*-style poster, divided into smaller frames that tell a story, features Lenin in the upper left corner pointing his finger toward a petition from

a peasant in the Samara Guberniia. MR A52101; Butnik-Siverskii, *Sovetskii plakat,* no. 2810. Another poster is A. Vinogradov's "Organizuite iacheiki obshchestva 'Doloi negramotnost'.'" This poster has a drawing of Lenin— larger than life—with outstretched right arm and pointed forefinger. Buildings, including one labeled "Punkt likvidatsii negramotnosti," are below. MR A36589. For a reproduction of essential features of the Cheremnykh– Deni poster, see Dmitrii Moor, *Azbuka krasnoarmeitsa* (Moscow, 1921), letter "I." An anonymous 1927 poster, "Doloi negramotnost'," reproduces the identical image from Sokolov's poster in a *lubok*-style composition that shows Lenin as a larger-than-life figure raising his hand, again ambiguously as both directional and a blessing, toward a literacy class for peasants. Above the building with the literacy class is the slogan: "Fulfill the legacy of Il'ich." MR A59086.

52. KP p2.g.3/1870–1924.
53. White, *The Bolshevik Poster,* 121.
54. In 1930, Gustav Klutsis, the Soviet master of photomontage, designed a striking poster that reproduces almost exactly Strakhov's 1924 design. In the Klutsis version, "Iz Rossii nepovskoi budet Rossiia sotsialisticheskaia (Lenin)," a photograph of Lenin (with an upraised left arm clumsily grafted onto the original image) strides like Gulliver over the site of a hydroelectric project. White, *The Bolshevik Poster,* 118, illus. 6.1.
55. Nina Lobanov-Rostovsky, *Revolutionary Ceramics: Soviet Porcelain 1917–1927* (New York, 1990), 32, 46. The Chekhonin plate has the motto "Workers of the World Unite" and Lenin's name (Ul'ianov); the Adamovich plate has the slogan "He who does not work does not eat" as well as the letters "RSFSR."
56. *Sovetskaia kul'tura: Itogi i perspektivy* (Moscow, 1924), 333.
57. MR A85572; Guerman, ed., *Art of the October Revolution,* fig. 260. The fabric portrait was produced between 1922 and 1924 at the Vladimir Aleksandrov cotton mill and was displayed in January 1925.
58. Tumarkin, *Lenin Lives!,* fig. 8.
59. Uspensky, *Semiotics of the Russian Icon,* 13.
60. Tumarkin, *Lenin Lives!,* 152–162.
61. Dobrenko dates this phenomenon from the mid-1920s, particularly in connection with the literary-artistic debates over the presentation of Lenin. Dobrenko, *Metafora vlasti,* 78. He borrows the term "aestheticization of power" from Walter Benjamin. For another account of the aftermath of Lenin's death, see Christel Lane, *The Rites of Rulers: Ritual in Industrial Society—the Soviet Case* (Cambridge, England, and London, 1981), 215–217.
62. Tumarkin, *Lenin Lives!,* 221–224. A photograph of a Lenin Corner in a factory appears in Berelowitch and Gervereau, eds., *Russie–URSS,* 262.
63. A stamp with Lenin's image, designed by I. I. Dubasov, appeared after Lenin's death. *Sto let russkoi pochtovoi marki 1858–1958* (Moscow, 1958), 45.
64. Tolstoy, Bibilova, and Cooke, eds., *Street Art of the Revolution,* no. 165.

65. Tumarkin, *Lenin Lives!*, fig. 14. Posters such as this followed the principle of *kleima* in Russian icons, in which scenes from a saint's life appeared in chronological order. Uspensky, *Semiotics of the Russian Icon*, 55, note 8.

66. Coquin, "L'image," fig. 7. The text appeared as part of the cover illustration of the magazine *Gudok* (January 27, 1924), which shows a peasant worker holding a mourning wreath and a globe, with hammers and sickles. Inside the wreath is Lenin's portrait with the phrase quoted above. In the background are mourners and the Kremlin.

67. Boris Groys, *The Total Art of Stalinism: Avant-Garde, Aesthetic Dictatorship, and Beyond* (Princeton, 1992), 66. For Maiakovskii's 1924 poem from which the phrase derives, "Vladimir Il'ich Lenin," see *V. V. Maiakovskii: Sochineniia v dvukh tomakh* (Moscow, 1988), 2: 232–301.

68. For this and other details concerning the mausoleum and Lenin's body, see Tumarkin, *Lenin Lives!*, 182–189.

69. In fall 1930, it was replaced by a permanent structure that still stands today. Fittingly, Stalin presided over the transfer of the embalmed body to the new mausoleum.

70. MR A52254; KP p2.g.3.b/Lenin. The poster was issued in an edition of 10,000 copies. Other posters issued in 1924 echoed a similar visual theme. See, for example, the Tomsk poster, "Sleduia zavetam svoego velikogo uchitelia." KP p2.g.3/sleduia.

71. Similar posters were issued in various parts of the country. See, for example, the Kharkov poster, "Edinstvo RKP distsiplina riadov 21 ianvaria 1924. Volia k pobede!" featuring Lenin's tomb surrounded by a crowd. KP p2.I.3.v/edinstvo.

72. The term "king's two bodies" originates in the legal and political discourse of the Middle Ages and was articulated by English jurists during the Tudor period. The subject receives definitive treatment in Ernest H. Kantorowicz, *The King's Two Bodies: A Study in Medieval Political Theology* (Princeton, 1957).

73. Dobrenko makes a related argument concerning the "genetic code" of Leninism/Stalinism that was established by two literary works: Maiakovskii's poem "Vladimir Il'ich Lenin" (1924) and Maksim Gorky's memoirs. The former created the archetype of Lenin as the *velikii vozhd'*, a savior who was sagacious and immortal, whereas Gorky's account emphasized Lenin the person, who was humane and simple. Dobrenko, *Metafora vlasti*, 78.

74. There were, of course, still some posters that emphasized Lenin as a revolutionary, as did Aleksandr Samokhvalov's "Rabochikh i Lenina soedinila v svoem porokhovom dymu revoliutsiia 1905 g." RU/SU 1763. For examples of Lenin as an industrial leader of the country, see the anonymous poster "Vse sily na podniatie proizvoditel'nosti" (1925), which shows Lenin with his right arm raised and left hand clenched in a fist, and around him many industrial scenes. *Russian Constructivist Posters* (Paris and New York, 1992), 79. See also

N. Akimov's poster "Lenin—eto marksizm v deistvii" (1924), with Lenin's portrait against a background of machinery and industrial sites. Ibid., 73.

75. KP p2.I.3/Lenin. The poster was issued in an edition of 2,000 by Gublit of Stalingrad.

76. *Sovetskoe izobrazitel'noe iskusstvo 1917–1941,* edited by B. V. Veimarn and O. I. Sopotinskii (Moscow, 1977), illus. 191; Igor Golomstock, *Totalitarian Art in the Soviet Union, the Third Reich, Fascist Italy and the People's Republic of China* (New York, 1990), 230, 314 (illus.).

77. An anonymous and undated poster from the second half of the 1920s, "Lenin vozhd' mezhdunarodnogo proletariata," would seem at first to celebrate Lenin's role as a revolutionary. But in fact the poster shows Lenin, a larger-than-life figure in the customary suit, vest, and tie, standing in front of a map of the world. His left hand gestures toward the red star on the map marking Russia; his right hand is clenched in a fist. In image and text, this poster strongly implies Lenin's dual role as the leader of Russia and the leader of the international communist movement. KP 2.g.3/Lenin. The poster was produced in Leningrad.

78. KP p2.p3/da zdravstvuet. The poster was produced in Leningrad in an edition of 15,000 copies. It is signed with the initials "M. T."

79. MR A52127, "Da zdravstvuet torzhestvo oktiabria" (1927). See also MR A52120, "Oktiabr' na severnom Kavkaze" (1927).

80. On the importance of the sun, see Anthony Netting, "Images and Ideas in Russian Peasant Art," *Slavic Review* 35, no. 1 (March 1976), 48–68.

81. *Piat'desiat let sovetskogo iskusstva (1917–1967): Skul'ptura* (Moscow, 1967), fig. 14.

82. This discussion is drawn from Dobrenko, *Metafora vlasti,* 80.

83. Medvedev, *Let History Judge,* 314.

84. White, *The Bolshevik Poster,* 90, illus. 5.1; Butnik-Siverskii, *Sovetskii plakat,* no. 17. In 1922, Trotsky promulgated a special decree honoring Moor for his service to the Red Army "with his vivid brush and sharp pencil." White, *The Bolshevik Poster,* 112.

85. White, *The Bolshevik Poster,* 31, illus. 2.18.

86. *Sovetskaia kul'tura,* 338; *The Great Utopia,* 627, fig. 6.

87. *Sovetskaia kul'tura,* 331.

88. The date of this calendar is uncertain. Stephen White (*The Bolshevik Poster,* 7, illus. 1.6) dates it 1920, whereas Mikhail Yampolsky dates it March 1, 1923 ("Quand les centaures deviennent icones," 27).

89. In the fourteenth century, the image of St. George became the emblem of Moscow. Later it was incorporated into the coat of arms of Moscow and the Russian Empire. S. A. Tokarev, ed., *Mify narodov mira,* vol. 1 (Moscow, 1987), 275. The image appeared often in posters of the tsarist era, especially during World War I. See RU/SU 1096 and RU/SU 682.

90. Nina Lobanov-Rostovsky, "Soviet Porcelain of the 1920s: Propaganda Tool," in *The Great Utopia,* 626–627. A plate by Vasilii Timorev, created in 1920 for the Congress of the Peoples of the East under the presidency of Zinoviev, appears in fig. 7.

91. Dobrenko, *Metafora vlasti,* 80–81.

92. F. Robinskaia, *Sovetskii lubok* (Moscow, 1929), 16–18. For a reproduction of the Lenin portrait, see illus. 18. Prior to 1928, the organization was called the Association of Artists of Revolutionary Russia (AKhRR). In 1932, AKhR was dissolved along with all other formal art and literary groups.

93. See, for example, Iraklii Toidze's "Vpered k mirovomu oktiabriu!" issued in 1935 in an edition of 150,000, KP p5.I.5/IV; Nikolai Dolgorukov's "Da zdravstvuet leninizm!" issued in 1937 in an edition of 200,000, KP p5.I 3/I.L.

94. Lenin appears as a statue in Nikolai Kochergin's 1933 poster, "Bez Lenina po leninskomu puti. Vpered k novym pobedam," which was published in an edition of 30,000. There are quotes from Stalin on the banners. KP p4.I.3.g/1.B. Lenin appears on a book in the Aleks Keil' poster "Leninizm rodilsia, vyros i okrep v bezposhchadnoi bor'be s opportunizmom vsekh mastei," printed in 1934 in an edition of 150,000. The quotation on the poster is from Stalin. KP p4.g.5/leninizm. An undated poster from Kuban, probably issued between 1930 and 1933, "Za sploshnuiu kollektivizatsiiu," is a *lubok*-style composition with seven frames; the largest shows a statue of Lenin with his right hand outstretched; in the top center of the poster is a picture of Stalin in profile. KP p4.IX/za sploshnuiu. A 1934 poster, "Rastet i krepnet kommunizma delo," by V. Kalmykov, shows two small boys writing Lenin's name in English on a wall while a fascist soldier looks on with surprise. Only 7,500 copies of the poster were issued. KP p4.I.3.d/rastet.

95. A 1932 poster by Vladimir Serov, "Bez Lenina po leninskomu puti," was severely criticized because "we see on [Lenin's] face sadness and alarm" instead of "his characteristic ironical smile." *Produktsiia izo-iskusstv* 3 (1933), 1. The review was by M. Neiman.

96. For further details, see chapter 1.

97. The quotes come, respectively, from S. Rashevskii, "Obraz Lenina v portretakh i kartinakh khud. Andreeva, Grabaria i Moravova," *Plakat i khudozhestvennaia reproduktsiia* 2 (1934), 6; G. Lelevich, "Plakaty khudozhnika Gerasimova," *Produktsiia izobrazitel'nykh iskusstv* 25–26 (1932), 1.

98. When the painting was issued as a poster, it was captioned only "Vladimir Il'ich Lenin (Ul'ianov)." *Sovetskoe izobrazitel'noe iskusstvo 1917–1941,* illus. 57.

99. See, for example, T. P. Kukushkin, "Vdvoe i vtroe," a 1930 poster published in an edition of 30,000, showing Lenin making a speech while standing on the back of a cart; his right arm is outstretched and he holds his cap. KP p4.i.3.8/vdvoe. For a discussion of this theme, see Yampolsky, "The Rhetoric of Representation," 103–104.

100. *Produktsiia izobrazitel'nykh iskusstv* 25–26 (1932), 1.

101. Ibid.

102. Ibid.

103. I. Rabinovich, "Lenin v plakate i massovoi kartine: Po poslednim vypuskam," *Produktsiia izobrazitel'nykh iskusstv* 1 (1932), 3–4.

104. The following account is drawn from Golomstock, *Totalitarian Art*, 228; Vladimir Papernyi, *Kul'tura "Dva"* (Ann Arbor, 1985), chap. 1; Catherine Cooke, "Mediating Creativity and Politics: Sixty Years of Architectural Competitions in Russia," in *The Great Utopia*, 707–710. For illustrations, see 680 and 699, figs. 1 and 16; and Golomstock, *Totalitarian Art, 364.*

105. The building "was to contain 17,500 square metres of oil painting, 12,000 of frescoes, 4,000 of mosaics, 20,000 of bas-reliefs, 12 group sculptures up to 12 metres high, 170 sculptures up to 6 metres high." Golomstock, *Totalitarian Art,* 275.

106. Tumarkin, *Lenin Lives!,* 254. The series was reissued in 1944, on the twentieth anniversary of Lenin's death.

107. "Obraz Lenina v izobrazitel'nom iskusstve," *Plakat i khudozhestvennaia reproduktsiia* 9 (1934), 23.

108. Typical of the posters issued that year was one showing small children admiring a photograph of Lenin as a young child, with the caption "My budem lenintsami." It was issued in an edition of 50,000. RU/SU 635.

109. RU/SU 527.

110. Berelowitch and Gervereau, eds., *Russie–URSS,* 160, fig. 4.

111. Moshe Lewin, *Russian Peasants and Soviet Power: A Study of Collectivization* (Evanston, 1968), 450–453.

112. Within a very few years, the cult of Stalin had become "one of Russia's great growth industries," as Robert Tucker has characterized the phenomenon. *Stalin in Power,* 159.

113. For an account of the entire incident and its aftermath, see ibid., 151–160. The letter appeared in the journals *Proletarskaia revoliutsiia* and *Bol'shevik.*

114. Tucker, *Stalin in Power,* 154.

115. KP p4.I.5/pod; V/A E404–1988.

116. See, for example, the 1930 poster by Viktor Deni, "So znamenem Lenina." The poster's message was conveyed by separating the composition into two parts: Stalin on the right in profile, against the background of an industrial site and a banner "Five Years in Four"; on the left side are the "enemies" of the First Five Year Plan (including a priest, a capitalist, and a Menshevik). Stalin wears a military-style hat and military-style tunic; he gazes upon the enemies with an expression that is firm, dignified, and determined, but not fierce. A quotation from Stalin establishes his continuity with Lenin: "With Lenin's banner we will be victorious in the struggle for the October Revolution . . . " BM 1930–5–9–28.

117. Tucker, *Stalin in Power,* 160. Tucker further notes that Lenin was subjected to a reinterpretation in the 1930s, and only those aspects of his life and work

connected with Stalin were emphasized. During the second half of the 1930s, images of Lenin were often accompanied by the words of Stalin. This was the case in the Kochergin and Keil' posters cited in note 94. A 1937 Ukrainian poster, "Khai zhive Leninam!" by the artist P. Gorilogo, shows Stalin with his right arm raised high and forefinger pointed; behind him is a banner bearing Lenin's image and a quotation from Stalin. A peasant woman and man stand behind Stalin bearing the traditional symbols—a sickle and hammer. KP p5.I.5/1.kh.

118. RU/SU 1424; KP p4.VI.4.b/1.p; V/A E1273–1989.

119. See, for example, "Lenin o stroitel'stve," issued in 1930 in an edition of 15,000. It shows Lenin standing on a railroad cart with his right arm raised, his left hand clenched in a fist. Four panels on diagonals show tractors, a factory, the Dneprostroi electrical station, and a train. A quote from Lenin in the center of the poster reads: "Without electrification we cannot progress to real construction." KP p4.g3.b/Lenin.

120. Tucker, *Stalin in Power*, 147.

121. Ibid., 151. According to Tucker, "Here appeared the holy quartet—Marx, Engels, Lenin, Stalin—which would become the symbolic centerpiece of Stalinist thought and culture, replete with the four huge, equal-sized portraits on the facade of Moscow's Bolshoi Theater for May Day, 7 November, and other special occasions."

122. *Produktsiia izobrazitel'nykh iskusstv* 30 (1932), 3–4. Another example of the equal presentation of Lenin and Stalin is a Dolgorukov poster, "Piatnadtsa-tiletie oktiabr'skoi revoliutsii," published by Izogiz in an edition of 10,000. Here the history of the country is shown in four panels; Lenin presides over the first and Stalin over the last panel. *Za proletarskoe iskusstvo* 9–10 (May 1932), 21.

123. KP p4.VII.6/pobeda.

124. This poster, published by Izogiz in an edition of 25,000, shows a capitalist, Kautsky, and Hitler looking through a window at a holiday demonstration and banners with revolutionary slogans and portraits of Stalin (large) and Lenin (small). E. Rusakova and A. Maisurov, "K 15-letiiu oktiabr'skoi revo-liutsii," *Produktsiia izobrazitel'nykh iskusstv* 31–32 (1932), 3.

125. Medvedev, *Let History Judge*, 315.

126. KP p4.I/vyshe.

127. For the 1936 version, see KP p5.I/vyshe. For the 1937 reissue of the poster, see KP p5.I/1v. Klutsis was arrested in 1938. I have not found evidence that the poster was reissued after 1937.

128. The 1936 and 1937 versions differed from the 1933 poster with respect to two details. In the later version, the quotations above each leader's head are omitted. More importantly, the photomontage surrounding Stalin is altered. In place of a peasant woman there is now a well-dressed woman with short

hair who appears to belong to an educated stratum of society and peers at the viewer with a direct gaze. Furthermore, inserted into the crowd just below Stalin's neck is a woman holding up a small child with an arm raised upward toward Stalin's gigantic face above. The insertion of the new images is consistent with patterns of representation introduced in the second half of the 1930s. On these points see chapter 3.

129. It is noteworthy that in the 1937 edition prepared for national minorities the final photograph of the lower panel has been altered to include a member of the particular minority group targeted by the poster.

130. A 1918 advertisement for *Izvestiia* featured portraits of Lenin (by Nappel'baum) and Marx with direct gazes. See the reproduction in Coquin, "L'image," 241.

131. One early example is Dmitrii Moor's 1920 poster, "Ty zapisalsia dobrovol'tsem?" in *Soviet Political Art* (Harmondsworth, 1985), fig. 10.

132. See Viktor Govorkov's "Vasha lampa, tovarishch inzhener" (1933) (fig. 1.15) and Nikolai Terpsikhorov's "Idi v kolkhoz" (1930) (fig. 3.4). These are discussed in chapters 1 and 3, respectively.

133. Uspensky, *Semiotics of the Russian Icon*, 39.

134. S. Shtykan, "Obraz vozhdia v plakate," *Produktsiia izo-iskusstv* 12 (1933), 1. Dobrenko, in his study *Metafora vlasti*, contends that 1934 was the turning point in the transformation of the image of the *vozhd'* with the formulation: "Stalin is the Lenin of today." My evidence indicates that this shift took place one year earlier, in 1933.

135. One poster issued in 1937, "Pod znamenem Lenina-Stalina vpered k novym pobedam," places the profiles of the two on a banner carried aloft by joyful marchers. Stalin's profile is in front of Lenin's. KP p5.I/1. A poster by Klutsis in 1933, "K mirovomu oktiabriu," presents two giant figures—Stalin (foregrounded in a military-style tunic, boots, and cap) and Lenin (in a suit, vest, and cap, with his left arm outstretched)—literally standing upon minuscule people below them. Here the semiotics depend on clothing as a marker. Significantly, Lenin is shown once again wearing a cap, apparel generally discarded after his death, when the statesman image superseded the image of the revolutionary leader. In this poster, Stalin is indisputably the leader of state. For a discussion of this poster, see Tupitsyn, "Superman Imagery," 303.

136. Tupitsyn, "Gustav Klutsis," 164.

137. Tucker, *Stalin in Power*, 161.

138. TsGALI, f. 652, op. 1, ed. khr. 13, p. 14. In addition, the plan called for 30 other posters of various other leaders, including Kaganovich (2), Molotov (2), and Mikoyan (2). Portraits were both paintings and photographs.

139. TsGALI, f. 652, op. 8, ed. khr. 119, p. 1.

140. Roziakhovskii, "Da zdravstvuet tvorets konstitutsii svobodnykh schastlivykh

narodov SSSR," KP p5.i.1.a/i.d. For further evidence on press runs, see, TsGALI, f. 652, op. 1, ed. khr. 10, pp. 17–19, 34; f. 652, op. 1, ed. khr. 44, p. 22–30; f. 652, op. 1, ed. khr. 82, p. 1.

141. KP p5.I.ch.2/da zdravstvuet.

142. Kibardin used this device in his 1931 poster, "Postroim eskradu dirizhablei imeni Lenina." Klutsis incorporated it into a montage published on the front page of *Pravda* on August 18, 1933, depicting Stalin saluting airplanes and dirigibles, the largest of them labeled "Maksim Gorky."

143. Golomstock, *Totalitarian Art,* 220, 223.

144. E. Povolotskaia, "O plakate i lubke," *Iskusstvo* 1–2 (1929), 112–113. In the 1920s, artists from this organization painted portraits of Stalin, Voroshilov, Budennyi, Kalinin, Lunacharskii, and Menzhinskii. Golomstock, *Totalitarian Art,* 71; Robinskaia, *Sovetskii lubok,* 40.

145. KP p4.i.9.a/01.

146. Small-scale private traders and manufacturers during the years of the New Economic Policy were called "Nepmen."

147. My research has not turned up an earlier official portrait of Stalin distributed in this manner. This was not Brodskii's first painting of Lenin, and he subsequently painted many more, presenting portraits and historical scenes with Lenin and Stalin. See Golomstock, *Totalitarian Art,* 180; and a review of his work in *Plakat i khudozhestvennaia reproduktsiia* 9 (1934), 23–24. In 1932, Brodskii painted a portrait of Stalin standing at a podium with a text in his right hand, looking out over the crowd. Hans Günther, ed., *The Culture of the Stalin Period* (New York, 1990), fig. 7

148. RU/SU 1866.

149. *Produktsiia izobrazitel'nykh iskusstv* 25–26 (1932), 2.

150. KP p4.VII.1.b. The quotation is from Stalin, whose name appears below it on the poster. Hans Günther, in his article "Geroi v totalitarnoi kul'ture," reprints three versions of the Klutsis poster. *Agitatsiia za schast'e,* 73. The first of these, which he labels a "sketch," is the one I found in the Lenin Library poster collection and is reproduced in fig. 4.15.

151. Tupitsyn, "Gustav Klutsis," 166, note 4.

152. Ibid., 162.

153. Terminology for Stalin in the 1930s included the following: *nash otets* (our father), *ispolin-mudrets* (giant sage), *sila predvideniia* (strength of foresight), *velichie geniia* (sublimity of genius), *krepkii khoziain* (strong boss or master), *uchitel'* (teacher), *boets* (warrior). Dobrenko, *Metafora vlasti,* 88; Regine Robin, "Stalinisme et culture populaire," in *Culture et révolution,* by Marc Ferro et al. (Paris, 1989), 152.

154. These aspects of the Stalin image are cited by Dobrenko from M. Chegodaeva, "Osleplenie," *Sovetskaia kul'tura* (June 24, 1989), 10. See Dobrenko, *Metafora vlasti,* 94. In the 1940s, Stalin was also praised as the great general.

Jørn Guldberg, in his essay "Socialist Realism as Institutional Practice," sees three main groupings of Staliniana in Soviet pictorial art: celebrations of Stalin as a state and party leader; reconstructions of Stalin's biography; disavowals of matters not discussed officially. See Guldberg in Günther, ed., *The Culture of the Stalin Period,* 168.

155. KP p.4.IX.1.b/udarniki. For a reproduction of the poster and a review of it, see *Produktsiia izobrazitel'nykh iskusstv* 22 (1932), 1–2. This poster was produced in an edition of 30,050. It is also discussed in Margarita Tupitsyn, "Gustav Klutsis," 162–163.

156. Two quotations from Stalin appear in the upper part of the poster, reinforcing his authoritativeness as an arbiter of the country's future: "By the end of the Five Year Plan collectivization of the USSR should be fundamentally completed"; "The working class of the Soviet Union firmly and faithfully carries forward the matter of technical retooling of its ally—the toiling peasantry." The remainder of the poster (the lower half) shows collective farmers, fields, and combines. Klutsis included "a small photograph of his mother-in-law next to a giant image of Stalin" in this poster. Tupitsyn, "Gustav Klutsis," 163.

157. *Produktsiia izobrazitel'nykh iskusstv* 22 (1932), 1–2.

158. *Plakat i khudozhestvennaia reproduktsiia* 2 (1934), 3–4.

159. Ibid., 4.

160. Ibid., 1 (1934), 1–2. The reproduction is on 2.

161. Ibid.

162. According to Roy Medvedev, extravagant praise of Stalin took a great leap forward in January 1933 (the Central Committee plenum); the first issue of *Pravda* in 1934 carried an extensive article "heaping orgiastic praise on Stalin." Medvedev, *Let History Judge,* 315.

163. KP p5.I.1.a/i.d.

164. See, for example, the 1939 poster by V. Arakelov, "Stalin—samyi mudryi iz liudei—vam ottsa liubimogo rodnei." KP p6.I.4.9/1s. After World War II, many posters carried inscriptions such as, "Da zdravstvuet nash vozhd' i uchitel', nash otets—velikii Stalin." KP p8.A.IV.01.

165. Moshe Lewin, *The Making of the Soviet System: Essays in the Social History of Interwar Russia* (New York, 1985), 275.

166. KP p5.I.4.*b*/kadry. This poster did not have nearly as large a press run as some other Stalin posters issued in 1936 (for example, the Roziakhovskii poster discussed above). Perhaps one reason for the relatively small press run (25,000) is the scale of the poster.

167. There are many examples of such a hand position in Ouspensky and Lossky, *The Meaning of Icons.* See especially the fifteenth-century icon "The Transfiguration," 210, and other examples from that same period, 138, 144.

168. Klutsis's 1933 poster, "K mirovomu oktiabriu," utilizes a similar perspectival

distortion to aggrandize Lenin and Stalin, whose giant feet are positioned near crowds of very small people. Tupitsyn, "Superman Imagery," in *Nietzsche and Soviet Culture,* ed. Rosenthal, 304.

169. KP p4.XXIV.1.b/1.3h.

170. KP p5.IX.5.b/1shire.

171. A. Reznichenko, 1935, RU/SU 1824; RU/SU 565, poster has no date; RU/SU 1816, 1938, the artists are Deni, Dolgorukov, and Dubchanov; RU/SU 2151, 1937, artists are G. Kun, Vasilii Elkin, K. Sobolevskii; RU/SU 1832, 1939.

172. Jamey Gambrell, "The Wonder of the Soviet World," *New York Review of Books* 61, no. 21 (December 22, 1994), 31.

173. Golomstock, *Totalitarian Art,* 237. See 315 for some of the paintings included in the exhibition.

174. The phrase belonged to Lazar Kaganovich. Tucker, *Stalin in Power,* 607–609.

175. KP p6.I.4.9/1s. The artist was V. Arakelov.

176. KP p6.I.4/o kazhdom.

CHAPTER 5. BOLSHEVIK DEMONOLOGY

1. Iurii M. Lotman and Boris A. Uspenskii [Uspensky], "Binary Models in the Dynamic of Russian Culture (to the End of the Eighteenth Century)," in *The Semiotics of Russian Cultural History,* ed. Alexander D. and Alice Stone Nakhimovsky (Ithaca, 1985), 31.

2. Ibid., 32–33.

3. For a discussion of Lenin's plan and the celebration of Bolshevik heroes, see chapter 4.

4. The poster was published by the All-Russian Central Executive Committee of the Soviets of Workers', Peasants', and Soldiers' Deputies. KP p1.VI.4.2/tsar'; B. S. Butnik-Siverskii, *Sovetskii plakat epokhi grazhdanskoi voiny, 1918–1921* (Moscow, 1960), no. 710; a reproduction appears on p. 585. The Ukrainian version can be found in Stephen White, *The Bolshevik Poster* (New Haven and London, 1988), 24, illus. 2.8. Variations of the poster appeared in a number of different languages of the Russian Empire, including Belorussian, Tatar, Hebrew, Latvian, and Chuvash. The Tatar version included two additional figures: a man with a turban and a man with a beard and striped shirt. KP p1.VI.2/tsar'.

5. Lars T. Lih, *Bread and Authority in Russia, 1914–1921* (Berkeley and Los Angeles, 1990), 139–142. Lih provides a detailed account of the evolution of the term "kulak" in Bolshevik usage during the Civil War. On nineteenth-century usage of the term, see Cathy A. Frierson, *Peasant Icons: Representations of Rural People in Late Nineteenth Century Russia* (New York and Oxford, 1993), chap. 7.

6. For an illustration, see Dmitrii Moor's 1919 poster, "Kto protiv sovetov." RU/SU 1270.

7. Elizabeth Kridl Valkenier, ed., *The Wanderers: Masters of Nineteenth-Century Russian Painting, An Exhibition from the Soviet Union* (Dallas, 1990), 30, 129.

8. See RU/SU 2282 for Apsit's "International." Lebedeva's "Ruination" can be found in V. P. Tolstoi, ed., *Agitatsionno-massovoe iskusstvo: Oformlenie prazdnestv, 1917–1932* (Moscow, 1984), Tablitsy, fig. 180; Vladimir Tolstoy, Irina Bibilova, and Catherine Cooke, eds., *Street Art of the Revolution: Festivals and Celebrations in Russia 1918–1933* (London, 1990), 129, fig. 119.

9. Joanna Hubbs, *Mother Russia: The Feminine Myth in Russian Culture* (Bloomington, 1988), 36–51.

10. The Russian capitalist was usually designated by the pejorative term *burzhui*. See chapter 5 for a discussion of capitalist types and images.

11. Elise Kimerling, "Civil Rights and Social Policy in Soviet Russia, 1918–1936," *Russian Review* 41, no. 1 (January 1982), 30. See also Sheila Fitzpatrick, "The Problem of Class Identity in NEP Society," in *Russia and the Era of NEP: Explorations in Soviet Society and Culture,* ed. Sheila Fitzpatrick, Alexander Rabinowitch, and Richard Stites (Bloomington, 1991), 13.

12. Alan M. Ball, *Russia's Last Capitalists: The Nepmen, 1921–1929* (Berkeley and Los Angeles, 1987), 76.

13. For examples of posters with these themes, see Moor's 1919 poster, "Belogvardeitsy i dezertir" (White Guardists and Deserter), which used a *lubok* format with two panels to tell the simple story of a deserter—a scruffy and foolish-looking peasant fellow—who at first carried on his back, as it were, the *burzhui* and other enemies but then straightened up (literally and figuratively) and threw the enemies into the Black Sea (RU/SU 1261); and the 1920 poster "Meshochnik vrag transporta, vrag respubliki" (The Bagman Is the Enemy of Transport, the Enemy of the Republic), which presents a rare image of the peasant trader who carried goods illegally between the countryside and the city. BM 1921–10–31–1.

14. Tolstoi, ed., *Agitatsionno-massovoe iskusstvo*, 28; James von Geldern, *Bolshevik Festivals, 1917–1920* (Berkeley and Los Angeles, 1993), 134.

15. Tolstoi, ed., *Agitatsionno-massovoe iskusstvo,* Tablitsy, fig. 161. Similar displays were exhibited during holiday celebrations in other cities during the Civil War years.

16. See fig. 4.1.

17. See figs. 1.8, 1.10, 2.3, 2.7.

18. For examples, see White, *The Bolshevik Poster,* 51–53, illus. 3.16, 3.17, 3.19.

19. Ibid., 102, illus. 5.23.

20. Deni's 1921 poster, "III-i internatsional," shows the words of the title striking, like lightning, a cringing capitalist. RU/SU 541.

21. James Hall, *Dictionary of Subjects and Symbols in Art* (New York, 1974), 285.

22. RU/SU 1008.

23. RU/SU 1081; Vladimir Denisov, *Voina i lubok* (Petrograd, 1916), 30. The artist is unknown. The poster was produced in 1915.

24. RU/SU 331.

25. IWM pst/6283.

26. See White, *The Bolshevik Poster*, 25–32, for a brief history of Apsit's life and career.

27. RU/SU 1546. The poster was accompanied by a poem by Dem'ian Bednyi.

28. This description is drawn from von Geldern, *Bolshevik Festivals*, 41.

29. RU/SU 2282.

30. MR A99667. An illustration appears in Viacheslav Polonskii, *Russkii revoliutsionnyi plakat* (Moscow, 1925), frontispiece.

31. The 1919 poster appears in White, *The Bolshevik Poster*, 94, illus. 5.6. According to White, this poster is based on a satirical drawing by a Czech artist, Frantisek Kupka. Ibid., 92. The 1920 Kievan poster is reproduced in Polonskii, *Russkii revoliutsionnyi plakat*, 127. The artist is unknown. It was prepared at the end of 1920 in an edition of 5,000 copies. Butnik-Siverskii, *Sovetskii plakat*, no. 477.

32. Polonskii, *Russkii revoliutsionnyi plakat*, 20. On the popularity of the Prometheus myth at this time, see chapter 1.

33. RU/SU 1287.

34. S. A. Tokarev, ed., *Mify narodov mira*, vol. 1 (Moscow, 1987), 246.

35. MR A52260. The artist is unknown.

36. V/A E442-19832. The artist is anonymous; the poster was published circa 1920.

37. On the meaning of the spider in folklore, see S. A. Tokarev, ed., *Mify narodov mira. Entsiklopediia*, vol. 2 (Moscow, 1988), 295. Deni's 1919 poster "Kulak-miroed" shows a kulak as a spider; "Pauk i mukhi" (1919) shows a priest as a spider. Polonskii, *Russkii revoliutsionnyi plakat*, 69. Deni's well-known 1920 poster, "Kapital" (see fig. 5.5), shows a capitalist surrounded by a spider's web.

38. RU/SU 1257. Butnik-Siverskii, *Sovetskii plakat*, no. 837.

39. See, for example, "Nauka nemtsu," 1914, artist unknown. RU/SU 144.

40. Polonskii, *Russkii revoliutsionnyi plakat*, following p. 112. A priest and *burzhui* also appear in this picture as birds. The meaning of the text is basically: It's too early to sing about victories—you may still be defeated.

41. White, *The Bolshevik Poster*, 70, illus. 4.6.

42. See chapter 2 for a discussion of the concurrent change in the image of women.

43. White, *The Bolshevik Poster*, 7.

44. Text at the bottom of the poster reads: "Help for Japan from America and England." MR A12601. Artist unknown.

45. White, *The Bolshevik Poster*, 7–8.

46. Ibid., 8; S. Isakov, *1905 god v satire i karikature* (Moscow, 1928); S. I. Mitske-

vich, *Al'bom revoliutsionnoi satiry 1905–1906 gg.* (Moscow, 1930); V. V. Shleev, ed., *Revoliutsiia 1905–1917 gg. i izobrazitel'noe iskusstvo,* 4 vols. (Moscow, 1977–1989); B. A. Bialik, ed., *Russkaia literatura: Zhurnalistika nachala XX veka: 1905–1907 gg.* (Moscow, 1984); *Russkaia satiricheskaia periodika 1905–1907 gg.: Svodnyi katalog* (Moscow, 1980).

47. White, *The Bolshevik Poster,* 8. Other artists whose work appeared in the satirical journals of 1905–1907 included Vladimir Serov, Il'ia Repin, Boris Kustodiev, Ivan Bilibin, and Aleksei Radakov.

48. See, for example, Moor's covers for *Budil'nik:* no. 5 (January 28, 1916), no. 11 (March 10, 1916), no. 24 (June 9, 1916), no. 25 (June 16, 1916).

49. See, for example, "Kak chort ogorod gorodil," which shows various root plants growing into the heads of enemy states. RU/SU 371. This idea was later utilized by Moor in a Soviet poster, "Sovetskaia repka," issued in 1920. White, *The Bolshevik Poster,* 46, illus. 3.8.

50. Denisov, *Voina i lubok,* 31–33; White, *The Bolshevik Poster,* 3–4.

51. The following account of Rosta Windows draws upon White, *The Bolshevik Poster,* chap. 4; B. Zemenkov, *Udarnoe iskusstvo okon satiry* (Moscow, 1930); V. Maiakovskii, "Proshu slova," *Ogonek,* no. 1 (1930).

52. TsGALI, f. 1688, op. 1, ed. khr. 31, p. 10.

53. Zemenkov, *Udarnoe iskusstvo,* 42.

54. White, *The Bolshevik Poster,* 67.

55. Petrograd Rosta Windows often were read vertically rather than horizontally.

56. RU/SU 525. The poster was printed in a rather large edition of 50,000 copies.

57. White, *The Bolshevik Poster,* 7. French, English, and American satirical journals also had an influence on Russian artists.

58. For example, see *Théophile-Alexandre Steinlen* (Turin, 1980), illus. 173; Peter Dittmar, *Steinlen: Théophile Alexandre Steinlen, ein poetischer Realist in der Epoche des Jugendstils* (Zurich, 1984), 99; Frank Kupka's "Liberty" published in *L'assiette au beurre* (January 11, 1902), reprinted in Donald Drew Egbert, *Social Radicalism and the Arts: Western Europe* (New York, 1970), fig. 39; Eric Hobsbawm, "Man and Woman in Socialist Iconography," *History Workshop* 6 (Autumn 1978), 122.

59. Shleev, *Revoliutsiia 1905–1907 godov,* 3: 90, illus. 91. For another example from 1907, see ibid., illus. 90.

60. *Budil'nik* 24 (June 9, 1916), cover.

61. According to D. N. Ushakov, ed., *Tolkovyi slovar' russkogo iazyka* (Moscow, 1935), 206, the word *burzhui* appeared in a text by Turgenev, who is quoted as having written: "The biggest penny pincher in Moscow is the *burzhui*— in one word!"

62. Tolstoi, ed., *Agitatsionno-massovoe iskusstvo,* Tablitsy, fig. 111.

63. A similar image of the capitalist/*burzhui* was created for Maiakovskii's play *Misteriia buff,* produced in the fall of 1918. The capitalist here was a Frenchman, and in the costume sketches he smoked a cigar. Von Geldern, *Bolshevik*

Festivals, 69, fig. 7. See also the drawings for the album *October 1917–1918. Heroes and Victims* published in October 1918 with a text by Maiakovskii. Mikhail Guerman, ed., *Art of the October Revolution* (New York, 1979), illus. 103.

64. V. Okhochinskii, *Plakat: Razvitie i primenenie,* vol. 1 (Leningrad, 1927), 81.
65. KP pl.XIV.1./kapital. According to Butnik-Siverskii, *Sovetskii plakat,* no. 237, the original text of the poster read "Bog—kapital" (God—Capital) but was subsequently changed.
66. Richard Stites, *Revolutionary Dreams: Utopian Vision and Experimental Life in the Russian Revolution* (New York and Oxford, 1989), 94. Guerman, ed., *Art of the October Revolution,* 28, illus. 38.
67. RU/SU 525; RU/SU 28. "Manifest" was issued in an edition of 50,000; "Na mogile" appeared in an edition of 20,000. Butnik-Siverskii, *Sovetskii plakat,* nos. 1357, 1412.
68. White, *The Bolshevik Poster,* 98, illus. 5.17.
69. RU/SU 520. Butnik-Siverskii, *Sovetskii plakat,* no. 1853. See White's comments on this poster, *The Bolshevik Poster,* 44, illus. 3.4.
70. Polonskii, *Russkii revoliutsionnyi plakat,* 93–94.
71. KP pl.XIV.1./kapital; IWM pst/6279. The poster was published first in an edition of 52,800 and then in an edition of 50,000. Butnik-Siverskii, *Sovetskii plakat,* no. 242. A poem by Dem'ian Bednyi is included in the poster.
72. RU/SU 63; IWM pst/6278.
73. Butnik-Siverskii, *Sovetskii plakat,* 55. This famous *lubok* poster is generally believed to be a commentary on Peter the Great and his conflict with the Old Believers. Many versions were created over the years. One of them is reproduced in *Lubok: Russkie narodnye kartinki xvii–xviii vv.* (Moscow, 1968), 31.
74. Peter Kenez, *The Birth of the Propaganda State: Soviet Methods of Mass Mobilization, 1917–1929* (Cambridge, England, and London, 1985), 113.
75. To conduct propaganda, the South Russian White government established a propaganda department, Osvag (Osvedomitel'noe agitatsionnoe otdelenie). Kenez, *Birth of the Propaganda State,* 63–65.
76. For an example of the Russian realist style in a White poster, see "Bezchinstva bol'shevikov v tserkvi," which shows Bolsheviks dismantling the interior of a church. The date of publication and artist are unknown. RU/SU 9.
77. Polonskii, *Russkii revoliutsionnyi plakat,* 75.
78. François-Xavier Coquin makes this point in "Une source méconnue: Les affiches contre-révolutionnaires (1918–1920)," in *Russie–URSS, 1914–1991: Changements de regards,* ed. Wladimir Berelowitch and Laurent Gervereau (Paris, 1991), 57.
79. RU/SU 1042. The date of publication and artist are unknown.
80. A similar use of the color red occurs in a White poster with a red devil surrounded by hell fires exemplifying the evils of communism. RU/SU 1782. The date of publication and artist are unknown.

81. RU/SU 1507. The date of publication and artist are unknown.
82. RU/SU 680. The date of publication was 1918 or 1919. The artist is unknown.
83. The text of the poster reads: "Kissing the pale lips, once again the grandson of Judas is sending [the guards] to crucify Christ on Golgotha. I believe the light of morning is nigh. Be patient, O heart, I have faith and I am praying! After the hard days of Easter week God will be resurrected and so will Russia!" RU/SU 898. The date of publication and artist are unknown.
84. Kenez, *Birth of the Propaganda State*, 65.
85. IWM pst/4906. The poster was issued by the publisher Narodnaia Kartina; the artist's initials are D. S.
86. IWM pst/6269.
87. IWM pst/4905. The poster was produced in Rostov-on-Don.
88. Fitzpatrick, "The Problem of Class Identity," 18–19; Sheila Fitzpatrick, *The Cultural Front: Power and Culture in Prerevolutionary Russia* (Ithaca, 1992), 115–148. For the definitive study of Nepmen, see Ball, *Russia's Last Capitalists*. The Shakhty trial, which took place in the Donbass in May 1928, involved fifty-three engineers accused of wrecking equipment and undermining production while maintaining ties with former owners of the coal mines.
89. Fitzpatrick, *The Cultural Front*, 125.
90. Beginning in 1918, the children of those classified as *lishentsy* suffered disabilities with respect to secondary and higher education. Between the fall of 1928 and December 1935, they were forbidden to enter institutions of higher learning or technicums. Kimerling, "Civil Rights and Social Policy," 26–27.
91. Fitzpatrick, "The Problem of Class Identity," 27.
92. The word also denotes pests.
93. In 1927, a sketch for a poster by Deni, "Zlovrednye mukhi," showed a kulak, priest, and shopkeeper as flies flying toward a door marked "Soviet." It is uncertain whether the poster was printed. TsGALI f. 2007 op. 1, ed. khr. 8, p. 1.
94. For example, the 1929 poster "Zavody nashi! Doloi krazhi! U nashikh zavodov vstanem na strazhe!" showed a man in black concealing a piece of machinery in his jacket. KP p3.V.7/zavody. The poster was published in an edition of 15,000. The artist is unknown. Another 1929 poster, issued in an edition of 25,000, "Von iz vybornykh organov kooperatsii kulakov i rastratchikov," depicted green kulaks and embezzlers. KP p3.XIII.g.
95. For posters using the "we/they" format on this theme, see "Boris' s chastnym torgovtsem. Ukrepliaia kooperatsiu," 1927. KP p3.XIII.g/boris'. A somewhat different version appeared in 1928 under the same title (25,000 copies). KP p3.XIII.g.
96. KP p3.XIII.g. The poster was produced in an edition of 25,000 copies.
97. See Sophie Coeure, "Le dessin satirique soviétique," for a discussion of satirical devices. *Russie–URSS*, ed. Berelowitch and Gervereau, 121–122.
98. Kimerling, "Civil Rights and Social Policy," 27.

99. The so-called Right Opposition consisted of Nikolai Bukharin and other supporters of the New Economic Policy.

100. Bernard Lafite, "Soviet 'Literary Policy' on the Eve of the 'Great Turning Point': Terms and Stakes (Results of a Study of 403 Articles on Art Published in *Pravda* in 1929)," *Sociocriticism* 2, no. 1 (1986), 186–193.

101. See Tolstoi, ed., *Agitatsionno-massovoe iskusstvo,* Tablitsy, figs. 259, 263, 265–279, 286–290. The November 1929 celebration in Moscow included a papier-mâché snake. Also see *Paris–Moscou 1900–1930* (Paris, 1979), 338.

102. The German Social Democrats should not be confused with the Russian Social Democrats. The former were adversaries of the German Communists and advocated a far more reformist policy than was acceptable to the revolutionary Communists. A holiday display in Leningrad on May Day 1930 showed a small fascist with teeth bared like a dog and a very large worker of the new type, that is, no longer the blacksmith icon. Tolstoy, Bibilova, and Cooke, eds., *Street Art of the Revolution,* fig. 183.

103. This term referred to the Right Opposition, that is, to advocates of the NEP, such as Bukharin and his supporters, who had been discredited in 1928.

104. Tolstoi, ed., *Agitatsionno-massovoe iskusstvo,* Tablisty, fig. 300; Tolstoy, Bibilova, and Cooke, eds., *Street Art of the Revolution,* fig. 185.

105. RU/SU 1072.

106. Robert C. Tucker, *Stalin in Power: The Revolution from Above, 1928–1941* (New York, 1990), 93.

107. See chapter 1.

108. For example, in January 1936, the following artists were scheduled to submit drafts of the poster "1-oe maia": Moor, Deni, Deineka, Efimov, Karachentsov, Klutsis, Keil', and Toidze. TsGALI, f. 652, op. 1, ed. khr. 24.

109. Lars Erik Blomqvist, "Introduction," in *Symbols of Power: The Esthetics of Political Legitimation in the Soviet Union and Eastern Europe,* ed. Claes Arvidsson and Lars Erik Blomqvist (Stockholm, 1987), 13.

110. On the preoccupation with heroes in the early 1930s, see chapter 1.

111. "Social fascist" was a term used to refer to German Social Democrats.

112. Kimerling, "Civil Rights and Social Policy," 26.

113. *Produktsiia izo-iskusstv* 6 (1933), 15.

114. RU/SU 640.

115. RU/SU 1859A.

116. Tolstoi, ed., *Agitatsionno-massovoe iskusstvo,* Tablisty, fig. 299; Tolstoy, Bibilova, and Cooke, eds., *Street Art of the Revolution,* fig. 186.

117. RU/SU 2291.

118. RU/SU 1934. The poster edition was 40,000.

119. A reproduction of the poster appears in G. L. Demosfenova, A. Nurok, and N. I. Shantyko, *Sovetskii politicheskii plakat* (Moscow, 1962), 308.

120. Tolstoi, ed., *Agitatsionno-massovoe iskusstvo,* Tablisty, figs. 317, 331, 337; Tol-

stoy, Bibilova, and Cooke, eds., *Street Art of the Revolution,* figs. 203, 206. Dmitrii Moor was the creator of one of these figures.

121. *Produktsiia izo-iskusstv* 5 (1933), 2. The title of the poster is a quotation from Stalin. The poster edition was 25,000.

122. *Plakat i khudozhestvennaia reproduktsiia* 1 (1934), 4.

123. A. Zaitsov, a reviewer of posters, noted that if an outmoded image of the kulak "disoriented" people in the class struggle, the responsibility lay with the artist who created the *tipazh* as well as the editor and publisher of the poster. Ibid., 5.

124. Boris Groys, "The Birth of Socialist Realism from the Spirit of the Avant-Garde," in *The Culture of the Stalin Period,* ed. Hans Günther (New York, 1990), 141.

125. KP P4.XVI.2.g/brak. The poster was printed in an edition of 20,000. A reproduction of this poster appears in Demosfenova, Nurok, and Shantyko, *Sovetskii politicheskii plakat,* 299. Korshunov was a member of a brigade of poster artists that had previously worked in the AKhR printing house and subsequently moved to Izogiz. Groys, "Birth of Socialist Realism," 99.

126. *Produktsiia izo-iskusstv* 8 (1933), 6.

127. *Za proletarskoe iskusstvo* 2 (February 1931), 12.

128. *Produktsiia izo-iskusstv* 8 (1933), 6.

129. Ibid. 2 (1933), 2. The poster was produced in an edition of 30,000. The poster includes images of the Pope, a mullah, a priest, and a rabbi.

130. RU/SU 1434.

131. N. Shantyko observes that the color symbolism and drawing of the main figure were intended to underline the resemblance to a black crow, which "created a definite ideological-symbolic accent." Demosfenova, Nurok, and Shantyko, *Sovetskii politicheskii plakat,* 98.

132. *Produktsiia izo-iskusstv* 8 (1933), 7.

133. Ibid. 8 (1933), 6. The poster was printed in an edition of 40,000 copies. For another poster with a class enemy presented as a rodent, see Viktor Govorkov's 1933 poster, "Kolkhoznik okhraniai svoi polia ot klassovykh vragov—vorov i lodyrei, raskhishchaiushchikh sotsialisticheskii urozhai." Demosfenova, Nurok, and Shantyko, *Sovetskii politicheskii plakat,* 297.

134. Glanders is a contagious and very destructive disease of horses, mules, and other animals, caused by a bacterium. It is communicable to human beings. The poster conveyed the idea that the professor was undermining the collective farm by spreading glanders among livestock. It was published in an edition of 50,000. *Produktsiia izo-iskusstv* 8 (1933), 6.

135. White, *The Bolshevik Poster,* 46, illus. 3.8. In Moor's poster, the enemies are pulling and the Red Army soldier is the turnip.

136. Kenez, *Cinema and Soviet Society,* 158, 164.

137. On the Pavlik Morozov myth, see Iurii Druzhnikov, *Voznesenie Pavlika Morozova* (London, 1988).

138. Kenez observes that in 1940, the internal enemy disappears from films, to be replaced by external enemies. Kenez, *Cinema and Soviet Society*, 165.

139. A poster by the Kukryniksy in 1934 was titled "Burzhuaziia odurachivaet massy, prikryvaia imperialisticheskii grabezh staroi ideologiei natsional'noi voiny." It appeared in an edition of 50,000. *Plakat i khudozhestvennaia reproduktsiia* 9 (1934), 13. In another poster, issued in 1935, a fascist with a savage animal head attacks Russia. IMW pst/o/69. The artist is unknown. In 1936, a poster by A. Keil', "Unichtozhim gadinu!" shows a man strangling a snake. Demosfenova, Nurok, and Shantyko, *Sovetskii politicheskii plakat*, 326.

140. Demosfenova, Nurok, and Shantyko, *Sovetskii politicheskii plakat*, 322.

141. RU/SU 671.

142. White, *The Bolshevik Poster*, 102, illus. 5.23.

143. RU/SU 645. The artist is unknown. The arm in the poster belongs to the French leader Poincaré, and the hand is labeled "wreckers." In place of the sword, a hammer and sickle device severs the hand.

144. Pavel Sokolov-Skalia, "Boets, ne otstupai," 1942, V/A E2787, 1962 (wolf); Kukryniksy, "Sverkhskotstvo," 1941, V/A E2790–1962 (cow); RU/SU2129; RU/SU 2139 (lion); V. Klimashin and N. Zhukov, "Bei nemetskikh zverei!" 1943, RU/SU 2128 (tiger); *Sovetskie mastera satiry* (Moscow-Leningrad, 1946), 7 (pig), 14 (crow), 128 (rat), 42 (kitten), 45, 57, 88 (dog), 76 (horse); Demosfenova, Nurok, and Shantyko, *Sovetskii politicheskii plakat*, 363 (donkey), 131 (boar), 170 (monkey or gorilla); G. L. Demosfenova, *Sovetskie plakatisty—fronty* (Moscow, 1985), 93 (crab), 101, 326 (snake); IWM pst/6408; KP p7.E.I.02/razdavim (snake).

145. KP 7 E.I.02./smert'.

146. See, for example, RU/SU 144, RU/SU 175, RU/SU 331.

147. "Grazhdane, zorko okhraniaite telegraf i telefon ot fashistskikh diversantov!" 70,000. KP p7.3.I.02/grazhdane.

148. L. V. Vandyshev, "Organizuem. Pomogai K. A. vylavlivat' shpionov i diversantov," 10,000. KP p7.3.I.02/organizuem.

149. Demosfenova, Nurok, and Shantyko, *Sovetskii politicheskii plakat*, 354.

150. See, for example, Moor's poster "Kak chort ogorod gorodil." RU/SU 371.

151. See the posters by Deni and the Kukryniksy in *Sovetskie mastera satiry*, 4–5, 41, 73, 74, 93.

152. For examples, see Demosfenova, Nurok, and Shantyko, *Sovetskii politicheskii plakat*, 361–363.

153. RU/SU 2177; V/A E 2788–1962; the poster is also available in the Russian State Library poster collection, no. 9876–84. The poster edition was 30,000 and includes a poem by I. Utkin.

154. See Deni's poster, "Krasnoi armii metla nechist' vymetet dotla," in *Sovetskie mastera satiry*, 11, and *Soviet Political Poster*, 101. See also Efimov's poster,

"Gitler—Kar-raul!," in *Sovetskie mastera satiry,* 129; Deni, "Krasnoi armii metla nechist' vymela dotla," 1945 (a different version from the first), in Demosfenova, *Sovetskie plakatisty,* 190.

155. RU/SU 541.

156. KP p7.EV02/Stalingrad; V/A E 2789–1962. The poster was issued in an edition of 50,000 copies.

157. See chapter 6 for further discussion of World War II posters.

158. There are many examples of such posters, such as "Pust' vdokhnovliaet vas v etoi voine," by Petr Aliakrinskii. It was issued in 1942 in an edition of 600,000 copies. The poster lists and then illustrates heroes of the past: Aleksandr Nevskii, Dmitrii Donskoi, Kuz'ma Minin, and others. IWM PST/0179. See also RU/SU 2145 and RU/SU 2198.

CHAPTER 6. THE APOTHEOSIS OF STALINIST POLITICAL ART

1. RU/SU 2225.

2. A Young Pioneer was a member of a mass communist organization for children aged nine to fifteen.

3. Victor Terras, ed., *Handbook of Russian Literature* (New Haven, 1985), 296. The quotation is from Nekrasov's narrative poem, "Komu na Rusi zhit' khorosho."

4. The painting, which was completed between 1870 and 1873, portrays a range of people from the old regime: the sage-philosopher, the former priest, a sailor or soldier, a Kalmyk, a Greek, a youngster, and an old man. Elizabeth Kridl Valkenier, ed., *The Wanderers: Masters of Nineteenth-Century Russian Painting* (Dallas, 1990), 33–34.

5. Jamey Gambrell, "The Wonder of the Soviet World," *New York Review of Books* 61, no. 21 (January 22, 1994), 31.

6. Grigorii Freidin, "Dve shineli, ili anekdot s borodoi: K voprosu o 'kul'ture' i 'subkul'turakh' v Rossii," *Znamia* 10 (October 1992), 223–224.

7. RU/SU 2136.

8. Vera Sandomirsky Dunham, *In Stalin's Time: Middleclass Values in Soviet Fiction* (Cambridge, England, and New York, 1976), 13, 17.

9. MR A 46035. It appeared in an edition of 105,000.

10. See, for example, fig. 6.7. A blond peasant woman steers a combine in Boris Semanov's "Bor'ba za vysokii urozhai—Bor'ba za mir," 1952 (5,000 copies). KP p9.3.v.02.6/Bor'ba.

11. MR A53762; KP p9.3.IV.01.2–03/aktivnost'. The press run was 100,000.

12. "The German Ideology," in *Karl Marx: Selected Writings,* ed. David McLellan (Oxford, 1977), 169. I am grateful to Gregory Freidin for suggesting this allusion.

13. RU/SU 2223.

14. The poster contains a careful statement about Stalin's relation to Lenin: the

book by Stalin lies on top of the book by Lenin; in the historical frieze, Lenin stands above Stalin and other old Bolsheviks.

15. On the subject of clothing, see Dunham, *In Stalin's Time,* chap. 3.

16. The poster "U nas, u vas," by the artists Buev and Iordanskii, appeared in an edition of 50,000 copies. A poem by Dem'ian Bednyi appears on this poster, which is designed in the *lubok* "we/they" style and includes a contrasting scene of the dismal life under capitalism. RU/SU 1830.

17. "Sovetskaia torgovlia est' nashe rodnoe bol'shevistskoe delo" (1937, 35,000 copies). RU/SU 2298.

18. Some examples: Viktor Koretskii and V. Gritsevich, "Sily demokratii i sotsializma nepobedimy!" (1949, 300,000 copies), KP p8.B.VIII/sily demokratii; Viktor Ivanov, "Sovetskoe radio verno sluzhit delu mira!" (1950), RU/SU 2221; Viktor Ivanov, "S prazdnikom, tovarishchi!" (1950, 100,000 copies), KP p8.B.VI/s prazdnikom; Vasilii Sur'ianinov, "Shire rasprostraniat' opyt novatorov!" (1953, 100,000 copies), KP p9.3.IV.01.2/shire.

19. Nina Vatolina, "Kazhdyi, kto chesten, vstan' s nami vmeste!" (1952, 300,000 copies). KP p9.3.IV.01.2.03/aktivnost'.

20. Dunham, *In Stalin's Time,* 22, 50.

21. See "I zhizn' khorosha, i zhit' khorosho!" for an image of a well-dressed woman with short blond hair wearing a red jacket. The poster, by A. G. Mosin, was published in Rostov-on-Don in an edition of 10,000. KP p9.D.I.01/i zhizn'.

22. For examples see Galina Shubina, "Bystree vosstanovim selo" (1946), KP p8.zh; I. Krupskii and N. Rodin, "Bol'shevistskii urozhai soberem vo-vremia I bez poter'!" (Kiev, 1951), KP p9.3.V.02.8/bol'shevistskii; Nina Vatolina, "Vyrastili otlichno—uberem bez poter'!" (1951), KP p9.3.V.02.8/vyrastili. In Viktor Ivanov's 1946 poster, "Za vysokii urozhai!" a peasant woman holding a large bundle of wheat in the field wears amber jewelry and an embroidered blouse. See *Viktor Semenovich Ivanov* (Moscow, 1988), 35.

23. Boris Berezovskii, "Den' vyborov—vsenarodnyi prazdnik!" (1950), MR A53757.

24. The rest of the poster's text reads: "None are brighter and more beautiful than you, our red spring." KP p8.5.VI(1946)/pogliadi. The poster was issued in an edition of 200,000 copies. On the folk revival in music, see Richard Stites, *Russian Popular Culture* (Cambridge, England, 1992), 117.

25. KP p9.zh/komu.

26. KP p8.zh/s novosel'em! I found two versions of this poster, both by Govorkov, in the archive. The one printed in Moscow is reproduced here. The other, printed in Leningrad, differed in some details. The female figure had a slightly different face but the same expression; she wears a red dress with a plain collar and a brooch in the center.

27. For those with long memories, the attractive woman may have been reminiscent of female images that appeared in prerevolutionary commercial advertis-

ing or film posters of the 1920s. See N. I. Baburina, *Russkii plakat: Vtoraia polovina XIX–nachalo XX veka* (Leningrad, 1988).

28. The painting is analyzed in Svetlana Boym, "Everyday Culture," in *Russian Culture at the Crossroads: Paradoxes of Postcommunist Consciousness,* ed. Dmitri N. Shalin (Boulder, 1996); Jørn Guldberg, "Socialist Realism as Institutional Practice: Observations on the Interpretation of the Works of Art of the Stalin Period," in *The Culture of the Stalin Period,* ed. Hans Günther (New York, 1990), 167–170.

29. Gambrell, "The Wonder of the Soviet World," 32. The following account draws extensively from Gambrell's essay and from the author's own observations and photographs following a visit to VDNKh in 1988.

30. Plans for the statue were abandoned after Stalin's death in 1953.

31. Peter Kenez, *Cinema and Soviet Society 1917–1953* (Cambridge, England, 1992), 201.

32. Taline Ter Minassian, "L'affiche stalinienne: Du photomontage productiviste aux appels patriotiques," in *Russie–URSS, 1914–1991: Changements de regards,* ed. Wladimir Berelowitch and Laurent Gervereau (Paris, 1991), 136.

33. RU/SU 2156; KP p7.A.IV.02.B.

34. See chapter 4.

35. KP p7.A.IV.01/v radostnyi.

36. For an example, see Aleksei Kokorekin's "Sorevnuites' na luchshuiu pomoshch' frontu!" (1942, 50,000 copies). A young, clean-cut blond worker holds aloft a red banner with three-quarter profiles of Stalin (in front) and Lenin in a gold circle. IWM PST/0185.

37. *The Soviet Political Poster* (Middlesex, 1985), 100.

38. The following account is drawn from Kenez, *Cinema and Soviet Society,* 228–235.

39. RU/SU 2237.

40. See, for example, Voloshin's "Pod znamenem Lenina—vpered k pobede!" which features a larger-than-life portrait of Lenin looking into the distance, with rows of soldiers holding bayonets below. MR A50664.

41. See, for example, Kokorekin's "Sorevnuites' na luchshuiu pomoshch' frontu!" in which a young worker carries the banner, cited in note 36 above.

42. KP p8.B.V(XXX).

43. The following posters incorporated these phrases: KP p9.A.IV.09 (1951); p8. A.IV.02 (1948); p8.A.IV.01 (1947); p8.A.IV.01 (1946); p8.A.IV.05 (1946).

44. KP p9.A.IV.09/velikii. The poster is signed and dated 1949. The version I found in the archive was issued in 1952 in an edition of 300,000, but there may have been an earlier edition as well.

45. See Guldberg's discussion in "Socialist Realism as Institutional Practice," 173.

46. RU/SU 2136.

47. RU/SU 2145. The poster is undated and appears in this version with an English subtitle.

48. RU/SU 2082.

49. The poster appeared in 1946 in an edition of 300,000. RU/SU 2161. It is reproduced in *The Soviet Political Poster,* 106.

50. *Viktor Semenovich Ivanov,* illus. 30.

51. Viktor Ivanov, "S prazdnikom, tovarishchi!" cited in note 18 above. The words appear on a red flag behind a handsome blond young man in a white shirt and tie.

52. The special status of the Russian nation in Soviet propaganda can be discerned from such phrases as "the leading nation," "first among equals," "elder brother," and "the most outstanding nation of all the nations that make up the USSR." Roy Medvedev, *Let History Judge: The Origins and Consequences of Stalinism* (New York, 1989), 803.

53. KP p8.I.iv.01v/trudis'.

54. Leonid Ouspensky and Vladimir Lossky, *The Meaning of Icons* (Crestwood, New York, 1983), 40.

55. Dunham, *In Stalin's Time,* 45.

56. The poster appeared in 1950 in an edition of 200,000. KP p9.A.IV.07/spasibo.

57. The artist is Victor Ivanov and the poster was published in 1948. KP p8. I.iv.01v/ty. See also Nina Vatolina's "Vyrastili otlichno—uberem bez poter'," which repeats the theme of an older collective farmer and a younger worker, in this case a handsome young man (1951, 50,000 copies). KP p9.3.02.8/vyrastili.

58. See chapter 1 for a discussion of heroes.

59. Viktor Koretskii, "My trebuem mira!" (1950), KP p8.b.ix/my trebuem; Lev Samoilov, "Po rukam!" (Riga, 1952), KP p9.zh/po.

60. See, for example, Nina Vatolina's "Fashizm-zleishii vrag zhenshchin," 1941; Fedor Antonov, "Syn Moi!," 1942; Veniamin Pinchuk, "Zhenshchiny goroda Lenina!" 1943; Vladimir Serov, "My otstoiali Leningrad," 1944. Demosfenova, Nurok, and Shantyko, *Sovetskii politicheskii plakat,* 342, 351, 364, 377.

61. See, for example, Iosif Serebrianyi, "Bei krepche, synok!" 1941; Tat'iana Eremina, "Na traktor devushki sadiatsia smelo," 1941; Viktor Ivanov and Ol'ga Burova, "Traktor v pole—chto tank v boiu!" 1942. Demosfenova, Nurok, and Shantyko, *Sovetskii politicheskii plakat,* 336, 341; RU/SU 2159.

62. RU/SU 2108.

63. Viktor Koretskii, "Voin Krasnoi Armii, spasi!" 1942; Viktor Ivanov, Ol'ga Burova, "Boets Krasnoi Armii! Smelo i stoiko beisia s vragom," 1942; Leonid Golovanov, "Msti fashistskim psam," 1942–1943; Dementii Shmarinov, "Smert' fashistam-dushegubam," 1943–1944; Fedor Antonov, "Okruzhim laskoi i zabotoi detei, postradavshikh ot fashistskikh varvarov!," 1942. Demosfenova, Nurok, and Shantyko, *Sovetskii politicheskii plakat,* 349, 357, 356, 353; IWM, pst 16534.

64. See also Fedor Antonov, "Boets Krasnoi Armii! Ty ne dash' liubimuiu na pozor . . . " 1942; Viktor Ivanov, "Blizok chas rasplaty," 1944. Demosfenova, Nurok, and Shantyko, *Sovetskii politicheskii plakat,* 350, 354.

65. Richard Stites, *Popular Culture,* xxxx, 83.

66. Peter Kenez, "Black and White," in *Culture and Entertainment in Wartime Russia,* ed. Richard Stites (Bloomington and Indianapolis, 1995), 169.

67. For a penetrating account of this phenomenon, see Rosalinde Sartorti, "On the Making of Heroes, Heroines, and Saints," in *Culture and Entertainment,* ed. Stites, 182–190.

68. KP p8.B.IX/prokliat'e. The poster is reproduced in *Viktor Semenovich Ivanov* (Moscow, 1988), illust. 68.

69. KP p8.I.IV.o1v/ty.

70. Nikolai Tereshchenko, "Da zdravstvuet mir mezhdu narodami!" (1953, 500,000 copies). KP p9.zh/da zdravstvuet.

71. The artist is Z. Pravdina. The poster edition was 100,000. RU/SU 2222.

72. Viktor Koretskii, "Za mir" (1951). MR A53740. Konstantin Ivanov and Veniamin Briskin, "Ostanovit' prestupnikov!" (1952, 200,000 copies). KP p9.3zh/ostanovit'.

73. Dolgorukov, "K otvetu" (1952, 300,000 copies), shows an American soldier with a cigar, holding a bottle marked "cholera." He is struck by red lightning. KP p9.zh/k otvetu.

74. Lev Samoilov, "Po rukam!" This poster was produced in many different languages throughout the Soviet Union. KP p9.zh/po.

75. Boris Shirokorad, "K otvetu!" (10,000 copies). KP p9.zh/k otvetu.

76. One poster by Cheremnykh, "Amerikanskii obraz zhizni," informed viewers that a serious crime took place every twenty-one seconds in the United States (1949, 200,000). RU/SU 1969; MR A55223.

77. Some posters tried to combine both, such as Kazimir Agnit's "Sviati dari" (Kiev, 1952, 50,000 copies). This poster reproduces the corpulent capitalist with a top hat. His appearance replicates the original class markers except for one detail: he has a long nose. The new image has much in common with the one that appeared at the beginning of the 1930s in the anonymous poster "Protiv klassa eksploatatorov" (fig. 5.12) and in Deni and Dolgorukov's 1933 poster, "Piatiletnii plan." KP p9/3h/sviati.

78. KP p9.zh/tsel'.

79. Medvedev, *Let History Judge,* 805–807. The impact of anti-Semitism on popular culture is discussed in Stites, *Popular Culture,* 118–119.

80. Dolgorukov's 1952 poster with the caption "K otvetu" depicts a Semitic-looking villain (see note 73). Similarly, the American soldier in the form of a rat in Shirokorad's 1953 poster has Semitic features (see note 75).

81. On freedom: Boris Efimov and Nikolai Dolgorukov, "Svoboda po-amerikanski" (1950, 200,000 copies). KP p8.3/svoboda po. On planning the economy: Mikhail Cheremnykh, "My nasazhdaem zhizn'! Dva mira—dva plana/Oni

seiut smert'!" (1949, 100,000 copies). KP p8.3/dva mira. On the Volga-Don canal: Iulii Ganf, "Volgo-Don postroili! Uollstritovtsev rasstroili" (1952, 300,000 copies). KP p9.3h/Volgo. On the right to work: Viktor Koretskii, "V stranakh kapitalizma—bespravie truda! V strane sotsializma—pravo na trud!" (1948). KP p8.3/v stranakh kapitalizma. On musicians: Viktor Koret-skii, "V stranakh kapitalizma—doroga talanta" (1949, 45,000). It compares violinists in the United States and the USSR. KP p8.3/v stranakh kapital-izma—doroga talanta.

BIBLIOGRAPHY

PERIODICALS

Brigada khudozhnikov, 1931–1932
Budil'nik, 1916
Iskusstvo, 1923–1929
Iskusstvo v massy, 1930
Na stroike MTS i sovkhozov, 1934–1937
Plakat i khudozhestvennaia reproduktsiia, 1934–1935
Produktsiia izobrazitel'nykh iskusstv, 1932
Produktsiia izo-iskusstv, 1933
Sovetskoe iskusstvo, 1925–1926
Za proletarskoe iskusstvo, 1929–1932
Zritel', 1905–1906

ARCHIVES

British Museum, London (BM)
Imperial War Museum, London (IWM)
Kollektsiia plakatov (Poster Collection), Russian State Library, Moscow (KP)
Muzei revoliutsii (Museum of the Revolution), Moscow (MR)
Russian and Soviet Poster Collection, Hoover Institution Archives, Stanford, California (RU/SU)
Tsentral'nyi gosudarstvennyi arkhiv literatury i iskusstva (Central State Archive of Literature and Art), Moscow (TsGALI)
Victoria and Albert Museum, London (V/A)

Abel, Ulf. "Icons and Soviet Art." In *Symbols of Power: The Esthetics of Political Legitimation in the Soviet Union and Eastern Europe,* edited by Claes Arvidsson and Lars Erik Blomqvist, 141–162. Stockholm, 1987.

Adaskina, Natal'ia. "The Place of Vkhutemas in the Russian Avant-Garde." In *The Great Utopia: The Russian and Soviet Avant-Garde, 1915–1932,* 282–293. New York, 1992.

Affiches et imageries russes, 1914–1921. Paris, 1982.

Agitatsiia za schast'e: Sovetskoe iskusstvo stalinskoi epokhi. Compiled by Hubertus Gassner. Dusseldorf-Bremen, 1994.

Agulhon, Maurice. *Marianne into Battle: Republican Imagery and Symbolism in France, 1789–1880.* Cambridge, England, 1981.

———. "On Political Allegory: A Reply to Eric Hobsbawm." *History Workshop* 8 (Autumn 1979), 167–173.

———. "Propos sur l'allégorie politique (en réponse à Eric Hobsbawm)." *Actes de la recherche en sciences sociales* 28 (June 1979), 27–32.

Alexander, Sally, Anna Davin, and Eve Hostettler. "Labouring Women: A Reply to Eric Hobsbawm." *History Workshop* 8 (Autumn 1979), 174–182.

Antologiia sovetskoi pesni, 1917–1957 (Moscow, 1957).

Baburina, Nina I. *Russkii plakat: Vtoraia polovina XIX–nachalo XX veka.* Leningrad, 1988.

———, ed. *The Soviet Political Poster.* Harmondsworth, 1985.

Baldina, Ol'ga Dmitrievna. *Russkie narodnye kartinki.* Moscow, 1972.

Ball, Alan M. *Russia's Last Capitalists: The Nepmen, 1921–1929.* Berkeley and Los Angeles, 1987.

Barron, Stephanie, and Maurice Tuchman, eds. *The Avant-Garde in Russia, 1910–1930: New Perspectives.* Cambridge, Massachusetts, and London, 1980.

Bartanov, A., O. Suslova, and G. Chudakov, eds. *Antologiia sovetskoi fotografii, 1917–1940.* Moscow, 1986.

Barthes, Roland. *Image/Music/Text.* Translated by Stephen Heath. New York, 1977.

Baudin, A., T. Lahusen, and L. Heller. "Le réalisme socialiste de l'ère Jdanov." *Études de lettres* 10 (October–December 1988), 69–103.

Baxandall, Michael. *Painting and Experience in Fifteenth Century Italy.* London, 1972.

Benjamin, Walter. *Moscow Diary.* Edited by Gary Smith. Cambridge, Massachusetts, 1986.

Berelowitch, Wladimir, and Laurent Gervereau, eds. *Russie–URSS, 1914–1991: Changements de regards.* Paris, 1991.

Berger, John. *Ways of Seeing.* London, 1977.

Bialik, B. A., ed. *Russkaia literatura: Zhurnalistika nachala XX veka: 1905–1907 gg.* Moscow, 1984.

Binns, Christopher A. P. "The Changing Face of Power: Revolution and Accom-

modation in the Development of the Soviet Ceremonial System. I." *Man* 14, no. 4 (December 1979), 585–606.

Blomqvist, Lars Erik. "Introduction." In *Symbols of Power: The Esthetics of Political Legitimation in the Soviet Union and Eastern Europe,* edited by Claes Arvidsson and Lars Erik Blomqvist, 7–19. Stockholm, 1987.

———. "Some Utopian Elements in Stalinist Art." *Russian History/Histoire Russe* 11, nos. 2–3 (Summer–Fall 1984), 298–305.

Bourdieu, Pierre. *Distinction: A Social Critique of Judgement of Taste.* Cambridge, Massachusetts, 1984.

Bowlt, John E. "Russian Sculpture and Lenin's Plan for Monumental Propaganda." In *Art and Architecture in the Service of Politics,* edited by Henry A. Millon and Linda Nochlin, 182–193. Cambridge, Massachusetts, 1978.

Bown, Matthew Cullerne and Brandon Taylor, eds. *Art of the Soviets.* Manchester and New York, 1993.

Boym, Svetlana. "Everyday Culture." In *Russian Culture at the Crossroads: Paradoxes of Postcommunist Consciousness,* edited by Dmitri N. Shalin, 157–183. Boulder, 1996.

Brandt, Paul. *Schaffende Arbeit und bildende Kunst im Altertum und Mittelalter.* Leipzig, 1927.

———. *Schaffende Arbeit und bildende Kunst vom Mittelalter bis zur Gegenwart.* Leipzig, 1928.

Bridger, Susan. *Women in the Soviet Countryside: Women's Roles in Rural Development in the Soviet Union.* Cambridge, England, 1987.

Brooks, Jeffrey. "Literacy and the Print Media in Russia, 1861–1928." *Communication* 11 (1988), 47–61.

———. "Revolutionary Lives: Public Identities in *Pravda* during the 1920s." In *New Directions in Soviet History,* edited by Stephen White, 27–40. Cambridge, England, 1992.

———. "Russian Cinema and Public Discourse, 1900–1930." *Historical Journal of Film, Radio and Television* 11, no. 2 (1991), 141–148.

———. *When Russia Learned to Read: Literacy and Popular Literature, 1861–1917.* Princeton, 1985.

Brown, Peter. *Society and the Holy in Late Antiquity.* Berkeley and Los Angeles, 1982.

Brumfield, William C. "Anti-Modernism and the Neoclassical Revival in Russian Architecture, 1906–1916." *Journal of the Society of Architectural Historians* 48, no. 4 (December 1989), 371–386.

Buchloh, Benjamin H. D. "From Faktura to Factography." *October* 30 (1984), 83–119.

Butnik-Siverskii, B. S. *Sovetskii plakat epokhi grazhdanskoi voiny, 1918–1921.* Moscow, 1960.

Buzinov, A. *Za Nevskoi zastavoi: Zapiski rabochego.* Moscow and Leningrad, 1930.

Carr, Edward H., and R. W. Davies. *Foundations of a Planned Economy, 1926–1929.* Harmondsworth, 1974.

Clark, Katerina. "Little Heroes and Big Deeds: Literature Responds to the First Five-Year Plan." In *Cultural Revolution in Russia, 1928–1931,* edited by Sheila Fitzpatrick, 189–206. Bloomington, 1984.

———. *The Soviet Novel: History as Ritual.* Chicago and London, 1981.

Clark, T. J. *Image of the People: Gustave Courbet and the 1848 Revolution.* Princeton, 1982.

Clark, Toby. "The 'New Man's' Body: A Motif in Early Soviet Culture." In *Art of the Soviets,* edited by Matthew Cullerne Bown and Brandon Taylor, 33–50. Manchester and New York, 1993.

Coeure, Sophie. "Le dessin satirique soviétique." In *Russie–URSS, 1914–1991: Changements de regards,* edited by Wladimir Berelowitch and Laurent Gervereau, 118–123. Paris, 1991.

Conquest, Robert. *The Harvest of Sorrow: Soviet Collectivization and the Terror-Famine.* New York, 1986.

Constantine, M., and A. M. Fern. *Work and Image: Posters from the Collection of the Museum of Modern Art.* New York, 1968.

Cooke, Catherine. "Mediating Creativity and Politics: Sixty Years of Architectural Competitions in Russia." In *The Great Utopia: The Russian and Soviet Avant-Garde, 1915–1932,* 680–711. New York, 1992.

Coquin, François-Xavier. "L'affiche révolutionnaire soviétique (1918–1921): Mythes et réalités." *Revue des études slaves* 59, no. 4 (1987), 719–740.

———. "L'image de Lénine dans l'iconographie révolutionnaire et postrévolutionnaire." *Annales ESC* 2 (March–April 1989), 223–249.

———. "Une source méconnue: Les affiches contre-révolutionnaires (1918–1920)." In *Russie–URSS, 1914–1991: Changements de regards,* edited by Wladimir Berelowitch and Laurent Gervereau, 52–60. Paris, 1991.

Davies, Robert William. *The Socialist Offensive: The Collectivization of Agriculture, 1929–1930.* London, 1980.

Demosfenova, G. L. *Sovetskaia grafika, 1917–1957.* Moscow, 1957.

———. *Sovetskie plakatisty—fronty.* Moscow, 1985.

Demosfenova, G. L., A. Nurok, and N. I. Shantyko. *Sovetskii politicheskii plakat.* Moscow, 1962.

Denisov, Vladimir. *Voina i lubok.* Petrograd, 1916.

Dittmar, Peter. *Steinlen: Theophile Alexandre Steinlen, ein poetischer Realist in der Epoche des Jugendstils.* Zurich, 1984.

Dobrenko, Evgenii. *Metafora vlasti: Literatura stalinskoi epokhi v istoricheskom osveshchenii.* Munich, 1993.

Dunham, Vera Sandomirsky. *In Stalin's Time: Middleclass Values in Soviet Fiction.* Cambridge, England, and New York, 1976.

Efimov, B. *Politicheskie karikatury, 1924–1934: Al'bom.* Moscow, 1935.

Egbert, Donald Drew. *Social Radicalism and the Arts: Western Europe.* New York, 1970.

Fainsod, Merle. *Smolensk under Soviet Rule.* New York, 1953.

Fitzpatrick, Sheila. *The Cultural Front: Power and Culture in Prerevolutionary Russia.* Ithaca, 1992.

———. "The Problem of Class Identity in NEP Society." In *Russia and the Era of NEP: Explorations in Soviet Society and Culture,* edited by Sheila Fitzpatrick, Alexander Rabinowitch, and Richard Stites, 12–33. Bloomington, 1991.

———. *Stalin's Peasants: Resistance and Survival in the Russian Village after Collectivization.* New York and Oxford, 1994.

Florinsky, Michael T., ed. *Encyclopedia of Russia and the Soviet Union.* New York, 1961.

Freidin, Gregory. *A Coat of Many Colors: Osip Mandelstam and His Mythologies of Self-Presentation.* Berkeley and Los Angeles, 1987.

———. "Romans into Italians: Russian National Identity in Transition." In *Russian Culture in Transition: Selected Papers of the Working Group for the Study of Contemporary Russian Culture, 1990–1991,* edited by Gregory Freidin, 241–274. Stanford, 1993.

———. "Dve shineli, ili anekdot s borodoi: K voprosu o 'kul'ture' i 'subkul'turakh' v Rossii." *Znamia* 10 (October 1992), 223–224.

Frierson, Cathy A. *Peasant Icons: Representations of Rural People in Late Nineteenth Century Russia.* New York and Oxford, 1993.

Fueloep-Miller, René. *The Mind and Face of Bolshevism: An Examination of Cultural Life in the Soviet Union.* New York, 1965.

Furet, François. *Interpreting the French Revolution.* Translated by Elborg Forster. Cambridge, England, and London, 1981.

Fusco, Peter. "Allegorical Sculpture." In *The Romantics to Rodin: French Nineteenth-Century Sculpture from North American Collections,* edited by Peter Fusco and H. W. Janson, 60–69. Los Angeles and New York, 1980.

Gambrell, Jamey. "The Wonder of the Soviet World." *New York Review of Books* 61, no. 21 (December 22, 1994), 30–35.

Geertz, Clifford. *Local Knowledge: Further Essays in Interpretive Anthropology.* New York, 1983.

Golomstock, Igor. *Totalitarian Art in the Soviet Union, the Third Reich, Fascist Italy and the People's Republic of China.* New York, 1990.

Gombrich, E. H. *Art and Illusion: A Study in the Psychology of Pictorial Representation.* Princeton, 1984.

Gombrich, E. H., and E. Kris. *Caricature.* Harmondsworth, 1940.

The Great Utopia: The Russian and Soviet Avant-Garde, 1915–1932. New York, 1992.

Groys, Boris. "The Birth of Socialist Realism from the Spirit of the Avant-Garde." In *The Culture of the Stalin Period,* edited by Hans Günther, 122–148. New York, 1990.

———. *The Total Art of Stalinism: Avant-Garde, Aesthetic Dictatorship, and Beyond.* Princeton, 1992.

Guerman, Mikhail, ed. *Art of the October Revolution.* New York, 1979.

Guldberg, Jørn. "Socialist Realism as Institutional Practice: Observations on the

Interpretation of the Works of Art of the Stalin Period." In *The Culture of the Stalin Period,* edited by Hans Günther, 149–177. New York, 1990.

Günther, Hans. "Geroi v totalitarnoi kul'ture." In *Agitatsiia za schast'e: Sovetskoe iskusstvo stalinskoi epokhi,* compiled by Hubertus Gassner, 71–76. Dusseldorf-Bremen, 1994.

———, ed. *The Culture of the Stalin Period.* New York, 1990.

Gushchin, A. S. *Izo-iskusstvo v massovykh prazdnestvakh i demonstratsiiakh.* Moscow, 1930.

Hall, James. *Dictionary of Subjects and Symbols in Art.* New York, 1974.

Hanotelle, Micheline. *Rodin et Meunier: Relations des sculpteurs français et belges à la fin du XIX siècle.* Paris, 1982.

Hellberg, Elena F. "Folklore, Might, and Glory." *Nordic Journal of Soviet and East European Studies* 3, no. 2 (1986), 9–20.

———. "The Hero in Popular Pictures: Russian Lubok and Soviet Poster." In *Populäre Bildmedien: Vorträge des 2. Symposiums für ethnologische Bildforschung Rheinhausen bei Göttingen,* edited by Rolf Wilhelm Brednich and Andreas Hartmann, 171–191. Göttingen, 1989.

Herbert, Eugenia W. *The Artist and Social Reform: France and Belgium, 1885–1898.* New Haven, 1961.

Hindus, Maurice. *Red Bread: Collectivization in a Russian Village.* Bloomington and Indianapolis, 1988.

Hobsbawm, Eric. "Man and Woman in Socialist Iconography." *History Workshop* 6 (Autumn 1978), 121–138.

———. "Sexe, symboles, vêtements et socialisme." *Actes de la recherche en sciences sociales* no. 23 (September 1978), 2–18.

Hobsbawm, Eric, and Terence Ranger, eds. *The Invention of Tradition.* Cambridge, England, and London, 1983.

Hubbs, Joanna. *Mother Russia: The Feminine Myth in Russian Culture.* Bloomington, 1988.

Hunt, Lynn. *Politics, Culture and Class in the French Revolution.* Berkeley and Los Angeles, 1984.

———. *The Family Romance of the French Revolution.* Berkeley and Los Angeles, 1992.

Isakov, S. *1905 god v satire i karikature.* Moscow, 1928.

Ivanits, Linda J. *Russian Folk Belief.* Armonk, New York, and London, 1989.

Ivanov, V. V., and V. N. Toporov. "Problema funktsii kuznetsa v svete semioticheskoi tipologii kul'tur." In *Materialy vsesoiuznogo simpoziuma po vtorichnym modeliruiushchim sistemam I (5),* 87–90. Tartu, 1974.

Kantorowicz, Ernest H. *The King's Two Bodies: A Study in Medieval Political Theology.* Princeton, 1957.

Kenez, Peter. *The Birth of the Propaganda State: Soviet Methods of Mass Mobilization, 1917–1929.* Cambridge, England, and London, 1985.

———. "Black and White: The War on Film." In *Culture and Entertainment in*

Wartime Russia, edited by Richard Stites, 157–175. Bloomington and Indianapolis, 1995.

———. *Cinema and Soviet Society 1917–1953.* Cambridge, England, 1992.

Khripounoff, Alexis. "Un parcours parmi les timbres, des origines à nos jours." In *Russie–URSS, 1914–1991: Changements de regards,* edited by Wladimir Berelowitch and Laurent Gervereau, 248–254. Paris, 1991.

Kimerling, Elise. "Civil Rights and Social Policy in Soviet Russia, 1918–1936." *Russian Review* 41, no. 1 (January 1982), 24–46.

Klingender, F. D. *Art and the Industrial Revolution.* London, 1947.

Koselleck, Reinhart. *Futures Past: On the Semantics of Historical Time.* Cambridge, Massachusetts, and London, 1985.

Kravchenko, E. K. *Krest'ianka pri sovetskoi vlasti.* Moscow, 1932.

Krupskaia, Nadezhda. *Pedagogicheskie sochineniia v desiati tomakh.* Vol. 7. Moscow, 1959.

Kumanev, Viktor. *Sotsializm i vsenarodnaia gramotnost': Likvidatsiia massovoi negramotnosti v SSSR.* Moscow, 1967.

Kuromiya, Hiroaki. *Stalin's Industrial Revolution: Politics and Workers, 1928–1932.* Cambridge, England, 1988.

Lafite, Bernard. "Soviet 'Literary Policy' on the Eve of the 'Great Turning Point': Terms and Stakes (Results of a Study of 403 Articles on Art Published in *Pravda* in 1929)." *Sociocriticism* 2, no. 1 (October 1986), 173–194.

Lane, Christel. *The Rites of Rulers: Ritual in Industrial Society—the Soviet Case.* Cambridge, England, and London, 1981.

Leniashin, Vladimir. *Soviet Art 1920s–1930s.* New York, 1988.

Lewin, Moshe. "The Civil War: Dynamics and Legacy." In *Party, State and Society in the Russian Civil War: Explorations in Social History,* edited by Diane P. Koenker, William G. Rosenberg, and Ronald Grigor Suny, 399–423. Bloomington, 1989.

———. *The Making of the Soviet System: Essays in the Social History of Interwar Russia.* New York, 1985.

———. *Russian Peasants and Soviet Power: A Study of Collectivization.* Evanston, 1968.

Leyda, Jay. *Kino: A History of the Russian and Soviet Film.* London, 1960.

Lih, Lars T. *Bread and Authority in Russia, 1914–1921.* Berkeley and Los Angeles, 1990.

Lincoln, Bruce. "Soviet Political Posters: Art and Ideas for the Masses." *History Today* 26, no. 5 (1976), 302–309.

Lobanov-Rostovsky, Nina. *Revolutionary Ceramics: Soviet Porcelain 1917–1927.* New York, 1990.

———. "Soviet Porcelain of the 1920s: Propaganda Tool." In *The Great Utopia: The Russian and Soviet Avant-Garde, 1915–1932,* 622–633. New York, 1992.

Lodder, Christina. *Russian Constructivism.* New Haven, 1983.

———. "Lenin's Plan for Monumental Propaganda." In *Art of the Soviets,* edited

by Matthew Cullerne Bown and Brandon Taylor, 16–32. Manchester and New York, 1993.

Lotman, Iurii M., and Boris A. Uspenskii [Uspensky]. "Binary Models in the Dynamics of Russian Culture (to the End of the Eighteenth Century)." In *The Semiotics of Russian Cultural History,* edited by Alexander D. and Alice Stone Nakhimovsky, 30–66. Ithaca, 1985.

Lubok. Russische Volksbilderbogen. 17. bis 19. Jahrhundert. Leningrad, 1984.

Lubok: Russkie narodnye kartinki xvii–xviii vv. Moscow, 1968.

Lunacharskii, A. V. "Lenin i iskusstvo (vospominaniia)." *Khudozhnik i zritel'* (Moscow) 2–3 (1924), 4–10.

Maiakovskii, V. V. *Groznyi smekh: Okna satiry ROSTA.* Moscow, 1938.

———. *V. V. Maiakovskii: Sochineniia v dvukh tomakh.* Vol. 2. Moscow, 1988.

Mally, Lynn. *Culture of the Future: The Proletkult Movement in Revolutionary Russia.* Berkeley and Los Angeles, 1990.

Marx, Karl. *Karl Marx: Selected Writings.* Edited by David McLellan. Oxford, 1977.

Maslennikov, Nikolai. *Plakat.* Moscow, 1930.

Mason, Tim. "The Domestication of Female Socialist Icons: A Note in Reply to Eric Hobsbawm." *History Workshop* 7 (1979), 170–175.

Medvedev, Roy. *Let History Judge: The Origins and Consequences of Stalinism.* New York, 1989.

Minassian, Taline Ter. "L'affiche stalinienne: Du photomontage productiviste aux appels patriotiques." In *Russie–URSS, 1914–1991: Changements de regards,* edited by Wladimir Berelowitch and Laurent Gervereau, 132–139. Paris, 1991.

Mitchell, W. J. T. *Iconology: Image, Text, Ideology.* Chicago and London, 1986.

———, ed. *The Language of Images.* Chicago, 1980.

Mitskevich, S. I. *Al'bom revoliutsionnoi satiry 1905–1906 gg.* Moscow, 1930.

Moor, Dmitrii. *Azbuka krasnoarmeitsa.* Moscow, 1921.

———. *Ia Bolshevik!* Moscow, 1967.

Naiman, Eric. *Sex in Public: The Incarnation of Early Soviet Ideology.* Princeton, 1997.

Nemiro, O. *V gorod prishel prazdnik: Iz istorii khudozhestvennogo oformleniia sovetskikh massovykh prazdnestv.* Leningrad, 1973.

Netting, Anthony. "Images and Ideas in Russian Peasant Art." *Slavic Review* 35, no. 1 (March 1976), 48–68.

Nochlin, Linda. *Women, Art, and Power and Other Essays.* New York, 1988.

Nora, Pierre. *Les lieux de mémoire.* Vols. 1–2. Paris, 1984–1986.

Nove, Alec. *An Economic History of the U.S.S.R.* Middlesex, 1982 [1969].

Novikov, A. V. *Leniniana v plakate.* Moscow, 1970.

Novosel'skii, A. A., ed. *Materialy po istorii SSSR: Dokumenty po istorii sovetskogo obshchestva.* Moscow, 1955.

Oginskaia, Larisa. *Gustav Klutsis.* Moscow, 1981.

Oinas, Felix J. "The Political Uses and Themes of Folklore in the Soviet Union." In *Folklore, Nationalism and Politics,* edited by F. J. Oinas, 77–96. Columbus, Ohio, 1972.

Oinas, Felix J., and Stephen Soudakoff, eds. *The Study of Russian Folklore.* The Hague and Paris, 1975.

Okhochinskii, V. *Plakat: Razvitie i primenenie.* Vol. 1. Leningrad, 1927.

Onasch, Konrad. *Icons.* London, 1963.

Ouspensky, Leonid, and Vladimir Lossky. *The Meaning of Icons.* Translated by G. E. H. Palmer and E. Kadloubovsky. Crestwood, New York, 1983.

Ozouf, Mona. *Festivals of the French Revolution.* Translated by Alan Sheridan. Cambridge, Massachusetts, 1988.

Panofsky, Erwin. *Meaning in the Visual Arts: Papers in and on Art History.* Woodstock, New York, 1974.

———. *Studies in Iconology: Humanistic Themes in the Art of the Renaissance.* New York, 1962.

Papernyi, Vladimir. *Kul'tura "Dva."* Ann Arbor, 1985.

Paris–Moscou 1900–1930. Paris, 1979.

Paulson, Ronald. *Representations of Revolution, 1789–1820.* New Haven and London, 1983.

Pavlov, G. N., ed. *The Soviet Political Poster.* Leningrad, 1976.

Pavlovskii, B.V. *V. I. Lenin i izobrazitel'noe iskusstvo.* Leningrad, 1974.

Peterburg–Petrograd–Leningrad v otkrytkakh, 1895–1945 gg. Leningrad, 1984.

Pethybridge, Roger. *The Social Prelude to Stalinism.* London, 1974.

Philippe, Robert. *Political Graphics: Art as a Weapon.* New York, 1982.

Piat'desiat let sovetskogo iskusstva (1917–1967): Skul'ptura. Moscow, 1967.

Plakate der Russischen Revolution, 1917–1929. Berlin, 1966.

Polonskii, Viacheslav. "Russkii revoliutsionnyi plakat." *Pechat' i revoliutsiia* 2 (April–June 1922), 56–77.

———. *Russkii revoliutsionnyi plakat.* Moscow, 1925.

Preminger, Alex, ed. *Princeton Encyclopedia of Poetry and Poetics.* Princeton, 1974.

Reeder, Roberta. "The Interrelationship of Codes in Maiakovskii's Rosta Poster." *Soviet Union* 7, nos. 1–2 (1980), 28–52.

Rigby, T. H. *Communist Party Membership in the U.S.S.R. 1917–1967.* Princeton, 1968.

Robin, Régine. *Socialist Realism: An Impossible Aesthetic.* Stanford, 1992.

———. "Stalinisme et culture populaire." In *Culture et révolution,* by Marc Ferro et al., 147–163. Paris, 1989.

———, ed. "Soviet Literature of the Thirties: A Reappraisal." In *Sociocriticism* 2, no. 1 (October 1986).

Robinskaia, F. *Sovetskii lubok.* Moscow, 1929.

Rossman, Jeffrey. "Politics, Culture and Identity in Revolutionary Russia: A Reading of the Life and Works of Viacheslav Polonskii." Unpublished seminar paper, Department of History, University of California, Berkeley, May 1990.

Rotberg, Robert I., and Theodore K. Rabb. *Art and History: Images and Their Meaning.* Cambridge, England, 1986.

Rowell, Margit, and Angelica Zander Rudenstine. *Art of the Avant-Garde in Russia: Selections from the George Costakis Collection.* New York, 1981.

Russian Constructivist Posters. New York, 1992.

Russkaia satiricheskaia periodika 1905–1907 gg.: Svodnyi katalog. Moscow, 1980.

Russkie revoliutsionnye pesni. Moscow, 1952.

Sartorti, Rosalinde. "On the Making of Heroes, Heroines, and Saints." In *Culture and Entertainment in Wartime Russia,* edited by Richard Stites, 176–193. Bloomington and Indianapolis, 1995.

Schutz, Hans J., ed. *Der wahre Jacob. Ein halbes Jahrhundert in Faksimiles.* Berlin, 1977.

Scott, Joan Wallach. *Gender and the Politics of History.* New York, 1988.

Seriot, Patrick. "On Officialese." *Sociocriticism* 2, no. 1 (1986), 195–219.

Sewell, William, Jr. *Work and Revolution: The Language of Labor from the Old Regime to 1848.* Cambridge, England, 1980.

Shleev, V. V., ed. *Revoliutsiia 1905–1907 gg. i izobrazitel'noe iskusstvo.* 4 vols. Moscow, 1977–1989.

Sidorov, A. A. *Russkaia grafika za gody revoliutsii, 1917–1922.* Moscow, 1923.

Siegelbaum, Lewis H. *Stakhanovism and the Politics of Productivityin the USSR, 1935–1941.* Cambridge, England, 1988.

Sovetskaia kul'tura: Itogi i perspektivy. Moscow, 1924.

Sovetskie mastera satiry. Moscow and Leningrad, 1946.

Sovetskie pesni. Moscow, 1977.

Sovetskii politicheskii plakat / The Soviet Political Poster. Moscow, 1984.

Soviet Political Art. Harmondsworth, 1985.

The Soviet Political Poster. Middlesex, 1985.

Stites, Richard. "Adorning the Revolution: The Primary Symbols of Bolshevism, 1917–1918." *Sbornik: Study Group of the Russian Revolution* (Leeds) 10 (1984), 39–42.

———. "The Origins of Soviet Ritual Style: Symbol and Festival in the Russian Revolution." In *Symbols of Power: The Esthetics of Political Legitimation in the Soviet Union and Eastern Europe,* edited by Claes Arvidsson and Lars Erik Blomqvist, 23–42. Stockholm, 1987.

———. *Revolutionary Dreams: Utopian Vision and Experimental Life in the Russian Revolution.* New York and Oxford, 1989.

———. *The Women's Liberation Movement in Russia: Feminism, Nihilism, and Bolshevism, 1860–1930.* Princeton, 1978.

———, ed. *Culture and Entertainment in Wartime Russia.* Bloomington and Indianapolis, 1995.

Sto let russkoi pochtovoi marki 1858–1958. Moscow, 1958.

Terras, Victor, ed. *Handbook of Russian Literature.* New Haven, 1985.

Théophile-Alexandre Steinlen. Turin, 1980.

Timasheff, Nicholas S. *The Great Retreat: The Growth and Decline of Communism in Russia.* New York, 1946.

Tokarev, S. A., ed. *Mify narodov mira. Entsiklopediia.* 2 vols. Moscow, 1987–1988.

Tolkovyi slovar' zhivogo velikorusskago iazyka Vladimira Dalia. Moscow, 1903.

Tolstoi, V. P., ed. *Agitatsionno-massovoe iskusstvo: Oformlenie prazdnestv, 1917–1932.* Moscow, 1984.

Tolstoy, Vladimir, Irina Bibilova, and Catherine Cooke, eds. *Street Art of the Revolution: Festivals and Celebrations in Russia 1918–1933.* London, 1990.

Tsekhnovitser, Orest. *Prazdnestva revoliutsii.* Leningrad, 1931.

Tucker, Robert C. *Stalin in Power: The Revolution from Above, 1928–1941.* New York, 1990.

Tumarkin, Nina. *Lenin Lives! The Lenin Cult in Soviet Russia.* Cambridge, Massachusetts, 1983.

Tupitsyn, Margarita. "Gustav Klutsis: Between Art and Politics." *Art in America* (January 1991), 41–50.

———. "Gustav Klutsis: Scenarios of Authorial Pursuits." *The Print Collector's Newsletter* 22, no. 5 (November–December 1991), 161–166.

———. *Margins of Soviet Art: Social Realism to the Present.* Milan, 1989.

———. "Superman Imagery in Soviet Photography and Photomontage." In *Nietzsche and Soviet Culture: Ally and Adversary,* edited by Bernice Glatzer Rosenthal, 287–310. Cambridge, England, 1994.

Ulasevich, Viktoriia, ed. *Zhenshchina v kolkhoze.* Moscow, 1930.

Ushakov, D. N., ed. *Tolkovyi slovar' russkogo iazyka.* Moscow, 1935.

Uspenskii [Uspensky], Boris A. *Filologicheskie razyskaniia v oblasti slavianskikh drevnostei (relikty iazychestva v vostochnoslavianskom kul'te Nikolaia Mirlikiiskogo).* Moscow, 1982.

———. *The Semiotics of the Russian Icon.* Edited by Stephen Rudy. Lisse, Belgium, 1976.

V. I. Lenin i izobrazitel'noe iskusstvo. Dokumenty. Pis'ma. Vospominaniia. Moscow, 1977.

Valkenier, Elizabeth Kridl, ed. *The Wanderers: Masters of Nineteenth-Century Russian Painting: An Exhibition from the Soviet Union.* Dallas, 1990.

Veimarn, B. V., and O. I. Sopotinskii, eds. *Sovetskoe izobrazitel'noe iskusstvo 1917–1941.* Moscow, 1977.

Viktor Semenovich Ivanov. Moscow, 1988.

Viola, Lynne. "*Bab'i Bunty* and Peasant Women's Protest during Collectivization." *Russian Review* 45, no. 1 (January 1986), 23–42.

———. *The Best Sons of the Fatherland: Workers in the Vanguard of Soviet Collectivization.* New York, 1987.

Volin, Lazar. *A Century of Russian Agriculture: From Alexander II to Khrushchev.* Cambridge, Massachusetts, 1970.

von Geldern, James. *Bolshevik Festivals, 1917–1920.* Berkeley and Los Angeles, 1993.

Waters, Elizabeth. "The Female Form in Soviet Political Iconography, 1917–1932." In *Russia's Women: Accommodation, Resistance, Transformation,* edited by Barbara Evans Clements, B. A. Engel, and Christine D. Worobec, 225–242. Berkeley and Los Angeles, 1991.

White, Stephen. *The Bolshevik Poster.* New Haven and London, 1988.

———. "The Political Poster in Bolshevik Russia." *Sbornik: Study Group on the Russian Revolution* (Leeds) 8 (1982), 24–37.

Wilentz, Sean, ed. *Rites of Power: Symbolism, Ritual, and Politics Since the Middle Ages.* Philadelphia, 1985.

Williams, Albert Rhys. *Through the Russian Revolution.* London, 1923.

Williams, Robert C. *Artists in Revolution: Portraits of the Russian Avant-garde, 1905–1925.* Bloomington, 1977.

Wortman, Richard S. "Moscow and Petersburg: The Problem of Political Center in Tsarist Russia, 1881–1914." In *Rites of Power: Symbolism, Ritual, and Politics Since the Middle Ages,* edited by Sean Wilentz, 244–274. Philadelphia, 1985.

———. *Scenarios of Power: Myth and Ceremony in Russian Monarchy.* Vol. 1. Princeton, 1995.

Yampolsky, Mikhail. "Quand les centaures deviennent icones." In *Russie–URSS, 1914–1991: Changements de regards,* edited by Wladimir Berelowitch and Laurent Gervereau, 26–34. Paris, 1991.

———. "The Rhetoric of Representation of Political Leaders in Soviet Culture." *elementa* 1, no. 1 (1993), 101–113.

———. "Vlast' kak zrelishche vlasti." *Kinostsenarii: Literaturno-khudozhestvennyi al'manakh* 5 (1989), 176–187.

Zemenkov, B. *Udarnoe iskusstvo okon satiry.* Moscow, 1930.

ILLUSTRATION CREDITS

Kollektsiia plakatov (Poster Collection), Russian State Library, Moscow: plates 4–5; figs. 1.14–1.15, 2.9, 2.12, 3.6, 3.8–3.9, 3.11–3.12, 4.1–4.4, 4.6, 4.8, 4.12–4.13, 4.15–4.17, 5.1, 5.5–5.6, 5.13, 5.15, 5.17, 6.5–6.7, 6.9–6.10, 6.12–6.13, 6.15

Mikhail Mikhailovich Cheremnykh, edited by O. Savostiuk and B. Uspenskii (Moscow, 1970): fig. 2.14

Modernism Gallery, San Francisco, California: jacket illustration, fig. 4.11

Muzei revoliutsii (Museum of the Revolution), Moscow: figs. 1.5, 1.7, 1.9, 4.5, 4.9, 5.3, 6.2–6.3

Russian and Soviet Poster Collection, Hoover Institution Archives, Stanford, California: plates 1–3, 6–8; figs. 1.1–1.4, 1.8, 1.10–1.13, 1.17, 2.1–2.8, 2.10–2.11, 2.13, 3.1–3.5, 3.7, 3.9, 3.10, 4.14, 5.2, 5.4, 5.7–5.12, 5.14, 5.16, 6.1, 6.4, 6.8, 6.11

Sovetskoe izobrazitel'noe iskusstvo, 1917–1941, edited by B. V. Veimarn and O. I. Sopotsinskii (Moscow, 1977): figs. 1.6, 1.16, 4.7, 4.10

Viktor Semenovich Ivanov (Moscow, 1988): fig. 6.14

INDEX

mopolitanism" in, 263; and chauvinism, 249, 263; direct gaze in, 260; "divine order" in, 243–44, 251, 258, 262, 264; dominant emotions in, 260; encouragement of consumer aspirations in, 249–50; and High Stalinism, 7, 9–10, 243, 249, 251; iconography of enemies in, 263–64; images of women in, 261–62; imperial ethos and patriotism in, 167, 253, 254, 255–57, 330 n.52; maternal themes in, 262; nationalist and folk revival in, 222, 249, 257; new Soviet man and woman in, 259; as secular icons, 258; and socialist realism, 7; use of diagonal in, 104, 259–60; use of perspectival distortion in, 254; use of "we/they" format in, 264

Power, 2, 8, 9, 11, 19, 68, 255; aestheticization of, 148, 309 n.61; iconography of, 19; social construction of, 18; symbolic representation of, 45–46, 253, 314 n.121

Pravda, 5, 36, 114, 141, 156, 158, 160, 244; Demchenko's letter in, 121

Priest, 202, 204; attributes of, 189; as enemy, 188

Proletariat, 2, 9, 27, 38, 74, 150, 188; as collective hero, 22; "dictatorship" of, 74, 79; displaced by Stalin, 162, 255; hegemonic status of, 28; male domination of, 23; NKVD as "unsheathed sword" of, 221; as Prometheus, 33; and *rabotnitsa,* 77; sacralization of, 43. See also Worker; Working class

Prometheus, 33–34, 196, 289 n.55; sovietization of myth, 36

Prorokov, Boris: *Fascism—the Enemy of Culture,* 220

Provisional Government, 2, 65, 196

Prozhektor, 152

Rabotnitsa (women worker), 8, 66, 67, 75–76, 78, 82, 84

Radin, L.: *Boldly, Comrades, March in Step!,* 69, fig. 2.1

Raise Higher the Banner of Marx, Engels, Lenin, and Stalin! (Klutsis), 158–59, plate 5

Ranger, Terence, 18

Rats, 209, 219, 221, 263

The Reality of Our Program Is Living People, You and I (Klutsis), 162–63, fig. 4.15

Rebellions, 107, 300 n.30; of peasant women, 109–10; reaction of authorities to, 109. See also *Bab'i bunty*

Red Army, 2, 152, 206; breast badge, 25; newspapers, 5; and Red Corner, 148; soldier, 28, 33, 44, 66, 81, 223

Red star, 3, 33, 68, 152; as official emblem, 24, 25

Refectory (Perov), 190

Repin, Ilya, 327 n.4; *Barge Haulers on the Volga,* 243–44

Results of the Five Year Plan Showed That the Working Class Is As Capable of Building the New As It Is Capable of Destroying the Old (Moor), 216

Retribution, 205, fig. 5.8

Revolution of 1905, 22, 24, 68, 198

Reznichenko, A.: *The Stakhanovite Movement,* 45, fig. 1.17

Rodina, 31, 71, 72, 255–57; etymology of, 165; and Russia, 256; and Stalin, 255

Roman republic, 67, 68, 69, 70; and notion of citizenship, 74

Rosta. See Russian Telegraph Agency

Rosta Windows, 5, 199–200, 209, 292 n.3, 321 n.55; and *lubok,* 66, 199; and satire, 81, 206

Rotov, Konstantin: *"Shliapy" in the Collective Farm,* 213–14

Roziakhovskii: *Long Live the Creator of the Constitution,* 164–65

Ruination (Lebedeva), 190

Russia and Her Soldier, 71, fig. 2.4

Russia—for Truth, 71, 194, fig. 2.5

Russian Orthodox Church, 4, 148; and all-seeing eye, 42, 159; art of, 23; and color red, 106; icons of, 4, 12, 32, 33, 118, 144, 146, 147, 166, 258; imagery and pageants of, 22, 70; and incorruptibility of bodies of saints, 149; and Mother of God, 6, 293 n.7; and use of *podlinnik,* 66; and visual culture, 4

Russian society: class structure, 37; rural population, 79; workers in, 44–45

Russian State Library, 15

Russian Telegraph Agency (Rosta), 5, 142, 199, 200
Russo-Japanese War, 66, 71, 197
Rytsar', 33

Sacred center, 9, 45–46, 162, 255; shift of, 8. *See also* Stalin
Saints, 66
Sans-culottes, 21, 68; symbolized by Hercules, 33. *See also* French Revolution
Satire and caricature, 9, 198, 209, 212, 214, 216, 264; based on class markers, 214–16; in Civil War posters issued by Whites, 206–7; of female peasant, 81; visual conventions of, in posters, 198; Western European sources of, 200
Scott, Joan Wallach, 8, 304 n.83
Sculpture. *See* Monumental sculpture
Second Five Year Plan, 117, 118–19; and nationalist and folk revival, 118; and "new life" in countryside, 117–20
Seletskii, Vasilii: *Long Live the Social Revolution and the Democratic Republic,* 194–95
Semenov, Ivan: *The Goal of Capitalism Is Always the Same,* 263–64, fig. 6.15
Serpent, 32, 71, 72, 73, 153, 194, 195, 295 n.36. *See also* Hydra
Sewell, William H., 15
Shagin, Ivan: *Under the Leadership of the Great Stalin—Forward to Communism!,* 253–54, plate 8
Shantyko, N., 17, 325 n.130
Shatan, D. I.: *Conclusion of a Union,* 24, 68
Shchuko, Vladimir: statue of Lenin at Finland Station, 150–51, fig. 4.7
Shkulev, Filip, 30, 287 n.33
Shliapa, 213
"Shliapy" in the Collective Farm (Rotov), 213–14
Shock Work at Reaping Befits a Bolshevik Harvest (Voron), 117, fig. 3.10
Shock Worker Women of Factories and State Farms, Enter the Ranks of the Communist Party (Bolshevik) (Kulagina), 113–14
Shock workers, 114; campaigns, 35, 37, 106; as heroes, 36; and Nikolai Vasil'evich Lebedev, 119
Siegelbaum, Lewis, 36, 290 n.76

Silhouette, 39, 40, 41, 146, 147, 156, 168, 289 n.61; criticized as "schematic," 35–36; Stalin in, 120, 252
Simakov, Ivan: *Long Live the Proletarian Holiday May 1,* 81
Simplicissimus, 200
Sitaro, Aleksei: *Toward a Prosperous Cultured Life,* 116, fig. 3.9
Snakes, 141, 194, 217, 220, 221, 289 n.53, 324 n.101, 326 n.139
Socialist realism, 7, 38, 105, 119, 259; and photomontage, 40; of postwar era, 254
Sokolov, A. L.: *Let the Ruling Classes Shudder before the Communist Revolution,* 145–46, 147, fig. 4.3
Sokolov, Nikolai, 11, 209
Solov'ev, Mikhail: *Under the Leadership of the Great Stalin—Forward to Communism!,* 253–54, plate 8
Sosnovskii, Lev, 141
Soviet Turnip (Moor), 219
Spartak, 25
A Specter Haunts Europe, the Specter of Communism, 143–44, fig. 4.2; 307 n.38
Spider, 196, 197, 202, 205–6, 218
Spoilage Is a Present to the Class Enemy (Korshunov), 217, fig. 5.13
St. George, 32, 65, 70–71, 72, 194, 221, 294 n.26, 311 n.89
St. George the Conqueror (L. Trotsky) (Deni), 152–53
Stakhanov, Aleksei, 36, 45, 166. *See also* Stakhanovites
The Stakhanovite Movement (Reznichenko), 45, fig. 1.17
Stakhanovites: attributes of, 39; campaigns, 36, 37, 45; as heroes, 36; and Mariia Demchenko, 120, 166; of postwar era, 247
Stalin: accolades for, 163–64, 168, 254, 316 n.153; as aging leader, 252, 255, 259; with arm outstretched, 165–66; and cap, 143, 158, 252; cult of, 10, 153, 155–58, 164–65, 167, 168, 253, 255, 316 nn.153,154; and direct gaze, 159, 162; displacement of proletariat by, 162, 255; as Father of the Peoples, 43, 257; as generalissimo, 252, 253; as Great Helmsman, 45, 254; as Hephaestus, 46; and individual heroes, 36,

Compositor:	G & S Typesetters
Text:	12/14.5 Adobe Garamond
Display:	Perpetua and Adobe Garamond
Printer:	Data Reproductions
Binder:	John H. Dekker and Sons